DOCUMENTARY FILM
AN INSIDER'S PERSPECTIVE

EDITED BY **DR. MARY CARDARAS**

CALIFORNIA STATE UNIVERSITY - EAST BAY

 FIRST EDITION

 cognella® | ACADEMIC PUBLISHING

Bassim Hamadeh, CEO and Publisher
Michael Simpson, Vice President of Acquisitions and Sales
Jamie Giganti, Senior Managing Editor
Miguel Macias, Graphic Designer
Kristina Stolte, Senior Field Acquisitions Editor
Alexa Lucido, Licensing Coordinator
Rachel Singer, Associate Editor
Kat Ragudos, Interior Designer

CONTENTS

Dedicated to my students—past, present, and future—who have always inspired me and influenced the work that I do.

You were, are, and always will be the best part of my day on campus.

"There are no rules in this young art form, only decisions about where to draw the line and how to remain consistent to the contract you will set up with your audience."

–Michael Rabiger
Founder, Documentary Center of
Columbia College, Chicago

"Anyone who believes that every individual film must represent a 'balanced' picture knows nothing about either balance or picture."

–Edward R. Murrow
Broadcast Journalist,
CBS News

"Tell me a **story**. The issue was evil in the world. The **story** was Noah."

–Don Hewitt
Creator, 60 Minutes

"The documentary film can be seen to function as a prophet, explorer, painter, advocate, bugler, prosecutor, observer, catalyst, guerrilla, performer, therapist, spin doctor."

–Henrik Juel
Scholar, Technical University
of Denmark

INTRODUCTION

FROM THE TIME I was a young girl, I have always loved the movies. In fact, I remember the first movie I ever saw, at least in a movie theater. It was *The Miracle Worker*, the 1962 film starring Patty Duke, which chronicled the life of Helen Keller. It was one of our early biopics. I was only seven years old as I sat on my father's lap to watch a matinee at the old State Theater in downtown Gary, Indiana.

I came to documentary film later in life and remember the two movies that channeled my intense interest in—and cultivated my love for—documentary film. They were *The Times of Harvey Milk*, the 1984 film directed by Bob Epstein, which told the story of the man who was the first openly gay supervisor in San Francisco and was probably the first, or one of the first, gay politicians in the country. Harvey Milk was murdered along with the mayor of San Francisco, George Moscone, in 1978. It was historically significant, contributed to the discourse about gay rights in America, and was, above all else, extremely moving.

The other film was *Paris is Burning*, the 1990 Jennie Livingston film, featuring the incomparable Pepper LaBeija, which told the story of the people and subculture of African American, transgender, and Latino drag queens in New York City, and the "ball culture" that they celebrated. It, too, was significant and inspired a conversation "about race, gender, class, and sexuality in America." It, too, was moving and poignant. In fact, it was so much so for me that it inspired a five-part series about gender, which I produced for my television station in Philadelphia. It won an Emmy, surprisingly drove up our ratings, and garnered accolades from our colleagues in print journalism. This was long before we realized that documentaries could attract an audience and make money.

After a long career in journalism, I now teach, among other courses, documentary film studies. It has been a joy to teach this course about this particular genre of filmmaking. Most students come to this course skeptical and jaded owing to their impression of documentaries, which is that they are boring and slow. They have no or little idea about what they are, or about the enrichment and knowledge they can provide—and how they will most likely be transformed into avid documentary fans who seek them out and plunk down money to experience them in a movie theater. For a teacher, that is gratification enough.

I have never found a book on documentary film that I liked well enough for my students, so I was thrilled to have been able to curate and edit this anthology about documentary film written by some people I greatly admire and who direct and produce documentaries. This book is for my students and all students and their teachers who want to explore documentary film with the scholars who know about them, the people who promote, discuss, and write about them, and the people who make them.

I myself know—after years of paying to see documentaries, studying them, discussing them, and teaching about them—that they can change lives. And perspectives. They can change attitudes on the important issues of our time. They educate. They shine light in dark places we may have otherwise never known about. They introduce us to people we would have never met. They can inspire us and they can motivate people to action. They are powerful.

Documentaries are important because they provide mirrors for us. They are reflections of us as they visually amplify our society and the people in it to tell the stories of their conflicts, life situations, and predicaments. They can also tell the stories about powerful and elite people who may abuse their positions in government, business, and education. They sometimes tell the stories of human beings in all their misery or in all their glory, as they struggle to create a better world. We need to know about all these stories so that we can also help to make the world a better place. Being aware of these stories, understanding them, and talking about them all represent a first step in moving for social change and justice.

Documentary film can be artistry, works of art, or about art. They can be truth-telling, fact based, and pieces of journalism. They can be advocacy or advocate. They can also be entertainment.

And they are necessary.

MARY CARDARAS, PhD
assistant professor, journalist, documentary producer

1 A BRIEF HISTORY OF DOCUMENTARY FILM

BY *TED BARRON*

DOCUMENTARY INQUIRY WAS AT the root of cinematic form as the medium developed in the late 1800s. Artists, scientists, and inventors all played roles in determining what would ultimately become film form. British photographer Eadweard Muybridge was renowned for his motion picture studies, including his famed phase photography experiment in 1879. Muybridge arranged a multiple camera setup around the perimeter of a racetrack to demonstrate that all four hooves of a horse were momentarily off the ground when in full gallop. French scientist Etienne-Jules Marey developed the chronophotographic gun in 1882 to capture the successive motion of birds in flight; it recorded shots at a rate of twelve images per second. American inventor Thomas Edison filmed a series of twenty- to forty-second, constructed yet observational works in the confines of his noted Black Maria studio, which was designed to help showcase the phonograph since Edison initially thought moving images were a mere gimmick. In each of these examples of pre-cinematic inquiry, the unique power of the moving image suggests a greater indexical representation of the natural world than other media or art forms had achieved thus far.

ACTUALITIES

As Tom Gunning notes in his essay, "The Cinema of Attraction," early cinema was defined by its focus on "attractions" before narrative became widely incorporated into film form. In its earliest days, the space of the cinema was not unlike a carnival with a liveness to the audience experience that has since dissipated. Films of this period included trick films that used visual effects such as stop-motion photography to create the illusion of magic. This period also included actualities, single-shot films that whether staged or spontaneous captured an event in everyday life. Film historians

credit Auguste and Louis Lumière as the first filmmakers, based on the premiere exhibition of *Workers Leaving the Lumière Factory* in December 1895. This milestone film is an exemplar of the tensions that continue to challenge definitions of documentary film. In terms of content, the film could not be more simple and mundane: the doors to a factory open as workers exit. Yet the scene is clearly staged, as the subjects of the film follow a pre-determined pattern that allows the Lumières camera to capture an unobstructed view of the exiting process.

The notion of actualities as attractions becomes more evident in subsequent Lumière films such as *Arrival of a Train at a Station* and *Demolition of a Wall*. The first exhibitions of *Arrival of a Train at a Station* were noted for frightening audiences with the illusion that the subject of the film, the arriving train, would burst through the cinema screen. *Demolition of a Wall* captures workers tearing down a wall using sledgehammers. In early exhibitions of the film, projectionists would reload the projector in between screenings by running the film backward. When this process was projected, it gave the illusion of the demolished wall being reconstructed, which proved popular with audiences fascinated with the new possibilities of cinema.

With the monumental success of D. W. Griffith's *Birth of a Nation* in 1915, the cinema experience forever changed. Films expanded from the short films of the early 1900s to feature-length (though most were not quite as long as Griffith's epic) and storytelling replaced the more spectacular interests of the trick films and actualities. When considering the history of documentary, it is significant that the first feature film to achieve great notoriety was a historical fiction film. Griffith's adaptation of *The Klansman* marked the fiftieth anniversary of the end of the Civil War. Looking back to the period of Reconstruction, Griffith created several historical tableaux of noted events such as the assassination of Abraham Lincoln to give the film a mark of authenticity. These scenes are noted for their resemblance to illustrated representations of these events, similar to pages out of history books, which is perhaps one of the reasons why President Wilson proclaimed that *Birth of a Nation* was "like writing history with lightning." While contemporary audiences recognize the great flaws of the film for its virulently racist depictions of African Americans (as did the NAACP, which organized protests of the film upon its release), it is important to note how the film has been legitimized in the past for what were perceived as accurate historical representations.

FLAHERTY AND GRIERSON

In his 1926 review of Robert Flaherty's *Moana*, John Grierson praised the film for its "documentary value," one of the first instances in which the term documentary had been applied to nonfiction film. Grierson gained renown during this period for his work with the United Kingdom's GPO Film Unit. Along with Flaherty, he would be responsible for innovations in filmmaking that resulted in documentary feature film production. Born in the United States, Flaherty made several visits to Northern Quebec where he became fascinated with the lives of indigenous people and decided to make a film that focused on the life of an Inuit family.

With funding from Revillon Frères, who sought to promote the fur-trading industry, Flaherty produced *Nanook of the North* (1922), regarded as the first feature-length documentary film.

A groundbreaking production, *Nanook* is often considered in terms of how Flaherty staged the film's pivotal events. In his initial expeditions to the Arctic, Flaherty shot hours of Inuit people footage that he accidentally destroyed. He claimed, however, to be less enthusiastic about that footage when compared with what he ultimately filmed for *Nanook*. He noted, "(o)ne often has to distort a thing to catch its true spirit." Among these distortions were the shooting of a scene inside an igloo that was only partially constructed to allow for better lighting, and the use of spears during the walrus and seal hunts even though it was common practice for the Inuits to use guns during this period. But Flaherty did not set out to simply document life as it is but rather to realize a more romanticized vision of man against nature.

John Grierson had achieved success as a film critic in the 1920s before moving toward film production. While greatly inspired by Flaherty's films, Grierson was more concerned with how film could be used as a tool for social change at the local level. His first feature documentary, *Drifters* (1929), offers a poetic reflection on herring fisheries in the North Sea. Grierson would have even greater influence in his leadership positions with both the Empire Marketing Board and the GPO Film Unit. Under his management, these organizations established an infrastructure for the modern British documentary movement that employed filmmakers such as Basil Wright, Harry Watt, Alberto Cavalcanti, Humphrey Jennings, Edgar Anstey, and Arthur Elton. Films such as *Housing Problems* (1935) and *Night Mail* (1936) both continued in the romantic style of Flaherty, which alternately addressed social concerns and celebrated the lives of the British working class. In addition to these major works of British cinema, one of Grierson's greatest contributions to the history of documentary film is his articulation of documentary film as "the creative treatment of actuality," acknowledging the distinct form of documentary as an intersection between real-world referent and its mediation.

KINO PRAVDA

Filmmakers associated with the Soviet Montage movement who came to prominence in the aftermath of the Russian Revolution are regarded for their remarkable experiments with film editing. Among these filmmakers, Dziga Vertov offers a most radical vision of documentary form. Before directing his own films, Vertov served as head of the state-run newsreel division. Here, he worked as a cinematographer documenting the tumultuous period at the end of World War I. Like many of the Soviet Montage filmmakers, Vertov was also an accomplished film theorist. His concept of "kino eye" advocated for the superiority of cinematic representation over other art forms and media by noting that the camera provides a more ideal vision of the world than is possible with the human eye. He also celebrates "kino pravda" or "film truth," noting that the truth of cinema is the ability of the newsreel to record "life caught unawares."

Vertov's masterpiece of this period, *Man with a Movie Camera* (1929), presents a day-in-the-life of the Soviet people in which ordinary actions (e.g., brushing one's teeth, performing calisthenics) are invigorated by the director's remarkable formal interventions. Passionately reflexive, the film inserts the character of the cameraman into this collection of actions, with the cameraman orchestrating a series of split-screen images, superimpositions, and impossible camera angles to demonstrate an enlightened cinematic vision that marries formal experimentation to political ideology. While robust, Vertov's career as a documentary filmmaker was short-lived as the national doctrine of Socialist Realism was imposed by Stalin in the 1930s, which rejected the experimentation of the Montage movement in favor of simple narrative films that glorified the life of the worker. Vertov's work is also considered among the great city symphonies of the silent era—documentary films that offered poetic visions of everyday life in various urban milieus. These films included Walter Ruttman's *Berlin: Symphony of a Great City* (1927), Alberto Cavlacanti's *Rien Que Les Heures* (1926), Paul Strand's *Manhatta* (1921), and Joris Ivens's *Regen* (1929).

SURREALISM AND DOCUMENTARY

The 1920s was a fertile period of experimentation in film history with many art movements expanding beyond traditional visual forms (painting, sculpture, photography) into the cinematic arts. Among these movements, surrealism became most noted for its attempts to represent the unconscious and to offer anarchic challenges to institutions of power. French filmmaker Jean Vigo gave a lecture on cinema, later published as "Toward A Social Cinema" (1930), in which he advocates for a new form of social documentary that documents a point of view and, like Vertov, captures subjects "unawares." These ideas are realized in his 1929 short film, *À propos de Nice*, a city symphony of sorts that he filmed clandestinely on the streets of the Riviera resort town with Boris Kaufman, Vertov's younger brother.

Working with artist Salvador Dalí, Luis Buñuel produced two canonical works of surrealist film: *Un Chien Andalou* (1929) and *L'Age d'Or* (1930). When he conceived of the idea to apply these concepts in a documentary context, Buñuel chose a study of a remote, mountainous village in Spain. *Land Without Bread (Las Hurdes)* (1933) challenged viewer expectations in that it appeared visually analogous to a travelogue film yet provided none of the more accessible imagery associated with the genre. The film offers a scathing portrait of peasant life in the Las Hurdes region including images of malnourished children, diseased animals, contaminated rivers, and infertile land. Among the film's formal disparities are its emotionless, often harshly worded narration presented in contrast to images of poverty in the region. Despite Buñuel's fascination with this unwieldy land and its people, the film was banned by the Spanish government for its targeted critique. The president of the governing council of Las Hurdes would not support the film's release because Buñuel neglected to show more positive images such as the delivery of bread to the villagers and folk dances, images that Buñuel insisted did not exist.

FROM THE LEFT

Concurrent with Vigo's call for social documentary in the 1930s, leftist documentary film-makers organized in New York to address the struggles of the working class. The Workers' Film and Photo League founding members included Tom Brandon, Sam Brody, Leo Hurwitz, Irving Lerner, David Platt, Ralph Steiner, Lewis Jacobs, Leo Seltzer, and Harry Alan Potamkin. Most of the League's members had little experience in photography or filmmaking and were motivated by their varying degrees of commitment to Communist Party ideology. While documentation of the working class was a primary concern, members of the League also published numerous critical essays in journals such as *Experimental Cinema* and *Workers Theatre*. They also established a film school and distributed and exhibited international films both within New York and throughout the United States.

In 1934, a schism emerged among the League's filmmakers between those invested in cinema as reportage and those who aspired to more creative forms. As a result, members of the League branched out to form Nykino, which gave them more opportunities to create documentary films with dramatic elements, including collaborations with the Group Theatre. Nykino's creative ambitions were furthered in 1935 with the addition of notable figures such as Paul Strand, Pare Lorentz, Willard Van Dyke, Ben Maddow, and Dutch filmmaker Joris Ivens. In this period, Nykino produced more poetic works such as *The Plow That Broke the Plains* (1936) and *The River* (1937), which eschewed the League's focus on reportage in favor of more expressive qualities. In 1937, Nykino filmmakers made the public announcement that they had reorganized to form Frontier Films, effectively severing their ties with the Film and Photo League.

Directed by Lorentz with assistance from Steiner, Strand, and Hurwitz, *The Plow That Broke the Plains* was commissioned by the United States Resettlement Administration, a forerunner to the Department of Agriculture. Covering a period of fifty years, the film portrays the fertile agricultural history of the American Midwest, its aggressive industrialization during World War I, and, finally, the devastation of the Dust Bowl in the 1930s. Tensions over the film's political ideology escalated as Strand and Hurwitz pushed Lorentz to be more direct in his critique of capitalism, which ultimately led to their removal from the project, forcing Lorentz to use stock footage to complete the film.

While Frontier Films continued to produce an impressive collection of documentaries such as *People of the Cumberland* (1937) and *China Strikes Back* (1937), its most ambitious project, Leo Hurwitz and Paul Strand's *Native Land* (1942), proved to be its most costly. The filmmakers began production in 1937 but the film would not be ready for release for another five years. During that time, Frontier Films was dissolved and Hurwitz and Strand had to seek independent support. Thanks to a partnership with actor and activist Paul Robeson, who served as the film's narrator, *Native Land* was finally released in 1942. Episodic in structure, the film chronicles a history of injustices in the United States, from the suppression of labor unions to the brutal vigilantism of the Ku Klux Klan. Released shortly after US entry into World War II, the film provided an unpopular counter-narrative to Hollywood's more patriotic slate of films.

Sidney Meyers was a younger member of the Film and Photo League who worked as an editor on *Native Land* before directing his own feature documentary, *The Quiet One* (1948). In addition to Meyers, writer and film critic James Agee wrote the film's narration. Photographers Helen Levitt and Janice Loeb collaborated with Meyers on the screenplay and shot much of the film's footage. Both Agee and Loeb previously worked with Levitt on her silent short film, *In the Street* (1948). *The Quiet One* was commissioned as a fundraiser for the Wiltwyck School, in Upstate New York, which enrolled troubled children from New York City. The film centers on "Donald," a boy neglected by his family who gradually accepts the support of the teachers and staff members at Wiltwyck. Like *Native Land*, the film presents a more hybrid form of fiction and nonfiction than traditional documentary reportage. The film received Academy Award nominations for both Best Screenplay and Best Documentary Feature. Despite the history of dispute among New York's leftist documentary practitioners, the result of their work was often in the gray area between the discrete forms of fiction and nonfiction.

WAR AND PROPAGANDA

In the aftermath of the First World War, filmmakers around the world used the medium to express outrage at the devastating toll of the war in films such as *J'Accuse* (1919), *The Big Parade* (1925), *What Price Glory* (1926), and *All Quiet on the Western Front* (1930). As events developed that led to the outbreak of World War II, the majority of filmmakers struck a very different tone in their messaging about the war. This was largely due to the mobilization of national cinemas throughout Europe as well as in Hollywood, which recognized and exploited cinema's ability to reach mass audiences through propagandistic means.

As the Nazi Party rose to power in 1933, Adolf Hitler established the Ministry of Propaganda, which was tasked with using film and other means of communication to influence the German people. A star and director of the popular "mountain films" (dramatic features often filmed on location in the Alps), Leni Riefenstahl had garnered the attention of Hitler who asked her to film the 1934 rally at Nuremberg. The result, *Triumph of the Will* (1935), was a staggering feat of scale thanks to Riefenstahl's innovative use of tracking shots, cranes, and aerial cinematography that became a massive success in Nazi Germany. Her next film, *Olympia* (1938), a document of the 1936 Summer Olympics in Berlin, was noted for its innovations in sports cinematography given Riefenstahl's unprecedented access to the competition as well its reinforcement of the grandeur of the Third Reich as host of the games.

As Riefenstahl's films served as a powerful reflection of the Nazis' propaganda machine, Frank Capra's seven-part *Why We Fight* series marked a new level of collaboration between the United States government and Hollywood. Commissioned by the War Department, Capra served as producer for the complete series and directed three chapters that provide a pointed history of events leading up to the war, a cautionary vision of what could happen if international threats were not contained, and a jingoistic paean to freedom. Constructed from what

André Bazin has characterized as an "enormous accumulation of documentary footage of the war" (specifically newsreels) and a striking collection of animated map sequences designed by the Walt Disney Animation Studios, the films provide a fascinating demonstration of documentary as a powerful means of argumentation. The films were originally intended to rally enlisted men but were so well received that they were released commercially.

Capra was not the only Hollywood director to work with the War Department during this period. John Huston directed a series of three films for the US Army Signal Corps: *Report from the Aleutians* (1943), *The Battle of San Pietro* (1945), and *Let There Be Light* (1946). In contrast to Capra's celebratory accounts of the Allies' heroic containment of the Nazis, Huston presents the harsh realities of the soldiers' experiences in *The Battle of San Pietro* in a style that evokes films produced in the aftermath of the First World War. The Army expressed concern about Huston's frank depictions of dead soldiers being removed from battle in body bags and delayed the film's release for fear it would weaken the morale of the soldiers. But Huston continued to demonstrate a marked compassion to the experience of enlisted men. *Let There Be Light* offers a portrait of veterans under treatment at a psychiatric hospital for various forms of post-traumatic stress as they tried to reintegrate into society. Austrian émigré Billy Wilder was commissioned by the War Department to make a film intended to be screened within postwar Germany to reveal the atrocities of the Holocaust. An unforgiving reflection on the catastrophic toll of the war, *Death Mills* (1945) graphically depicts the liberation of the concentration camps with footage of survivors and victims using newsreel footage shot by the Allies.

In the United Kingdom, Humphrey Jennings offered a more idealistic vision of British society that focused on life at home rather than the experiences of soldiers on the battlefield. Jennings originally worked with Grierson's GPO Film Unit in the 1930s but his affiliation was short-lived as he was less interested in using film as a means to solve social problems and more concerned with its creative potential. With the outbreak of war, the nation's agenda shifted and the GPO Film Unit evolved into the Crown Film Unit under the direction of the Ministry of Information. Jennings became one of the most prominent filmmakers associated with Crown Film Unit, producing such notable shorts as *London Can Take It!* (1940), *Listen to Britain* (1942), and *A Diary for Timothy* (1945) as well as his feature film, *Fires Were Started* (1943). *Listen to Britain*, codirected with Stewart McAllister, stands out among these works for its poetic depiction of life in London during the blitzkrieg. Designed for audiences in the United States and British Commonwealth countries outside of Europe, the film recreates Vertov's "day-in-the-life" structure to demonstrate the perseverance of the British people.

CINÉMA-VÉRITÉ AND THE LEFT BANK

Post–World War II France is home to many significant developments in the history of documentary film. The most prominent and influential figure of this period is ethnographer Jean Rouch. Rouch worked as an engineer in West Africa during the 1940s and became fascinated

with the rituals of its native people. He produced a series of ethnographic studies, some of which provided simple reportage but others that incorporated more narrative elements as Flaherty has done with *Nanook of the North* including *Les Maîtres Fous* (1955), *Jaguar* (1955), and *Moi, un noir* (1958). In the summer of 1960, Rouch collaborated with sociologist Edgar Morin on an "experiment" in which they asked the question "Are you happy?" to people on the streets of Paris. *Chronicle of a Summer* (1961) is noted for its sense of immediacy as Rouch and Morin exploited the opportunities made possible by the development lightweight, portable 16mm cameras and sync sound recording, an approach that would become known as cinéma-vérité. Far removed from the overly instructional artifice of war-era propaganda, this movement offered a new realization of Vertov's ideal of "life caught unawares" by relying on spontaneous interactions with people on the streets of Paris.

While the propagandist works of World War II tended toward didacticism, documentary movements began to shift in the postwar era toward techniques that maximized the immediacy of new technologies to assert greater truth claims. Alain Resnais directed a series of documentary short films in the 1950s including *Guernica* (1950), *Statues Also Die* (1953), *Tout la mémoire du monde* (1956), and *Le Chant du styrène* (1958), films that combined poetic elements of the city symphonies with the more absurdist concerns of surrealism. In all of these works, Resnais offers a thoughtful consideration on the function of time in cinema, whether in representations of historical events or more reflexive questions about the medium itself. A staggering visual essay on the war and its consequences, *Night and Fog* (1955), is the apotheosis of this form of representation. The film combines archival footage of the war (as well as reappropriated footage from *Triumph of the Will*, also a source for Capra's *The Nazis Strike* episode of *Why We Fight*) with present-day footage of Auschwitz and the dormant concentration camps. Accompanying this footage is narration performed by actor Michel Bouquet.

Resnais has become associated historically with a group of filmmakers known as the Left Bank Group, which also included Agnès Varda and Chris Marker. Contemporaries of the French New Wave directors, these filmmakers were slightly older than film-obsessed cineastes such as François Truffaut and Jean-Luc Godard and gave value to connections between film and other art forms such as literature and photography. They also offered insightful reflections on the function of time and memory. Resnais's decision to intercut footage shot during the liberation of the camps with contemporary footage in *Night and Fog* demonstrates the immediacy of change within a space whose history could be forgotten were it not for his cinematic intervention.

Varda and Marker also provide some notable contributions to the history of documentary during this period. In the 1960s, Varda primarily directed fiction films such as *Cléo from 5 to 7* (1963) and *Le Bonheur* (1965), which furthered the aesthetic and ideological concerns of the Left Bank. Her sole documentary work from this era, *Salut les Cubains* (1962), documents a visit by the director to post–revolutionary Havana and uses still photography to both illustrate the country's imperial history and celebrate its vibrant art and music culture. Later films

such as *Jacquot de Nantes* (1990), *The Gleaners and I* (2000), and *The Beaches of Agnès* (2008) are first-person accounts in which her relationship to the documentary subject is emphasized. As Varda did with *Salut les Cubains*, Marker famously used still photography as a narrative device in his experimental science fiction short film *La jetée* (1962). His feature-length documentary, *Le Joli Mai* (1963), employs the vérité techniques of *Chronicle of a Summer*, but also incorporates more essayistic reflections that were common among the Left Bank filmmakers. This approach would be explored further in later films including his fascinating travelogue of experiences in African and Japan, *Sans Soleil* (1983).

CANDID EYE AND CINÉMA DIRECT

In 1938, John Grierson was invited by the Canadian government to examine the country's filmmaking infrastructure, which resulted in formation of the National Film Board of Canada. As its first commissioner, Grierson primarily oversaw the production of propaganda films during the war years. Following his departure from the NFB in 1945, the NFB shifted its focus to short form films with more domestic content designed for a television audience. Beginning in 1958, *Candid Eye*, airing on the BBC, presented the work of filmmakers Tom Daly, Terence Macartney-Filgate, Wolf Koenig, and Roman Kroitor. This thirteen-episode film series continued in the Griersonian tradition of social problem films while making use of the new portable 16mm technologies.

While *Candid Eye* reflected a mobilization of English-language filmmaking within Canada, the decision to relocate the NFB headquarters from Ottawa to Montreal in 1956 created new opportunities for French Canadian filmmakers. Michel Brault was responsible for a series of short films in the late 1950s that echoed the style of the *Candid Eye* series; but through the use of camera lenses with shorter focal lengths, he sought to achieve greater intimacy with his subjects. Brault would later work as an assistant to Rouch and Morin on the production of *Chronicle of a Summer*, where many sources credit him for introducing shooting techniques that would become directly associated with cinéma-vérité. Brault directed several films in the 1960s that employed these techniques, most notably his 1963 collaboration with Pierre Perrault, *Pour La Suite du Monde*. The film portrays life in a remote Quebecois fishing community where the practice of whale hunting has been revived.

DIRECT CINEMA

New approaches to documentary filmmaking that suggested a lack of artifice and a heightened sense of immediacy in representation came to be part of the practice of American filmmakers through a series of developments among independent filmmakers. Morris Engel was a member of the photography unit of the Film and Photo League in the 1930s and achieved acclaim as a commercial photographer. In the 1950s, he directed and codirected (with his wife, photographer Ruth Orkin) a series of three independent fiction features (*Little Fugitive*

[1953], *Lovers and Lollipops* [1955], *Weddings and Babies* [1958]) that would greatly influence the directors of the French New Wave as well as the burgeoning practitioners of documentary film in the United States. Among the documentarians, British-born Richard Leacock wrote an essay on *Weddings and Babies* for *Harper's* in which he praised Engel's innovations with hand-held cinematography. Leacock had served as cinematographer on Robert Flaherty's final feature film, *Louisiana Story* (1948), a poetic hybrid of documentary and fiction commissioned by Standard Oil that explored the lives of oil rig workers in the bayou as framed through the eyes of a Cajun boy. He would later gain acclaim for his work with the Drew Associates.

Robert Drew was an experienced journalist for *Life* who became renowned for his candid photo essays. He decided to bring together a group of like-minded filmmakers who were eager to transform documentary from the more prescriptive style of newsreels to a form that allowed subjects to speak for themselves. Under Time Inc., Drew Associates, which included filmmakers such as Leacock, D. A. Pennebaker, Terence Macartney-Filgate, and Albert Maysles, produced a series of documentary films in the early 1960s that reflected these concerns. The first and most widely known of the Drew films, *Primary* (1960), follows the 1960 Democratic presidential primaries, specifically focusing on the race between John F. Kennedy and Herbert Humphrey to win the state of Wisconsin. Among the film's feats are its unprecedented access to the candidates—both on-stage giving stump speeches, and recovering and planning on tour buses and in hotel rooms. In one of the film's most celebrated moments, Kennedy enters a crowded rally and must weave through the crowd to give a speech. Maysles shot the scene by raising the camera above his head while still keeping his subject within the frame through this complicated movement. The fact that these kinds of films could more effectively capture events as they were unfolding suggested new potential for documentary to serve as a reflection of everyday life.

While *Primary* employs the device of voiceover narration, what sets apart the American directors who came to be associated with "direct cinema" from the French cinéma-vérité practitioners was their desire to minimize the intervention of filmmakers with the subjects they filmed. Documentary theorist Bill Nichols categorizes the American approach as "observational" in which the filmmakers seem "invisible" in relation to the events they document, whereas the French directors are referred to as "participatory" or "interactive," since they acknowledge their presence in a process that still asserts greater access to reality.

The direct cinema practitioners thrived in the 1960s, in part due to their focus on performers as subjects. D. A. Pennebaker's *Dont Look Back* (1967) goes behind the scenes with Bob Dylan as he travels through England on tour, revealing a "warts and all" private side to Dylan's idealized public persona. Pennebaker's film of the 1967 rock festival, *Monterey Pop* (1967), provides up-close access to some of the most popular musicians of the period including Janis Joplin, Otis Redding, and Jimi Hendrix. Albert Maysles would have a long career as a filmmaker along with his brother, David. Regardless of who they filmed, the Maysles applied the direct cinema ethos to studies of the rich and famous (*Showman* [1962]) as well

as the average worker (*Salesman* [1968]). But an interesting shift occurred in their work beginning with their 1970 documentary of the Rolling Stones' ill-fated concert at Altamont, *Gimme Shelter*. The film is framed by shots of band members seated at a Steenbeck (editing machine) watching the footage that makes up the film. The Maysles are heard off-camera talking to the band members, first as they indulge in their stage personae and later, as they watch in horror, scenes of a concertgoer being fatally stabbed by members of the Hell's Angels whom the band had hired as security for the concert. The Maysles would further embrace this more interactive approach with their 1975 film, *Grey Gardens*, which follows the secluded lives of the Beales, relatives of Jacqueline Kennedy Onassis.

Another major filmmaker who developed techniques comparable to the Drew Associates but was never affiliated with them as a group is Frederick Wiseman. Wiseman directed his first feature film in 1967, *Titicut Follies*, which examines the day-to-day activities at the Massachusetts Correctional Facility at Bridgewater. The film proved so controversial that the commonwealth passed injunctions to limit the film's release until 1991, arguing that Wiseman had violated the privacy of his subjects who were unfit to consent to appear on-screen. Most critics recognized that the state government was likely more concerned with its liability in management of the institution.

For most of his career, Wiseman employed a minimal crew in the filming process; in the earliest works, he would serve as sound recordist working with a single cinematographer. Wiseman perceived the small crew as minimally invasive, which allowed his subject to perform more naturally when being filmed. He would apply this approach to a lifelong study of (mostly American) institutions whether filming a Philadelphia high school (*High School* [1968]), a Kansas City police force (*Law and Order* [1969]), or a New York medical center (*Hospital* [1970]). Wiseman has gone on to have a remarkably prolific career directing an average of one film per year and, until recently, limiting access to his works to public television broadcasts and noncommercial/educational screenings.

YOU KILLED CINÉMA-VÉRITÉ

The influence of both the French school of cinéma-vérité and the North American practices of cinéma direct and direct cinema cannot be understated. Documentary filmmakers had reasserted and reestablished the ability to create films that made much bolder truth claims than their predecessors could have imagined. Yet, critical discourse in the 1960s also allowed for filmmakers to question these strategies in forms that replicated the vérité approach and challenged its truth-telling assertions. Shirley Clarke was one of the key figures of the New American Group, a collective of New York-based filmmakers who established systems of support for independent film production, distribution, and exhibition. In the 1950s she directed a series of experimental shorts, some of which drew on her experience as a dancer and others that celebrated her love of jazz. In 1960, she directed a film version of the Living Theater's play *The Connection*, a portrait of a group of heroin addicts waiting for their dealer. The significant

change from the play to the film is that Clarke introduces a documentary crew who are present to film the addicts for a "direct cinema"–style project; however, their subjects refuse to follow the rules of this observational approach and engage with the filmmakers, raising questions about its assumed naturalism.

Jim McBride provided a similar critique of nonfiction truth claims with his pseudo-documentary, *David Holzman's Diary* (1967). The film presents a young filmmaker, David Holzman (L. M. Kit Carson), who decides to record his daily life on film. During this process, he struggles with his personal relationships and the limits of his creative process. The film was so convincing on its initial screenings that audiences were upset when the film's end credits revealed that Holzman was a character played by Carson and not an actual filmmaker. After D. A. Pennebaker screened the film, he reportedly approached Carson and declared, "You killed cinéma-vérité. No more truthmovies," to which Carson replied, "Truthmovies are just beginning."

Both Clarke's and McBride's films reveal the constructed elements of the direct cinema practitioners that most worked very hard to conceal. But one of the most radical films of this period that both critiques documentary form yet still functions as documentary is William Greaves's *Symbiopsychotaxiplasm: Take One* (1968). A true renaissance man, Greaves had talents as an artist and dancer before he enrolled in the Actors Studio alongside then-unknowns such as Marlon Brando. Limited to acting roles in "race" films, Greaves relocated to Canada in the 1950s where he worked with the *Candid Eye* unit of the NFB, directing the short film *Emergency Ward* (1959). Through the assistance of Shirley Clarke, Greaves eventually returned to the United States where he conceived of an idea for a film about conflict.

In *Symbiopsychotaxiplasm: Take One*, Greaves leads a crew in filming a scene in Central Park between two actors portraying a couple whose marriage is in crisis. While filming the scene, another crew records behind-the-scenes footage of both his filmmaking process and the reactions of passersby in the park. To provoke the crew, Greaves intentionally directs the scene badly, which prompts them to later film themselves in private discussing his ineffectiveness as a filmmaker. The film was originally conceived to be filmed as a five-part series but distribution problems caused the film to be shelved until it was rediscovered in the mid-2000s by Steven Soderbergh and Steve Buscemi, who facilitated its re-release. Buscemi also helped Greaves produce a sequel, *Symbiopsychotaxiplasm: Take 2 ½* (2005), in which Greaves again tries to create tension among his crew members but fails to find the same level of resistance as he did with the first film, which stands as a masterful reflection on documentary authorship.

REFLEXIVITY AND PERFORMATIVITY

Extending his categorization of documentary further, Bill Nichols acknowledges the emergence of new forms of documentary, beginning in the 1970s, that questioned the essentialist claims of the observational and interactive forms. What he describes as "reflexive" and later "performative" documentaries are films that foreground subjectivity by acknowledging the

process of mediation between filmmaker and subject. Vietnamese filmmaker and theorist Trinh Minh-ha addressed these concerns in her films *Reassemblage* (1982) and *Surname Viet Given Name Nam* (1985). *Reassemblage*, shot in Senegal, interrogates the relationship between filmmaker and subject in the context of ethnographic film. *Surname Viet Given Name Nam* also questions how documentary reveals information "about" its subjects (in this case, the history of Vietnamese women) through a complex interplay between archival footage and a series of present-day testimonies performed by amateur actresses.

Jill Godmilow has spent many years challenging what she describes as "the pornography of the real," the problematic drive of viewers to want to see the lives of others, further complicated by "the pedigree of the real," the process by which a director claims authority over her or his subject. When she attempts to make a film about the Solidarity movement but is unable to obtain a visa to travel to Poland, Godmilow instead chooses to make a film about the problems associated with this form of representation. *Far from Poland* (1984) was made with no access to actual footage of the labor strikes. Instead, Godmilow elects to recreate these scenes using American actors and shooting in a Pennsylvania coal-mining town.

Marlon Riggs reimagines documentary representation in his frank and powerful studies of gay African American male identity, *Tongues Untied* (1989) and *Black Is ... Black Ain't* (1994). A combination of poetry, dance, and first-person accounts by Riggs, *Tongues Untied* unleashed a firestorm of controversy on its release through a partnership with PBS's POV series for its honest depictions of homosexuality. The film was condemned by Senator Jesse Helms on the floor of the US Senate, outraged that taxpayer funding was used to support PBS and the NEA, which led to legislation to drastically reduce funding to these vital avenues of support for independent filmmakers. *Black Is ... Black Ain't* chronicles Riggs's final effort to seek answers to ongoing questions about African American identity as he was succumbing to complications from the AIDS virus. (Riggs died before the film was completed.)

PERSONAL DOCUMENTARY

The films of Marlon Riggs reflect a shift toward documentary forms, which, unlike their vérité predecessors, directly address questions of subjectivity. His work can also be considered in relation to an emergent group of autobiographical documentarians whose work came to prominence in the 1970s and 1980s. A locus for this approach to filmmaking was the MIT Film Section headed by Richard Leacock and Ed Pincus. Leacock left Drew Associates in the early 1960s and would direct films such as *Happy Mother's Day* (1963) that placed greater emphasis on narrative elements—such as character and story than the more observational works of his direct cinema peers—before joining Pincus in the late 1960s at MIT. After making his first films in the 1960s, Pincus would write *Guide to Filmmaking*, later adapted to *The Filmmaker's Handbook*, coauthored by Steven Ascher, which became a staple of film production programs.

Pincus's first films, *Black Natchez* (1967), *One Step Away* (1968), *Panola* (1970)—codirected with David Neumann—were produced using techniques similar to those of the direct cinema filmmakers, but Pincus began to question these strategies and sought to make something more personal. The result, the three-and-half-hour *Diaries* (1971–1976) (1980), provides an unflinching portrait of his marriage to writer Jane Pincus (*Our Bodies, Ourselves*). Remarkably intimate (Pincus was often a crew of one) yet socially relevant, the film realizes the feminist edict: "the personal is political," which Pincus espoused and utilized to produce a stunning portrait of 1970s American family life.

At MIT's Film Section, Pincus and Leacock would influence the work of a new generation of filmmakers who were inspired by the approach of personal documentary. Ross McElwee is one of the more prominent former students of the MIT Film Section. Drawing inspiration from Pincus's *Diaries*, McElwee has directed a series of works in which his own subjectivity as filmmaker is central to the documentary experience. His breakthrough film, *Sherman's March* (1986), follows McElwee's journey along General William Sherman's destructive path through the South during the Civil War. The trip serves as a parallel for the director's attempts to forge new relationships after breaking up with his girlfriend. Made on a budget of $75,000, the film became a massive success for specialty distributor, First Run Features. McElwee would continue over the next three decades to make films that were both autobiographical yet socially relevant, including *Time Indefinite* (1993), *Six O'Clock News* (1996), *Bright Leaves* (2003), and *Photographic Memory* (2011).

Jeff Kreines and Joel DeMott were students of both Leacock and Pincus who later became involved with the Middletown Film Project, an ambitious documentary series organized by Peter Davis, director of the Academy Award-winning documentary feature *Hearts and Minds* (1974). *Middletown*, a six-part series, aired on PBS in 1982. But Kreines and DeMott's contribution, *Seventeen* (1982), never made it to air. The *Middletown* series features portraits of life in Muncie, Indiana. Kreines and DeMott chose to focus on the lives of high school students, with Kreines filming the boys and DeMott covering the girls. On the surface, the film looks comparable to the direct cinema works in its observations of the teens but because the filmmakers achieved a striking intimacy and candor with their subjects, the film proved too controversial for PBS, which dropped the film from the television series. Kreines and DeMott would release the film theatrically to great critical acclaim, winning the Grand Jury Prize at the 1985 Sundance Film Festival.

COMPILATIONS/FOUND FOOTAGE

Another post-vérité subgenre of documentary that gained prominence in the 1970s and 1980s was the compilation film. Compilation films date to the 1920s when Esfir Shub culled clips from old newsreels to mark the tenth anniversary of the Russian Revolution in her film, *The Fall of the Romanov Dynasty* (1927). Often comprised of footage secured from multiple sources, newsreels are, in many cases, the purest example of the compilation film. *The March of Time*

series (1935–1951) provided a semi-monthly summary of current events that were broadcast in American cinemas to millions of viewers (and famously parodied by Orson Welles in his "News on the March" sequence from *Citizen Kane* [1941]). Like Shub's film, these pieces were often designed to glorify accomplishments in American society, most notably the war effort.

The tone of the compilation film took a more critical turn in the 1960s with the work of Emile de Antonio. De Antonio wore many hats in the world of modern art and independent film, as an agent for the likes of Jasper Johns, Robert Rauschenberg, and Andy Warhol (featured in DeAntonio's 1972 documentary *Painters Painting*) and a distributor of Robert Frank's Beat Cinema classic *Pull My Daisy* (1959), which connected him to the New American Cinema group. His first film, *Point of Order* (1963), drew from more than 188 hours of footage originally broadcast in their entirety on network television of the infamous Army–McCarthy hearings, in which Senator Joseph McCarthy sought to unmask Communist subversives in the US military and bringing about his own congressional censure. With the help of Dan Talbot, founder of the independent film distributor New Yorker Films, DeAntonio achieved one of his greatest commercial successes in a film that recasts the raw footage of McCarthy as an indictment of the senator's ruthless tactics.

De Antonio would employ similar techniques in his angry antiwar film, *In the Year of the Pig* (1968). Made during the height of the Vietnam War, the film combines archival footage with interviews to call out the destructive forces of imperialism and cast North Vietnamese leader Ho Chi Minh as a patriotic figure. De Antonio's then-radical positions caused the film to have a troubled release including bomb threats and vandalism at cinemas that booked it. This did not deter DeAntonio from his assault on the American political establishment. *Millhouse: A White Comedy* (1971) was released during Richard Nixon's first term in office and earned him a spot on the president's infamous "enemies list." The film chronicles Nixon's rise to office from his first congressional victory in 1946 to his triumph in the 1968 presidential election. Relying almost entirely on Nixon's own words and public appearances (including his famous "Checkers" speech), De Antonio intentionally avoided voiceover commentary, which he considered a fascist device, to allow Nixon to speak for himself.

Compilation becomes an avenue for rethinking historical representation in Connie Field's *The Life and Times of Rosie the Riveter* (1980). The experiences of working women during World War II are reconstructed by five former "Rosies" whose interviews are intercut with archival films and other media from the period used to champion the war effort. Field's work was praised not only for its inventive reimagining of war propaganda but also for providing the rare instance of feminist history in documentary film, using the voices of the former workers to shape the historical context.

In 1982, Jayne Loader, Kevin Rafferty, and Pierce Rafferty formed The Archives Project, which produced one of the more commercially successful compilation films, *The Atomic Cafe*. An homage to De Antonio, the film is composed entirely of newsreels, military propaganda, and hygiene films (including the oft-cited *Duck and Cover* cartoon that advised students to hide under their desks in the event of a nuclear attack). The source films were produced at the

height of the Cold War and generally espouse the value of nuclear proliferation and atomic testing. As De Antonio had done with McCarthy and Nixon, the filmmakers present many of these films in their entirety without commentary, using period music to draw out the ironies in the film's original intent.

FIRST PERSON: ERROL MORRIS AND MICHAEL MOORE

Over the last three decades, two filmmakers stand out both for their far-reaching influence and controversial filming techniques: Errol Morris and Michael Moore. Morris's films were distinct for many reasons, most notably for his use of reenactments, his regular collaborations with Philip Glass, and his unconventional approach to interviewing subjects. While most documentary filmmakers frame interviews with subjects looking off-camera toward their interviewer, Morris invented a device known as the Interrotron (first used in production of his 1997 film, *Fast, Cheap and Out of Control*), a system of teleprompters that allowed Morris to project an image of his face directly onto his camera lens so that his subjects would look directly at the camera when responding to his questioning. This technique radically altered not only the subject's relationship to the filmmaker but also the audience, as it seems the subjects are speaking directly to them.

Morris's breakthrough film, *The Thin Blue Line* (1988), investigates the criminal case of Randall Dale Adams, wrongly convicted of murdering a police officer in Dallas in 1976. Through interviews and reenactments, Morris uncovers discrepancies in testimonies and identifies the actual killer. As a result of the film, Adams's conviction and death sentence (which had been commuted as a result of a Supreme Court ruling) were overturned and he was released from prison. While Morris's accomplishment was perceived by some as a remarkable feat of investigative journalism, the director was outspoken in that his films should bear the imprint of the filmmaker and challenge the claims of disinterest made by both the direct cinema practitioners and mainstream journalism.

Michael Moore also made his presence known in films that developed from his background as a journalist for alternative newspapers and magazines. *Roger and Me* (1989) was provoked by the announcement that General Motors planned to close its plants in Flint, Michigan, Moore's hometown. Through a series of interviews with Flint residents as well as reappropriating found footage in a manner similar to the compilation films, Moore crafts a humorous and devastating exposé of Reagan-era economic policies and their devastating effect on Rust Belt communities. Despite its critical and commercial success, Moore weathered a backlash of questions stemming from his manipulation of statistics and chronologies of events presented in the film. These ethical questions would resurface in later films such as *Bowling for Columbine* (2002) in which Moore aggressively confronts actor and NRA President Charlton Heston with questions about gun violence. Moore has steadfastly defended these choices, acknowledging the popular appeal of his films would not have the same impact and call to action had he employed a more nuanced approach.

Both Moore and Morris played significant roles in changing the popular culture of documentary film culture in the early 2000s. As first-time nominees and eventual winners of the Academy Award for Best Documentary Feature in 2002 (*Bowling for Columbine*) and 2003 (Morris's *The Fog of War*), respectively, they represented a dramatic shift in the controversial category, long criticized for its arcane voting process that omitted many documentaries such as Steve James's critically acclaimed *Hoop Dreams* (1994) from ever being nominated. Moore is also credited with fostering the growth of commercial interest in the documentary during this period. *Bowling for Columbine* earned a record-breaking $21 million at the box office, only to be outdone by his 2004 film *Fahrenheit 9/11*, which earned nearly $120 million and still stands as the all-time highest-grossing documentary film.

Bibliography

Alexander, William. *Film on the Left*. Princeton: Princeton University Press, 1981.

Andrew, Dudley. *André Bazin*. New York: Oxford University Press, 1978.

Arthur, Paul. "The Status of Found Footage." *Spectator* 20.1 (1999–2000): 57–69.

---. *A Line of Sight: American Avant-Garde Film Since 1965*. Minneapolis: University of Minnesota Press, 2005.

Barsam, Richard. *Nonfiction Film: A Critical History*. Bloomington and Indianapolis: Indiana University Press, 1972.

Barron, Ted. "Truthmovies are Just Beginning: American Independent Cinema in the Postwar Era." *The Wiley-Blackwell History of American Film*, eds. Cynthia Lucia, Roy Grundmann, and Art Simon. Malden: Wiley-Blackwell, 2011.

Bates, Peter. "Truth Not Guaranteed: An Interview with Errol Morris." *Cineaste* 17.1 (1989): 16–17.

Bazin, André. *What is Cinema?* Vol. 1. Trans. Hugh Gray. Berkeley and Los Angeles: University of California Press, 1967.

---. *What is Cinema?* Vol. 2. Trans. Hugh Gray. Berkeley and Los Angeles: University of California Press, 1971.

---. *Bazin at Work*. Trans. Alain Piette and Bert Cardullo. London and New York: Routledge, 1997.

Beattie, Keith. *Documentary Screens: Non-Fiction Film and Television*. Houndmills, Basingstoke, and New York: Palgrave Macmillan, 2004.

Brender, Richard. "*The Quiet One*: Lyric Poetry of the Fair Deal." *Millennium Film Journal*, Fall/Winter 1983-84: 81–97.

Bruzzi, Stella. *New Documentary: A Critical Introduction*. London and New York: Routledge, 2000.

Campbell, Russell. *Cinema Strikes Back: Radical Filmmaking in the United States 1930–1942*. Ann Arbor: UMI Research Press, 1982.

Carney, Ray. "American Narrative Art Film: The First Thirty Years, 1949–1979." <http://people.bu.edu/rcarney/indiemove/survey2.shtml>.

Carroll, Noel. "Nonfiction Film and Postmodern Skepticism." *Post-Theory: Reconstructing Film Studies*, eds. David Bordwell and Noel Carroll. Madison: University of Wisconsin Press, 1996. 283–306.

Carson, L. M. Kit. *David Holzman's Diary: A Screenplay by L. M. Kit Carson, from a Film by Jim McBride*. New York: Farrar, Straus and Giroux, 1970.

Corner, John. *The Art of Record: A Critical Introduction to Documentary*. New York: St. Martin's Press, 1996.

De Moraes, Vinicius. "The Making of a Document: *The Quiet One*." *Hollywood Quarterly*, Summer 1950: 375–384.

Gaines, Jane, and Michael Renov, eds. *Collecting Visible Evidence*. Minneapolis and London: University of Minnesota Press, 1999.

Gilliard, Bari Lynn, and Victoria Levitt. "The Quiet One: A Conversation with Helen Levitt, Janice Loeb and Bill Levitt." *Film Culture* 1976: 135.

Green, Jared. "This Reality Which Is Not One: Flaherty, Buñuel and the Irrealism of Documentary Cinema." *Docufictions: Essays on the Intersection of Documentary and Fictional Filmmaking*, eds. John P. Springer and Gary D. Rhodes. Jefferson, NC: McFarland, 2005.

Grierson, John. *Grierson on Documentary*, ed. Forsyth Hardy. Berkeley: University of California Press, 1966.

Halleck, DeeDee. "Remembering Shirley Clarke." *Afterimage* 25.4 (January–February 1998): 3.

Hollister, Sidney. "David Holzman's Diary." *Film Quarterly* 23.4 (Summer 1970): 50–52.

Jacobson, Harlan. "Michael and Me." *Film Comment* 25.6 (November–December 1989): 16–26.

James, David. *Allegories of Cinema: American Film in the Sixties*. Princeton, NJ.: Princeton University Press, 1989.

Kepley, Jr., Vance. "The Workers' International Relief and the Cinema of the Left 1921–1935." *Cinema Journal*, Autumn 1983: 7–23.

Knee, Adam and Charles Musser. "William Greaves, Documentary Film-Making, and the African-American Experience." *Film Quarterly* 45.3 (Spring 1992): 13–25.

Lane, Jim. "Notes on Theory and the Autobiographical Documentary Film in America." *Wide Angle* 15.3 (1993): 21–36.

---. *The Autobiographical Documentary in America*. Madison: University of Wisconsin Press, 2002.

Leacock, Richard. "For an Uncontrolled Cinema." *Film Culture Reader*, ed. P. Adams Sitney. New York: Copper Square Press, 2000. 76–78.

---. "Weddings and Babies." *Harper's Magazine* September 1958: 86–88.

MacCabe, Colin. "Realism and the Cinema: Notes on Some Brechtian Theses." *Screen*, Summer 1974: 7–27.

---. "Theory and Film: Principles of Realism and Pleasure." *Narrative, Apparatus, Ideology: A Film Theory Reader*. New York: Columbia University Press, 1986. 179–197.

MacDonald, Kevin, and Mark Cousins, eds. *Imagining Reality: The Faber Book of Documentary*. London: Faber & Faber, 1996.

MacDonald, Scott. "Jim McBride on *David Holzman's Diary*." *A Critical Cinema 4*. Berkeley: University of California Press, 2005. 179–195.

---. "Sunday in the Park with Bill." *The Independent* (May 1992): 24–29.

---. "The Country in the City: Central Park in Jonas Mekas's *Walden* and William Greaves's *Symbiopsychotaxiplasm: Take One*." *Journal of American Studies* 31.3 (Dec 1997): 337–360.

---. "William Greaves." *A Critical Cinema 3: Interviews with Independent Filmmakers*. Berkeley: University of California Press, 1998.

Mamber, Stephen. *Cinema Verite in America: Studies in Uncontrolled Documentary*. Cambridge: MIT Press, 1974.

Nichols, Bill. *Blurred Boundaries: Questions of Meaning in Contemporary Culture*. Bloomington: Indiana University Press, 1994.

---. *Introduction to Documentary*. Bloomington: Indiana University Press, 2001.

---. *Representing Reality: Issues and Concepts in Documentary*. Bloomington: Indiana University Press, 1991.

---. "The Voice of Documentary." *New Challenges for Documentary*, ed. Alan Rosenthal. Berkeley: University of California Press, 1988. 48–63.

Plantinga, Carl. "The Mirror Framed: A Case for Expression in Documentary." *Wide Angle* 13.2 (Summer 1991): 40–53.

---. *Rhetoric and Representation in Nonfiction Film*. Cambridge: Cambridge University Press, 1997.

Rabinovitz, Lauren. *Points of Resistance: Women, Power, and Politics in the New York Avant-Garde Cinema, 1943–71*. Urbana and Chicago: University of Illinois Press, 1991.

Raeburn, John. *A Staggering Revolution: A Cultural History of Thirties Photography*. Urbana and Chicago: University of Illinois Press, 2006.

Renov, Michael. *The Subject of Documentary*. Minneapolis: University of Minnesota Press, 2004.

---, ed. *Theorizing Documentary*. New York: Routledge, 1993.

Rony, Fatimah Tobing. *The Third Eye: Race, Cinema, and Ethnographic Spectacle*. Durham, NC: Duke University Press, 1996.

Romney, Jonathan. "Sign of the Times: William Greaves's *Symbiopsychotaxiplasms*." *Modern Painters* (December 2005–January 2006): 44–47.

San Filippo, Maria. "Lost and found: *Symbiopsychotaxiplasm: Take One* and *Take 2 1/2*." *Cineaste* 31.2 (Spring 2006): 48–49.

---. "What a long, strange trip it's been—William Greaves' *Symbiopsychotaxiplasm: Take One*." *Film History* 13.2 (April 2001): 216–255.

Sitney, P. Adams, comp. and ed. *Film Culture Reader*. New York: Praeger Publishers, 1970.

---. *Visionary Film*. New York: Oxford University Press, 1974.

Sweet, Fred, Eugene Rosow, and Allan Francovich. "Pioneers: An Interview with Tom Brandon." *Film Quarterly*, Autumn 1973: 12–24.

Trinh, Minh-Ha T. "Documentary Is/Not a Name." *October* 52 (Spring 1990): 76–101.

---. *Framer Framed*. Routledge: New York, 1992.

Van Haaften, Julia. "Morris Engel: Photographer/Filmmaker." *Morris Engel: Early Work*. New York: Ruth Orkin Photo Archive, 1999. 1–9.

Vertov, Dziga. *Kino-Eye: The Writings of Dziga Vertov*, ed. Annette Michelson and trans. Kevin O'Brien. Berkeley: University of California Press, 1984.

Vogels, Jonathan. *The Direct Cinema of David and Albert Maysles*. Carbondale: Southern Illinois University Press, 2005.

Williams, Linda. "Mirrors without memories: truth, history and the new documentary." *Film Quarterly* 46 (Spring 1993): 9–21.

Winston, Brian. *Claiming the Real: The Griersonian Documentary and Its Legitimations*. London: British Film Institute, 1995.

Wright, Basil, and Arlene Croce. "*The Connection* by Shirley Clarke." *Film Quarterly* 15.4 (Summer 1962): 41–45.

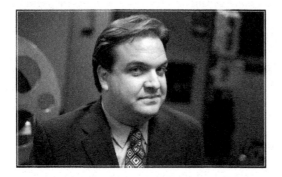

TED BARRON is the senior associate director of the DeBartolo Performing Arts Center at the University of Notre Dame where he oversees programming of the Browning Cinema. He previously served as senior programmer of the Harvard Film Archive at Harvard University and director of programming of the Coolidge Corner Theatre Foundation in Brookline, Massachusetts. His film programming has received numerous accolades including a special commendation from the Boston Society of Film Critics in 2006. He has also worked as an educator in the Media Arts Lab at the Jacob Burns Film Center in Pleasantville, New York.

Ted also serves as a concurrent assistant professional specialist in the Department of Film, Television, and Theatre at Notre Dame where he teaches courses in film history. He previously served as a lecturer at Harvard University, Montclair State University, Boston University, Tufts University and University of Massachusetts, Boston. He holds a PhD in visual studies from the University of California, Irvine, where his studies focused on American independent film and documentary film. His contribution to *The Wiley-Blackwell History of American Film* examines intersections between fiction and nonfiction praxis by filmmakers such as Morris Engel, Ruth Orkin, Shirley Clarke, and Norman Mailer. He has worked as a film critic and a freelance writer for WBUR-FM and *International Documentary* magazine and is currently a contributing editor for the online journal *The Straddler*. He has also served as a juror and delegate for numerous film festivals including the Goteborg International Film Festival, Munich International Film Festival, Newport International Film Festival, and Provincetown International Film Festival.

2 CONTEMPORARY TRENDS IN NONFICTION CINEMA

BY *SARA ARCHAMBAULT*

DOCUMENTARY FILM IS HAVING a renaissance. Though the genre is as old as the medium itself, we are in a contemporary cultural moment of broad enthusiasm and warm embrace for reality-based stories. Some critics and scholars mark the beginnings of this new love affair with the form as early as Errol Morris's 1988 ground-breaking film *The Thin Blue Line*. Others note the wave starting with Michael Moore's *Roger and Me* (1989), Joe Berlinger's *Brother's Keeper* (1992), Steve James's *Hoop Dreams* (1994), Jeffrey Blitz's *Spellbound* (2002), Morgan Spurlock's *Supersize Me* (2004), and Marshall Curry's *Street Fight* (2005). These films weren't your boring lecture and slideshow snooze fests that many people associated with documentary film. They were compelling, character-driven dramas with great cinematography, suspense, and emotional power. In every way, these films represented what worked best in Hollywood narratives. But they had a special quality most Hollywood films don't possess—these were *real* stories about *real* lives in the *real* world. And, noticeably to the powers that be, they also drew returns at the box office. Regardless of when the renaissance started, we are now living in a time when there are more artful, high quality documentary films available than ever before. In the words of critic David Edelstein: " ... the cool kids are making docs. The form is not just good for you these days. It's incredibly sexy."[1]

How did we arrive here? What are the conditions of this renaissance? And, significantly, what does it mean for the form? If we are to assess the current climate for the creation of and engagement with contemporary nonfiction, we need to look at the following:

1. Film equipment is more affordable and portable than ever before. The story of the evolution of documentary filmmaking is also a story of technical

1 (Edelstein, 2013)

innovation. Clunky, difficult to maneuver 35mm cameras (in use since the earliest days of the medium in the 1890s) were supplemented by more lightweight 16mm cameras in the mid-1930s. These were then enhanced by doc filmmakers such as Ricky Leacock, Robert Drew, and D. A. Pennebaker who created portable 16mm units enabling cinematographers to follow action for the first time. Film cameras gave way to video cameras, allowing for cheaper, faster, more flexible recording, with a notable sacrifice of image quality. Now we are in the digital age, where artists can easily access the best of all these worlds—lightweight, flexible, fast, and high quality image recording. DSLR cameras such as the Canon 5D, 7D, and the Panasonic Lumix series brought HD production into the realm of the financially possible. Typically the terrain of photojournalists, these cameras increased their video recording capabilities and at a fraction of the cost of most professional video-recording equipment while becoming a great asset to filmmakers of all skill sets. As Danfung Dennis, director of the award-winning documentary *Hell and Back Again*, noted in an interview with *The Guardian*: "The end result is all about image quality and the narrative style of feature films rather than the conventional video look of many typical documentaries."[2]

Small, versatile GoPro cameras, designed for athletes to wear while performing extreme sports, allowed filmmakers access to unique angles, daring maneuvers in the field, and unusual points of view. Given the low cost of the GoPro, filmmakers can risk bringing cameras into dangerous environments or experimental conditions with very low effect on their production budgets. Even smartphone video footage is good enough these days to work its way into feature films or on television broadcasts. Also, the move from video tape stock to data storage on cheaper, smaller SD cards (secure digital cards, providing high capacity memory on small discs) allowed for much more flexibility in the field at a lower cost.

Tools for editing share a similar narrative. What began as a practice of physically cutting and pasting lengths of film together has traversed the same landscapes from analog to digital production. Despite the immeasurable value of working with a professional editor, filmmakers are able to edit their films using home computers, laptops, and cheap monitors. Software such as Final Cut Pro, Adobe Premiere, and AVID can make any office into an edit studio. The story repeats yet again when considering technical advances in sound recording, both in the field and mixing and recording in post.

This is not to say that these films don't require high cost finish work, or that, for example, international travel can't increase a budget, or that a filmmaker can't shoot for even higher levels of professionalism and polish. But due to these technologies, entry into the field is remarkably lower, and the ability to make a feature film at a substantially lower cost than in years past is a part of this reality.

2 (Carter, 2011)

2. Platforms that used to distribute documentary films have broadened extensively in the last ten years. Artistically inspiring, challenging films are now widely available both within and outside the PBS broadcast and classroom circuit where the majority of audiences have encountered them for decades. Just as home video players and cameras revolutionized how we create and consume moving images, digital technologies are continuing to change how we view, see, and interact with stories. Thanks to online video streaming through channels such as Vimeo, YouTube, iTunes, Netflix, and Hulu, as well as advances in cell phone capabilities, artists have more outlets for sharing their work. Audiences can likewise watch an extensive amount of material from anywhere in the world with a Wi-Fi connection.

 There are an increasing number of broadcast outlets searching for nonfiction material. Although PBS and its doc strands (such as POV and Independent Lens) remain at the top of the list, HBO, A&E Indie Films, CNN, Discovery Channel, History Channel, National Geographic, Al Jazeera, BBC 4 Storyville, CBC (Canadian Broadcasting Corporation), Canal, Arte, and NHK (Nippon Hōsō Kyōkai in Japan) are among the broadcasters privileging documentary content worldwide. All of these organizations have well-recognized brands and marketing machines that drive eyes to screens. And, as is happening in all sectors, each of these companies is expanding to all screen sizes (phones, computers, tablets, more), making their content available on multiple platforms to suit viewers watching habits and interests.

 Notably, there is also an expanding number of festivals focused on nonfiction films. Festivals such as Hot Docs, Camden International Film Festival, CPH:DOX, IDFA, Sheffield, and True/False have raised the profile for documentary all over the world.

 Though a long-held documentary tradition, particularly among more activist-focused documentary artists from the late '60s and '70s, contemporary filmmakers are expanding their skills, becoming more sophisticated in their outreach strategies and working with engagement producers to craft change-making initiatives around their films (sometimes community-focused, awareness-raising, or, at times, policy altering). For some, this means foregoing a traditional theatrical run to bring their work to nontraditional venues and audiences in museums, libraries, union halls, churches, backyards, or any other place where people gather. Despite the move to private spaces (home, phone, laptop) for entertainment consumption, event-based film-going for nonfiction continues to grow.

 In short, there are more ways for audiences to find nonfiction content, and there is evidence they are drawn to it more now than before.

3. Audiences for nonfiction content are larger than ever. With distribution in a state of growth and flux, viewers are choosing to watch more content on demand and are watching nonfiction content in record numbers. Some attribute this shift to the

popularity of "reality" (quotes intentional) television. Although documentary has long been a key part of the televisual landscape, the public imagination was captured by "reality" programming in the early 1990s. The MTV and VH1 networks in particular exploded with this type of programming, leaving their typical fare of music videos behind.

This push to "reality" programming was in many ways tied to the Writer's Guild strike of the late 1980s. Desperate to fill the slots left empty by lack of content from the writers, networks worked around the strike by creating new programs sourced from real events. Shows such as *Unsolved Mysteries* and *Cops* emerged for the networks in the wake of this crisis, and the reality television craze began. Today there is nary a network without its own reality franchise. Arguably, there is little connection between the majority of today's reality shows and what we commonly call documentary or nonfiction film. But what the popularity of these shows demonstrates is a strong audience appetite for stories based on real life events.

While "reality" television may have laid the ground for an increased market share dedicated to nonfiction programming, this is not where the market ends. Viewers are engaging with all types of nonfiction content—from the reality programming described here to more festival-worthy feature films—at an increasing rate. According to a recent market study of Canadian audiences conducted by Hot Docs, one of the leading marketplaces for documentary content internationally, 68 percent of respondents are watching more docs today than they were three years ago.[3] From *The Economist's* arts/entertainment blog *Prospero*: "Recent British Film Institute data show that the number of documentaries released in British cinemas has grown steadily every year over the last decade, from a measly four in 2001 to 86 last year. Documentaries now also account for about 16% of the Cannes film market according to its director, Jerome Paillard, compared with 8% five years ago."[4] All of these indicators demonstrate advances in the marketplace for nonfiction storytelling.

4. The dawn of crowdfunding has created new paths for filmmakers to support their work. The concept of crowdfunding is simple: skip the gatekeepers and go right to the audience to get the necessary funding to get a film started, edited, or distributed. In short, if they want you to build it, they will fund. This is particularly useful at the early stages of funding a film, which can be the most challenging. Platforms such as Kickstarter, Indiegogo, and Seed&Spark have sparked a revolution in audiences, breaking past the curatorial reach of gatekeepers (funders, festival programmers, distributors, broadcasters). Famous cases such as Zach Braff's or Amanda Palmer's

3 (Burgess, 2014)
4 (F.S., 2013)

campaigns to support their passion projects showed fans' abilities to erase the brokers and connect directly with the work they care about most. Documentary filmmakers have directly benefited from this new methodology. Tyler Measom and Justin Weinstein raised $250,000 toward production for their documentary *An Honest Liar* (covering a good chunk of their $400,000 budget), and Academy Award nominees Rachel Grady and Heidi Ewing raised $72,000 (of a $60,000 goal) to self-distribute their film *Detropia*. As of this writing, Kickstarter is now distributing more funds directly to artists throughout the United States than the National Endowment for the Arts. According to the *Washington Post*, "For 2012, the NEA had a total federal appropriation of $146 million, of which 80 percent went toward grants. Kickstarter funded roughly $323.6 million of art-related projects if you include all design and video-related projects, which make up $200 million of the total."[5] Additionally, the largest percentage of successfully funded projects through Kickstarter (currently the most used of the multiple platforms) are independent films.

This does not mean that it's easy to fund an entire documentary film budget through Kickstarter. Traditional funding mechanisms for documentary film—foundation grants, private equity investments, presales, and coproductions—are all still necessary for getting high-quality feature documentary films made and seen. But the advent of crowdfunding technologies, with the support of social media, have lowered the bar for entry to the field and enabled many projects to go forward when the traditional gatekeepers were not yet ready to leap into the fray.

The above four points enumerate the key components of what has created space for more nonfiction filmmaking to occur and be seen: increased audience; creating a larger market for the materials; inspiring more outlets to carry the materials, matched by cheaper means of production; and new methodologies to raise funds. But what is occurring in the form itself? How are artists engaging with nonfiction material today? What, exactly, is flickering up on the screen that we are so driven to watch?

Since the earliest days of the form, documentary has been a space of formal innovation and technological experimentation, a key tool for civic engagement, cultural conversation, and change. Documentary has acted as a vital space for revealing unknown histories, exposing injustices, and giving voice to the voiceless. Despite the significant developments in production technology, audience engagement, and distribution, the core artistic questions—What is truth? How do filmmakers ethically handle telling the stories of others? Does the camera's presence change the action before it?—and inspirations—life itself!—remain largely unchanged.

Given the above, as nonfiction continues to be a space for formal innovation, ethical inquiry, and in-depth storytelling, what are the trends in documentary cinema today? The rise

5 (Boyle, 2013)

of the hybrid form, the evolution of the ethnographic film, the expansion of the journalistic documentary (in lieu of long-form journalism once supported by newspapers), and the explosion of the form in digital, online, and nontraditional environments all merit examination. We are in a moment of pushing the form, questioning the genre, and blurring the boundaries. While these experiments and challenges are part of the ever-evolving narrative of the nonfiction film, they are being performed on a much larger stage.

BLURRED LINES: Performance, Metaphor, and Collaboration in Hybrid approaches to the Nonfiction Form (Stories We Tell, Actress, Bombay Beach, and Act of Killing)

> *Even though notions of documentaries as bearers of unfiltered truths—via verité or other apparently unvarnished strategies—have long since been called into question, there still exists a certain discomfort with the idea, or rather the fact, of the constructedness of nonfiction cinema, and with those works that call attention to the fact that they are merely versions of realities rather than impartial distillations of them. … Not every documentary is an overt chimera (or hybrid, hydra-head, whatsit or whatever), but they are of course all constructions—Frankensteins of various shapes and sizes, variously willing to reveal, flaunt, and scrutinize their seams.—Eric Hynes/Cinema Scope[6]*

In the early fall of 2014, the International Documentary Association produced a conference meant to examine the current state of documentary professional practice. Among the many discussions taking place was a panel on ethics. A number of accomplished directors including Stanley Nelson (*Freedom Summer*), Jesse Moss (*The Overnighters*), and Tracy Dros Tragos (*Rich Hill*) shared moments in their own filmmaking practice when they felt the need to draw lines or boundaries. At the close of this session, Academy Award-winning filmmaker Ross Kauffmann (*E-Team, Born Into Brothels*) said, "Every film offers its own ethical challenges, and every filmmaker has to answer the questions that come to them. What is right for the film? What is right for the subjects? What is right for the audience? Each filmmaker determines these things anew for every film they make."

The same could be said of the artistic challenges facing the filmmaker. How can I best visually communicate the story of this film? What are the strengths and limitations affecting my access to the primary story and characters? What is my relationship to the subject I'm filming and how will that relationship manifest on screen? How do I want the audience to experience the ideas at play in this narrative? There is a perhaps mistaken—though all too common—perception that documentaries do not demand the same level of creative participation on the part of the director; a sense that documentaries simply require tossing a camera into the action, shooting an interview, or researching some photographs and the decision-making is complete. This, like most assumptions, is far from accurate.

6 (Hynes, 2013)

Nonfiction filmmaking has always included all the tricks of the trade we commonly associate with narrative filmmaking. Early nonfiction filmmakers frequently reenacted scenes and collaborated with their subjects to choreograph for content or aesthetics. Filmmakers experimenting with the formal elements of camera and storytelling, such as Stan Brakhage and Shirley Clarke, involved themselves in the nonfiction form.

In Robert Flaherty's seminal film *Nanook of the North*, it is widely known that Flaherty worked with Nanook (real name Allakariallak) to recreate scenes of Inuit hunting traditions that were rarely, if ever, used at the time. For example, in historian Erik Barnouw's extensive recounting of Flaherty's experience in shooting *Nanook*, he describes how a snowstorm surprised the crew. The Inuit built igloos for protection; however the igloos were too small for the camera, so they had to construct a special "film" igloo that fit the demands of filming.[7] The women playing Nanook's wives in the film were not his wives at all. Additionally, in a particularly memorable scene when the men of the tribe were hunting walrus in dangerous conditions, they called to Flaherty to shoot the walrus with a rifle to prevent the men from being dragged into the sea. Flaherty pretended not to hear them and continued to shoot the scene he felt would have the best effect for the film.[8] For Flaherty, the film he was capturing was more than an exercise in cultural accuracy. Rather it was the expression of his ideas about the purity of native practices. Barnouw recounts this excerpt from Flaherty's diaries: "I am not going to make films about what the white man has made of primitive peoples. … What I want to show is the former majesty and character of these people, while it is still possible—before the white man has destroyed not only their character, but the people as well. The urge that I had to make *Nanook* came from the way I felt about these people, my admiration for them … "[9] Here we see the direct correlation between a filmmaker's personal beliefs, reality as he sees it, and how what he shoots in the field can reinforce these concepts on screen (and, subsequently, in the minds of audiences worldwide). In this context, the "truth claims"[10] of the nonfiction form are at their most potent, and potentially dangerous, without the additional understanding of the artistic and personal complexities at play in the making a film. As Patricia Aufderheide explains in her book *Documentary Film: A Short Introduction*, a documentary is "a movie about real life. And that is precisely the problem; documentaries are ABOUT real life; they are not real life. They are not even windows onto real life. They are portraits of real life, using real life as their raw material, constructed by artists and technicians who make myriad decisions about what story to tell to whom, and for what purpose."[11]

At the time Flaherty was mixing elements of docudrama, documentary, and reenactment in sophisticated ways, his audience was still developing its understanding of the rules of the game. But through years of education born of film viewing, audiences have adapted and

7 (Barnouw, 1993, 38)
8 (Barnouw, 1993, 36–7)
9 (Barnouw, 1993, 45)
10 (Aufderheide, 2007, 2)
11 (Aufderheide, 2007, 2)

learned how to read cinematic texts. Films such as Luis Bunuel's *Land Without Bread*, William Greaves's *Symbiopyschotaxiplasm: Take One*, Jim McBride's *David Holtzman's Diary*, Orson Welles's *F for Fake*, Abbas Kiarostami's *Close-Up*, Werner Herzog's *Little Dieter Needs to Fly*, and Errol Morris's *The Thin Blue Line* are all projects experimenting in reenactment, hybrid forms, or genre conventions, and have all benefitted from this evolving set of skills over the decades. Today, documentary filmmakers are still playing with the techniques of reenactment, performance, and docudrama. They are mixing fictional and nonfictional elements into stories to create hybridized treatments with new and multiple meanings. They are embracing documentary as narrative nonfiction cinema, with less concern about a film's connections to "ultimate truth" and more interest in what the *filmmaker's* understanding of "truth" might be.

Some may say this violates the contract with the audience. When audiences see a documentary they expect to walk away "knowing" something that is "true." But today's filmmakers have a feather in their quivers that Flaherty didn't: an audience raised on the moving image and deeply familiar with the tropes of documentary film. They understand that documentaries are typically stories based on actual events, and they are experienced in watching them in a way early audiences couldn't be. They understand that media is used to inform, to educate, to manipulate, to provoke, to proselytize, to entertain, and sometimes all of these things at once. Their sophisticated knowledge of the form allows room for filmmakers to be "at play" with more direct, artistic intention. There are an increasing number of examples in recent years of documentaries that have taken a hybrid approach to the form, relying on a deep trust that the audience will come with them on a journey into nonfiction storytelling from the point of view of an artist. Four from the last five years are standouts, each experimenting with documentary in different ways, to different ends.

In Robert Greene's *Actress*, as the title suggests, Greene is intentionally playing with the concept of performance in life, art, and documentary. The opening shots show the film's protagonist, Brandy Burre, in a Douglas Sirk–like scene posed at her kitchen sink in a '50s–looking red dress with a heavily art-directed set (her own kitchen) around her, loosely holding a glass after washing dishes. In voice-over, Brandy recalls a scene she was in when she was working on TV (we see the scene, from HBO's *The Wire*, later in the film): "I was thinking the other day about that scene where I say 'I'm a type A and I tend to break things.' And it just occurred to me it wasn't just the character, it was me." In this opening scene, Greene sets up the rules of engagement with the audience. Burre is performing for the camera, and yet her voice-over has the qualities of the confessional testimony that is the "good stuff" of nonfiction. In this film, Greene demonstrates that he will mix documentary and fiction in ways that will get to a truth of Burre's experience (or, one might say, of Greene's experience of Burre; or, more accurately, the audience's experience of Burre through Greene's lens). The themes at play in the story will be performance and reality through the eyes of a woman, an actress, currently experiencing life from outside the spotlight in her domesticated, suburban existence as caregiver to her two children and partner. The opening sequence takes on the full breadth of the narrative and artistic complexity of the film, then prepares you for what comes

next. In an industry bereft of meaty roles for women "of a certain age," Brandy captures the role of a lifetime—herself.

The film weaves in and out of scenes that feel at times rehearsed, scripted, or directed and then chaotic, spontaneous, and fresh. Yet, by interweaving these approaches, this tapestry of moments also mimics the character study of Brandy herself—where does Brandy begin and the *Actress* end? She performs for the camera, for her mother, her partner, her kids, her friends and neighbors, she auditions for new roles. But the raw Brandy is a scarce presence and, therefore, even more precious. Through knowing her as a performer (in life, in art), we begin to understand her emotional depth with more clarity. By understanding her patterns, and those of the film, we are able to discern between real vulnerability and emotional armor. For example, there are two key scenes in the film—one when it is revealed that she is having an affair while the rest of her family is away on a trip, and another when her partner, Tim, realizes she had the affair and moves out—where this balance between performance and vulnerability is crucial to the understanding of the character. Greene handles these scenes very differently and to great effect.

In the first scene, we are in a car with Burre as she describes the lack of romance that can creep into a marriage after years of children, finances, and responsibilities crowding out passion. As she continues to address the camera, we understand she's looking for a thrill she can no longer get from her partner. The next shots are then dominated by music. Burre crosses a bridge over a highway, flirtatiously twirling in the light for the camera. On the other side, we see her in silhouette by the bridge caressing a tall man, laughing and throwing her head back. As she leans in to kiss her paramour, the camera crowds him out and focuses only on Brandy. We see half a kiss, a star in the spotlight. Though perhaps unrehearsed, the scene feels choreographed, and the music adds to the feeling of performance and control. Skip to Brandy speaking directly to the camera, recounting the story of Tim discovering her infidelity. She tells the story as if she is objectively listing the forensic facts of the encounter in an effort to avoid feeling their impact. But this façade breaks down over time. As she continues to discuss her failing marriage to Greene behind the camera (to us, her confessors, the audience), she begins to spill over at the sides. The performance has cracked, and now Brandy needs to deal with the consequences of these burning needs—the need to feel wanted sexually, professionally; the need to be a mother, but not *just* a mother. This deft handling of the material allows us to access the humanity of Brandy and therefore connect to an understanding of her beyond simple stereotypes and easy solutions. Indeed, the themes of the film are very familiar: women forced to choose between their creative selves, their sexual selves, and their mothering selves, or trying desperately to negotiate a compromise between all of them.

In the last frames of the film, Brandy is talking about her fall from a car in which she smashes her face to the point of severe bruising. She sees this as a message from the universe: "I'm clumsy. Perhaps not so graceful." The moment stands in direct contrast with the rehearsed and choreographed scene at the film's start. We see a Burre with no makeup, looking and sounding vulnerable. In the "type A" scene at the beginning of the film, the things we

imagine she breaks are on the outside. In the end, it seems, she breaks herself. When comparing the two scenes, this change from the staged (at the outset) to the confessional (at the end) punctuates our understanding of Burre with more power than a more traditional or vérité approach to the film would accomplish. It is the embrace of the hybrid approach that, in the end, brings us to a deeper "truth."

As Robert Greene himself writes in an article he crafted on cinematic approaches to nonfiction: "Nonfiction cinema would best be described as a *way of seeing* and less a rigid and prescriptive 'genre.' The most interesting documentaries push narrative bounds, re-shoot situations (as opposed to the somewhat tired practice of reenactment), play with the idea of performance, etc. They break the rules."[12] It is here that Greene makes his most significant point, by understanding nonfiction cinema as a "way of seeing." Documentary is, often, mistakenly understood as simply the retelling of actual events. But as we can see, these films include a series of choices on the part of the director, choices that shape our understanding of what we see. It is perhaps more accurate to understand nonfiction as an understanding of real events through the artistic lens of a filmmaker who uses the techniques of cinema to communicate their ideas.

In Sarah Polley's film *Stories We Tell*, Polley crafts fictional scenes, shot as archival footage, scripted from memories her family and friends of the family share about her mother. These sequences are presented in the film as Super 8 family home movies, and due to the familiar tropes of documentary film, the audience reads these sequences as true artifacts of her family's life. To the keen observer, one might suspect that this treasure trove of footage is almost too good to be true; however, for those suspending their disbelief, it is not until the closing credits that the audience learns much of the archival footage was scripted and performed. Have we been duped? Or is the filmmaker playing with concepts of memory and point of view when investigating her own family history? As Peter Bradshaw writes in his review of the film for *The Guardian*: "It is a work of some audacity, even effrontery, mixing pastiche Super 8 footage and faux home movies in with her genuine archive material, avowedly because the film is about the unreliability of memory and the consequent importance of democratizing personal histories, allowing everyone to tell their stories and give their view."[13] Polley relies on the notion that her audience is a sophisticated one, familiar with the visual cues of nonfiction, and she uses their own understanding of those cues to both lure them into the narrative and to play with the themes in the piece (What is truth? Whose point of view counts most? What do memories tell us?). In all this meta-cinematic play, Ms. Polley's father reminds her of what is really at stake in the film: her own search for a father. In this moment, we concede that what is "real" in this story is not of little consequence to the filmmaker herself.

In Alma Har'el's *Bombay Beach* (2011), the filmmaker mixes reality and performance to interpret the lived experience of the residents of one trailer park by the Salton Sea, a retreat

12 (Greene, 2013)
13 (Bradshaw, 2013)

for the lonely, forgotten, poor, and needy. Har'el finds the heart and soul of the place through the lives of the people who live there. There is no clear story arc in *Bombay Beach*, as one might find in a more traditional narrative approach. What Har'el assembles are collections of moments from life in a shared space. Her storytelling techniques include a mix of character-driven vignettes (delivered mostly through montages filled with painterly images and monologues where the audience gains access to the characters' points of view) and music-driven, highly-stylized, choreographed performances. In the extended music sequences, Har'el teases out the conflict, crisis, and emotion at play in the characters' lives through dance. These moments serve as fantasy, metaphor, and reflection for the audience. In some ways this is a directorial boast, a way of saying that she understands her characters so well as to be able to represent their dreams and anxieties. In another way, the performative segments of the film help us understand dynamics that may be more difficult to fully understand, capture, or, more significantly, *feel* without their inclusion. This move away from realist depictions of the lives before her camera, when a nonfiction film moves to more fantastic cinematic techniques deviating from the real, is called *formalism*. Explains scholar Patricia Aufderheide: "In contrast to realism are approaches that call attention to the artist's and the technology's role in creating the film. Some of these approaches have been grouped under the term formalism, meaning the highlighting of formal elements in the film itself.... Proponents of formalism charged realists with illusionism, with tricking viewers into believing that they are watching something real; instead, these makers argued, let viewers notice and even celebrate the artist's role in creating the work."[14]

Two such "fantasy" scenes include the youngest character, Benny, a boy of maybe six or seven troubled by family dysfunction and a full pharmacy's worth of medications to help him cope. In one sequence, Benny is pitted against his siblings and the children in his neighborhood in a dance number illustrating the bullying he withstands and what it feels like to be a kid ostracized by your near peers. In the final sequence of the film, as we feel that the prospects for Benny and his healthy survival in this space feels most fragile, we see Benny light paper on fire in the middle of the street. In moments, a fire truck arrives and as it does, in what quickly moves into a fantasy sequence, he pushes the truck back and it spins away from him. As the truck passes again, we see Benny is now on top of it wearing a firefighter uniform (complete with mustache). The feeling we are left with is that Benny's fate is not sealed in this film, his story is not fully written. There are dreams for him yet, and perhaps all is not lost.

Possibly the most discussed film of recent years, pushing these themes of truth, performance, memory, and reality, is Joshua Oppenheimer's *The Act of Killing*. Nominated for an Academy Award in 2014, this film looks at a group of small-time gangsters turned death squad leaders during the Indonesian genocide of 1965. During their reign of terror, they assisted in the killing of nearly one million alleged communists and intellectuals. The leader of the gang, Anwar Congo, probably killed hundreds of these victims by his own hand. Fast-forward to

14 (Aufderheide, 2007, 26)

today and Congo is a leader in a powerful paramilitary organization continuing to intimidate, extort, and threaten the people under his thumb. In the film, we witness a group of men never held accountable for their crimes; their power now augmented. The narrative of the documentary is shaped by this group of gangsters, Congo at the helm, creating a Hollywood-style fiction film of the atrocities they committed in the 1960s from their perspective. As this former death squad engages in dramatic reenactment, they (and we) are afforded reflections on what they did, how they feel about it, and what it means today.

Despite its Academy nomination, the film is not without controversy. Director Jonathan Oppenheimer was attacked for giving voice—even humanity—to the violent, brutal men who continue to oppress the Indonesian community to this day. There is no doubt that their brutality is still felt in the film. In one scene, Anwar and his buddies are driving down the street together and discussing their "Crush the Chinese" campaign, laughing as they recalled killing every Chinese person they saw walking along the street. In another, they speak with delight about the good old days when they raped any woman they encountered.

But we also sense an understanding among some of them, that what they did was not as noble as their memories portray. In one such moment, the gangsters are getting ready for shooting an interrogation scene. Anwar's friend and comrade in this violence, Adi Zulkadry, rehearse together. Anwar interrogates another friend playacting as an accused Communist, saying, "Why do you recruit people to join an illegal party?" Adi breaks the scene: "Back then it wasn't illegal.... . It's easy to make the Communists look bad after we destroyed them ... "

Later, Anwar and Adi go fishing. Adi mentions that he understands why the children and widows of their victims suffer, saying, "You kill their father, then do not allow them to get a job, marry, go to school. And there has been no public apology. An apology would be 'like medicine' and sooth the pain." Anwar admits that he is haunted in his dreams by what he's done.

In one of the most powerful scenes in the film, the gangsters are on stage preparing for another shoot. Another man joins them who we have not seen before. He is Suryono, Anwar's neighbor. He's laughing as he enters and mentions that he has a true story he can share with them. The gangsters urge him on, confirming that all the stories in this film must be true. Suryono tells the story of his stepfather, a Chinese shopkeeper, who was taken from their home in the middle of the night. They found his body the next day under an oil drum. No one in the area dared help them for fear they would be seen as Communist sympathizers. So Suryono, at age twelve, and his grandfather buried the body at the side of the road "like a goat." Soon after, all Communist families were exiled. His family was dumped in a shantytown at the edge of the jungle, left without resources or opportunity.

As Suryono recounts this tale, the gangsters try to listen calmly, knowing they are implicated in this tragedy. Suryono laughs nervously as he speaks, all too aware that sharing his story with this group could put him at great risk. He says, "I promise this is not criticism of what we're doing. It's only input for the film. I promise I'm not criticizing you." The gangsters then respond to the story, not on its own merits, but in its possibilities for the film. They protest that they

can't include everything, because the script is already written and it would take too many extra days to shoot.

They immediately move on to the day's shoot, in which Suryono is playing the victim to be interrogated. They discuss how to question and torture him, a fate that probably befell his stepfather. Suryono breaks down in a way that appears to be directly linked to his own past, begging to speak to his family one last time. Adi warns all present in the conclusion of this scene: "If we succeed in making this film, it will disprove all of the propaganda about the Communists being cruel. And show that we were cruel… . We must understand every step we take here … "

As the filming progresses, Anwar gets worn down. Particularly as he continues to play the victim in these reenactments, he becomes more emotionally vulnerable. At the start of the film, Anwar takes Oppenheimer to one of the killing rooms, and with great pride describes the method for execution he used to practice that produced the least amount of blood. In the last scene, they revisit the killing floor. The mood is much less jovial than at the start. Anwar begins to retch. Is a conscience emerging? Is this too a performance for the camera? The mix of actuality, memory, and performance in this film can bring us to different, disturbing, and often warring conclusions.

In a much-circulated critique of the film written by BBC Storyville's Nick Fraser, titled "Do not give an Oscar to this snuff film," Fraser shares that "What I like most about documentary film is that anything can be made to work, given a chance. You can mix up fact and fiction, past and present. You can add to cold objectivity a degree of empathy… . But documentary films have emerged from the not inconsiderable belief that it's good to be literal as well as truthful."[15] For Fraser, the problem with *The Act of Killing* is not the formal experiment, but the premise. He believes that in this case, the recreations of atrocities made by the perpetrators themselves as they gleefully restage the horror fails to reveal anything new or inspire the catharsis we hope we're experiencing at the end of the film.

Academy Award-winning documentary director Jill Godmilow believed the film was tragically disrespectful to the Indonesian people. "Throughout the film, Oppenheimer encourages his collaborators to produce ostentatiously surreal and violent dramatic film reconstructions of their death squad activities. Ever since Robert Flaherty asked his Inuit collaborator Nanook … to fake the capture of a seal … we have seen hundreds of social actors perform 'real' re-enactments of their lives for the cameras of documentary filmmakers. There is nothing new in *The Act of Killing* but carnage, and the special, cozy relationship we are urged to enjoy with the killers."[16] Like Fraser, she has no trouble with recreation as a tool of the trade, but feels its use in this film is unproductive and, in her word, "unclean." She goes on to make a series of recommendations to filmmakers on making sure their films are ethically sound, reading much like a manifesto on ethical nonfiction filmmaking to

15 (Fraser, 2014)
16 (Godmilow, 2014)

some and a public scolding to others. The article sounded a battle cry in the field, inspiring some and infuriating others.

Act of Killing's executive producer, Errol Morris, jumped to the film's defense with a different reading of its formal success and artistic intent: " ... there is method to Oppenheimer's madness—the idea that by re-enacting the murders, he, the viewers of the movie, and the various perpetrators recruited to participate could become reconnected to a history that had nearly vanished into a crepuscular past... . Oppenheimer is not offering a historical account of what happened in Indonesia, but rather an examination of the nature of memory and of history."[17] He goes on to compare the film's central conceit as linked to Shakespeare's *Hamlet:* " Hamlet, of course, suspects that his uncle, Claudius, has murdered his father, the king of Denmark, then married his mother, the widow of the murdered king. Hamlet learns from his father's ghost ... that Claudius really is the killer... . Hamlet asks: Can the play capture the conscience of the king? *The Act of Killing* asks: Can the play capture the conscience of a nation?"[18] For Morris, the reenactments in the film are less a vehicle for the victors to relive their glory days, but instead a method by which the people of Indonesia may finally have a "historical reckoning" that has been, for decades, overtly suppressed.

Joshua Oppenheimer, responding to criticism of the film, noted that his intent was to make a film about the survivors of the genocide, but found that it was a film too dangerous to make in the current political climate of Indonesia. Instead, he collaborated with survivors on trying to expose the current corruptions as linked to the genocide through the eyes of its perpetrators. Oppenheimer clarifies: " ... in this sense ... *The Act of Killing* is not a documentary about a genocide 50 years ago. It is an exposé of a present-day regime of fear. The film is not a historical narrative. It is a film about history itself, about the lies victors tell to justify their actions, and the effects of those lies; about an unresolved traumatic past that continues to haunt the present."[19]

Although the film has traveled the world, its most significant outreach has been in Indonesia itself. This is a difficult project as political censorship prevents it from being shown publicly; however, human rights activists, journalists, and filmmakers inside the country have persevered (Oppenheimer cannot return as the conditions are too dangerous for him) in organizing approximately fifty private screenings in thirty cities in an effort to inspire a dialogue on the current political situation in Indonesia that previously felt impossible.

The firestorm the film has set off in Indonesia, and the possible social change it could inspire, is of far more significance than the firestorm it has set off in documentary circles about the ethics of its making. Oppenheimer's project, however, has opened a dialogue within the field about the future of the form, what documentary means today, and what responsibilities filmmakers have to their subjects, their audiences, and to the very art they practice.

17 (Morris, 2013)
18 (Morris, 2013)
19 (Oppenheimer, 2014)

This debate continues from the fringe edges of formal innovation to the biggest names in nonfiction. In his keynote speech at the 2014 Toronto International Film Festival, provocateur Michael Moore listed thirteen treaties for nonfiction filmmakers to adopt. Chief among them, a reminder to filmmakers that the core of what they do is not to create lectures or polemics on a topic, but to create movies that entertain. From Moore: "We are not documentarians, we are filmmakers…. . This word, 'documentarian'? I am here today to declare that word dead. That word is never to be used again."[20]

Of course, "entertain" may be the wrong word when considering films engaging an audience on the history of a genocide. But the films described herein fit within a territory of movies crafted to do more than educate or serve as historical documents. These films and filmmakers seek to entertain their audiences, engage them, and share stories about "real life" while making creative, compelling cinema. This is not, however, a new practice of nonfiction film, as evidenced briefly here; today's artists are pushing the boundaries to see where experimental or hybrid approaches can take their storytelling practice, and the lives and histories they hope to share.

EVOLUTIONS IN THE FIELD: HARVARD'S SENSORY ETHNOGRAPHY LAB (*SWEETGRASS*, LEVIATHAN, FOREIGN PARTS, MANAKAMANA)

"From the near-revolutionary Sensory Ethnography Lab at Harvard comes one of the most important documentaries ever made. By pushing their immersive verité portrait of a [New Bedford] fishing boat and its crew past the point of observation and into pure abstraction, co-directors Castaing-Taylor and Paravel have created a new type of experiential cinema and have drawn the map to the future. There is no going back after a masterwork like Leviathan. The game has changed."—Robert Greene, Filmmaker[21]

It could be said that all cinema (and all art, in some ways) is on a quest to explore, understand, and excavate the human condition. While some pursue this mission using an artist's lens (as we read above), others use a more scholarly approach where film is one of many tools with which they examine and interpret the world for the sake of deeper learning. It is here that the documentary filmmaking tradition crosses paths with one its closest companions— ethnology. Ethnography is a subset of anthropology, the study of human cultures, where the researcher sets a hyper-focus on a specific environment. Whereas an anthropologist might study a tribal region, an ethnographer might study one tribe in one location over a period of time. For many years, the field was defined by the work of researchers (mostly white men) from the Global North studying cultures from the Global South. Researchers went into the field for months or years and recorded what they learned about cultures foreign to their own.

20 (Ravindran, 2014)
21 (Greene, *Leviathan is a Non-Fiction Gamechanger*, 2013)

These studies resulted most typically in books designed to enlighten readers (primarily other anthropologists) about the customs of a variety of tribes and cultures.

As new technologies became available, these scientists illustrated their study, first in photography and then film. Film seemed a perfect complement to the field, as it had the unique capacity to capture customs and practices in real time, often recording a ritual or activity from start to finish with little interruption. In short, the camera could observe unobtrusively (this would later be argued) the activities of the people it captured on celluloid. For anthropologists, the "observational" style of cinematic engagement was crucial to their practice and ethics. The films acted in support of the larger research and fieldwork, and even mimicked the traditional written research in style. Working in the expository mode, early ethnographic films would often employ voice-over narration to thoroughly explain the researchers' observations and interpretations of the activities seen on screen.

Among the earliest practitioners of ethnographic filmmaking was John Marshall. As a young man in 1950, Marshall traveled with his family to Kalahari where he made his first films of the !Kung Bushmen, *The Hunters* (1957). He would go on to document this culture off and on for the next fifty years. As Marshall shared of his process: "I tried to follow what people were actually doing and saying. I filmed thoroughly instead of covering complex events with a few shots to illustrate my own mental constructs and informal scripts."[22] Like Robert Flaherty, Marshall felt a sense of obligation to the people he recorded. An early collaborator of John Marshall, Robert Gardner also began making ethnographic films in the 1950s and had his first great critical success in 1963 with the film *Dead Birds*, about the Dani tribe of New Guinea. This project was a breakthrough in many respects as it was among the first ethnographic films to take advantage of the technological advances in 16mm film recording. Although this feels like a constraint in today's digital age, magazines loaded with four hundred feet of film gave filmmakers the freedom to shoot long takes (up to about twelve minutes), contrasted with the two- to three-minute takes that a windup Bolex camera was capable of shooting.[23] For *Dead Birds*, Gardner broke from the more clinical voice-over narration often offered in ethnographic films and crafted extensive, poetic monologues describing Dani thoughts about death and played them over the images of the rituals he captured on film. Was this an insight into the culture? An artistic flourish? An overstep?

As the form grew into more common practice, it also evolved through critical response. Ethnographic filmmakers became more aware of the power dynamics at play between filmmaker and subject, and how these dynamics affected the resulting films. What are the ethical responsibilities at play in these relationships? How do a filmmaker's own notions of a culture (sometimes essentialist, naïve, or, at times, racist) seep into portrayals on screen (exotic other, innocent native, etc.)? How does storytelling shorthand affect an audience's understanding of what is "true"? As Scott MacDonald discusses in his book *The Cambridge Turn*, "Ethnographic

22 (Tames, 2005)
23 (Lee)

filmmaking … has its occupational hazards. What may at one time have seemed obvious to ethnographic filmmakers about a cultural group, that is, what they assume was "true" or important according to their understanding of then-current anthropological research, has often been rendered misguided and false by subsequent research. Indeed, decisions that may have been made with the best intentions … have often come to seem, even to the filmmakers themselves, a myopic romanticizing of history that ignored the broader realities of that moment."[24]

Also troubled by the power dynamics at play and the limitations of the medium, filmmaker and theorist David MacDougall made the study and critique of ethnographic filmmaking a focus of his work. He suggests that early ethnographic films made by John Marshall or Robert Gardner succeeded with audiences because in these works the ethnographer acts as a trusted guide to an audience at sea in a world they don't understand. They trust the researcher's analysis because they trust "the process that produced him." In these films, the ethnographer is omniscient with a personal interpretation that stands in as "truth" in the minds of audiences. But, as MacDougall describes in his article "Beyond Observational Cinema," this methodology ignores the imbalance in power between the filmmaker and subject: "No ethnographic film is merely a record of another society; it is always a record of the meeting between a filmmaker and that society. If ethnographic films are to break through the limitations inherent in their present idealism, they must propose to deal with that encounter. Until now they have rarely acknowledged that an encounter has taken place."[25] Despite the safe and apparent distance the observational approach to shooting places between the filmmaker and filmed, there are power balances, political interests, interpretations, and aesthetic choices that influence first the filmmaker's and then the audience's perception. Even simply in making the selections of what to shoot or what to include in the film, the filmmaker exercises his or her judgment and voice. In this way, a seemingly "neutral" film is revealed as nothing of the sort. MacDougall argues that beyond observational cinema lies a "participatory cinema" in which the relationship between filmmaker and filmed is acknowledged, where the filmmaker's role or intervention is somehow a part of the cinematic document itself. The ethical, practical, and aesthetic questions multiply with these considerations: What is film best at communicating? What is the ethnographic filmmaker's mission? What is the filmmaker's responsibility to his or her subject, audience, story, and to "the truth" that she or he witnessed? What are the limitations of the pursuit of "truth" and, indeed, whose "truth" is present in any filmed document?

It is important to note that the trailblazers of the medium were among its strongest critics. John Marshall's practice evolved from observation to participation to activism, noting the ways in which filmmakers such as himself may have harmed the very people they were studying. Robert Gardner continued to push his work artistically, striving for a visually engaging filmmaking practice that exposed his privileged position as artist. He prioritized crafting an

24 (MacDonald, 2013, 336)
25 (MacDougall, 1995, 125)

experience "true" to the one *he* had in the field. He was also troubled by the heavy hand of the filmmaker in the creation of meaning. As he wrote in his book about making one of his most noted films, *Forest of Bliss* (1986), " … I thought that the audience would not simply wait for the mysteries to be dispelled but would come up with their own solutions, supply their own answers, and so, in that way, they would be doing their own anthropology."[26] Gardner also worked to grow the field itself, founding the earliest departments dedicated to the study and practice of ethnographic film (first at the Peabody Museum, then the Film Study Center at Harvard).

Timothy Asch identified the tensions in his own work and that of his colleagues, and dealt with these tensions in his own practice. For example, in his film *The Ax Fight*, Asch plays with formal aspects of filmmaking and anthropological reportage in an effort to examine the problematics of the ethnographic approach. The film has four sections, all depicting the same ten minutes of footage from a much longer fight that broke out between two villages. One section attempts to show the ten minutes of recorded footage uninterrupted. Another breaks down the fight into more clarifying detail, what the filmmakers thought was happening at the time and what they learned afterward. A third section examines the cultural relationships and historical connections between the villages, and a final section offers a shorter, more polished, edited version of the fight. As Patricia Aufderheide points out in her look at the film: "Thus, *The Ax Fight* forced viewers to ask themselves how they would interpret what they saw. Although it did not result in many imitators … it precipitated an anthropological debate about how best to use film."[27] Ethnographic film pioneer Jean Rouch championed a collaborative form of filmmaking—working with his subjects to craft the storytelling—in a process he called "shared anthropology." Rouch's most famous documentary *Chronique d'un été* (*Chronicle of a Summer*) is a formal experiment in which Rouch and collaborator Edgar Morin, in no way the silent observers of a behavior, actively engage passersby on a Parisian city street with the question, "Are you happy?" The results expose the political and social tensions past and present in French life in the summer of 1969. As Richard Brody writes in *The New Yorker*, "It's one of the greatest, most audacious, most original documentaries ever made, one that poses—and, what's more, responds to—questions of cinematic form and moral engagement that underlie the very genre, the very idea of nonfiction film."[28]

Today's leaders in creative approaches to the ethnographic film come from Harvard University's Sensory Ethnography Lab, continuing Harvard University's long legacy of innovating the form. Soon after Robert Gardner's retirement from the Film Study Center, filmmaker and anthropologist Lucien Castaing-Taylor, former student of Timothy Asch, founded the Sensory Ethnography Lab (SEL). The media work (film, installation, soundscape, interactive, and more) emerging from the Lab is encouraged to provide audiences

26 (Ostor, 2002, 25)
27 (Aufderheide, 2007, 111)
28 (Brody, 2013)

with an understanding of how a particular environment is experienced through the senses (with an emphasis on sight and sound for the cinematic work). How can we understand this space? Whose perspectives are privileged? Who or what uses this space? How does it move, smell, change over the course of a day? The aim is not an omniscient overview, but the ability to translate a specific practice, space, or experience into a form where audiences might understand what it could be like to be *in* this space from the perspectives of the people and animals (and at times, the relationships between them) inhabiting it. As Castaing-Taylor related to Dennis Lim, director of programming at the Film Society at Lincoln Center, "[The SEL] takes ethnography seriously. It's not as though you can do ethnography with a two-day, fly-by-night visit somewhere. But it also takes 'sensory' seriously. Most anthropological writing and most ethnographic film, with the exception of some truly great works, is so devoid of emotional or sensory experience.... It takes what art can do seriously. It tries to yoke it to the real in some way."[29]

The first critical success from the SEL was Castaing-Taylor and Ilisa Barbash's film *Sweetgrass* (2009). In a familiar trope of ethnographic work, *Sweetgrass* follows the *last* sheep-herding drive up the Absaroka-Beartooth Mountains. With breathtaking cinematography, *Sweetgrass* transports the audience with an observational technique so immediate you feel you are in the moment with the cowboys, moving a stubborn flock up rocky terrain. There is no voice-over narration, no title cards, no music, nothing to distract the viewer from the experience and nothing to impose a meaning to the events as they play out beyond what an audience might interpret on its own.

Sound design is crucial to the sensory experience films from the SEL attempt to create. For *Sweetgrass*, sound artist Ernst Karel crafted raw field recordings into a masterpiece of place. Sharp and harsh in moments, serene in others, the experience of sound in the film locks the viewer deeply into the locations. One particular moment that stands out is when, the cowboys, John Ahern and Pat Connolly, notice the sheep have wandered into a terrain dangerous for the flock and difficult to pull them from. Tired from the long journey and lack of sleep, Connolly attempts to round them up and right their path. As he does, we hear, in close-up, his frustration articulated in a long, and at times hilarious, obscene rant directed at the sheep. As the rant continues, the camera slowly pulls back to reveal the majesty of the landscape, the difficulty facing the cowboys as they continue the journey, and the rawness of the environment. Because of this unique sound/image relationship, viewers understand quickly the beauty, absurdity, and levels of difficulty at play in this practice.

There is little dialogue in the film overall, but another scene again features Connolly as he shares a litany of complaints about the journey, the job, the conditions, his health and that of his horse to his mother by cell phone. He shares with her in almost a cry, saying, "I'd rather enjoy these mountains than hate 'em." There is something remarkably intimate and vulnerable about this moment when a hardworking, seemingly tough cowboy living for

29 (Lim, 2012)

weeks in the wilderness is crying to his mother about his hardships. There is also something odd about seeing a cell phone in this space that for the majority of the film evokes a sense of the premodern, a time before technology and cell towers. Importantly, it is a moment when we feel a break from romanticized notions of a pure and perfect past often felt in "salvage ethnographies" (the recording of a practice threatened by extinction). By including scenes such as this, Castaing-Taylor and Barbash place the practice into a moment of flux; no cultural custom is static enough to be preserved, easily captured, or cleanly translated. All that a film can capture is a moment along a trajectory of constant change.

Although the experience of the film on screen has a simplicity about it—a lack of seeming "constructedness"—where the film appears to emerge naturally from observed moments in the field, the filmmakers are painstaking in the amount of preparation and research they commit to their projects. They have a deep understanding of the political and social realities of the people and situations they encounter. In each of these projects, the filmmakers attempt to craft an experience for the audience that reflects their understanding of what they observed in the field and their research on the culture they investigated. How did this place sound? What are the human dynamics of this space? How do human, animal, nature, and technology interact and interweave? What power relationships are at play? Film artists using these methods attempt to create an experience as close to the one they participated in for the audience to make their own deductions, to do their own investigative work. This does not, however, suggest that these texts lack meaning at the hands of their makers. As critic Robert Koehler writes, "For in *Sweetgrass*, the guiding force behind these representations of working on the surface of the earth is an overwhelming sadness at the process of collapse and the end of things, alongside the unspoken drama of human beings stuck in a cycle with no escape. The politics is therefore immensely angry, and more forceful due to the recordists' refusal to announce their anger in literal means. Instead, it seeps out, like water trickling from rocks to form a creek, and the moral burden of the political ideas is borne purely by the cinema acts of watching and listening."[30]

After the completion of this project, *Sweetgrass* became, in many ways, the "theoretical foundation for the Sensory Ethnography Lab" and demonstrated the evolution of the approach from early ethnographic practices. As scholar Scott MacDonald explains, "A certain strand in the weave of ethnographic film—originated by Flaherty in *Nanook of the North* and *Moana* and epitomized by John Marshall's *The Hunters* and Robert Gardner's *Dead Birds*—has proposed to offer a representation of a traditional culture "uncorrupted" by modernization. For Barbash and Castaing-Taylor the quest to represent this kind of cultural "purity" is pointless, because culture by its very nature is always in transition, and every particular cultural practice is regularly confronted by, even formed by, influences from outside itself."[31]

Among its many features, *Sweetgrass* was noted for its minimal dialogue. *Manakamana* (2013) brings a new understanding to this phrase. In this film, codirectors Stephanie Spray

30 (Koehler)
31 (MacDonald, 2013, 321)

and Pacho Velez place viewers directly into one experience, traveling up and down a mountain in the Gorkha district of Nepal in a gondola as visitors trek to Manakamana Temple to pay homage to the Hindu goddess Bhagwati. There is no speaking in the film until about the twenty-minute mark. Each shot matches the length of the ride up or down the mountain, approximately ten minutes, so that the experience of that ride for the audience is a close approximation of what it might be for the travelers and creates some of the most unusual tracking shots in cinematic history. Shot on the same 16mm camera Robert Gardner used for *Forest of Bliss*, in *Manakamana* the myth of the unobstrusive camera is quickly disregarded. Given the space available and the gear required for recording, the camera looms large in the creation of the experience for all involved—passenger, filmmaker, and audience. Some make the journey in silence, others note the changes in the landscape and how the journey itself has changed over time, but a part of the magic of the film emerges from bearing witness to the passengers as they come to terms with their own understanding of being on film. Some are guarded, others perform for the camera like the three young, long-haired musicians in heavy metal T-shirts who brought a kitten with them on their journey (a gift for the goddess?). In a particularly funny scene, two women, one quite elderly, the other who might be her daughter, travel down the mountain after their visit and enjoy an ice cream treat. The audience marvels as they try to eat the melting confection before it messes their clothes. They begin by snacking demurely, but end in laughter, one covered in dripping cream, poking fun at each other. In these scenes you see a deliberate move away from romanticizing, infantilizing, or purifying other cultures on screen, but taking each subject as a unique human being with their own experiences to share or conceal. As Manhola Darghis writes in the *New York Times* of her experience of one particular scene in which a silent woman travels down in the gondola alone: "Because [Mr. Velez] and Ms. Spray don't try to control your viewing experience or steer your gaze … it's hard even to guess what that woman's face expresses. She may be experiencing fear or awe; she may also have had heartburn or a full bladder. She may have been tired of being on camera. This insistent uncertainty may drive some viewers to distraction, yet the incertitude makes the film as ethically radical as it is formally rigorous: By refusing to reduce this woman to a documentary prop—especially during her sacred journey—Mr. Velez and Ms. Spray affirm both the limits of their own knowledge (and the constraints of their method) and the ethical obligations that come when people become subjects.… By focusing on such a narrow slice of Nepali life, Ms. Spray and Mr. Velez have ceded any totalizing claim on the truth and instead settled for a perfect incompleteness."[32]

Manakamana is a document of a culture in transition, socially and technologically. Although little contextual information is shared in the film—What is the temple? Who or what do the travelers worship? How long has this been a cultural practice? These and other mysteries of context are not to be discovered within the film itself—the audience gets a very clear sense of what it is like to take this particular journey and, in that experience, gleans

32 (Dargis, 2014)

more about who visits, why, and what changes are occurring in this community than one might expect from the approach. Significantly, the filmmakers put the onus on the audience members to do this extra work themselves—to do their own anthropology.

Foreign Parts, cocreated by filmmakers Verena Paravel and J. P. Sniadecki, visits Willets Point in Queens, an ecosystem of car repair shops and a community of many cultures in a space selected for redevelopment by the city of New York (Willets Point is adjacent to Citi Field, home to the New York Mets). Marked by a rough and muddy terrain with chemical green puddles, mountains of tires, and galleries of car doors, Willets Point is at once a place of refuse and possibility, as demonstrated by the scrappy ingenuity of the entrepreneurs and the products they help people reuse. Although the film is similar to others from the SEL in its vivid description of the environment, this film engages much more readily in the dimension of human experience and interaction, with its own world of dramas, joys, and traumas. Some of these moments are small and singular—two men singing along with radio about their beloved Puerto Rico, a couple expertly dancing together reflected in a wall covered in rear-view mirrors, two Hassidic Jews drinking vodka with friends in a tiny office. But the film also establishes deeper relationships with a small handful of characters. The film has no clear narrative driving the film forward, though Paravel and Sniadecki revisit Luis and Sara (a homeless couple living in a van), Joe (the only legal resident of Willets), and Julia (a beloved panhandler and fixture at Willets Point) throughout the film. Through these characters, we understand the space over time and through seasons. Joe futilely fights City Hall's encroaching control over the space. Luis and Sara fear freezing to death in the depths of winter and celebrate Luis's homecoming from a short jail stay in the summer. In one scene as sad as it is sweet, Julia celebrates her birthday at a small bar/restaurant and dances with the camera. Again, the film provides little context to guide the viewer, no narration, no non-diegetic music, no on-screen text. But by the end of the film, the viewer gains a deep understanding of Willets Point, soon to be lost to gentrification, and the people that make it shine.

Verena Paravel went on to partner with Lucien Castaing-Taylor to create the critically acclaimed *Leviathan*, released in 2013. Although it is difficult to find words to describe the viewing experience of this film, it might more closely resemble a horror poem about the sea than a documentary about the New Bedford fisheries it follows over the course of its eighty-seven-minute running time. *Leviathan* forces an abandonment of any expectations about what documentary films should be and takes the viewer on an absolutely unique cinematic ride. The sensory experience extends to movement as the kinesthesia of the film rocks the viewer to and fro. Some audiences reported feeling seasick upon viewing the film; others walked out of the theater asking "is it going to be like this the whole time?" Despite these powerful reactions, *Leviathan* was a critical and formal success, some marking it as a game-changer for the field. Along the way, the filmmakers certainly suffered for their art. As programmer Dennis Lim describes: " In rough seas and frigid temperatures nearly 200 miles off the coast, perpetually wet and rarely sleeping more than two hours at a stretch, the filmmakers faced constant reminders that fishing has one of the highest mortality rates of any occupation. Mr. Castaing-Taylor was

seasick much of the time; Ms. Paravel was so physically battered from the outings that twice she had to be taken to the emergency room upon returning. They made six trips in all, each one lasting up to two weeks. 'The film became a physical reaction to the experience of being out at sea,' Ms. Paravel said."[33]

A significant marker of projects emerging from the Sensory Ethnography Lab is that the artworks created by the anthropologists are not a supplement to their cultural research, but the primary expression of it. In this, the artists provide the materials for understanding an experience and the audience become participants, witnesses, and, in some regards, researchers in their own right. Paravel and Castaing-Taylor pushed the concept of crafting a sensory experience beyond what many films created by artists of the SEL have accomplished to date, perhaps because of the violence of their own experience. They plotted an approach to their cinematography that varied perspective and gave equal weight to all forms of life engaged in the sea journey—the fishermen, the fish, the gulls. Affordable and durable Go-Pro cameras contributed much to this on-screen dynamic. Sometimes mounted onto the helmets of fishermen hoisting a catch into the ice chambers or severing fish heads from bodies in a nonstop onslaught of wet (from the sky, the sea?), sometimes floating among the discarded, ill-fated sea creatures on an ever-tilting deck; the point of view most represented feels distinctly not-human or, at least, not always human. In some of the most stunning imagery of the film, the camera dips below the surface of the sea looking up toward the boat's hull from beneath the waves, evoking the feeling of a fish about to be plucked from the depths by either the fisherman aboard or the menacing seagulls circling above. There is one scene that occurs in the below-deck sanctuary of the sailors, a moment that serves as a break from the relentless rawness of the life above. In this scene, we visit the boat's captain, weary and nodding off to sleep while sitting upright in a kitchen booth as he watches television. After experiencing the tumult of the world above deck, this scene is noteworthy for its stillness. We still feel the swaying, but our focus is primarily on three things: listening to the television (a strange mix of reality shows and commercials that evoke a comic reaction in this space), the drifting eyes and nodding head of our featured sailor, and the clock on the wall behind his head ticking away the minutes as we wonder, "How long will this scene last?" By including this moment in the film, the filmmakers balance the endless activity and danger of the work and conditions surrounding them with the contrasting boredom of a life at sea.

As a significant part of the documentary "renaissance," the films coming from the artists connected to or trained by the Sensory Ethnography Lab are a part of a long-term trajectory of filmmakers exploring the responsibilities, ethics, and aesthetics of capturing the "real." As scholar Karen Nakamura points out: " … it is clear that more than any other single institution right now, the Harvard Sensory Ethnography Lab is producing a new generation of filmmaker-anthropologists who have the potential to change the field of visual anthropology."[34] Their approaches are a part of a continuum of engagement with examining how film (or other

33 (Lim, 2012)
34 (Nakamura, 2013, 134)

media) can best serve an understanding of environments and human practices. Significantly, the films coming from the Lab are not just altering anthropological methods, but are affecting documentary practices field-wide.

DOCUMENTARY AS LONG-FORM JOURNALISM: A LONG-HELD RELATIONSHIP FINDS NEW SIGNIFICANCE *(RESTREPO, CRUDE, AND CITIZENFOUR)*

> *I think independent filmmakers, documentary filmmakers—they are journalists. I'm not a lawyer, but I do know this: we need to protect our ability to tell controversial stories. More filmmakers are taking up this mantle. They are doing some of the best investigative journalism right now, as the line between journalism and entertainment is getting blurred.* —Robert Redford[35]

When examining documentary filmmaking, which at its core explores and interprets the real, the questions inevitably arise: Is there a difference between documentary film and journalism? And, if so, what is it?

These are not simple questions to answer, as much depends upon the approach of the filmmaker, and each filmmaker answers these questions in his or her own way. Some see themselves as visual artists, others as anthropologists. Some enter the practice as activists, historians, or educators. Many—some would argue most—blur the lines between all these approaches at once. There are, however, a number of documentary filmmakers who place their work firmly within the journalistic tradition.

Of course, the links between documentary and journalistic practice are long-standing. CBS's early documentary strands of *See It Now* and *CBS Reports*, both with respected journalist Edward R. Murrow at the helm, brought regular documentary investigations into US homes from the early '50s through the mid-60s. *CBS Reports'* most famous film, *Harvest of Shame*, chronicled the lives of migrant agricultural workers and exposed what life in poverty can be like for the first time for many Americans. Peter Davis's film *Hearts and Minds* (1973), about American involvement in the Vietnam War, was incredibly controversial at the time and, yet, went on to win the Academy Award. Since the early 1980s, the PBS series *Frontline* has been a destination where documentary form and journalistic practice meet. *Frontline* produces its own journalism but also incorporates the work of documentary filmmakers such as David Sutherland (*The Farmer's Wife, Country Boys*) and Steve James (*Hoop Dreams, The Interrupters*) into their broadcast schedule. Acclaimed filmmaker Errol Morris (*The Thin Blue Line, The Fog of War*) fits his work within the realm of journalism. As he shared during his commencement speech at the Berkeley School of Journalism: " ... despite the job descriptions—filmmaker, detective, journalist—the enterprise that I was involved in was always similar. Asking

35 (Konrad, 2010)

questions: What is going on here? What does this mean? What really happened? … There is a world in which things happen and the journalist's job is to figure out what those things are. Anything less, is giving up on the most important task around—separating truth from illusion, truth from fantasy, truth from wishful thinking."[36]

The relationship between documentary film and journalism holds new significance in the current cultural moment. The overwhelming public embrace of digitally distributed information has threatened the survival of newspapers financially by making content available for free and luring away its primary advertisers from print mediums. Since the mid-2000s, newspapers across the United Staters (and the world) have been either shutting their doors, restructuring their organizations (some becoming nonprofits), eliminating their overseas bureaus, or reinventing themselves for the digital era by including increased video content and catering the work of journalism to an average page-view length of less than one minute.[37]

As these shifts in the field continue to make waves, one of the major casualties is the work of long-form journalism. Apart from a small handful of outlets, long-form print journalism has rapidly decreased over the last ten years. This decline was explicitly illustrated in a 2013 article from the *Columbia Journalism Review*: "*The Los Angeles Times*, for instance, published 256 stories longer than 2,000 words last year, compared to 1,776 in 2003—a drop of 86 percent, according to searches of the Factiva database. *The Washington Post* published 1,378 stories over 2,000 words last year, about half as many as 2003 when it published 2,755. *The Wall Street Journal*, which pioneered the long form narrative in American newspapers, published 35 percent fewer stories over 2,000 words last year from a decade ago, 468 from 721. When it comes to stories longer than 3,000 words, the three papers showed even sharper declines. The WSJ's total is down 70 percent to 25 stories, from 87 a decade ago, and the *LA Times* down fully 90 percent to 34 from 368."[38]

In some ways, documentary film has filled gaps left by long-form print. There are a number of films within the last ten years that occupy this territory between nonfiction storytelling and documentary journalism, including *Blackfish*, *The Invisible War*, *After Tiller*, *Give Up Tomorrow*, and the Academy Award-nominated *The Square*. Institutions such as the Knight Foundation and BRITDOC Foundation are looking for more ways to expand the work of documentary journalists in the field. As noted in the Knight Foundation's initiative connecting journalists and filmmakers, filmmaker Kevin MacDonald (*One Day in September*) notes: "The demand for documentary material is being driven by a decline in trust of the news media. There are terrible things going on in journalism and one of the reasons that documentary is thriving is because journalism is in crisis." [39] Universities see this change and are working to prepare their students for a new industry. Journalism schools are now bringing documentary filmmakers onto their faculties and making documentary more primary in their curriculums.

36 (Morris, Lecture: Berkeley School of Jounalism Commencement)
37 (Langeveld, 2009)
38 (Starkman, 2013)
39 (Search, 2014)

Young journalists are now expected to be multiskilled in sound and image collection. Noted documentary programmer Thom Powers (Toronto International Film Festival, DOC NYC) also spoke to this trend in a 2012 interview: " … in recent years newspapers have severely cut back their reportorial staff, almost down to the bone. Television news departments have been cut … . And it's left a real gap for long-form investigative reportage. What's encouraging is the way documentary film has entered that space. I think by no means is documentary film filling the loss of the cutbacks in other media in recent years, but one thing that documentary makers do uniquely is take a long time with a story. They take a year, or often longer than a year, to sit with a story, to pursue different sources, invest more resources—not because documentary filmmakers are richer than other media, far from it. But they're usually the work of an obsessed individual or collective single-mindedly focused on one story. That's compared with most news organizations, where reporters are lucky if they can concentrate on one story for a whole week."[40]

Given the above, one might argue that it is more important now than ever to distinguish documentary practice from journalistic inquiry. For instance, journalism has a tradition of reporting on many sides to a story, while documentary filmmakers do not necessarily need to follow this guideline. Documentaries often rely on character, emotion, and dramatic tension (the toolbox of storytelling) more than the pure reportage of facts. Some might argue that formal journalism acts within the confines of a particular set of rules, a code of ethics (as outlined by the Society of Professional Journalists). These codes include such guidelines as "minimize harm," "act independently," and "seek truth and report it."[41] But a study by the Center for Media & Social Impact called "Honest Truths" reveals that, though not formerly codified, the majority of filmmakers interviewed for the study followed a code of ethics not dissimilar to the ones followed by journalists. According to the study, "Documentary film-makers identified themselves as creative artists for whom ethical behavior is at the core of their projects… . Their comments can be grouped into three conflicting sets of responsibilities: to their subjects, their viewers, and their own artistic vision and production exigencies. Filmmakers resolved these conflicts on an ad-hoc basis and argued routinely for situational, case-by-case ethical decisions. At the same time, they shared unarticulated general principles and limitations. They commonly shared such principles as, in relation to subjects, 'Do no harm' and 'Protect the vulnerable,' and, in relation to viewers, 'Honor the viewer's trust.'"[42]

Given these overlaps and what we know about the varying approaches to cinematic non-fiction, are we then left to determine journalism as one might determine profanity—I know it when I hear it? Filmmaker AJ Schnack mused, when asked what kind of storyteller can be called a journalist, "Who deserves the right that has been so far afforded to traditional journalism? Documentarians have been on the outside looking in on a lot of those rights—and

40 (Chadha, 2013)
41 (Society of Professional Journalists, 2014)
42 (Patricia Aufderheide, 2009)

sometimes we've liked it that way because its given us more freedom to make artistic choices in our films—so it's an interesting question. As we move forward, are we going to codify the relationship between documentary filmmakers and journalists in a specific way, or will it really even be necessary?"[43]

It may be useful at this point to examine three recent documentaries in more depth, where filmmakers took a journalistic approach to their work with questions about how these two disciplines fit together.

Photojournalist Tim Hetherington and journalist Sebastian Junger codirected and coproduced the Academy Award-nominated documentary *Restrepo* (2010), which followed a year in the life of the soldiers deployed to the Korangal Valley, one of the most dangerous outposts in Afghanistan. In a raw depiction of the realities of modern-day warfare, the film follows military stationed there from the day of their deployment to the day they return home. In this case of reporting, Hetherington and Junger chose to position the information they collected along the way differently on a variety of platforms: broadcast news, magazine features, two books (one a narrative of the journey, another a photo-essay), and, of course, the feature film. Each medium demanded its own kind of treatment and focus. In thinking about how the different platforms served different audiences and purposes, Hetherington described the distinction between the film and the work they did for ABC news: "You can present something on network news that has clarity but doesn't necessarily have nuance ... ABC News told us that our audience figures for dispatches from Afghanistan were 22 million. For the first time, a large number of Americans were beginning to see that the war had slipped out of control. That was an effective message, but it didn't have the nuance we were able to imbue into the film."[44] The film made about $1.5 million in its international box office sales, so when you compare the numbers of people their stories reached through traditional news broadcast versus the seats they filled in the theaters, the broadcast numbers boast a more expansive touch.

But the experience of the news story on air and the film itself are vastly different. Most are familiar with contemporary broadcast war coverage and how it fits into a nightly newscast. Viewers are connected to imagery and commentary giving them up-to-date information over thirty-second to seven-minute blocks (on the longer end), therefore the potential depth and detail of these stories is limited. The feature film is a vastly different experience for the viewer. Using the methods of cinema verite in the style of Frederick Wiseman (*Titicut Follies, LA Dance*) or the Maysles brothers (*Salesman, Gimme Shelter*) with occasional interviews with servicemen, this team embraced the complexity, confusion, boredom, bravery, and tragedy of the war experience in Afghanistan. Whereas the on-air news footage featured short clips in montage of battlefield action, the film was told in full, dramatic scenes. The news programs gave thorough context through interviews and data, while the film established the camera as

43 (Kasson, 2012)
44 (Kasson, 2012)

an "independent observer," allowing viewers to come to their own conclusions about what they saw. Which approach is journalism? Neither? Both?

In the opening scene to the film, the filmmakers are traveling in a convoy of armored jeeps on a mountain pass when the first vehicle, occupied by the cinematographer, is hit by an IED (improvised explosive device). There is the initial chaos of checking to see who is okay and what to do next, then the soldiers move into position for a short firefight with their enemies. The scene is filled with adrenaline. As a viewer, the camera is your guide to the action, and perilously close to the danger. Guns go off and the camera loses sound, much in the way you would imagine you losing hearing after being in a car hit by a makeshift bomb. This experiential, visceral form of documentary reportage evokes the narrative journalism of novelists such as Norman Mailer or James Agee, reporters who brought you the scent, touch, taste, and emotion of a situation (essentially using the tools of fiction and poetry to relate what they experience) as much, or more than, the objective facts at hand. Their form of literary journalism shares similarities to the artistic narratives crafted by many documentary filmmakers today. Still journalism? Not?

Joe Berlinger's work as documentary filmmaker has often taken an investigative approach. In *Brother's Keeper* (1992, codirected by Bruce Sinofsky), Berlinger examines the case of the Ward brothers of Munnsvillle, New York, as one of the brothers, Delbert, is accused of smothering another in a mercy killing. The film examines the rural vs. urban reactions to the case as the brothers are finally embraced and defended by their community when the "big city" media comes to town to violate their privacy and indict their way of life during the trial. Also in collaboration with Sinofsky, the West Memphis Three trilogy (*Paradise Lost, Paradise Lost 2: Relevations, Paradise Lost 3: Purgatory*) unlocks the infamous 1993 murders of three boys in a small Arkansas town and the conviction of three "metalhead" teenagers for the crime. The films raise questions about their guilt, asking if these young men were convicted more on the basis of their clothing and music tastes (linked to a "Satanism scare") than on any damning evidence. At first, following what they thought was an open-and-shut case, the filmmakers' investigation led them to believe that the men imprisoned were innocent and crafted the films to expose the flaws of the case, raise alternate theories, and probe the tensions in the community that can lead to judgments based on prejudice. In many ways it was their work that inspired a movement to release these men years later. Given their approach and these results, would this be advocacy or effective, investigative journalism?

These questions of point of view and bias plagued Berlinger's work on the 2009 documentary film *Crude*. Footage from the film, a story about the legal battle between the Chevron Corporation and the people of Ecuador over environmental damages, became central to the court case itself. Chevron claimed that Berlinger had outtakes from the film (additional footage that did not make it into the final product) that revealed misdeeds on the part of the Ecuadorian legal counsel and it wanted access to the footage (approximately six hundred hours) to use as evidence in its case. Attorneys for Chevron argued that Berlinger was not an "objective journalist" in his approach to the project, but a filmmaker with bias regarding

his position to the story. Therefore, according to their argument, Berlinger's footage should not be protected by journalistic privilege. The judge in the case, Lewis A. Kaplan, ruled that Berlinger is, indeed, a journalist with First Amendment protections in place; however, because it was "likely relevant to a significant issue in the case" and was "not reasonably obtainable from other available sources" (citing the precedent of the case *Gonzales v. NBC*), the court allowed access to the footage to the opposing attorneys.[45]

The actions of the court and assumptions of the prosecuting attorneys beg the question: If Berlinger was reporting news through a broadcast affiliate, as Hetherington and Junger did with some of their footage, as opposed to sharing the story as an independent filmmaker, would his footage be protected under the rights of a reporter's privilege (aka confidentiality of sources)? Berlinger notes that the role of independents is more important now than ever before. " … in today's world where serious journalism is under attack, we need serious, social issue filmmaking more than ever. Print journalism has been gutted and the corporate control of most networks has meant certain subjects are off limits out of fear of offending advertisers. So, most of the important social issue reporting is being done by independent documentarians who often take great risks to bring their stories to the screen."[46] A number of journalistic organizations, including the Associated Press, *New York Times*, *Hearst Corporation*, and NBC Universal, came to Berlinger's defense, signing an amicus brief on his behalf and noting the chilling effect such an action would have on the work of journalists worldwide. If documentary filmmakers such as Berlinger are not protected by shield laws, then this might lead to sources refusing to work with filmmakers knowing they are at increased risk. As filmmaker Michael Moore expressed to the *New York Times*: "If something like this is upheld, the next whistle-blower at the next corporation is going to think twice about showing me some documents if that information has to be turned over to the corporation that they're working for … . Obviously the ramifications of this go far beyond documentary films, if corporations are allowed to pry into a reporter's notebook or into a television station's newsroom."[47]

In some cases it may not be corporations, but government doing the digging. Possibly one of the most significant documentaries released in recent years is Laura Poitras's *Citizenfour*. Poitras's film chronicles the post–9/11 surveillance culture of the US government as seen through the eyes of whistle-blower Edward Snowden (who leaked top-secret documents detailing the surveillance practices of the NSA) in the days before he went into hiding. The film maintains the driving tension of a science fiction thriller and the shocking exposé of *All the President's Men*. *Citizenfour* is a part of a trilogy of films Poitras created examining post–9/11 culture, including *My Country, My Country* (2006 Academy Award nominee) about a Sunni doctor during the time of conflict and transformation in Iraq, and *The Oath* (2010) about the lives of two Yemeni brothers-in-law who worked for Osama Bin Laden,

45 (Isler, 2012)
46 (Berlinger, 2014)
47 (Schwartz, 2010)

one imprisoned on Guantanamo Bay and the other living freely in Yemen. In the making of this body of work, Poitras became a target of the US government, earning a place on the Department of Homeland Security's "watch list" that subjects her to searches, interrogation, and harassment (including copying all of her hard drives and other devices) when she travels internationally, despite the fact that she is not guilty of nor accused of any wrongdoing. These searches and detentions occur every time she reenters the country. The harassment forced her to take extreme measures to protect her research and her sources, which only escalated when her work with Snowden began. Poitras's partner in the story about Snowden was journalist Glenn Greenwald, who has also suffered from harassment. Both chose to pursue the majority of their work related to this story outside the United States (Greenwald in Brazil, Poitras in Germany) as a way of protecting their work and their sources.

The most dramatic scenes of the film are when Poitras and Greenwald are alone with Snowden in the hotel room. In some ways these scenes feel like a record of the process of journalism, as much as it is an investigation into Snowden's claims and a window into his perspective. What the cinematic space offers beyond reportage, however, is the emotion and tension at play in these moments. When asked about the distinction between documentary film (as journalism) and print journalism in relationship to her work on *Citizenfour*, Poitras responded, "They are totally different. They are both bound by journalistic principles of making sure you do your fact checking and all that kind of stuff but it also needs to have more lasting meaning and raise more universal questions.... When I work on a news story, it has a certain impact but in a documentary, we were very clear in the editing room our job is not to break news. That I can continue to report on this material and work on the news but the film needs to say something that is not just interesting for a certain amount of time but that will have lasting resonance and so for me, it is a question about individuals who take personal risks and that becomes more of a universal story. Yes, it is about NSA and NSA surveillance but it's about human nature in different ways."[48] The point Poitras makes here is significant—what films can offer in the visual storytelling mode is different from reporting a scoop. The distinction of taking work like hers outside of the twenty-four-hour news cycle, letting it breathe and understanding the universality of the story apart from following the trail of facts, is a significant advantage to the long-form approach, particularly in documentary film.

As changes to journalism continue, the role of the independent documentary filmmaker will continue to take on more significance. These questions about where the lines are between the art of nonfiction documentary and the rigors of journalistic practice will continue to press and deepen. It is important to recognize the contributions of these filmmakers to the field; just as there are multiple approaches to the documentary form, there are many approaches to journalistic practice. As Laura Poitras describes of her own experience: "Clearly I'm a documentary filmmaker, and I do think I do visual journalism, and that's different than print journalism. And I would also say that I'm an artist. So I think that those things cross. So, a

48 (Minow, 2014)

long form of film is not just about journalism. It's about narratives and stuff like that … . There are plenty of great print journalists that can report on the NSA stuff. But I think that my skills are maybe better used in other ways."[49]

NEW TECHNOLOGIES—STORYTELLING IN THE DIGITAL SPACE (18 DAYS IN EGYPT, HIGHRISE, AND HOLLOW)

"This project has ruined me as a filmmaker. After this, I can't just make a short film. I'm constantly thinking about the better way the story could be told."

—Elaine McMillion, creator of Hollow[50]

As digital technology has altered human experience on numerous planes, so too has it altered modern storytelling. As people, en masse, have been migrating from the TV or movie screen to the computer screen, there is an accelerated interest in finding out "what's next" for online content. Of course, some of this migration has simply inspired moving single-channel work online, with outlets such as HBO Go and Amazon Prime essentially extending content from one platform (broadcast, DVD, theaters) to another (online digital streaming). There are, however, a number of artists experimenting with the possibilities of online space as a place for collaboration, cocreation, and inspiration in digital storytelling, creating new forms of engagement using the unique benefits of the digital space.

For those familiar with the history of documentary filmmaking, it comes as no surprise that the nonfiction field is an early adopter of digital innovations. As William Uricchio, principle investigator at MIT's Open Documentary Lab, noted: "… historically, documentary has been a driver of technological innovation … . Documentarians were among the first filmmakers to experiment with cinema technologies of the past—sound recording, color film, 16mm film stock, and portable cameras. In fact, nonfiction storytellers quickly embraced cinema itself. Eighty-percent of the movies copyrighted in the first decade of film (1895–1905) were nonfiction … . We're seeing new forms that have not yet been tamed. There's not yet orthodoxy for people to fall back on. There's nothing but possibility."[51]

MIT's Open Documentary Lab, in collaboration with IDFA's Doc Lab, created *Moments of Innovation* in an effort to outline the history and development of how human beings interact and interpret "real" content for the purposes of deeper understanding through (as they subdivide it) data visualization, immersion, location, participation, interactivity, and remix. As one example of this progression, "data visualization" began with the cave painting, emerged into numerical accounting, and now, with the help of creative vision and newly available technologies, brings us to online projects such as We Feel Fine, which sources the phrases "I feel" or "I am feeling"

49 (Rapold, 2014)
50 (Costa, 2013)
51 (Katie Edgerton, 2012)

and their corresponding feelings (sad, happy, elated, etc.) from blogs worldwide and translates these graphically by geographic location, resulting in a database of human emotion numbering in the millions. Human beings have been experimenting with the feeling of "immersion" since the creation of the panoramic photograph. Now we have IMAX film and projects such as C.A.P.E., which uses virtual technology to put the user into the shoes of a person touring a fictitious future world. Better understandings of "location" began with early cartography and now enter our lives through devices such as Google Street View or Foursquare. Another way to engage with this material is through creative reuse, a project such as Welcome to Pine Point takes photographs, old films, interviews, maps, and newspapers to recreate a community that was significant in the lives of the developers. Entering the website feels like walking into a 1970s small town replete with the colors, sounds, and language of the time.[52]

Significantly, in many of these digital projects, the "viewer" is no longer treated as a passive recipient of story information, but instead is transformed into a "user" or a "collaborator." Gaming has long dominated this collaborative space in enabling players to become active participants in the game's story world, encountering allies and working with other game players from around the world. Other projects require content from users as a part of the storytelling design itself. For example, 18 Days in Egypt (http://beta.18daysinegypt.com/) provides a model for crowd-sourced content. Both an engineer and documentary filmmaker by trade, creator Jigar Mehta was working on projects in collaborative journalism during a fellowship at Stanford when the Arab Spring erupted in Egypt. It was there that he saw his opportunity. As Mehta related in an interview with COLLABDOCS: "… there was this very clear imagery of me seeing so many people with cell phones during the Revolution documenting themselves in that moment. So I thought, Wow! Millions of people have been documenting their lives in some format, whether it's email, Tweets, texts, videos, photos, what-not, during an incredible three weeks. The original idea was, how could we create a documentary that would be more innovative using that media? And that's where '18 Days in Egypt' started."[53] For Mehta, the idea of collaboration here was not just a triumph in journalism, where people could get on-the-ground accounts of what was happening in Tahrir Square when reliable journalism was limited, but by activating regular people using cell phone recordings and social media to express their experiences and drawing them into the storytelling, he was providing a new way to share, connect, elevate, and validate these voices.

One of the most successful digital nonfiction projects is Katerina Cizek's HIGHRISE (http://highrise.nfb.ca/). Inspired by the fact that more than a billion people worldwide reside in tall apartment buildings, HIGHRISE is a multi-platform, multiyear, multi-focus project exploring the experience of "vertical" communities. This award-winning project was produced by the National Film Board of Canada, an early forerunner in the field of digital nonfiction (the NFB pioneered its interactive filmmaking unit prior to the release of YouTube). When HIGHRISE

52 (MIT Open Documentary Lab)
53 (Collabdocs: Where Documentary Meets Networked Culture)

began, it started as an online story experience (via a website) where users could find a collage of data, maps, photographs, and stories (using sound and video) looking at the global experience of high-rise living at about a dozen sites around the world. The project has grown from this first effort to include ONE MILLIONth TOWER, a project bringing together the voices of architects, residents, artists, and 3D animators to envision ways to reimagine dilapidated high-rise spaces; A SHORT HISTORY OF THE HIGHRISE, a Peabody award-winning collaborative project with the *New York Times* Op Docs team using the *Times* photo archive to create a history of high-rise living in urban environments (also using a lyrical, rhyming voice-over); and OUT MY WINDOW: INTERACTIVE VIEWS FROM THE GLOBAL HIGHRISE, a 360-degree documentary, which allows the viewer to maneuver within, experience, and explore high-rise spaces and the people who live in them from around the world.

Cizek is a master of foregrounding the story and viewer experience beyond the "wow factor" of the technology. Interacting with the documentary, which gives the term "web native" true teeth, feels organic. The viewers' authorship comes through navigating the experience through the many spaces. In one moment you are listening to musicians serenade young children at their doorstep in Havana, and in the next you are walking the grounds of a high-rise complex in Amsterdam. Although replete with data and context, the experience is decidedly human.

Notably, the project does not live solely online. Cizek has made social change and community engagement key components of her work. For example, as a part of the HIGHRISE projects, she has paired actual architects and urban planners with the residents of particular structures featured in the project to help residents realize their visions of how the spaces could change.

These kinds of collaborations inspire the question of how the role of the storyteller or documentary artist has changed when considering the digital nonfiction space? As Michel Houle mentions in his 2011 report to the Documentary Network: "For filmmakers, the platforms throw into question the entire creative process that has existed until now. This widening of the documentary field challenges creators to think differently about their relationship to reality, to the work, and to the audience."[54] Katerina Cizek explored these ideas further in an interview with MIT Open Documentary Lab's Sarah Wolozin. "I love what Walter Murch says about conventional filmmaking: 'The director is the immune system of the film.' And in interactive, that fundamental role doesn't change. It's the director's responsibility to see the big picture, to collaborate, and to create an environment for people with talent and expertise to do the best that they can do (whatever that may be!), and keep bad things away from the production."[55] In sum, these platforms allow for new relationships with the audience and new production models to learn and consider. Therefore, the visionary behind the project

54 (Documentary Network, 2011, 2)
55 (MIT Open Documentary Lab, 2013)

(traditionally called the director or creator) must be open, adaptable, knowledgeable, and collaborative; essentially the requirements of any creative project.

In these digital frameworks, the members of the creative team do necessarily change. The new era demands the skills brought by technologists, 3D artists, engineers, and web coders. For traditional filmmakers, making the leap into these new terrains is, at times, daunting. Luckily there have been industry supports for this type of work at the university level (MIT Media Lab and Open Documentary Lab), at the foundation level (Tribeca Film Institute's interactive branches), at the distribution level (POV's Hackathons), and at the festival level (IDFA DocLab). Of course, these are just some examples of the resources supporting new exploration in the digital storytelling space. It does, however, indicate the industry-wide investment in what is seen as the next wave of storytelling and audience engagement.

Another award-winning digital storytelling project is Elaine McMillion's Hollow (www. hollowdocumentary.com). Hollow is a "web native" documentary exploring life in McDowell County, West Virginia, one of the many small counties throughout the United States where "more people leave than stay." Users engage with stories through two primary modes: an interactive timeline (beginning in 1940) noting significant data, images, and stories over the years; and an interactive story map (separated into themed collections about the area's history with the coal industry, the deep roots of the community there, their future visions, etc.) where users scroll through a rich collage of imagery from the county and have the option to learn more about the characters they see through short videos, photos, music, and more. Additionally, users are prompted to contribute their own content along the way, connecting themselves to the stories and spaces they experience. In this way the projects engage users on three levels: as viewers of content, as contributors of content, and as story navigators.

The experience is incredibly rich—visually, audibly, emotionally. The effect is not dissimilar to walking through a small town and meeting people along the way. There's Nessie Hunt who plays bluegrass banjo, first with her family band and now with her husband. Nessie is raising her family in McDowell County, where she grew up, while looking for ways to play music or just be happy. There's Alan Johnston, a resident who has undertaken his own photographic archive of the place as it changes, or Mayor Tom Hatcher who took on his town's drug problem and was killed during a break-in at his own home. The project incorporates the major events and issues facing the county—infrastructure, industry, education. Very actively responding against the stereotypes of people living in Appalachia as somehow "affected" or "backward" (think *Deliverance* and how the popularity of such films shapes the public imagination of a place or people), McMillion created an online space that humanizes and universalizes the people from McDowell. These are people who are witness to the end of the industry that once sustained them, who watch as the young people flee to find jobs and build families elsewhere, and who are trying to maintain hope, reinventing themselves and planning for a new future unsure where it may lead. This is a description fitting many places in the nation and around the world, particularly after the 2008 financial collapse. What

McMillion, in the end, has created is a modern, relevant connection between Appalachia and the rest of the world.

Projects such as Hollow also pose unique technological challenges. For example, it can only really be experienced through a desktop using Google Chrome, as it was designed. Not all users have access to this platform. Significantly, not all users have access to the Internet. As scholar Patricia Zimmerman stresses: "Worldwide, however, user-generated content is sometimes known as 'American-generated' content. People in first world countries have time and technology; they can participate in crowd-sourced projects. Technologies, networks, and nodes are not the same around the globe."[56] These conditions, however, continue to grow and change. In Tom Perlmutter's article "The interactive documentary: a transformative art form," he marks the evolution of the field and the potential for future growth and change: "Globally, the interactive or digital audience continues to grow exponentially. As of December 31, 2013, 39 percent of the global population was connected to the Internet. There is nowhere in the world that has not experienced massive growth in Internet connectivity: In Africa the growth rate was over 5,000 percent in the period 2000–14. In China, Yang Weidong, president of Tudou, the most popular video streaming site, told me the site boasts 70 million unique viewers a day. In Brazil, 87 percent of connected users watch online video, meaning 75 million viewers a month … . The Pew Research Centre, a nonpartisan think tank based in Washington, DC, canvassed close to 2,000 experts on what they expect digital life to be like in 2025. Most of the experts agreed that we are moving to 'a global, immersive and ambient computing environment.'"[57]

As the number of these projects grow and the audience expands, there is the additional question of how to archive digital work. Almost every other type of media has a way to archive, not only their source materials (photographs, code, videos, order of display, etc.), but also their fully intended viewing experience (true for film, video, music, etc.). This is incredibly difficult for digital storytelling, and one of the challenges the field will be contending with in years to come. Questions also remain about how to monetize this kind of cultural work. Audiences are used to buying a ticket to a movie theater or buying a DVD, or even purchasing a movie on demand or a streaming link. Will the practice of purchase extend to digital storytelling?

Finally, in this experimental space, nomenclature poses a challenge. Given the numerous ways these projects engage users (crowdsourcing content, mapping, navigating the story experience, gaming, immersing, and more), it's hard to find umbrella terms under which they can all live. When an artist proposes a "transmedia" project, will audiences know what it means as clearly as they do when they hear the words "film" or "TV program?" Terms used to describe this work vary and include phrases you've seen above, such as digital nonfiction, multi-platform storytelling, interactive storytelling, or transmedia. Artists are often frustrated by the terms because they do not clearly suggest the creative possibilities of the storytelling experiences themselves. But according to i-Docs, a website of information and articles curated by a small group of

56 (Katie Edgerton, 2012)
57 (Perlmutter, 2014)

leaders in this field, these projects are all linked by the quality of occupying—"an intersection between digital interactive technology and documentary practice."[58]

There is no doubt that what this writer is calling "digital nonfiction" is a contemporary space for growth and experimentation. As eyes collectively move more rapidly to smaller screens with increased interactive capabilities, artists will continue to push into this space providing more dynamic, interactive, collaborative opportunities for "viewers" to become users, players, and artists in their own right. The projects described herein offer only a small window onto the ever-expanding field of the possibilities at play. With support for research and design, significant funding in place, and enough room to find out what doesn't work as much as what does, digital nonfiction will be the sandbox that will transport us to the storytelling modes of the future.

CONCLUSION

> *I am proud to say I make documentaries. I no longer think it conjures up the false image of 'bad tasting medicine' ... I think many fans recognize that a good documentary can be every bit as fascinating and involving as a good scripted movie, in some cases, more so. There is no one way to make a film and no one path to success. Some of us come to the documentary form for cinematic reason— to be storytellers; some approach documentary as a form of political activism; some want to be advocates for their subjects while others want to be critics of their subjects; some approach their material as journalists and other as personal essayists about their own experiences—and some, like me, approach their material for a combination of these aforementioned impulses ... so let's not put documentary into one box and let's not judge the success by whether or not people buy movie tickets.*
> —Joe Berlinger, Indiewire[59]

This chapter attempted to mark the contemporary renaissance in nonfiction storytelling through the conditions that fueled its possibility and the creative practices currently in play. But this is by no means an exhaustive portrait of this moment in the history of documentary. Filmmakers are reinventing the way archival footage is used in nonfiction work. Instead of using it as evidence proving the veracity of claims from the past, filmmakers such as Penny Lane (*Our Nixon*), David France (*How to Survive a Plague*), Asif Kapadia (*Senna*), and Jason Osder (*Let the Fire Burn*) use archival footage to transport the audience back to the very moments in time they explored to heighten the sense of drama, tension, and character in ways rarely experienced with archival films prior. Storytellers working in radio (*This American Life, RadioLab, Snap Judgment*) and podcast (*99% Invisible, The Moth*) have become leaders in craft and innovation in narrative nonfiction work. The serialized documentary has caught

58 (i-Docs)
59 (Berlinger, 2014)

fire with audiences. Though neither without controversy, both *Serial* (from producer Sarah Koenig and the team at *This American Life*) and *The Jinx* (from director Andrew Jarecki and HBO) have demonstrated a hungry appetite for long-form, investigative storytelling from some of today's leading nonfiction artists. The long history of documentary's connection to social change movements has expanded through deep foundation investment, artistic support, and the professionalization of "impact producers" with specific expertise in how to help a film make "a difference" (see films such as *Gasland*, *The Cove*, *Invisible War*, and *American Promise* for case studies). In sum, this is not the complete story, nor is it the end.

It is also worth noting that, as much as the field is bursting with creative energy and possibility, there are still challenges needing attention. Although the bar to enter the industry with a first film or project has significantly lowered, the ability to sustain a career remains difficult. The majority of working independent filmmakers are balancing passion projects with work-for-hire, which allows them the time, money, and flexibility to pursue the former. It's rarely as glamorous as a red carpet suggests.

The representation of women and minorities in key roles (directors, gatekeepers, etc.) continues to be a place in need of more focused attention. Although the nonfiction field performs better on issues of representation than most other branches of the film industry (for example, 35 percent of docs were directed by women vs. 17 percent of narrative films from the Sundance Festival catalogue between 2002–2012),[60] there is still work to be done. A 2014 report by the Center for Media & Social Impact revealed that public media were performing the best when it came to including documentary work from directors and producers of color in their schedules, but that there was still room for growth: "*Independent Lens* showcased works by minority creators much more frequently than did the other programmers. Last year, almost a third (30%) of *Independent Lens* documentaries had at least one minority director, compared with only 13% of HBO documentaries and absolutely no CNN or ESPN documentaries. More than a quarter (26%) of *Independent Lens* documentaries had at least one minority producer, compared with 17% for CNN, 11% for ESPN, and 9% for HBO."[61] Clearly, the industry needs to gain traction in seeing women and minorities in top jobs and including their voices more actively within the televisual landscape.

Beyond challenges of representation, finding the funding to make the films at all continues to be difficult and many filmmakers shrink their budgets by not paying themselves or paying their crew. As filmmaker Dawn Porter (*Gideon's Army*) points out: "Funding is always an issue when it comes to documentaries ... but the fact that the equipment has gotten better and less expensive has made the production playing field a bit more level. So many people can shoot and edit on their own—and that's where it gets tricky. When you're looking to get funding for projects, oftentimes there are unrealistic expectations. [Potential funders] look at a budget I've given them and exclaim that it's higher than they'd anticipated. That's because

60 (Silverstein, 2014)
61 (Brown, 2014)

I *pay* everyone to do everything. A lot of filmmakers are doing multiple jobs with little or no pay to get their movies made. We all do that for these labors of love, but it's not a realistic or long-term business model."[62] This, of course, does not create a sustainable model for growing the careers of storytellers in this field. Projects need funding to succeed and artists need to be compensated to continue making the kind of work that we need as a society for powerful, cultural conversation or making the space for innovation.

Finally, over the course of this essay, the goal was to demonstrate a link between contemporary trends in nonfiction and how each trend is part of a continuum of growth and change in the field over time. None of this is revolution; it is all evolution. Driving this work from the start is a deep and abiding fascination with the "real"—real people, real places, real stories, real lives—and what we can learn as artists grapple with the real to interpret stories of our shared, lived human experience. Patricia Aufderheide notes the key questions that have faced narrative nonfiction filmmakers since its earliest days, "… two assertions, as we have seen, create the most basic tension in documentary. When does artistry conflict with reality and when does it facilitate representation? These filmmakers [Flahery, Vertov, Grierson] variously grappled with that question and set the stage for later arguments."[63] Indeed, these arguments still resonate today. The debates around ethics, representation, point of view, approach, authenticity, and authorship persist. With documentary work, or any field that makes claims on representing reality, there is a unique tension. What does it mean to be working in the stuff of real lives? What are the responsibilities of the artists, subjects, and audience members to the relationship they engage in? What is the gap between the "whole truth" and the "truth as we see it" represented on screen? Where does the artistic voice of the filmmaker enter into the conversation and how does it affect what we feel, see, and know from viewing their work? In the projects highlighted in this chapter, each filmmaker answered these questions on their own and with their collaborators in their attempts to do justice to the stories they shared. Regardless of the approach—artistic, anthropological, journalistic, or in the digital sphere—the filmmakers and creators represented herein are all visual storytellers crafting stories from their experiences and research into real-life events, people, and places at a most fertile time for creativity in the nonfiction medium. Through their craft, they relate *their* experience of real-life events through their art and their unique points of view, and all in an effort to help us all better understand humanity, culture, and crisis. The only "truth" that appears on screen is the truth of what they discovered for themselves, and it is for the audience to do the work of determining if this is their truth too. As we find ourselves in this moment of renaissance in narrative nonfiction, the excitement around these kinds of questions and the way artists tackle them is what drives us forward. Documentary cinema continues to be a fertile space where change, experimentation, reflection and growth are possible. As filmmaker AJ Schnack reflects: "One of the greatest developments in the current age of documentary

62 (Valentini, 2014)
63 (Aufderheide, 2007, 25–6)

filmmaking is an underlying assumption that there is no specific rulebook, that each of us is charged with wrestling with the documentary form in our own way. Some of us will be more successful than others, of course, but few feel constrained by dogma or the rules and views of a particular movement of filmmaking and less and less feel the need to fit within a specific political ideology."[64] With that, we await what's next.

Bibliography

Aufderheide, P. 2007. *Documentary Film: A Very Short Introduction.* New York: Oxford University Press.

Barnouw, E. 1993. *Documentary: A History of the Non-Fiction Film* (2nd ed.). New York: Oxford University Press.

Berlinger, J. "Joe Berlinger on Michael Moore and The Changing Market for Documentaries." Retrieved from IndieWire: http://www.indiewire.com/article/joe-berlinger-on-michael-moore-and-the-changing-market-for-documentaries-20140915 (accessed September 15, 2014).

Boyle, K. "Yes, Kickstarter raises more money for artists than the NEA. Here's why that's not really suprising." (*Washington Post*) Retrieved from washingtonpost.com: http://www.washingtonpost.com/blogs/wonkblog/wp/2013/07/07/yes-kickstarter-raises-more-money-for-artists-than-the-nea-heres-why-thats-not-really-surprising/ (accessed July 7, 2013).

Bradshaw, P. "Stories We Tell"—review. (*The Guardian*) Retrieved from theguardian.com: http://www.theguardian.com/film/2013/jun/27/stories-we-tell-review (accessed June 27, 2013).

Brody, R. "The Extraordinary 'Chronicle of a Summer.'" (*The New Yorker*) Retrieved from newyorker.com: http://www.newyorker.com/culture/richard-brody/the-extraordinary-chronicle-of-a-summer (accessed February 21, 2013).

Brown, S. "Public TV Docs Feature More Diverse Creators and Characters than Cable." (Center for Media & Social Impact) Retrieved from cmsimpact.org: http://cmsimpact.org/blog/future-public-media/public-tv-docs-feature-more-diverse-creators-and-characters-cable (accessed October 1, 2014).

Burgess, M. D. 2014. "Learning from Documentary Audiences: A Market Research Study." Hot Docs Canadian International Documentary Festival. Hot Docs Canadian International Documentary Festival.

Carter, M. "New technology opens up documentary-making." (*The Guardian*) Retrieved from theguardian.com: http://www.theguardian.com/film/2011/jun/06/new-technology-documentary-making (accessed June 6, 2011).

Chadha, R. "The State of Docs in 2012: An Interview with Thom Powers." (Stranger Than Fiction) Retrieved from stfdocs.com: http://stfdocs.com/news/a-conversation-with-thom-powers-on-the-state-of-documentary-in-2012/ (accessed January 2, 2013).

Collabdocs: Where Documentary Meets Networked Culture. (n.d.). "Jigar Mehta on 18 Days in Egypt." (Collabdocs) Retrieved from collabdocs.wordpress.com: https://collabdocs.wordpress.com/interviews-resources/jigar-mehta-on-18-days-in-egypt/)

64 (Schnack, 2014)

Costa, A. L. 'Hollow': The Next Step for Social Documentary? (Public Broadcasting System) Retrieved from pbs.org/mediashift: http://www.pbs.org/mediashift/2013/09/hollow-the-next-step-for-social-documentary/ (accessed September 26, 2013).

Dargis, M. "Soaring Trips to a Temple in Nepal: In 'Manakamana' Pilgrimages by Cable Car to Hindu Site." (*New York Times*) Retrieved from nytimes.com: http://www.nytimes.com/2014/04/18/movies/in-manakamana-pilgrimages-by-cable-car-to-a-hindu-site.html (accessed April 17, 2014).

Documentary Network. 2011. *Documentary and New Digital Platforms: an ecosystem in transition*. Documentary Network. Montreal: Documentary Network.

Edelstein, D. "Edelstein: How Documentary Became the Most Exciting Kind of Filmmaking." Retrieved from Vulture.com: http://www.vulture.com/2013/04/edelstein-documentary-is-better-than-filmmaking.html (accessed April 14, 2013).

F. S. *The rise of documentary film: The shocking truth.* (A. C. Prospero/Books, Producer & The Economist) Retrieved from theeconomist.com: http://www.economist.com/blogs/prospero/2013/08/rise-documentary-film (accessed August 27, 2013).

Fraser, N. "The Act of Killing: Don't give an Oscar to this snuff movie." (*The Guardian*) Retrieved from theguardian.com: http://www.theguardian.com/commentisfree/2014/feb/23/act-of-killing-dont-give-oscar-snuff-movie-indonesia (accessed February 22, 2014).

Godmilow, J. "Killing the Documentary: An Oscar-Nominated Filmmaker Takes Issue with 'The Act of Killing.'" (indieWire) Retrieved from indiewire.com: http://www.indiewire.com/article/killing-the-documentary-an-oscar-nominated-filmmaker-takes-issue-with-the-act-of-killing (accessed March 5, 2014).

Greene, R. "Cinematic Nonfiction 2012." (Hammer to Nail) Retrieved from hammertonail.com: http://www.hammertonail.com/editorial/cinematic-nonfiction-2012-robert-greene/ (accessed January 3, 2013).

Greene, R. "Leviathan is a Non-Fiction Gamechanger." (*Filmmaker Magazine*) Retrieved from filmmakermagazine.com: http://filmmakermagazine.com/65679-leviathan-is-a-nonfiction-game-changer/#.VJheYJAUA (accessed February 28, 2013).

Hynes, E. February 2013. "Some Kind of Monster: True/False 2013." (Cinema Scope) Retrieved from cinema-scope.com: http://cinema-scope.com/cinema-scope-online/some-kind-of-monster-truefalse-2013-2/

i-Docs. (n.d.). *i-Docs About.* (i-Docs) Retrieved from i-Docs: (http://i-docs.org/about-idocs/

Isler, T. 2012. "Chevron Corp. v. Berlinger and the Future of the Journalists' Privilege for Documentary Filmmakers." *University of Pennsylvania Law Review, 160*, 865–919.

Kasson, E. 2012. "The Message Is the Medium: The Difference Between Documentarians and Journalists." (International Documentary Association/*Documentary Magazine*) Retrieved from documentary.org: http://www.documentary.org/feature/message-medium-difference-between-documentarians-and-journalists

Katie Edgerton, C. "Documentary Film and New Technologies." (Massachusetts Institute of Technology, MIT Communications Forum) Retrieved from web.mit.edu: http://web.mit.edu/comm-forum/forums/documentary_technology.html (accessed March 20, 2012).

Koehler, R. (n.d.). "Utopias/Dystopias: The New Nonfiction." (Cinema Scope) Retrieved from cinema-scope.com: http://cinema-scope.com/features/features-agrarian-utopiasdystopias-the-new-nonfiction/

Konrad, A. "Are documentary filmmakers journalists?" (*Fortune Magazine*) Retrieved from fortune.com: http://archive.fortune.com/2010/07/13/news/robert_redford_journalism.fortune/index.htm (accessed July 14, 2010).

Langeveld, M. "NAA/Nielson stats show newspapers own less than 1 percent of online audience page views, time spent." (Nieman lab) Retrieved from NiemanLab.org: http://www.niemanlab.org/2009/08/naanielsen-stats-show-newspapers-own-less-than-1-percent-of-u-s-online-audience-page-views-time-spent/ (accessed August 5, 2009).

Lee, D. M. (n.d.). "Influence and Controversy of Robert Gardner and His Classic Film Dead Birds." Retrieved from tieff.sinica.edu.tw: http://www.tieff.sinica.edu.tw/ch/2007/part/e-part5_41.html

Lim, D. "The Merger of Academia and Art House: Havard Filmmakers' Messy World." (*New York Times*) Retrieved from nytimes.com: http://www.nytimes.com/2012/09/02/movies/harvard-filmmakers-messy-world.html?pagewanted=all (accessed August 31, 2012).

MacDonald, S. 2013. *American Ethnographic Film and Personal Documentary: The Cambridge Turn.* Berkeley: University of California Press.

MacDougall, D. 1995. *Principles of Visual Anthropology.* Edited by P. Hockings. Berlin: Walter De Gruyter.

Minow, N. 2014. "Movie Mom Interview: Laura Poitras of the Edward Snowden Documentary 'Citizenfour'". (BeliefNet) Retrieved from Beliefnet: http://www.beliefnet.com/columnists/moviemom/2014/11/interview-laura-poitras-of-the-edward-snowden-documentary-citizenfour.html

MIT Open Documentary Lab. (n.d.). "Moments of Innovation." (MIT Open Documentary Lab) Retrieved from momentsofinnovation.mit.edu: http://momentsofinnovation.mit.edu/

MIT Open Documentary Lab. "The New Digital Storytelling Series: Katerina Cizek." (*Filmmaker Magazine*) Retrieved from filmmakermagazine.com: http://filmmakermagazine.com/70273-the-new-digital-storytelling-series-katerina-cizek/#.VItD00jdis8 (accessed May 9, 2013).

Morris, E. (n.d.). Lecture: Berkeley School of Jounalism Commencement. Retrieved from errolmorris.com: http://www.errolmorris.com/content/lecture/berkeley.html

Morris, E. "The Murders of Gonzago." (The Slate) Retrieved from slate.com: http://www.slate.com/articles/arts/history/2013/07/the_act_of_killing_essay_how_indonesia_s_mass_killings_could_have_slowed.html (accessed July 10, 2013).

Nakamura, K. 2013. "Making Sense of Sensory Ethnography: The Sensual and the Multisensory." *American Anthropologist , 115* (1), 132–135.

Oppenheimer, J. February 2014. "The Act of Killing has helped Indonesia reassess its past and present." (*The Guardian*) Retrieved from theguardian.com : http://www.theguardian.com/commentisfree/2014/feb/25/the-act-of-killing-indonesia-past-present-1965-genocide

Ostor, R. G. 2002. *Making Forest of Bliss: Intention, Chance, and Circumstance in Non-Fiction Film.* Cambridge: Harvard Film Archive.

Patricia Aufderheide, P. J. 2009. "Honest Truths: Documentary Filmmakers on Ethical Challenges in Their Work." Center for Media & Social Impact, School of Communication at American University.

Perlmutter, T. November 2014. "The interactive documentary: A transformative art form." (Policy Options) Retrieved from policyoptions.irpp.org: http://policyoptions.irpp.org/issues/policyflix/perlmutter/

Rapold, N. "Interview: Laura Poitras." (Film Comment) Retrieved from filmcomment.com: http://www.filmcomment.com/entry/interview-laura-poitras (accessed October 24, 2014).

Ravindran, M. "TIFF '14: Michael Moore presents 13-point doc manifesto." (Real Screen) Retrieved from realscreen.com: http://realscreen.com/2014/09/09/tiff-14-michael-moore-presents-13-point-doc-manifesto/ (accessed September 9, 2014).

Schnack, A. "It Came From Inside the House: Community, Criticism, and 'The Act of Killing.'" (*Filmmaker Magazine*) Retrieved from filimmakermagazine.com: (http://filmmakermagazine.com/84922-it-came-from-inside-the-house-community-criticism-and-the-act-of-killing/#.VJiIy5AUA (accessed March 10, 2014).

Schwartz, J. "A Filmmaker's Quest for Journalistic Protection." (*New York Times*) Retrieved from nytimes.com: http://www.nytimes.com/2010/05/08/us/08pollution.html (accessed May 7, 2010).

Search, J. "Initiative connects journalists and filmmakers to enrich storytelling." (Knight Foundation) Retrieved from knightfoundation.org: http://www.knightfoundation.org/blogs/knightblog/2014/11/20/initiative-connects-journalists-and-filmmakers-enrich-storytelling/ (accessed November 20, 2014).

Silverstein, M. "Statistics on the State of Women and Hollywood." (IndieWire) Retrieved from indiewire.com: http://blogs.indiewire.com/womenandhollywood/statistics (accessed February 23, 2014).

Society of Professional Journalists. SPJ Code of Ethics. (Society of Professional Journalists) Retrieved from spj.org: http://www.spj.org/ethicscode.asp (accessed September 6, 2014).

Starkman, D. "Major papers' long-form meltdown." (*Columbia Journalism Review*) Retrieved from cjr.org: http://www.cjr.org/the_audit/major_papers_longform_meltdown.php?page=all (accessed January 17, 2013).

Tames, A. A. July 1, 2005. *Remembering John Marshall.* (NewEnglandFilm.com) Retrieved from newenglandfilm.com: http://www.newenglandfilm.com/news/archives/05june/marshall.htm

Valentini, V. September 2014. "Career Opportunities: An Interview with GETTING REAL Keynote Speaker Dawn Porter." (International Documentary Association) Retrieved from documentary.org: http://www.documentary.org/magazine/career-opportunities-interview-getting-real-keynote-speaker-dawn-porter

PHOTO TAKEN BY MIMI EDWARDS.

SARA ARCHAMBAULT is program director at the LEF Foundation, and programmer/cofounder of the award-winning documentary film series *The DocYard*. Sara has an extensive professional history in production, programming, and foundation work. She was executive director of the Rhode Island Council for the Humanities, managing producer for Ebb Pod Productions on the Emmy-nominated documentary *Traces of the Trade: A Story From the Deep North*, and producer with Christopher Lydon's radio show *Open Source*. Sara is producing the feature documentaries *Rainbow Farm* (in development) and *Street Fighting Man* (premiered in spring 2015), which has received support from IFP Week's Spotlight on Documentaries, Hot Docs International Pitch Forum, Film Independent Documentary Lab, San Francisco Film Society, and the Sundance Documentary Fund. She is frequently an advisor, juror, moderator, and panelist with a number of film festivals and foundations. Sara is a 2013 Sundance Creative Producers Lab fellow and was sited among the "Ten to Watch" in 2013 by *The Independent*. She has a BFA in film from Syracuse University's Visual and Performing Arts Program, an MA from the University of Wisconsin–Madison in Cultural Studies, and studied at the Salt Institute for Documentary Studies in Portland, Maine.

3. FOUR FRINGE DOCUMENTARIES

BY *TIM JACKSON*

▶▶ ## INTRODUCTION

THE IDEAL OF OBJECTIVITY in documentary, as with both journalism and memory, is hoped for but never actually achieved. These days it is more difficult than ever. The thousands of digital sources and the endless consumption of fact, rumor, and gossip endlessly dilute truth and the validity of facts. With the advent of blogging and social networking, authority is diminished. Filmmakers may strive for truth, but make choices: they edit, have a points of view, personal attitudes, and often an agenda. The old notion that documentary film is the creative treatment of actuality sounds quaint; more like advice for good living than a definition.

Documentary film responds and evolves to the new ways we understand the world. Old arguments about what defines the form lose traction. Should nonfiction film accept reenactments? Should the director interact with the subject? How much editing becomes unfairly manipulative? How much advocacy is considered reasonable? Can the slices of life found on YouTube be considered documentary? Does tradition, audience expectation, and attention span always necessitate a story line? Poetic documentaries, such as the work of Agnes Varda, develop through an accumulation of associative ideas. Nature documentaries have been known to stage footage. If a documentary has human subjects is it ethical tell them where to stand, what to do, or put words into their mouths? If a subject has been prodded or coerced, as in reality television, is that still actuality?

Documentary might have once been defined as a set of expectations: the use of real footage, voice-over narration, a story arc, expectation of a revelation, or the privilege of a fly-on-the-wall–look at some area of the world we never knew. Faux documentaries and mock-documentaries have become a new genre, while narrative

films use the conventions of documentary to create the illusion of authenticity. Handheld cameras, vérité–style point-of-shooting, the casting of nonprofessional actors, improvisational acting are all examples. Mockumentaries have devolved into real-world pranks and *Candid Camera*[1]–style stunts. In the realm of performance art, Sasha Baron Cohen (*Borat: Cultural Learnings of America for Make Benefit Glorious Nation of Kazakhstan and Brüno*) documents events provoked by a character of his creation. Is this still documentary? In narrative film, "soft-scripting," or the loose use of a script and casting of nonprofessional actors, edges narrative film closer and closer to documentary. In the movement labeled "mumblecore," young actors build scenes from extensively rehearsed improvisations. Directors such as the Dardenne brothers in France, Austin's David Gordon Green, and Academy Award-winning director Richard Linklater work with nonprofessional actors in order to bring narrative work closer to a documentary reality.

Some of the best documentarians use recreated or reenacted segments. Manipulation is no longer controversial. While traditionalists might call reenactments dishonest, Errol Morris finds them much like memory:

> *Memory is an elastic affair. We remember selectively, just as we perceive selectively. We have to go back over perceived and remembered events, in order to figure out what happened, what really happened. My re-enactments focus our attention on some specific detail or object that helps us look beyond the surface of images to something hidden, something deeper—something that better captures what really happened.* **(2)**

Werner Herzog's notion of "ecstatic truth" finds a lack of poetry and of truth in the cinéma vérité style:

> *Our entire sense of reality has been called into question. But I do not want to dwell on this fact any longer, since what moves me has never been reality, but a question that lies behind it: the question of truth. Sometimes facts so exceed our expectations—have such an unusual, bizarre power—that they seem unbelievable.*
>
> *But in the fine arts, in music, literature, and cinema, it is possible to reach a deeper stratum of truth—a poetic, ecstatic truth, which is mysterious and can only be grasped with effort; one attains it through vision, style, and craft.* **(3)**

Documentaries outside tradition raise questions about the formal requirements of nonfiction. They stimulate discussion, argument, and ultimately broaden creative possibilities. Each of the "fringe films" I will discuss strays from the ordinary conventions of documentary to experiment with form. They are unique in their intention and in the way they present their subjects. Each manipulates the material in ways that make for interesting arguments about performance and authenticity in nonfiction.

The films include:

William Greaves's *Psychosymbiotaxiplasm* (1967)
Trent Harris's *The Beaver Trilogy* (1979, 1980, 1984)
Todd Haynes's *Superstar: The Karen Carpenter Story* (1987)
Dominic Gagnon's *Hoax_Canular* (2014)

PSYCHOSYMBIOTAXIPLASM

Psychosymbiotaxiplasm, filmed in 1968, is an early self-reflexive documentary. Today it might be called a "meta-documentary." The film was an anomaly for the director, William Greaves, whose background as an actor, producer, writer, and passionate devotee of and advocate for African American life and heritage belies the strangeness of this film. The soft-spoken Greaves, who died in August 2014, produced and directed hundreds of films having to do with black culture and identity. This contributed to his interest in the dynamics of authority and representation. His early study as an actor with Lee Strasberg informed his interest in the artifice of performing. Both are blended into a film that examines itself as a film. In the late sixties, early "faux" documentaries were doing similar things. Jim McBride's *David Holzman's Diary* (1969) follows a film student (played by L. M. Kit Carson) attempting to record his day-to-day life. It's a brilliant send-up of the vanity of the art-film student. Milton Moses Ginsberg's *Coming Apart* (1969) features Rip Torn in a tour-de-force performance as a sex-obsessed psychotherapist who seduces his clients within view of a hidden camera.

We find similar self-reflexive filmmaking in Greaves's *Psychosymbiotaxiplasm*, although it is authentic. The film is an experiment in the dynamics among a director, his actors, and his crew. Greaves documents the shooting of a separate film he has allegedly written and is directing called "Over the Edge." Shot in vérité style, it documents the reactions of the crew to his poorly organized production, and of the actors to a badly written script. It uses split screens, which were popular in the '60s and '70s. These provide multiple perspectives on the behavior of the actors hired to perform a scene for the non-existent film. We observe the interaction of crew with actors, with Greaves as director, and with one another. Periodically they meet in a group to discuss the director's competence and sincerity. The shooting of the movie becomes a source of confusion and speculation. What is our vantage point as an audience? The first-time viewer doesn't know whether the crew is questioning the authority of the director, or if this an elaborately staged stunt to examine the power dynamic between a director and his crew. Meanwhile, the actors struggle with making sense of the script, the story, and their characters.

Greaves uses several cameras. One is recording the scenes being performed and rehearsed. The other is shooting a version of a "making-of" vérité–style documentary. The film begins without titles. In a long shot from above Central Park we hear a man calling out:

"Alice."
''*No,*" says Alice.

"Alice, wait a minute."
The man pulls her aside.
"What's the matter with you?"
"Just how stupid do you think I am?"
"What are you talking about?"
"You know perfectly well what I'm talking about."

The camera zooms in awkwardly.
The man continues:

Freddy: *"You really got me foxed. Really."*
Alice: *"Look at what just you've been doing."*
Freddy: *"What's so funny?"*
Alice: *"You're funny, Freddy. You're a very funny man."*
Freddy: *"You got me foxed really."*
Alice: *"Why don't just you go away? Why don't you just get out of my life? Permanently."*
Freddy: *"Stop acting, will you?"*
Alice: *"Don't touch me."*

At that moment, the film cuts to a close-up of a different actor who repeats the (ironic) line:

"Come on, Alice. Stop acting."

Suddenly the screen splits into two square images on either side of the frame.
A second actress playing Alice (Susan Anspach) is now on screen. Both actors are framed in close-up. Alice responds with even greater melodramatic flair:

Alice: *"Don't touch me please. Don't touch me ever again ever."*
Freddy: *"You know you're really acting quite impossible. I'm not a mind reader, sport."*
Alice: *"I wish was. I wish I knew what goes on in that screwy little brain of yours."*
Alice: *"How come you think everybody in the world is stupid except for you?"*
Freddy: *"Boy, you're really talking in circles."*
Alice: *"How much of a phony can you be?"*

The scene suddenly moves back to a full frame two-shot with two new actors, Don Fellows and Pat Gilbert. The scene plods on. These two actors will act most of the movie. They do their utmost to make sense and drama out of an underwritten scene. Neither actor is particularly compelling nor convincing. The dialogue is improbable and it's difficult to tell whether the acting is stiff and under-rehearsed or if it is what happens when actors are left to their own devices with a poor script and little direction. The scene goes on. Alice accuses Freddy of being a closeted homosexual and forcing her to have an abortion.

Alice: *"You've been killing my babies one right after the other."*
Freddy: *"Look, I want children, too"*
Alice: *"I've been having abortion after abortion"*
Freddy: *"Look, I want babies too."*

The scene is so melodramatic that there is no way for an actor to redeem himself. This will be repeated over and over and is the only scene where we get to watch the actors perform. It is all as Greaves intended, a cruel examination of the artifice of method acting. Nevertheless, Greaves claims he was serious about his use of the actors.

Greaves stated:

> *We've got some great stuff, including, by the way, some wonderful material with Susan Anspach. Susan and the young fellow who played opposite her sang some of their lines. In fact, each player dealt with the scenario in a different way. The interracial couple made a psychodrama. We drew on the works of J. L. Moreno, a student of Freud, who conceived psychodrama as a therapeutic tool, a way of assessing an object to find the subconscious, and brought it to this country. We had a psycho dramatist, someone who had been trained by Moreno, come onto the set and work with the actors.(5)*

Meanwhile, the crew watches the actors struggling to make sense of their characters and motivations. In fact, the actors don't really seem to like each other. They whisper asides to the director about one another. Tempers flair. The entire event, with its use of inappropriate close-ups, split screens, Greaves yelling "cut!", microphones feeding back, bystanders gawking, a policeman looking for permits, a jam in the film magazine, and other disruptions has the effect of distancing us from the exercise. What we see more closely resembles a college acting class.

As things start to fall apart, the crew begins to wonder what exactly is going on with the production. It is an absurdist view of the artifice of filmmaking and something with which film students can identify. It is about keeping your head while those around you—including the director—may be losing theirs. The young, enthusiastic and loyal crew is trying to keep the process moving while privately questioning the competence of their director. The candid group sessions are about trust and the power relationship between a director and his crew. Sociologically, it mirrors the political power struggles of the times.

They meet as a group to shoot a discussion of what they think is happening in Bill Greaves's film:

Crew Member 1 (Jonathan Gordon):

> *We're just sitting around here and we just can rap a little bit about the film. We'll get into it and when we get into it the people out there will understand, you know, they'll catch on. And we'll explain as we go along.*

Crew Member 2 (Bob Rosen):

> *Explain how upset you are to be here this way without the director, without the actors*
> *and with something we know is not part of the film or at least as far as we know. We*
> *were sitting around the other night and we realized, here is an open-ended film with*
> *no plot that we can see with no end that we can see with no action that we can't follow.*
> *We're intelligent people and the obvious thing is to the fill in the blanks, to create for*
> *each of our own selves a film that we understand and try to think about the reasoning*
> *of the director for allowing us the opportunity to do this. By giving us the circumstances*
> *to be able to sit here we can only conclude that he wants it like this.*

The scene splits into three images with the crew's discussion moving center. The image gets smaller, shrinking between the bordering shots of Greaves talking to his confused actors.

Crew Member Rosen one adds some cogent observation about the dynamic of the day's shooting:

> *All the people that are sitting here right now are members of the crew. The director does*
> *not know that we are photographing this scene. We are doing it on our own. It occurred to*
> *us while we were trying to figure out what the film was about, that we should be filming*
> *this. We are the only people who are in a position so far to be able to comment about the*
> *film because the director, Bill Greaves, he is so far into his making the film that he has no*
> *perspective. And if you ask him what his film's about he just gives you some answer that's*
> *just vaguer than the question. It's so vague that it would be better if you hadn't asked*
> *question in the first place. And if you ask the actors what they think the film is about, all*
> *they can tell you is about the lines they are reading. They're just plugged into just one line.*

The brilliance of the scene is in the way the crew members seem highly aware of the film's failure and how they may be inadvertently participating in another experience altogether. It is summed up with insight by crew member and soundman Jonathan Gordon:

> *Consider looking at it this way. Rather than commenting on the goodness or badness*
> *of the direction maybe it would be more useful to talk about how interesting the non-*
> *direction is. It doesn't make any difference at this point whether Bill's direction is good*
> *or bad. Bill's direction has enabled us to sit here and talk like this—compelled us—to*
> *be interested this way. It's really his non-direction that interests us.*

This serendipitous moment serves many functions. One-third of the way into the film the crew is acting like a Greek chorus reflecting on the process of filmmaking. What we have seen and judged on our own as an audience is complicit with the impressions of the crew, which is strangely comforting. On another level, Rosen and Gordon's insights are so good that we begin to wonder whether they are also in on the experiment. At that point one doesn't know

what is being acted, what is a prank, and what is actually real. The shooting moves along in this way, with the crew reflecting and revolting against the director, and the actors questioning themselves. Themes of sexual politics, control, and power run throughout the production.

The soundtrack is integral to the film's structure. Composed by Miles Davis, the music accentuates the film's structure. Greaves has created a film of jazz riffs and improvisations. Much as jazz musicians, the players in his story are riffing off one another. The tone held fast by Greaves has emotional highs and lows, and spontaneous mistakes surface like blue notes in jazz. Split screens come and go. Actors change places. The Davis score comes and goes and ties the piece together thematically.

A final remarkable and serendipitous scene comes out of the blue at the end, as the crew confronts a homeless man who claims to be living in the bushes of Central Park. In his rasping smoker's voice he launches into a full alcoholic rant. The crew rushes for performance releases, which he signs: "I have a name that's so fucking long godammit that you better have a paper that's long enough." He has a vaguely upper-class accent. His monologue careens from topic to topic: he was once a watercolor artist, he was a machine gunner on the USS Alabama, a graduate of Columbia University and Parsons College. He rants against politics, race, sex, the establishment, the wealthy, and the press, angrily veering from topic to topic. Whether his stories are fabricated or whether he is at the end of a remarkable and tragic life is impossible to know. His gin-soaked ideas belie a deeper truth of hopelessness, frustration, and tragedy. The film ends with the entire crew following the vagrant up a hill, recording every word as he babbles on.

Reality at last.

Quotes from Psychosymbiotaxiplasm: *Copyright © by William Greaves Productions. Text reprinted with permission.*

THE BEAVER TRILOGY: DOCUMENTING THE DOCUMENTARY

QUESTIONS OF REENACTMENT

Trent Harris's *The Beaver Trilogy* is constructed in three parts; only Part One can be considered true documentary. This first section is a randomly defined wandering storyline. The two subsequent variations revisit, duplicate, and enhance the first. Richard LaVon Griffiths's story becomes a docudrama. The first perspective is about authenticity. Harris appropriates his own work, and by doing so exploits his subject by making assumptions on the emotional reality of the first section. Parts Two and Three stray from authentic documentary filmmaking, questioning the authenticity of the original documented subject. In this way the film highlights the fact that all documentaries necessarily construct narrative, build conflict, tease out themes, and provide insight. Jared Green in an essay "This Reality Which is Not One: Flaherty, Bunuel, and the Irrealism (sic) of Documentary Cinema," makes the point:

> *Given that all filmed material is by definition mediated and therefore re-presents real-ity, in lieu of the generic distinctions between fiction and non-fiction and the scientistic (sic) criteria of objectivity and subjectivity, we might well substitute the categories of "mediated" and "unmediated" ... all documentary cinema is a mediated real ... " (6)*

Appropriation provides a second discussion. In other arts, appropriation is a means to create. Elaine Sturtevant has long reproduced the work of her contemporaries. As a statement about authorship and the photograph, Sherrie Levine finds work by well-known artists, then photographs and presents them as her own. In 2001, Michael Mandiberg created a website, AfterSherrieLevine.com, in which he appropriated the Sherrie Levine photographs appropri-ated from Walker Evans. He then allowed them to be downloaded from the Internet with a certificate of authenticity that they were now his work. British artist Glenn Brown builds his art from previous works. Even Picasso did variations on Velázquez's *Las Meninas*.

A third discussion the film raises is about copyright. Today in the online world, moving images are endlessly reproduced, borrowed, mashed up, overdubbed, and recut for the web. What is copyright infringement and what justifies fair use is an ongoing issue. The Beaver Trilogy borrows from itself to make second and third enacted documents of the first. It blatantly appropriates Olivia Newton John's song "Please Don't Keep Me Waiting." Because Newton-John would not give permission for the song (as of this writing), the film can't be legally distributed. The retooling of the first serendipitous video into new form with two professional actors raises issues of appropriation and adaptation, legality and piracy, authenticity and manipulation.

A fourth concern is exploitation of the subject. In reshooting the first part of the trilogy, did Trent Harris unfairly and dangerously exploit the naivety of his subject? How far should a documentarian go artistically and ethically to manipulate and reconstruct his story? These ideas, in addition to the film's performances, make it a documentary worth another look.

THE BEAVER KID PART 1

In 1979, Trent Harris, a relatively unknown filmmaker, was testing a video camera for a Salt Lake City TV station. He stumbles upon Richard LaVon Griffiths, a young man who goes by the handle "Groovin' Gary" and who is thrilled with the opportunity to be on TV. When asked what he does in Beaver, he claims he is "kind of Beaver's Rich Little." (Rich Little was a famous Canadian impressionist at the time who still performs in Las Vegas). He begins to do impressions: "Here's Sylvester Stallone." He launches into a questionable impression of Stallone followed by an indecipherable impression of Barry Manilow. He drops in passing that he also impersonates Olivia Newton-John, but lets the suggestion pass. Intermittently, he breaks out in a self-conscious horsey laugh, his whole body shaking with the thrill of being on "the tube." "Am I really on television?" he asks. "I guess this is just my lucky day." Not intending anything more than a quirky profile of a charismatic young man in bell-bottom pants and a rainbow-striped 1970s polo shirt, Harris follows him to a car where "Gary" shows off engravings etched on the vent window of Farah Fawcett and Olivia Newton-John. They

are barely recognizable. The car won't start so he quickly hot wires it and drives off. "Thanks, buddy," he says enthusiastically.

That by itself would barely qualify as a documentary, but then Harris receives a letter from Groovin' Gary: he will be performing his Olivia Newton-John impression with a band at a local talent show and would Harris like to shoot it?

Gary writes:

> "This assembly means so much to me. You really made my day that day. I was so glad to have the pleasure of meeting you. I've gathered some of the best talent that I could find for the show. I'm so honored to have you doing this for us and you Trent for taking the time and the interest in me. I need the exposure so bad that two only together could give me. (sic) It's scheduled to go off at 10 o'clock in the morning. Please be there … I've been so upset about this that the only thing that calms me down is Mr. Rogers Neighborhood on TV, not mention Sesame Street. Ha Ha. Please try to come down. I'm pleading. I'm begging. PS. I will be putting on my makeup in the open mortuary at 8 AM. You may want to get some shots."

We move next to the local funeral parlor where he is having makeup applied. He self-consciously explains what he is doing:

> "This is … heh heh. I still am a man I'm doing outrageous things, but I enjoy being a guy. I really do. Ha Ha. I have to convince the audience that I have not gone crazy. I think the hardest thing is going to be the voice. It's hard to do her voice. It is. I don't what to say. It was a gift from God. But for a man to be of the change his voice up that high. (sic) It comes off pretty good."

He continues to have the makeup applied taking on all the glamour of a corpse. There are close-ups of Cheryl from the funeral parlor spreading the pancake foundation, applying the eyeliner and lipstick. These shots will be duplicated in the throughout the variations. He nervously continues:

> I just do it for fun. I'm a man, not a girl. Heh heh. But it's fun to dress up and be a (he stumbles) your impersonation, make-up's so much a part of the impersonation. It helps you to perform better when you're in make-up. Your best make-up. I have a hard time expressing myself, you know. Maybe I'm just nervous. I dunno. Ha ha."

The funeral parlor makeup adds a surreal touch. Heading for the next room, he says, "Well, I think I'll get into my threads. I'll be right back." When he returns he slips into a pair of high heel leather boots. He sits. More serious now, he continues:

OK. I hope the viewer doesn't think I'm like that. It's just for fun. I just do it for a kick. I don't take a lot of this seriously. I take the impersonation itself seriously. But as far as really wanting to be like Olivia—BE Olivia—No. I'm Dick Griffiths. I'm a guy. But I love Olivia Newton -John. I do. (looking down in great thought). I think she's fantastic.

The makeup artist gives him along blond wig that looks unlike any hairstyle ever worn by Olivia Newton-John. She tucks in the tag. Breaking from his serious moment, now in full regalia, he speaks with a sudden falsetto in a British accent. (John is Australian).

I really don't know what to say. I just got to get going.

This is not a drag parody, but a kind of drag homage. These moments will be repeated two more times. Harris will use Gary's reflection and self-consciouness and enhance it later. Whether this is true, or honest, is open to question. At the talent show things get even stranger.

The opening acts are typical small town entertainment. An MC introduces two sisters, Joan and Julie Kessler, "accompanied by their lovely mother" singing the "Happiest Girl in the Whole USA." A girl sings a country and western–style "Let Me Be There." A troop of majorettes performs. These acts will also be repeated in Part Two.

Finally, a fog of dry ice creeps onto the stage and "Olivia Newton-Dawn" enters in full regalia. The band consists of an amateur but very enthusiastic, smiling, bleached-blond drummer, and a pretty good piano player. The singing nowhere resembles the artist known as Olivia Newton-John and the singer's long body rocks awkwardly to the music. Then as the song "Please Don't Keep Me Waiting" finishes, a character in a Halloween mask inexplicably carries Gary off. As he leaves the theater, Gary says, "I think that went pretty well." End.

When I first saw the film, it couldn't understand what type of documentary this represented. It screened at the New York Video Festival well before the age of YouTube. I assumed this was authentic, but then Part Two began.

THE BEAVER KID, PART II.

Shot in 1981, a very young Sean Penn now plays Groovin' Gary; Harris claims that Penn auditioned for the part as a struggling actor. The performance repeats much of the dialogue from the original. Penn does an admirable impression of Groovin' Gary right down to his horsey laugh. The performance is reminiscent of his character Spicoli from *Fast Times at Ridgemont High,* which he was about to shoot and which would make him a star. Penn's character is called Larry. Harris calls his filmmaker Terrence. This sequence is shot in black-and-white video. The filmmaker is now more exploitive of his subject, playing himself as a filmmaker smoking pot and laughing about how great this is all going to be. At first filled with braggadocio, Penn's Larry will become gradually more troubled by his drag performance.

The second film transforms from a documentary to a staged version of the same scenario. The first version is the result of happenstance and editing. Now, exact lines of dialogue are repeated as shots are duplicated. Without knowing the context, one would assume both Gary and Larry were actors and that this performance is just more developed and elaborate than the first. Actually, it becomes a dramatization of the first documentary with tension and motivation elevated. Essential visual details are duplicated.

Penn revisits the funeral parlor with its makeup lady. Penn's Gary dons the same wig and recites many of the same lines. For the talent show he uses clips of the same MC and the opening acts from the first. This time there is no band, but a fog of dry ice again precedes Larry's entrance on the stage. This time the singing of "Please Don't Keep Me Waiting" is horrific. Penn's vocals are even worse.

The biggest change comes in a fabricated dénouement. The character Larry, conflicted by his poor and silly drag performance, sits staring at a picture of Olivia Newton-John. He pulls out a rifle and puts in into his mouth, gagging. This dark tension is suddenly interrupted when his phone rings. The person on the other end says, "Larry? I think you're a real jerk. (pause) Just kidding, Larry. I think you were great. Would you perform next week at my party?" Cue the Newton-John song again. Larry has come back from the brink.

Questions remain unanswered. Is this a narrative enhancement or is it an actual incident that occurred? Could it be a catharsis for the filmmaker who felt he had exploited his subject the first time? He does, after all, portray himself as a pot smoking and joking filmmaker with a flippant attitude. Does Part Two add false conflict or reveal new details about the subject and the situation?

PART THREE: *THE ORKLY KID*

Shot in 1981 and now called *The Orkly Kid*, Crispin Glover offers a third interpretation of the subject. His performance heightens the eccentric qualities of the original. Glover has reinvented Groovin' Gary (now called Larry Huff), and the narrative has added key elements to the story: motivation, background, relationships, cutaways, and reaction shots. Harris is attempting to add narrative cohesion.

The Orkly Kid begins with Glover in silhouette atop a mountain, a scarf and his hair blowing in the breeze accompanied by Olivia Newton-John's "Please Don't Keep Me Waiting." The image lets us know right away that this will be a story of triumph. The more elaborate opening sequence cuts to Glover sitting alone in the shadows of his bedroom. His mother (Lila Waters) cries out from downstairs, "What are you doing in there? Do you need another quilt?"

"Nope. Toasty warm. Good night, Mom" he calls back timidly. Larry stares from the darkness into a mirror, a fish tank light wavering behind him. "Please Don't Keep Me Waiting" comes up on the soundtrack as the camera moves into a poster of Newton-John

This chapter is clearly built around identity crisis, fictional or not. It riffs on the previous two chapters with new characters, friendships, and relationships. Glover's remarkable

impersonation is more blatantly insecure, which serves to build greater conflict, deepen the characterization, and provide a more triumphant resolution.

After the elaborate introduction, the film cuts to Larry entering a coffee shop. "Heeere's Larry," he announces enthusiastically. Two boys at the counter cringe. Here he meets his pal Merrill (Stefan Arngrim). He does a quick impression of Marlon Brando and whispers to Merrill, "I'm gonna try and get on television." "Television!" exclaims his friend. The two at the counter laugh out loud. Larry shyly defends himself. "I'm not saying I'm great or nothin'. But I'm gonna give it a shot." "Larry" the kids tell him, "You couldn't get on TV if you was a train wreck." Larry gives a halting self-conscious laugh. Merrill defends him. Harris has established Larry Huff's anxiety and has provided a reason why he might be hanging around a cable station. This is where the story continues.

The familiar scene outside the station begins as Glover/Larry reenacts more impersonations for Trent Harris, now called Terrance. In the process of shooting that opening scene, the camera with its huge three-quarter-inch video tape malfunctions. Rather than give up being on TV, there is now a reason for him to organize his own talent show. Harris devises new scenes to build backstory and subtext, and Larry's issues with sexual identity are made more blatant. Glover has taken Richard Griffiths's halting laugh that was a signature part of his character and turned it into a laugh that belies both an extroverted nature and a deeply insecure young man. It is an enormously clever performance—both comic and troubled.

He develops a friendship with Merrill, who helps Larry organize and decorate for the upcoming show. In a second coffee shop scene he is befriended by an older man named Byron (John Bluto) who wants to put his daughter into the talent show.

The funeral parlor costuming is revisited. There is a new MC and the opening acts from the previous two parts are recast with new performers but with the same songs. Byron's daughter is now performing.

Glover makes a grand entrance performing as "Olivia Neutron-Bomb." The audience is thin. The filmmakers look like they are savoring the moment like a kind freak show. In the audience, Larry's mother squirms.

When the show is over everyone, including the MC, is aghast. Larry's pride at performing on television is completely deflated. He loses the alliance of everyone who seemed to respect him. "Take that stupid fucking wig off!" barks Byron. "Goddam fool, you've embarrassed the entire town. I mean look at you. You look like some kind of fruit." Merrill won't even talk to him and leaves silently.

Again, Larry calls to ask Terrance not to air the performance, but the filmmaker explains, "You look great. Besides, I got a deadline to meet. Would I lie to you?" The distraught Larry reaches for a rifle and sticks it in his mouth, nearly gagging on the barrel. The strains of the Newton-John song return while the fish tank glow is reflected on the Olivia poster in the background.

From there we cut to the coffee shop exterior. Larry pulls up. He places the wig on his head, struts into the coffee shop and stands proudly at the door. "How 'bout a cup to go?" Then, in his falsetto British accent, says, "Well, I really don't know quite what to say. I guess I ought to get going." He leaves the shop and says to himself, "Man, this town's enough to drive a guy nuts."

As the customers stare out the window, he waves, and sticks an eight-track tape into his car deck. As "Please Don't Keep Me Waiting" comes up on the soundtrack, Larry's car zooms into the horizon. Triumph.

Because Glover's performance is both sincere and enormously quirky, the ending is quite moving. The stakes and the conflict have been raised and focused. This is a coming-of-age story of sexual identity, friendship, and the pride of individuality.

The question of how far we've strayed from the original character is important here. The trilogy began with an actual person we don't know. Anyone seeing the three sections for the first time would have no idea that any of this was real. While Part Three was intended as a self-standing short film, it works best as a layer after the first two. Docudramas are often labeled as "based on real events," "a true story," or "inspired by actual events." Here the "real event" is enhanced to what purpose? Is Trent Harris satisfying his own creativity by returning repeatedly to the same material while exploiting Richard Griffiths? The performances themselves are fascinating, but the sequences pose questions about the differences between documentary and docudrama. How much manipulation is necessary to build a theme? To what degree does a documentary reorder and select facts to build a better story and add clarity? As the real subject disappears, unanswered questions about consent and exploitation remain.

Original footage is always going to be manipulated in an effort to build a stronger narrative. Did these films exploit Richard Griffiths, or did they bring him the notoriety he seemed to crave as evidenced by his enthusiasm in the first sequence? Did he care? All documentary requires consent and release, but how ethical is it to make up narrative details to heighten a theme? Viewers are generally unaware of the relationship of the subject to the filmmaker. Here, each sequence of *Beaver* interrogates the context of the previous one. By adding imagined or perhaps actual motives to the subject, it highlights the issue of representation and fairness.

There is no evidence that Griffiths was sexually confused. In actuality, he was a Mormon. When he says he thought his voice was a gift from God, he's probably not being sarcastic, despite the fact that the singing is terrible. His drag performance is something that he appeared to do in good fun. The subsequent representations of Griffiths show him in dire states of sexual confusion. While that makes a good story, and in a third segment a story of triumph, we have no idea how that affected him personally. What is most troubling is that Griffiths actually attempted suicide. He shot himself, but not fatally.

Richard Levon Griffiths eventually did achieve the recognition he had desired for himself. The entire trilogy appeared at Sundance in 2001 and for one night Griffiths was treated like a celebrity. The film has gone on to achieve cult status.

Beaver Trilogy Part IV appeared at Sundance in 2015. (8)

Griffiths passed away from a heart attack in 2009 at the age of 50. (9)

Suggested Reading:

Trent Harris interview with Ryan Bradford for *Vice* magazine.
http://www.vice.com/en_ca/read/new-york-trent-harris-is-sick-of-beaver-and-sean-penns-big-fat-stupid-fucking-face-but-hell-talk-about-them-anyway-and-other-things-too

This American Life producer Starlee Kine recounted her experience seeing this film for the first time and the subsequent appearance of Griffiths at The Sundance Festival. An audio of the show is archived at the This American Life archives at:
http://www.thisamericanlife.org/radio-archives/episode/226/rerunson

Quotes from The Beaver Triology*. Copyright © by Trent Harris. Text reprinted with permission.*

SUPERSTAR: THE KAREN CARPENTER STORY: A DOCUMENTARY WITHOUT ACTORS

Superstar: The Karen Carpenter Story (US, 1987) is a film biography directed by Todd Haynes cowritten with Cynthia Schneider about the pop singer and drummer Karen Carpenter, who died of anorexia nervosa in 1983 at age thirty-two. The film has a reputation as an underground classic. It is available on the Internet in various locations. It was banned from commercial distribution for its unauthorized use of film material, and also due to Richard Carpenter, Karen's brother and musical partner, and his issues with the film content. These issues are understandable. The film is acted entirely with Barbie Dolls using voice-over characterizations, mock interviews, and an audacious blend of vintage information campaigns, text, and newsreel footage. The dolls, used as puppets, act out the musical rise and tragic early death of Karen Carpenter. We are first distanced from the story, then moved to a deeper understanding—what Bertold Brecht called "the distancing effect." The following definition of this idea from an MIT glossary describes it as *"a technique used in theater and cinema that prevents the audience from losing itself completely in the narrative, instead making it a conscious critical observer. The actor accomplishes this by directly addressing the audience, barring them from feeling empathy (film), interrupting the narrative (cinema), or drawing attention to the filmmaking or theatrical process." (10)*

There are no actors in *Superstar*. The use of dolls is blatantly artificial; the voice-over is often pedantic and overly dramatic. The voice-acting sounds stiff and amateurish, and there are actual and staged visuals that disrupt the flow of the story. These elements are in direct opposition to Karen Carpenter's mellifluous singing. The audience is intentionally distanced from the narrative. The collage and collision of image and artifice eludes emotional involvement, compelling the audience to interpret the information for itself. Brecht often

collaborated with composer Kurt Weill to write songs that distanced his audience from the politics of his plays. Haynes fills his film with Karen Carpenter singing to the opposite effect. Although we are intellectually and visually at a distance, the impact of Karen's singing builds an emotional bond. The result is a complex and surprisingly moving film.

Superstar is only forty-three minutes long. A description of the first ten minutes makes clear the complexity of Hayes's approach to the story.

Superstar opens with the date on a black screen: February 4, 1983. Shot in black and white and appearing to be old home movie footage, a handheld camera glides through the interior of a suburban house. A title reads: "A dramatization." A mother's voice calls out:

"Karen. It's nearly a quarter after. Saks is jammed by eleven. You better get going. Karen?"
A hand knocks on a bedroom door.

"Karen?" The hand pushes into a bedroom and we move toward an unmade bed and to what appears to be a leg and a sheet.

The mother screams, "Oh my God, Karen!"
Black.

Cut to the exterior of a typical suburban California house as a dramatic and authoritative voice asks:

> *"What happened? What at the age of thirty-two was this smooth-voiced girl from Downey, California, who led a raucous nation smoothly into the '70s, found dead in her home? Let's go back, back to Southern California to where Karen and Richard grew up, back to the home in Downey where their parents still live today."*

On the soundtrack we hear Karen Carpenter's extraordinary voice singing the pop hit "Superstar":

> *Long ago, and, oh, so far away*
> *I fell in love with you before the second show*
> *Your guitar, it sounds so sweet and clear*
> *But you're not really here, it's just the radio*

The camera, now shooting in color, travels along a street to the front of another house as Carpenter's plaintive voice finishes the song:

> *Don't you remember, you told me you loved me baby?*
> *You said you'd be coming back this way again baby*
> *Baby, baby, baby, baby, oh baby*
> *I love you, I really do*

The lower third title reads:
"A Simulation."

As we move into the window of the house we hear her singing the Burt Bacharach/Hal David classic: "What Do You Get When You Fall in Love?"

The figure in the window is a Barbie Doll.

The shot cuts to a small pan across a miniature living room to a Barbie and Ken doll and a voice says:

"Now Richard, I'm not trying to criticize. I love your music. It's just that it needs more …"

"More punch," says the Ken Doll, representing Richard Carpenter.

Mother's voice continues: "What you need is a singer."

"Mother, I can't sing and play keys and lead a band."

Karen is heard in the distance.

"Wait. What's that? Is that Karen? It is. Richard, I think we just found you a singer."

Soon the figurines are in the office of a record executive.

"Now listen to me. You kids are young and fresh. And it'll just be up to me to make young and fresh a happening thing."

A hand passes into the frame as ambient music rises.

The executive voice continues:

"It's a rough road out there and the stakes are high. But don't you worry. We're a real family here at A&M. All you have to do is put yourself in my hands."

The pitch of the voice is being manipulated lower and lower.

Shots cut from the hand to the Barbie/Karen face, and back again as a close-up of a puppet hand moves forward.

The shots cut more quickly as an ambient electronic tone rises in pitch. As it reaches its peak, a woman screams, and we cut to Vietnam War footage.

Bodies are being thrown into a pit.

Next, another jarring segue to a piece of paper on which is written:

> *As we investigate the story of Karen carpenter's life and death we are presented with an extremely graphic picture of the internal experience of contemporary femininity. We will see how Karen's visibility as a popular singer only intensified certain difficulties many women experience in relation to their bodies*

The film makes another abrupt shift to a dreamy music video of the song "We've Only Just Begun": the Karen figurine is onstage at a microphone and Richard is at the piano. Interspersed with a real hand playing a tambourine, we see them driving through L.A., picking out costumes, and walking along a projection of a beach. It finishes with Karen (doll) lying in a short nightgown on her bed.

The artificiality of the dolls with their manipulated and stiff movements, amateur voice-overs, and stilted dialogue suddenly gives way to images of the American flag, the Kent State shootings, and war protests. An officious narration begins:

The year is 1970 and suddenly the country finds itself asking the question: What if instead of the riots and assassinations, instead of the angry words and hard rock sounds, we were to hear something smooth, and something of wholesome and easy-handed faith?

The montage continues with shots of the Nixon family and homecoming queens. There is an immediate cut to a recording studio with the opening piano chords of the hit song "Close to You." Karen is coughing:

"I'm sorry, Richard. Goddamn. I'm really flubbing it up today, aren't I? I'm sorry, guys. I don't know what's the matter with me. I just want it to be perfect."

The essential theme has been introduced. The camera zooms back from the doll and image and a rise-to-success montage common to movie biographies begins. The montage is disrupted by more Richard Nixon and antiwar footage when suddenly a real hand turns off a radio and the song stops abruptly.

"I can't hear myself think," says Karen's mother. Karen and mother are discussing Karen's worries about her weight. Richard enters and informs them that they've been asked out to dinner. The electronic tone rises ominously.

A female narrative voice declares:

The affliction that eventually destroyed Karen Carpenter is one that plagues many, many young women like her? The name of this private obsession? Anorexia nervosa.

The shot cuts to a plate of food and a box of Ex-Lax.

A woman on the street asks: What is *anorexia nervosa?*

The voice-over continues to describe in medical fashion the definition of the disease as the camera zooms in on a medical text.

Another woman on the street asks: *Do anorexics ever get hungry?*

To images of food, the narration describes:

Those who suffer from it are obsessed with food and its preparation while they deny their hunger and their body's need for nutrients."

A woman asks:

"Do they think they look attractive like that?"

An extended narration on body image gives way to Karen singing "Top of the World" to a montage of food being served, a box of Ex-Lax, lips singing, a scale decreasing in weight, maps of cities being toured, and a little girl from what appears to be a talent show lip-syncing the song as it ends.

The film is only fifteen minutes in. The collage style continues with testimonials on the social and artistic significance of the Carpenters' music. A theme of domineering parents is introduced. The Carpenter parents attempt to keep the act squeaky clean and the children at home. Set pieces trace Karen's affliction, her rise and demise. Her voice soars over the doll dramatizations, over found and enacted footage, over informational narrations, and over factual text. The various song lyrics provide an added layer of irony. The disconnection between traditional and counter culture politics and commercial success and self-image are made obvious. The clash of sugary pop songs with social and political unrest parallels Karen's alienation from her own body.

The most obvious device is the use of the Barbie Doll instead of actors. Ruth Handler, the cofounder of Mattel, introduced the doll in 1959 as the first doll with adult features. Handler intended that the doll would allow little girls to imagine and role-play ideas of adulthood. But with a figure whose measurements in real life would be 36-18-38 the doll became, fairly or unfairly, controversial for its unrealistic and potentially damaging modeling of an impossible body image. There is also criticism of the culture of materialism it generates to young consumers with its spin-offs (the Ken Doll, for example) and endless accessories. Use of the the popular figurine becomes an inherent commentary on the dangers of middle-class consumption and the social construction of identity and self-image.

The range of thematic and stylistic elements is both playful and serious in other ways. The narrative echoes many behind-the-scenes biopics with topics of fame and mental illness. (11) The use of outdated information campaigns popular in classrooms of the 1950s and 1960s points out how Karen and Richard's upbringing was out touch with the times, particularly as musicians. These educational films instructed on everything from dating to the dangers of drugs and homosexuality.

At the simplest level this film is about playing with dolls. They are moved around like little girls and boys playing house, then voiced by amateur-sounding actors. Haynes's status as a gay filmmaker contributes to the point that social and gender representation and approval are an important part of the film's aesthetic. In addition to anorexia, The Carpenters' mainstream status and conservative roots appear to be a source of conflict. Todd Haynes's camp approach to his subject and empathy for—rather than accusation of—Karen Carpenter is empathic and appropriate.

Two quick moments in the film further address the notion of social deviance, a status that homosexuality may have still experienced during the late 1960s. The first is a twice-recurring image of a Barbie being spanked. Is the spanker her father? Does this represent the constraint and lack of independence that Karen felt as a popular figure and as a woman? The second digressive moment occurs when Richard finds a package of Ex-Lax on the table. Karen has relapsed. She pleads, "Don't tell mom and dad." He yells back, "Why shouldn't I? Why shouldn't I tell them?" Karen threatens, "If you do I'll tell them about your private life." Continuing the argument, she tells him, "They're gonna find out sooner or later." And finally she asks, "Do the Carpenters have something to hide?"

This isn't a question that will be answered. There is no authentic footage of the Carpenters with which to judge the actuality of the Carpenters' emotional or professional life. Through a

creative combination of fact and play, Todd Haynes creates a unique document that compels his audience to engage in a more personal way, and one with all the emotional power and insight of traditional nonfiction.

HOAX_CANULAR: SOCIAL MEDIA AS DOCUMENTARY

Canadian artist Dominic Gagnon primarily works as an installation and performance artist. He has created a trilogy of films in which YouTube videos are sequenced into an inventory of voices clustered around doomsday and survivalist scenarios. The first two, *Pieces and Love All to Hell* and *RIP in Pieces America*, are compiled from clips of so-called "preppers," the name given to people preparing for the coming apocalypse. Women make up the first film composed entirely of online posts. The second film is made up exclusively of posts by men. These randomly compiled clips sequenced by the artist are made up of conspiracy theorists, fringe conservatives, paranoiacs, and survivalists. They talk about strange machines, weapon arsenals, about stockpiling food, of FEMA concentration camps, and the "New World Order." Gagnon maintains a low distribution level because he doesn't have the rights to the visuals. His work, which was not intended for festivals and cinemas, has been gradually gaining more attention and receiving more public screenings.

Gagnon cites Hannah Arendt when discussing his motivation for finding and giving form to the uncensored ramblings of individuals on the fringes of society. A well-known Arendt quote reads: "Clichés, stock phrases, adherence to conventional, standardized codes of expression and conduct have the socially recognized function of protecting us against reality." The overall effect of these videos is to push back against just this danger of officially sanctioned speech and ideas. This work is not about the quality of an argument nor coming to a conclusion about right and wrong, desirable or undesirable. These are pure documents, unmediated expressions, and are a bit frightening.

Hoax_Canular is the third of Gagnon's series and has gotten significantly more attention than the first two films. The title *Hoax_Canular* translates as "hoax hoax." "In Canada," said Gagnon, "everything is bilingual and it made sense to title the piece as such. This third film is a compilation of YouTube clips posted exclusively by teenagers. The artist set up a bank of computers to record postings in the hours before a popularly anticipated apocalypse predicted by the Aztec calendar: 21 December 2012. The teenaged YouTubers share their views and perspectives, make amateur disaster and zombie films, and become a mad chorus of farfetched scenarios, opinions, and ideas. Watching it is like seeing a global teenage car crash. These are films *meant* for our consumption. Some are intended as warnings while others express naïve philosophies about the final days. The film's structure is not built around plot but, having been carefully gleaned and assembled from the massive YouTube stockpile, it moves chronologically toward the midnight hour of the day of the alleged apocalypse.

The direct address videos are posted from bedrooms and homes. From the safety of their private spaces, teens confess, vent, warn, and yell at the world. What at first seems

repetitive and indulgent becomes hypnotic and themes begin to emerge. The voices of these children—twisted, half-formed responses to a looming nihilistic scenario—are alternately naïve, thoughtful, hopeful, angry, and sometimes disturbingly violent. They are also bittersweet and sad. While there have always been doomsday predictions, monsters and dystopian visions, what is different today is that these are young people who are coming of age in a world of media images unfiltered and violent, both real and virtual. Recorded fringe ideas "go viral," reaching countless viewers. Never before has a young generation had unrestricted access to ideas and images that were once filtered or censored by media gatekeepers, the government, or even families. Simultaneously these youth are empowered as media creators and all anxieties can be given expression. Parents are obviously and conspicuously absent.

The documentary took about two months to complete with most of the footage coming from the night before the impending end of the world. Gagnon, using a large number of computers, downloaded the postings in real time. This generated seventy hours of footage in eight hours. He had no time to watch the clips, but collected them according to title and by looking at faces. Later, the films were sorted out and stitched together. Everything is what he calls «saved footage.» Some of the youth are masters of postproduction savvy, not only at lighting and sound, but also editing and creating special visual effects. Some of the posts are mini-movies featuring spaceships, robots, lasers, gunshots, and explosions. Some even appropriate footage from blockbuster films into their own work. Many of the youth brag that they don't believe the prediction and at the same time are trapped by their lack of perspective hidden beneath the boasting.

Gagnon's clips parade one film after another, interweaving and riffing off one another. In the face of catastrophes and threats of global annihilation, extreme weather conditions, conspiracies, predictions, and religious prophecies, the imagination and resilience of these young people is impressive. Some rant interminably about fringe ideas, others struggle to rationalize and philosophize about the approaching end times, or express their restlessness through homemade disaster and zombie movies. A small sample of clips illustrates the madcap display of performances and opinions:

A young Muslim girl in a headscarf:

> "Being Muslims we know the world can end at any time and there's only one way to prepare ourselves for the end of the world—by doing the things we should've done in completing the things that should've been completed. Live like we're dying tomorrow."

An American southerner:

> "Anyone who thinks this is a hoax is out of their mind. Trust me this will happen. I know I have evidence. God spoke to me in my dreams and I trust him with my life. So repent. Repent now, sinners please."

Cut to a shot of a first-person shooter video game in an apocalyptic discussion:

"I really honestly believe that the world was ending for sure ending in two days that people be would killing people like crazy because there is no reason to live"

Cut to a mournful young girl singing a full version of "The End of the World," a popular hit by Skeeter Davis in 1963 (1), intercut with a boy in a Batman mask dancing on his bed in his boxers smearing himself with chocolate.

As the hour approaches, the comments become darker and direr.

One boy sings an original song about the end of the world, intercut with a boy acting as a reporter witnessing doomsday:

"As you can see, it is raining fire. I'm walking down my driveway and it's very cold. It's a terrible sight."

A sweet British teenager in a low-cut T-shirt says:

"We can thank common sense and logic. Nobody really expected there to be an apocalypse. I was just about to call people idiots. Where was I going with this? Yeah, but no. The apocalypse is supposed to be …"

Suddenly, the lights go out. She leaves the frame to check the source. She returns.

"We have no power."

She giggles. Clearly nervous, she assumes it is a power company prank, but gets increasingly distraught. She starts to cry. She looks desperately at the camera.

"Um. Guys. This is starting to freak me out. This is probably just stupid coincidence. This can't really be the end of …"

The lights suddenly come back on. She sits shaken and immobile.

A Chinese boy returns with a refrain of "The End of the World," intercut with a particularly violent zombie apocalypse film.

Such juxtapositions are jarring. *Hoax_Canular* contains many troubling glimpses into private worlds, intimate visions of radical insecurity that are baffling, frightening, and flat-out bizarre. What Gagnon has put together here transcends conventional documentary. This is a provocative sociological study of youth, social media, and the transformation of communication. Individuals around the world now have the technology to voice their deepest fears publicly. The possibility also exists that kids growing up in a saturated media environment of DIY (do-it-yourself), reality stars, and flickering nanofame (2)

are performing more than they are actually venting. Perhaps the line is impossible to distinguish.

Hoax_Canular is an objective study of teenage youth in a time when we are simultaneously questioning what it means to have an ubiquitous soapbox, theater that is self-programmed, or a platform for every idea and opinion. It is documentary without a camera. The movie is allowing expression without preconceptions. By typing in keywords, Gagnon gets personalized, random, and uniquely generated responses. Originally intended for the Internet or as installation art, the meaning of the film changes when shown to a theater audience. We enter into a group discussion about what these short performances mean, individually and collectively. The filmmaker has no agenda about the portrayal of his subjects. The audience becomes essential in completing the meaning of the work.

Unlike previous times, diligent administrators today at YouTube flag and remove questionable content: nudity, threats, cruelly, brandishing of weapons, etc. As a result, the clips that made up Gagnon's earlier work have been taken down due to statements that were threatening and incendiary. Today, clips such as these don't stay up long. The community of viewers is self-censoring and doesn't tolerate the most extreme views. His earlier works, *Pieces and Love All to Hell* and *RIP in Pieces America,* are not indexed for web viewing.

Not so *Hoax_Canular*. About half of these still remain somewhere on YouTube, though they are hard to find. Many of the titles are the same, which buries the content: Doomsday, End of the World, etc. Many of the youth probably took down their own clips once they saw that the end of the world never came. Gagnon has attempted to contact some of the subjects, occasionally succeeding, but many have started their own channels, then grow tired and abandon them. The teenagers who do respond to Gagnon are happy to be part of something. It is, after all, what they wanted in the first place. They are a generation that understands, more than their parents, that everything on the Internet is free and open to everyone.

"I don't make films about people," says the artist. "I make films about people who film themselves: the mise-en-scène, the costumes, the scripting, and playing. My subject is the making of those videos, not necessarily the people you see in them. I believe there is a lot of information in the background, on their walls." Not driven by plot and randomly displayed, *Hoax_Canular* is about reading the frame and assessing the details. The walls, the pictures, the clothing or costumes together with the words require continuous interpretation. How each clip, or the sum of clips, is interpreted depends on each viewer's background, politics, age, and attitude toward teenagers. All is shaped by the outlandish context of this melancholy and gullible group. "If cinema, as was predicted, is dead, where's the body?" (3) muses Gagnon. "In every crack of life, there is a little bit of cinema. My job is to stitch them together for some sort of Frankenstein idea or vision of cinema. There are stiches and pieces that come from different areas, a bit of comedy, a bit of set design, performance, music; all the things that make cinema happen, but not coming from cinema professionals, studios, craftsmen, and screenwriters. It's all DIY." It is Dominic Gagnon's exquisite corpse.

Contained in this piece are quotes and content derived from interviews with Dominic Gagnon in February 2015. Copyright © by Dominic Gagnon. Text reprinted with permission.

Suggested Readings

"15 Minutes of Fame? More Like 15 Seconds of Nanofame." Alex Williams. *New York Times Magazine*, February 6, 2015.
"The Decay of Cinema." Susan Sontag. *New York Times*, February 25, 1996.

Footnotes and Sources

INTRODUCTION
1. *Candid Camera* was a popular television show in the 1960s produced by Allen Funt. It used hidden cameras to catch people's reaction to pranks and setups.
2. Errol Morris. "Play It Again, Sam (Re-enactments, Part One)." *New York Times*, April 3, 2008.
3. "On the Absolute, the Sublime, and Ecstatic Truth." http://www.bu.edu/arion/on-the-absolute-the-sublime-and-ecstatic-truth/

PSYCHOSYMBIOTAXIPLASM
4. Greaves discusses his background in a video at THE COLLEGIUM Forum & Television Program Berlin, William Greaves and Audrey Henningham.
5. All dialogue from "*Psychosymbiotaxiplasm: Two Takes*" (1968). Criterion Collection.
6. Scott MacDonald in *A Critical Cinema 3: Interviews with Independent Filmmakers*, p. 53.

Later, McDonald quotes Greaves from his interview:
"I wanted to harness the paradox of doing failure, of using failure and error and confusion and chaos and unhappiness in conflict! The film is a tour de force. You are drawn inexorably through this cosmic flux. At the end you say, "Wait a minute, why was that about, and why was I so transfixed by it?" Well, life is like that, life keeps you totally absorbed from moment to moment to moment and yet oftentimes you can't tell what it's about. I like that paradox." p. 60

BEAVER TRILOGY
7. *Docufictions*. Jefferson, NC: McFarland & Co., 2006.
8. Chapter 4: "This Reality Which Is Not One: Flaherty, Bunuel and the Irrealism of Documentary Cinema," Jared F. Green (p. 64).
9. A description of the *The Beaver Trilogy Part IV* can be found at http://www.sundance.org/projects/beaver-trilogy-part-iv
10. Griffiths's obituary was published in the *Salt Lake Tribune*. It is archived at http://archive.sltrib.com/article.php?id=11628966&itype=NGPSID

SUPERSTAR
11. The Global Shakespeare MIT website. http://globalshakespeares.mit.edu/glossary/distancing-effect/
12. In his book, *Todd Haynes* (University of Illinois Press), Rob White puts the film squarely in the tradition of biographical melodrama.

HOAX_CANULAR
13. "The End of the World" was a global hit by American country singer Skeeter Davis.
14. **Exquisite Corpse**
 In surrealism, the exquisite corpse or exquisite cadaver is a parlor game where participants each draw a portion of a figure (or a sentence). The paper is folded over, concealed, and the drawing or writing is passed to the next person. The result is an unintended whole.

TIM JACKSON has been a professional musician and actor in the Boston area for forty years. He is currently an assistant professor at the New England Institute of Art in Digital Film and Video. He has directed three documentaries: *Chaos and Order: Making American Theater*; *Radical Jesters*; and *When Things Go Wrong: The Robin Lane Story*, and a documentary short called *The American Gurner*. He is a member of the Society of Boston Film Critics and writes on film and theater for *The Arts Fuse*, an online arts journal. He is currently editing "Wes Anderson: Interviews" for the University Press of Mississippi Press Series.

4 DOCUMENTARY FILMS ABOUT ART

BY *MARK LEVY*

THE DOCUMENTARY FILM ABOUT art, as with all documentaries, has a problematic relationship with the "real world." In the documentary art film, "facts" are often subject to debate or are merely a skeletal scaffolding for a story line constructed by the filmmaker. As the postmodernists have shown, signification is always ideological. In the words of Frederick Nietzsche, a premonitory postmodernist, "there are no facts, only interpretations."[1] This is especially the case in film as the filmmakers' interpretations are interwoven with the means of representation or presentation. The process of editing, camera angle, focal points, music, etc., offers a mediated world created by the filmmaker. Reality is never transparent in the documentary film, although the illusion of a matter-of-fact style and the accompanying self-effacement of the director supports the truth claims of the project. Documentary filmmakers usually do not view themselves as auteurs.

To be sure, Nietzsche's claim that there are no facts is somewhat exaggerated; there are events in history that compel agreement. In other words, some signs or facts are uncontroversial and do not offer multiple significations. There is a difference, for example, between Chris Marker's *Letter from Siberia* (1957), an erstwhile documentary film, and *La Jettée* (1962), a work of science fiction surrealism. But Marker has deconstructed the documentary form of *Letter from Siberia* by offering multiple commentaries on the same signs or facts, and by the creative representation of his subjects. For Marker, there is a thin line between documentary and fiction. Ultimately both films are fictional, although *Letter from Siberia* and *La Jettée* are still from different film genres.

1 Quoted in Walter Kaufman, *The Portable Nietzsche*, Viking Press, 1960, p. 454.

For me, fictional films about artists can reveal more about the character and mind of the artist than documentaries as long as they adhere to the basic historical facts. The relationship between the indexical sign and the referent, the identity between the photographic image and the actual subject and his or her surroundings, in documentary films is not a guarantee that the documentary film will be more truthful than a fictional film. As Picasso exclaimed in 1923: "Art is a lie that makes us realize truth, at least the truth that is given us to understand."[2]

In this essay, I will discuss some fictional films about artists that I think are especially revealing, along with more or less traditional documentaries on the same subject. A brief overview of documentaries about art is also my goal here. As I am an art historian, I will focus on visual art and select what I hope are representative examples from the vast number of films on this subject. To my knowledge, a survey of the documentary film about the visual arts has not been systematically attempted, although reference to individual films of this category is found in the literature on documentary film.

For this essay I have set up the following categories for documentaries about art:

1. Grand narratives about art.
2. Films focusing on single artists, collaborations of artists, and movements.
3. Outsider art.
4. Films about the art world, including those about collectors, the art business, Nazi plunder, fakes, and so forth.
5. Couples and family: films that emphasize the relationship between an artist and significant others who are also artists.

These categories overlap as do the modes of documentary filmmaking that inform them. Noted film scholar Bill Nichols summarizes these modes in his books as "expository," "observational," "participatory," and "reflexive" and I will make reference to them in the course of this essay for they are valuable analytical tools that unpack both documentary films in general and documentary films about art.[3]

GRAND NARRATIVES

For the most part, the grand narratives follow the expository mode, setting themselves up as objective inquiries into their subjects. They convey information by means of a "voice of god" narrator accompanied by images. The authority and expertise of the narrator is implicit and remains unquestioned. It is enhanced by a sober presentational style that accompanies a disingenuously straightforward film style. According to Nichols, in most traditional expository films the verbal narration is privileged over the images. By and large, however, this is

2 Quoted in Alfred Barr, *Picasso: Fifty Years of His Art, Museum of Modern Art*, 1946, p. 270.
3 See Bill Nichols, *Representing Reality*, Indiana University Press, 1991, pps. 32–75.

not the case with documentaries about art where visual images of art have a more important position in the film.

The titles of these grand narrative documentary films about art—*Civilization* (1969), *The Shock of the New* (1982), *Story of Painting* (1996), *Power of Art* (2006), etc.—indicate that their author/narrators purport to make sense of large swathes of art history and culture. These grand narratives are television series for public networks that are intended to inform and entertain an art-loving audience with or without some knowledge of art. Indeed, the entertainment value of these grand narratives goes far beyond the boring and pedantic educational films that I was obliged to watch as an undergraduate and graduate student in art history. The voice of god narrators who appear in the films—Kenneth Clark, Robert Hughes, Simon Schama, and Sister Wendy—are witty, dramatic, idiosyncratic, opinionated, and eloquent. For the most part, they do not rely on other authorities, which only adds to their voice of god omniscience.

Unlike Clark and Hughes, who are experts, and Sister Wendy, who has read much art history, Schama is a historian who uses the work of art as a pretext to dilate on a historical topic. He does not have a good understanding of the aesthetic achievements of his subjects nor their aesthetic milieu. His producers make up for these deficiencies with dramatic actor reenactments of the artists' life, a spare-no-expense location shooting, and an inspiring sound track of classical music. The makers of *Civilization*, *The Shock of the New*, and *Story of Painting* also received lavish budgets for location shooting and have selected music that greatly enhances the entertainment value of their work

Yet in Hughes and Clark, and Sister Wendy's films, no reenactments are necessary; their thick narrative carries the film. In Schama's segment on Caravaggio, for instance, are the poorly staged sword fights and tavern brawls by second-rate actors really necessary to establish connection between the artist's violent life and the gory details of some of his paintings?

To be sure, staged sequences have long been an important device in documentary film to provide a good story, although they mostly appear in the observational mode of documentary film rather than the expository. Flaherty reenacts various scenes of Inuit life in *Nanook of the North* (1922), but the presence of his native actors in his reenactments maintain the audience's suspension of disbelief.

In Derek Jarman's *Caravaggio* (1986), which is not a documentary, the director reenacts the life of Caravaggio with English actors. Jarman has created a fictional treatment of Caravaggio that is consistent with the known and somewhat controversial facts about this artist's life. Although there are many anachronisms in this film, including contemporary props and the highbrow and lowbrow accents of the English actors, the film works because it affirms the relevance of Caravaggio's life to the present struggles of artists. Obviously, the life of Caravaggio meant much to Jarman, who was also an artist and filmmaker.

On the whole, Jarman's imaginative *Caravaggio* is much more convincing than Schama's about how Caravaggio's mind works; on how the artist's sensuality influenced his art; on how Caravaggio's artistic milieu influenced his work; and how Caravaggio's painting would appeal

to highbrow patrons—in this case, the upper-Catholic clergy. I think Jarman's *Caravaggio* is, in part, what Nichols would call a "reflexive" documentary; Jarman deconstructs the idea that a typical documentary can do justice to the life of such an extraordinary and controversial artist.

Notwithstanding the financial critical and popular success of the grand narrative documentaries, I have cited, this genre has declined in recent years. Although the production values of these grand narratives values have much appeal, costs have significantly risen while revenues have declined for public broadcasting stations, even with corporate support.

Moreover, I think there has been a significant paradigm shift among filmmakers to the postmodernist notion that grand narrative concept is flawed. Essentially, the grand narrative has a beginning, middle, and end, following Aristotle's idea of good drama in the *Poetics*. This dramatic structure helps make sense of the world. In postmodernism, signification is open-ended, signs multiply without signifiers. The meaning of a story is still another story; a process that goes on indefinitely without closure. Why is an overall meaning even necessary? Why isn't the play of signs or signifiers sufficient? If meaning occurs, it is localized, fluid, and contingent, says the postmodernist artist or thinker. The idea that Kenneth Clark will define civilization—for him, it is mostly Western civilization—or Robert Hughes defines modernism; or Schama informs us of the power of art; or Sister Wendy affirms the canon of masterpieces is inflated as so many meanings or significations are possible, so many individuals making the significations, and so many works of art that do not fall within the accepted canon of "great" art but are worthy of consideration.

Sister Wendy, for instance, makes the claim that Velazquez's painting is the "greatest painting in the world." Although she cannot support this claim, her significations about this painting are valuable; she shows how Velazquez "stops time" as a way of achieving his own immortality. Although Schama cannot give us a workable general definition about the power of art, he shows us moments when art has power. In 2003, before Colin Powell's talk at the United Nations on the necessity of invading Iraq, someone noted that his speech was to take place under a tapestry reproduction of Picasso's *Guernica*, which depicts the bombing of innocent civilians during the Spanish Civil War, so the tapestry was covered. As Schama exclaims, this was an enormous backhand comment on the power of art, but this is the only account he can offer about the power of Picasso's work, especially as he does not understand how style and content work together to produce a strong Picasso painting.

In postmodernism, the authority of the narrator is decentered, or a least hidden.

Grand narratives given by a single individual have given way to counts by multiple narrators with different points of view. Focus has also been narrowed to a particular artist or group of artists, rather than the epic film spanning centuries of art. More prevalent now are observational films of the artists at work with varying levels of commentary, and participatory films where the director and the artist or artists collaborate in the making of the film about a particular artist or groups of artists. Furthermore, there are more films in recent years about

artists who are not highbrow or exhibit in highbrow venues. The authority of the artist, an original creator who makes great masterpieces, has also been decentered in postmodernism.

Robert Crumb never intended to make masterpieces; his early career was drawing comics for underground publications, which turned him into a cult figure. In order to understand Crumb and his work, director Terry Zwigoff, by no means an art expert, gets Crumb, his brothers, wife, and old girlfriends as well as Robert Hughes (the art critic cited earlier) and Deirdre English (former editor of *Mother Jones* magazine) to participate in the making of a documentary film. How much this observational/ participatory reveals about Crumb and his artwork is open to question, but Zwigoff has made a very entertaining film. Crumb comes across as witty, nerdy, incorruptible, and uncompromising. He is undoubtedly neurotic and has strong sexual appetites, but Zwigoff plays this for up for all he can. He pins Crumb's neurosis on his awful childhood, which is recounted in the movie by his mother and brothers, Max and Charles, all deeply troubled souls. The camera dwells far too much on the lives of these individuals. There is a whole discussion, for instance, on the nail bed that Max uses as a wannabe yogi. Are the people in this film, including Crumb, just place markers or signifiers for Zwigoff's own significations? Zwigoff also juices up his idea of Crumb's overheated sexuality by having Crumb pose with a number of voluptuous women in various stages of undress at a breast and leg beauty contest. Yes, they resemble the figures in Crumb's artwork, but again, in a bit of a stretch for a documentary, participation has become manipulation.

Notwithstanding his difficult background and the erotic fantasies manifest in his artwork, Crumb seems to have a good marriage and partnership with Aline, also a cartoonist. Crumb is also seen doting on his young daughter. Even his ex-wife and girlfriends have good things to say about him. We learn that Crumb possesses the necessary equipment and desires to lead a more or less healthy sex life. As Robert Hughes suggests in the film, there is nothing really demented or unusual about an artist expressing his sexual fantasies in art, though it may be politically incorrect. Unlike Deidre English, who condemns Crumb's depictions of women, Hughes understands there is a difference between having sexual fantasies and acting them out. Everyone, male and female, has sexual fantasies that may be considered dirty or sordid by his or her society. Crumb is simply being honest about the contents of his own mind, which is similar to the contents of other male minds. Moreover, he is unafraid of his fantasies and refuses to censor them. These are some possible reasons why his work resonates, especially given Crumb's imaginative powers and his ability to embody them in art. Hughes even refers to Crumb as the Breughel of the twentieth century.

Crumb himself is unwilling to say what his work means. After much prompting, he states in the film that he does not know what he is doing, and that his work has "no meaning." This allows for many significations of his works, not just Zwigoff's significations. Crumb's attitude is quite postmodernist.

While Zwigoff has essentially made a modernist film about Robert Crumb for wide commercial release, using the worn modernist trope of the artist as neurotic, sexually obsessed genius. John Walter's *How to Draw a Bunny* is an excellent example of a more postmodernist

documentary film. Walter's documentary is about Ray Johnson (1929–1995), an artist who also happens to be a precursor of postmodernism. I do not know how it fared at the box office but it received excellent reviews from both film and art critics. Essentially, *How to Draw a Bunny* is a loosely linear mosaic of archival film footage and photographs, actress Judith Malina's readings of Ray Johnson's writings, and interviews.

The film begins with an interview of Sag Harbor (New York) Police Chief Ialacci, charged with investigating the death of Ray Johnson to determine whether the cause of death was other than an apparent suicide. Ialacci has found Johnson's address book with names and proceeds to call the people listed. He learns that Johnson was an artist with a significant reputation among many well-known New York City artists, poets, and gallerists including Andy Warhol, Billy Name, Roy Lichtenstein, John Cage, Richard Feigen, etc., but that none of his contacts really knew him well. For the most part, Johnson eschewed museum venues and galleries, focusing on performance and correspondence art. He would send collages of found images, which he painted or wrote over, in mail-size envelopes to friends and acquaintances. These collages were often quite witty and contained cryptic messages. They reveal no more of his inner thoughts and feelings than his friends and acquaintances got from being around him or speaking on the phone—his main means of communication outside his collages.

It is a postmodernist idea that the self is not a whole entity but a series of fragments loosely strung together by the stories we tell and the stories that other people tell about us. Not only is Johnson decentered as a subject in *How to Draw a Bunny*—his life and art were a series of fragments—but also there is no single authority who can make sense of it. Actually, Chief Ialacci tells us as much about Johnson as anyone in the film. After Johnson's death, the police chief was the first to enter Johnson's house near Sag Harbor and found that all the collages were covered and turned to the wall except a large two-by-three-foot framed photograph of Ray Johnson. The police chief speculates that Johnson was leaving a message; "His way of saying goodbye," says Ialacci. In a later trip to his house, Francis Beatty, one of Johnson's gallerist acquaintances, discovers a drawing Johnson made that points to a green box of small collages. Inside the box the collages have been opened to a series about the suicide of Andrea Feldman, a star of several Andy Warhol films. This series of collages has the following text:

WE ALL STOOD BY
HELPLESS WATCHING
HER AS HER SELF- INFLICTED
SUFFERINGS
BECAME REALITY
AND WE WERE NOT
ABLE TO DO ANYTHING ABOUT IT...
SHE SAID OF HERSELF
THIS TIME I AM GOING TO THE TOP
TO EXPLODE LIKE DYNAMITE

I AM UNIQUE AS AN ANTIQUE
SHE ALSO SAID
NO ONE TAKES ME SERIOUSLY BECAUSE THEY THINK OF ME
AS A JOKE

Was Johnson's suicide actually performance piece, as a number of individuals who are interviewed in the film suggest? There is no closure here, no narrative with an overall signification. Walters does not even create a clear case for the quality of Johnson's actual artistic output as he includes only brief glimpses of his collages, footage from his performance pieces that appear idiotic taken out of context, and interviews with artists who are occasionally dismissive and depreciatory about Johnson's work.

Early in the film, Johnson demonstrates how to draw a bunny, basically a simple line drawing, to the musical accompaniment of a Max Roach drumming score. This is quite amusing and the line-drawn bunny alone becomes Johnson's standard template for all his portraits and self-portraits. These bunny portraits are an underwhelming visual experience, although he may be making a comment about portraits here. To be sure, Johnson was a pure soul, a kind of Zen master of the art world whose life and work (essentially indistinguishable) was a puzzle of signs and gestures, but it took Johnson's suicide—perhaps his best performance art piece—for Walter and others to take him seriously. *How To Draw a Bunny* is a significant film about an artist of questionable significance. Although the postmodernists are loath to admit it, the absence of significance is itself significant if it is framed significantly.

I should point out here that there is a mode of documentary film, the observational documentary that also tries to avoid narratives. Hans Namuth's short documentary *Jackson Pollock* (1951) is a classic among observational films because of its influence on generations of art students and artists. I first viewed it on an elementary school field trip to the Museum of Modern Art when I was eleven. At that tender age I was astounded how loose and improvisational was Pollock's mode of creation. In the Namuth film, Pollock claims, in his very brief commentary about his work, that he can control the flow of paint by flicking and pouring it from a can. We see him doing this on a large canvas that is laid on the ground near his studio in Long Island.

Pollock also used collage elements and painted around them on a glass plate while Namuth filmed him from a trench below the plate. Despite Pollock's unusual painting process, he makes direct contact with both the paint and the canvas or glass without the intermediary of a subject matter. As Pollock himself says in the film: "I am expressing my feelings rather than illustrating them." Although I was still puzzled by the lack of subject matter in his painting when I first saw the film—Pollock was the first purely abstract American painter after the Second World War—I was carried away by his sheer creative exuberance and how this was embodied in his work. It is no accident that critics and art historians call him the founder of action painting. It is appropriate to make a film on an action painter by showing him in action, and this is why I believe the film continues to be a resounding success on some levels.

In graduate school I was similarly entranced by Henri-Georges Clouzot's *The Mystery of Picasso* (1956), in which he draws and paints over twenty works in fairly close succession on a smooth semi-translucent white surface. From one side, the ink lines and colors appear as if by magic. On the other side, we see a bare-chested Picasso applying the inks. Each work was erased before Picasso began a new one. There is minimal commentary by the artist during the film and the viewer is left to focus on Picasso's virtuosity. The director even stages a time trial in which Picasso has a limited period to complete a painting.

For some bullfighting scenes on glass, Clouzot chose as a musical accompaniment Spanish castanets and guitars, and for other scenes he picked kitschy jazz or ponderous semi-classical music. Clouzot's idea is that Picasso's abundant creativity is a mystery that is somehow linked to drama, animal machismo, heightened seeing, and intense concentration. This a joyous, even ecstatic film but does not tell us much about Picasso, who was going through a fallow period at this stage of his career. At the beginning of the film, Clouzot claims that although we can never understand what went through the mind of Rimbaud when he wrote *The Drunken Boat* or Mozart when he composed the *Jupiter Symphony*: "To know what goes on in a painter's mind, one can just look at his hand." This is not true of Jackson Pollock, nor is it is true of Picasso; there is a process of reflection behind their works in their choice of subjects and style. The frenetic activity of Picasso in *The Mystery of Picasso* disguises the thinness of his late work in which he was mainly recycling his old subjects and styles: bullfights, voluptuous women reclining, voluptuous women and satyrs, still lives, and so forth, in the cubist, surrealist and neoclassical manner.

It is a weakness of the purely observational film about art in that it does not account for the reflective side of creation nor the emotional turmoil that sometimes accompanies the process of making works of art. These elements are represented and discussed by witnesses and art experts in documentaries combining observational film footage with narrative. For me, however, the best films that give insight into the creative process of Picasso and Pollock are fictional films. In *Pollock* (2000), a film directed by Ed Harris, who also plays the main role, the mental and emotional agony that Pollock suffered and inflicted on his wife Less Krasner, a significant artist in her own right, is amply demonstrated. While Ed Harris's *Pollock* is also a "couples" film, it is not a happy couples film

In Namuth's film, the process of creation looks effortless and becomes an entertainment for the viewer. In the fictional *Pollock*, the incredible struggle Pollock went through to get to the point where he could flick or pour paint on a canvas is a story that has a more satisfactory weight. Essentially, Pollock's life was a mess as amply demonstrated in the fictional film; the only way he could connect with his inner self was through the act of painting. He could not handle the pressures of being a successful artist, and at the end of the film we watch him commit suicide.

There was a dark side to Picasso as well. In *Surviving Picasso* (1996), a Merchant/Ivory fictional film based a memoir by François Gilot, Picasso's main female companion from 1946–1953, Picasso's ambivalent attitudes toward women, which he continually acts out

in the film, are as helpful as any "objective" documentary to explain the stylistic treatment of women in his paintings. In *Surviving Picasso*, we learn far more about Picasso then in Henri-Georges Clouzot's *The Mystery of Picasso*.

While Ed Harris and Anthony Hopkins do not much resemble Pollock and Picasso, respectively, they are superb actors and seem to channel their characters. Moreover, the basic facts of these movies, including those concerning the artists' relationships, have been collaborated by other sources.

One of the rare mostly observational films about an artist that shows both the joys and travails of the creative process is *Rivers and Tides: Andy Goldsworthy working with time* (2004), directed by Thomas Riedelsheimer. Although some of Goldsworthy's sculptures have been placed in museums, the artist usually creates three-dimensional sculptures in different outside environments using the natural elements of the site. These sculptures are subject to the forces of nature: the ice sculptures dissolve, the stone cones on the beach are taken by the tides, and so forth. Indeed, the best way to experience Goldsworthy's works are through successive photographs or time-lapse movies that record the aesthetics of his pieces as they undergo entropy.

Goldsworthy's methodology of construction is often difficult and frustrating. In the first sequence of the film we see him with a backpack trudging through a snow-filled wintry landscape to reach his selected site. In another sequence, his battered fingers are almost frozen while working with ice; he cannot wear gloves because the touch of the materials is very important in the fabrication of his sculpture. As he says in the film, he must literally "shake hands with the material."

At times, his work just collapses through gravity or wind conditions. In *Rivers and Tides* he tries to build a sculpture out of small rocks that continually fall apart. Although he argues that he learns more about the stones and the particular natural environment in each attempt, his frustration is evident. Indeed, Goldsworthy labors hard for the perfect aesthetic moment—when the ice sculpture becomes incandescent in the late afternoon, for instance. While *Rivers and Tides* celebrates the sculpture of Andy Goldsworthy, who has had both considerable critical and financial success, in the end, *Rivers and Tides* is not solely about Goldsworthy. While Goldsworthy does wield a subtle and self-effacing hand on the landscape touch, for me this film sends the message that if we really looked around us, we would not need the artist to show us what is beautiful in nature.

In fact, there are a number of films about artists that also draw the viewer away from the artist to aesthetic, political, social, and environmental concerns—although they are, along with *River and Tides*, inescapably promotional. An observational/participational/narrative film that combines promotion of the artist with a very powerful social cause is *Waste Land* (2010), directed by Lucy Walker. It tells an uplifting story about a Vik Muniz art project using pickers of garbage dumps north of Rio de Janeiro. Along with shots of the enormous trash heaps, which make the viewer feel that he or she is also in the trash, a compelling

narrative comes from the subjects themselves, including Muniz, his friends and associates, and the pickers.

Muniz has an international reputation in the art world for employing unusual materials in his work such as dirt, chocolate syrup, wire, peanut butter, etc. In *Waste Land*, Walker sets the context for this film by showing *Sugar Children*, an acclaimed series of photographs in which Muniz combined actual sugar with photographic portraits of the children of sugar plantation workers. As Muniz explains in *Waste Land*, when these children become adults and have to start working in the sugar cane fields, "the sweetness of life is lost."

This *Sugar Children* series fetched very high prices in the international art market. In *Waste Land*, however, Muniz decides to give the proceeds of his work to his subjects in the hope it will change their life. Muniz spends much time with the trash pickers in getting to know their stories, which are often quite tragic. Literally and figuratively, the pickers and the trash are at the end of the line; they are the outcasts of Brazilian society. For the most part, bad circumstances and choices have forced most pickers into this job. Notwithstanding the foul smell and the near impossibility of good hygiene, both on the trash side (euphemistically labeled *Gamacho Jardim*, or "garden") and in the surrounding slums where they live, these individuals conduct themselves with dignity. As one of the female pickers argues," It is more interesting and honest than prostitution."

Valter, one of the few pickers to have spent twenty-six years in his job by choice, is proud of his occupation. He says that by picking out recyclable material form the landfill, he is helping to provide space for trash and also to reduce pollution. He argues that even the recycling of one bottle can make a difference. His refrain "99 is not 100" has become the motto of the pickers, and also becomes a powerful suggestion to viewers of this film to recycle their garbage.

Another notable story comes from Tariol, a former picker who has been instrumental in setting up a pickers' association of thirty thousand members. Tariol claims he has become an intellectual by reading the books brought to him by pickers from the trash pile. Having seen a cast-off reproduction of Jacques-Louis David's famous painting, *The Death of Marat*, which shows Marat lying in his bathtub after his assassination, Tariol identifies with this French revolutionary thinker. Muniz subsequently creates a mock tableau of Tariol in a bathtub surrounded by trash. The photograph becomes one of Muniz's works that are auctioned and sold to benefit the pickers. Another tableau is a Madonna with two children, showing the picker Isis and her children. Muniz makes a photograph of this giant tableau with trash substituting for some of the features, such as flip-flops for the eyebrows, etc. Isis's fondest wish is to be able to raise her children but her poor circumstances make this impossible, so she has given them to her mother in another slum town. Her boyfriend, the father of the children, is a dope dealer who abandoned Iris and the children. With money from the proceeds of Muniz's photographs, Isis is able to leave her job, find a new boyfriend, and support her children so she can be a full-time mother.

Muniz has given framed copies of the photographs to his subjects that they proudly hang on their walls. In the film, the pickers maintain that they never envisioned themselves in a work of art, especially a work of art that has found its way into museums. "I don't see myself in the trash anymore" is a typical comment. As we see in *Waste Land*, in giving the pickers a role beyond their job, Muniz's photographs have given some of his subjects the strength to actively seek better circumstances. The project has also been important in transforming's Muniz's desire for money and success in the art world, a desire shaped by his own relatively poor and culturally deprived background in Brazil. Muniz exclaims in the movie that he has gone from "wanting everything . . . to having everything," and now "giving something back."

Edward Burtynsky is also interested in both aesthetics and social concerns. *Manufactured Landscapes* (2006), a film directed by Jennifer Baichwal about Burtynksy's artwork and the issues it raises, amplifies our understanding of the photographer by taking us to the actual site, showing Burtynsky at work, and recording his brief comments. There is no other narrative in this observational/participational film. In the opening sequence there is a slow pan of the interior of a gigantic Chinese factory that produces unidentifiable electrical parts. Burtynsky creates large-scale photographs of industrial sites and wastelands, so Baichwal's pan is an appropriate way of introducing Burtynsky's panoramic photographs.

Although Burtynsky does not mention it in his short narratives, the industrial sublime, as we see both in this factory and also in Burtynsky's photographs, has largely replaced the natural landscape as the new source of grandeur. Of course, this new industrial landscape does not have the spiritual metaphysics of sublime landscapes, but ironically Burtynsky's photographs and Baichwal's shots of the sites that are interspersed in the film are incredibly beautiful. They include construction projects (Rivers Gorge in China), stacks of brightly colored metal shipping containers, huge parks filled with newly unloaded cars, accumulations of discarded computer parts, vast barren landscapes denuded by mining for coal and precious metals, huge ships being stripped for scrap metal, and so forth.

For the most part, the viewer is left to make his or her own moral implications from these images, but Burtynsky does not refrain from observing the low wages and dangerous working conditions of the recyclers. As in *Waste Land*, the metal strippers of ships in Bangladesh and the Chinese families employed in the breakup of old computers and electronics represent the bottom of the social pyramid. To his credit, Burtynsky also confesses that by using film with silver, cadmium, and other precious metals, he is part of the problem. He admits there are no easy solutions given our reliance on the manufacturing and shipping industries.

Moreover, Muniz and Burtynsky are good at transforming trash sites and manufactured landscapes into objects of beauty for the delectation of upper-middle-class art buyers. Indeed, Muniz and Burtynsky become a salutary example of how the negative side effects of capitalism can be recouped by capitalist enterprise, even though this may not be the principal intention of these artists—and in the case of Muniz, this recapitulation partly benefits the pickers.

To be sure, there are a number of artists who resist being recouped and several documentary films that record their activities. *Exit Through the Gift Shop* (2010) by Banksy is

about himself and other street artists who wage semiotic guerilla warfare against the signs and signifiers of authority—a typical postmodernist strategy. These artists put stencils and installations in public places, using well-known images, objects, and slogans from media and advertising in ways that deconstruct their original meanings. Much of this work is erased or destroyed by the authorities, who essentially consider these artists to be criminals. In *Exit from the Gift Shop*, for instance, Banksy puts a life-size doll of a person in a black hood and orange clothes—a replica Guantanamo Bay prisoner—on a fence near a ride in California's Disneyland. The Disneyland authorities soon react strongly, shutting down the ride and arresting Banksy's accomplice, Thierry Guetta. Banksy himself manages to change clothes and escape arrest. Obviously, Banksy has created a sign that is at odds with the signs of Disneyland that signify an American paradise.

Exit from the Gift Shop is a very unusual documentary in the observational and participational modes. Banksy only appears in the film disguised in a dark hoodie with his face blackened out. Even his voice is run through a distorter. Bansky's aim here, which is thoroughly postmodern, is to decenter himself as a personality in order to encourage everyone to be an artist and question authority through their own means of semiotic guerrilla warfare.

Since Banksy is not a filmmaker, he enlists the support of Thierry Guetta, who shoots the footage of Banksy and other street artists in addition to accompanying them on their guerilla expeditions. Guetta provides assistance by looking out for the authorities and by providing supplies, ladders, transportation, etc. Actually, as *Exit from the Gift Shop* shows, Guetta is also not a filmmaker; he was initially the owner of a successful recycled clothes shop in Los Angeles who became obsessed with documenting the events around his life—"capturation," as he calls it. While a young boy, Guetta's mother died unexpectedly without leaving much of a photographic trace, and he does not want to miss out again on preserving his memories. Besides film shooting, Guetta also becomes interested in the work of these street artists as a way of adding excitement to his rather bourgeois existence. Given the ephemerality of their work, the street artists, in particular Banksy, understand that documents of their work and reaction to their work can contribute to the whole project so they enlist Guetta's active participation.

Yet, as Guetta himself admits, he is a fraud as a filmmaker. He neither looks at the film when he is finished shooting nor edits the footage. It just results in an enormous pile of tapes. At some point in *Exit to the Gift Shop*, Banksy wants a documentary film from Guetta but he can only supply Banksy with ninety minutes of disjointed footage edited from the original shoots. Banksy realizes that Guetta cannot make films and suggests that Guetta leave the original footage with him. As Banksy notes in a later interview, making the film was a very trying process: "The film was made by a very small team. It would have been even smaller if the editors didn't keep having mental breakdowns."[4]

4 See Shelley Leopold, "Banksy Revealed," *L. A. Weekly*, October 8, 2010, http://www.laweekly.com/2010-04-08/art-books/banksy-revealed/

To get rid of Guetta's participation in making the movie, Banksy suggests that Guetta become a street artist himself. As we see in the film, Guetta does exactly that, calling himself Mr. Brainwash. After a while, however, he decides he also wants to be a commercially viable artist. He gathers a team of graphic artists to help him make silkscreens of found images from famous paintings, advertising images, etc, which he puts together in unusual ways similar to his street art. Guetta then stages an exhibition in a dilapidated warehouse in Los Angeles that is modeled on a similar earlier Banksy show, *Barely Legal*, that was a great critical and financial success. Guetta gets quotes from a reluctant Banksy and other street artists to promote his work. Banksy's quote is itself quite ambivalent: "MR BRAINWASH IS A FORCE OF NATURE. HE IS A PHENOMENON AND I DON'T MEAN IT IN A GOOD WAY." Yet, these quotes, stenciled all over L.A. and picked up by the media, draw much attention to Guetta's upcoming exhibition. Thousands of curious people come to the show and Guetta makes millions of dollars from sales. Banksy is aghast, saying in the film that he will never again enlist someone to make a documentary about street art. In fact, the title *Exit from the Gift Shop* is an ironic comment on this event.

It should be pointed out, however, that much of Banksy's work as well as those of the other street artists in the film have ended up in commercial galleries, where they continue to sell for high prices. Here, the phenomenon of capitalist recuperation is once again evident.

Is this also true of Burning Man, where all the artwork, including a wooden image of the MAN—the symbol of capitalist authority—is destroyed, dismantled, or burned? This is the culmination of the yearly happening in the Black Rock Desert of Nevada, which has taken place every year since 1990. As Burning Man is essentially a postmodern phenomenon where the participants make their own significations, the directors of the four Burning Man documentaries I have seen eschew making an overall signification about the subject and rely on commentaries by the participants. Three of the four documentaries are more or less observational/participational films that combine weak story lines from the participants as well as their mostly amateur film footage. For me, *Spark: A Burning Man Story* is the one documentary that stands out. Here directors Jessie Deeter and Steve Brown are able to present good, multiple story lines of the 2012 event by tracing the lives of several participants before and after the event, and by going into the history and philosophy of the festival and its ongoing evolution by means of archival film footage and interviews. They also show the participants, art installations, and spectacles of 2012 to good advantage in the magnificent desert landscape.

At the beginning of *Spark* we see a line drawn on the desert at the start of Burning Man 2012. We hear one of the founders say, "On the other side of this line, everything will be different." Indeed, Burning Man was envisioned by Larry Harvey and the other founders as "a temporary autonomous zone"[5] where the capitalist money system is supplanted by gifting

5 These word were originally coined by Hakim Bey in his manifesto on the lifestyle anarchism of 1985, titled "TAZ: The Temporary Autonomous Zone, Ontological Anarchy, Poetic Terrorism."

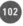

or barter, and the participants are encouraged to express themselves creatively through ritual, dance, music, and art in the absence of the usual societal inhibitions against nudity and forbidden substances. One of the original ideas of Burning Man is that everyone is expected to be a participant, not a spectator.

Although Burning man essentially began as a quasi-anarchist celebration among a small group of like-minded individuals—the first man, the symbol of capitalist authority, was burned on Baker Beach, California, in 1986 at the summer solstice—it has since turned into a huge production. A virtue of *Spark* is that the directors show how the original ideas of Burning Man have been, in part, compromised and the resulting consternation this has caused the founders. If you are going to have sixty thousand people gather in one place for a week, you need adequate facilities for a small city, albeit a temporary one. Subsequently there are now departments of public works, police, fire, as well as medical and psychiatric facilities. There also needs to be a full-time support staff for the overall organization that operates the entire year, including the logistics of dispensing tickets to satisfy the increasing demand for people who wish to attend. So many people wanted to attend Burning Man 2012 that the organizers had to establish a lottery and not even the old regulars were assured of a ticket, which now costs $400.

Moreover, for the well healed, there is Plug and Pay, which caters food and sets up living facilities. Not only has the ideal of self-sufficiency eroded—originally everyone had to being in their own supplies and dwellings—but Plug and Play has attracted more spectators who just want to enjoy the party. And the founders, who now have varying roles directing the event, also have a special camp for themselves at Burning Man 2012. After all these years of hard work, mishaps, and very difficult consensus building between themselves and the community, they have earned it. They look a little tired in the film and feel the need to justify themselves. Several founders argue that if they were going to include more people in Burning Man, one of their initial goals, it had to change, notwithstanding their displeasure at some of the results of this metamorphosis, including the need to be a responsible authority in the midst of many thousands of participants. At least some of the initial founders quit because they believed the initial ideals were too heavily compromised, particularly as Burning Man actually makes considerable money. We learn in the film, however, that after the 2012 event, Burning Man became a nonprofit organization.

For many of the participants of Burning Man, the event has also become a major production that takes the better part of a year. They construct artistic installations in their studios at home that they will dissemble and reassemble at the sites. A few artists have even received corporate funding for their projects. In *Spark* we see the trials and tribulations of Katy Boynton building a sculpture in her studio and then setting it up on the Black Rock Desert. We also see the enormous effort Otto Von Danger and his crew, who labored sixteen hours a day for weeks at Black Rock to construct a complex of buildings for Burn Wall Street. This was a veritable city of multiple buildings with names such as Goldman Sucks, Merrill Lynched, Bank UnAmerica, etc., which along with the Wooden Man, now a statue of about

seventy feet, is dramatically exploded and burned in the movie. The satisfaction of Boynton and Danger in bringing these difficult yet temporary projects to completion is shown on their faces in *Spark*, and this is a reason why we become interested in their stories.

Indeed, we see in *Spark* that for Von Danger, Boynton, and others, including Larry Harvey, Burning Man continues to be a transformative event; it has empowered them to change their lives. The Black Rock Burning Man has also inspired a number of satellite burning men on a smaller scale that perhaps retain more of the original idealism. *Spark*, however, is not concerned with the others for whom Burning Man is just an opportunity to suspend their normal routines in the computer and business world and then return to it with renewed vigor. The population of Burning Man has increasingly become insiders who play for a while at being outsiders.

There is a class of documentary films about artists, mostly self-taught, for whom art is mainly a means of therapy or escape. These artists remain on the margins of society, although galleries and museums of folk art may have recouped their work. They have also been recouped by the makers of films about outsiders who understand the American fascination with oddball characters from a distance, especially if they offer good stories of redemption.

With the collapse of the distinction between high, popular, and folk art in postmodernism, a corollary of the idea that all significations are more or less equal, the actual art of these outsiders is now being taken more seriously in the art world. The film *Marwencol* (2010), the debut feature film of director Jeff Malmberg, is about a brain-damaged veteran, Mark Hogancamp, who has assembled a one-sixth scale World War II village with dolls, buildings, and props in his backyard. The name Marwencol is an amalgam of the names Mark, Wendy, and Colleen that are important in Hogancamp's life, and are also present in the village along with other figures. By creating different scenarios with his model pieces, Hogancamp is able to bring back moments from his shattered memory, improve the steadiness of his hands, and recuperate from the psychological effects of his injury. Although must of the objects are bought in a hobby shop, *Marwencol* is a complex art installation with both dramatic and visual appeal.

The turning part in the film is when Hogancamp's therapy becomes art. White Columns, an important cutting-edge gallery in New York City, offers to stage an exhibition of photographs along with a small section of Hogancamp's model city. Malmberg shows Hogancamp's reluctance to leave his safe fantasy world and expose his innermost thoughts and fantasies in this highbrow art venue. Notwithstanding his social awkwardness at the opening, Hogancamp's exhibition is both a critical and popular success, and Hogancamp has shown the courage to take an enormous step forward in his recovery.

Also of considerable aesthetic merit is the fiber art of Judith Scott (1943–2005), who was born mute, nearly deaf, and suffering from Down syndrome. She was institutionalized for thirty-five years in Ohio before being released in 1985 to the care of her sister, who lived in California. In Oakland, Judith was able to attend Create Growth, an organization that supports the artistic expression of handicapped individuals. Here, with the help of visiting

fiber artist Sylvia Seventy, Scott's work blossomed. All this is recorded in Betsy Bayha's short documentary on Scott, *Outsider: The Life and Art of Judith Scott*, made in 2006 after the artist's death. While the story of Scott's rather difficult life story is quite moving, the most engaging parts of the film for me are the clips of Scott at work; she wraps different colored fibers around found objects, at times stolen from other members of Creative Growth. Scott's process is slow and repetitive, even obsessive, but this is not an unusual methodology for fiber artists. In the end, Scott's intricate infrastructures of fiber become unique abstract forms that offer positive comparisons with avant-garde modernist sculpture. Although Scott received popular and critical recognition for her sculptures while she was still alive and her works began to fetch high prices, her condition precluded substantial benefits from these successes.

On another front, Henry Darger (1892–1973) never received any acclaim for his work while he was alive; his magnum opus, a fifteen-thousand-page novel with more than three hundred illustrations, was discovered by his landlords following his death. Darger was a janitor who lived a very isolated existence in a single-room apartment in Chicago for forty-three years. When not working, Darger spent most of his time writing and illustrating this opus. It is difficult to summarize this complex, rambling epic, although the title alludes to some of its contents: "The Story of the Vivian Girls in What is Known as the Realms of the Unreal, of the Glandeco-Angelinian War Storm, Caused the Child Slave Rebellion." Suffice to say that Darger created a highly eccentric narrative in words and images, pitting the forces of evil (male figures and monsters) against children (pubescent girl hermaphrodites) interwoven with a bizarre and idiosyncratic cosmology and more traditional Catholic beliefs. Director Judith Yu provides a fascinating account of Darger's strange life with *In the Realms of the Unreal* (2004), using archival footage and interviews with his acquaintances, but the best parts of the film are the animations based on Darger's drawings. These are accompanied by voice-overs by actors, including Dakota Fanning, who play some of the principle protagonists of the epic.

The original sources of Darger's illustrations were taken from magazines, newspapers, and children's books. With the help of photographic enlargements, he sometimes traced these illustrations or cut them out and pasted them as collage elements in his images. From these sources he added his own intense color schemes and complex composition, fashioning a rich and diverse universe teeming with both recognizable and surreal landscapes and figures. In itself, Darger's visual world is a complete and remarkably inventive universe that continues to be admired by professional artists. In fact, the American Museum of Folk Art in 2008 put on an exhibition of Darger's illustrations along with the work of eleven artists who were influenced by him.

Just as there are significant outsider artists who do not follow the usual patterns for success in the art world, there are a few collectors who do not fit the normal profile for those who have major holdings of art works. Herbert Vogel (1922–2012) and Dorothy Vogel (born 1935), the subject of a 2008 documentary directed by Megumi Sasaki, created a superb collection of contemporary art with very limited funds. Herb was a postal employee and

Dorothy a librarian. After Dorothy paid the bills for their small rent-controlled apartment in New York City, they would spend Herb's salary on art. They attended art classes briefly after they married in 1960, but they dropped the practice of art for collecting, continuing instead to visit museums, galleries, and artist studios. There is a marvelous sequence in *Herb & Dorothy*, Sasaki's documentary, showing how Herb looks at a work of art for the first time: leaning forward intently in his chair and almost burning a hole in the piece with his gaze.

Often the artists the Vogels visited were beginning their careers and were very glad to deal with a couple who showed a lively interest in their work and were willing to buy at even modest prices. In one instance, as shown in the movie, Herb and Dorothy agree to take care of Christo's and Jeanne-Claude's cat for one of their collages. The works the Vogels bought also needed to be transportable by subway or taxi and had to fit into their apartment. Many of the artists from whom they purchased work eventually became well known and highly successful financially. Eventually, Herb and Dorothy could no longer afford the works but still maintained their friendships with these artists, as indicted in the movie.

In 1992, Herb and Dorothy donated their entire collection to the National Gallery in Washington and received a small annuity from the museum in return. At that time some of their works had become so valuable that they could have lived very comfortably for the rest of their lives by just selling one work.

It is instructive to compare *Herb and Dorothy* to Robert Hughes's last documentary film about art, *Mona Lisa's Smile* (2009), an expose about how big money has corrupted the art world. In *Mona Lisa's Smile* it becomes clear that most art collectors amass art for status and investment purposes, and do not make an effort to cultivate their taste. In addition to being a warm buddy film about a couple involved in the arts, one of growing category of films about couples and families in the art world, *Herb and Dorothy* provide an alternative story for a better and more authentic visual arts environment.

I think this is a good place to close this short narrative on documentary film about art, which has no closure as it is still an evolving medium; there are many more films that could be discussed, and many more significations by me and others to be made. Yet as the Chinese proverb tells us, an enormous journey begins with the first step.

MARK LEVY (PHD) has taught courses in modern European art, contemporary art and theory, Asian art, and shamanism and art at Kenyon College, University of Nevada at Reno, John F. Kennedy University, San Francisco Art Institute, and the Fromm Institute. For the last thirty-three years he has also taught at California State University, East Bay, where he is currently emeritus professor of art history. He was an art critic in the Bay Area for ten years and has published many reviews and articles on contemporary art in national and international publications. He is also a published poet and the author of two books, *Technicians of Ecstasy: Shamanism and the Modern Artist, and Void/ in Art*, about the significance of emptiness in Eastern and Western art. He is currently finishing a new book, *Tantra, Art and Anarchy*.

5 A CONTEMPORARY LOOK AT DOCUMENTARY FILMS AND THE PEOPLE WHO MAKE THEM

BY *JUDITH EHRLICH*

WHY I MAKE DOCUMENTARIES

I MAKE DOCUMENTARIES ABOUT people who have much more courage than I have.

These films choose me, and I just can't turn away. Through telling the stories of truly courageous individuals, I can continue to indulge my personal cowardice while observers say, "What a courageous thing you have done." Indeed, I am fully lacking in that quality. Don't ask me to film in a war zone, a refugee camp or in an Ebola clinic . . . too many guns and germs for me. At the airport, I'm the one who doesn't even have to take my shoes off, not the one held for hours for questioning. While I make films about people who are or have been considered enemies of the state, apparently I'm not a threat to national security, and I want to keep it that way. I want to sleep in my own bed, not in Russia, or in a powder room at the Ecuadorian Embassy as have a few famous whistle-blowers, or face long prison terms for their acts of conscience, similar to the characters I make films about. But I do hope I can tell a story that inspires others to be courageous, to provide models of game changers and truth-tellers, and to inspire new ones.

To my utter surprise and delight, it turns out I am in fact somewhat responsible for National Security Agency (NSA) whistle-blower Edward Snowden's act of conscience. Snowden, arguably the Daniel Ellsberg of the digital age, has on several occasions claimed publicly to Ellsberg that seeing our film, *The Most Dangerous Man in America, Daniel Ellsberg and the Pentagon Papers*, inspired him to leak the NSA secrets. His is the kind of audience engagement I've not had the audacity to imagine. I would never have anticipated that a film about the twentieth century's most famous whistle-blower could be the inspiration for the most significant public disclosure of classified documents in recent history. For me, this trumps all the accolades, awards,

successful grant proposals, limo rides, trips to far corners of the earth, and plaques, royalty checks, and standing ovations one sometimes reaps for a successful documentary.

In a much smaller way, a similar thing happened with my first Independent Television Service of the Corporation for Public TV (ITVS)-funded film as well. In *The Good War and Those Who Refused to Fight It*, Rick Tejada-Flores and I documented the stories of courageous pacifists who refused to fight in World War II, "The Good War." They were pastors and poets, Mennonites, artists, Quakers, and anarchists who were unwilling to kill other human beings, but were willing to pay the price for that unpopular stand during World War II. Some went to prison and others to camps for conscientious objectors. And after the war many of them were key to starting the anti-apartheid movement, the Pacifica Radio Network, the beat movement, the co-op movement—and a conscientious objector, Bayard Rustin, taught Martin Luther King Jr. about nonviolence. The prospect of inspiring others with their acts of courage and conscience motivated us to make the film. A woman named Liz Rivera Goldstein made us feel we had succeeded.

Goldstein wrote to us after seeing *The Good War* at the Port Townsend, Washington, Film Festival in 2001 and told us that these heroes of nonviolence had inspired her to dedicate her life to peace. She meant it. Since then she has worked with and led peace organizations in the Pacific Northwest and nationally, and now runs Peace Patch Farm, a peace education center in Port Townsend. Peace Patch Farm programs include an agricultural training program for veterans. I never expect to hear from the people who might be inspired to take action by the stories I tell. But her letter made that five-year process well worth it.

That's why I make documentaries—to telegraph to viewers the idea that those who go beyond the edge usually survive and often thrive, and that a revolution of our thoughts and minds is possible. I leave it up to the folks on the ground doing the hard work of activism and education to use the film to make real change and inspire students with the stories we tell.

When we were making *The Most Dangerous Man* it didn't cross my mind that the film had the potential to inspire a new generation of digital whistle-blowers. Our goal was much more modest. I hoped to keep Ellsberg's courageous act alive and to prevent that important history from being lost. When we began production, Daniel Ellsberg's release of the Pentagon Papers seemed a piece of deep history. There had been no public national security whistle-blowers for forty years. Ellsberg would jokingly ask the audience during the question and answer period, "Anyone got any secrets to share?" That got a hearty laugh because no one had done so since Ellsberg leaked the Papers in 1971. We didn't imagine that a new wave of much more effective national security whistle-blowing was about to emerge with the help of new technology and a new generation of "hacktivists."

But when we took the film on the road, we were surprised and delighted by the revered place Ellsberg held in the hearts of progressives at home and worldwide. His act of courage, releasing seven thousand pages of top-secret documents that exposed US government lies about the Vietnam War, still inspired audiences to demonstrate their love and respect through

ten-minute standing ovations. After screenings, young women asking for relationship advice would often surround Ellsberg's wife, Patricia.

I was so pleased to give Daniel and Patricia the opportunity to take those bows for their courageous service as truth-tellers. In the midst of our festival tour with the film, their story suddenly stopped being history and moved back to the front page. I remember sitting at the desk in my hotel room writing the keynote speech for the Sydney Film Festival when Daniel Ellsberg called to tell me about Private Bradley (now Chelsea after a sex change for which the government paid at taxpayers expense) Manning's arrest for a massive leak of classified documents to WikiLeaks.

Since then Daniel Ellsberg has been relaunched in a reinvigorated role as iconic whistle-blower and father confessor to a new generation of digital whistle-blowers. He often speaks to the press, supporting the people now being attacked for releasing secret information that the public has "the right to know." Ellsberg has visited Edward Snowden, who has taken refuge in Moscow, and Julian Assange, who has holed up in the Ecuadorian Embassy in London. When Assange was still free, Ellsberg took me along to London to meet him, encouraging us to cooperate on a film about WikiLeaks. That idea morphed into the film I am now making, *The Mouse that Roared*. It's the story of Birgitta Jónsdóttir, Icelandic member of Parliament, founder of Iceland's Pirate Party, and "hacktivist." Jónsdóttir was the coproducer, together with Assange, of WikiLeaks' infamous "Collateral Murder" video dramatically exposing brutal civilian casualities in Iraq.

Jónsdóttir's out-of-the-box Pirate Party barely squeaked into office two years ago but has since struck a chord in Iceland, emphasizing transparency, citizen participation, and Internet freedom. In the spring of 2015 they surprised even themselves by polling far ahead of the ruling party in Iceland. A lifelong poet and self-proclaimed geek, Birgitta is an unlikely politician. She calls herself a "poetician." This Buddhist, single mother of three, Internet pioneer, and founder of Iceland's Free Tibet movement was first elected in 2009 for her role in toppling the Icelandic government and jailing its "banksters." She founded the Pirate Party just months before three Pirates sailed into office in 2013. Our documentary follows Birgitta as she fearlessly pursues a dream of her tiny island nation as the New Media Haven where global whistle-blowers safely leak their information, journalists publish freely, and world citizens enjoy respite from surveillance.

So why do I make documentaries? I suffer from a daily deluge of bright ideas and a short attention span, so documentary film suits me. Given limitless resources and a full-time staff, I could launch a new documentary every month. But lacking both of those resources, as do many doc filmmakers, I limp along taking years to raise the funds and complete a film project. And on some level, perhaps the time spent deepens the story telling. If *The Mouse that Roared* had been finished in short order as I had hoped, I would have missed the surprising evolution of my character's story. When I make a documentary, I fully explore a subject, becoming a temporary expert on a particular moment in history and the individuals who reimagine our reality and shake up the world, as we know it. That takes time.

HOW I MAKE DOCUMENTARIES

The fully independent feature documentary film process is a long haul. These beasts require a lot of money, a lot of talented people, unrelenting fire in the belly for the story, and a bottomless pit of often ungrounded optimism. I don't have an organization or a regular staff. Others do, and perhaps their experience is very different than mine. I am lucky enough to have amazing interns from Berkeley City College, where I have taught History of Documentary Film for ten years; a partner in Australia who gives me daily feedback and support; and a faithful assistant producer (who has a well-paid day job but is always there to help when needed). I create pop-up organizations when the funding flows and bring in a team that numbers about twelve during the course of production.

I have been making long-form documentaries, sixty to ninety minutes, for broadcast, theatrical, and festival release for decades, and that form is what I know best and will use herein for the most part. I recently discovered new ways to work with products that are released online either first or fully, and it is liberating. I'm still in production on a long-form documentary, but I recently produced a twelve-minute documentary, which was broadcast on Democracy Now and posted on the front page of HuffPost on day one and widely disseminated online in the days following. The entire process from start to finish was about two months, with a small team of four and a very modest budget. I'll come back to that, but let me first share my process of producing and directing the long-form documentary.

THE BIRTH OF A FILM

A film has a life, and it starts as an idea. When such an electrifying idea hits me, I first try to swat it away. I have way too many ideas! I'm afraid to pick up the morning paper, or read the blogs because there is inevitably a story that would make a great documentary—and making a long-form documentary the way I do can take years. So I swat away 99 percent of those good ideas. What are left are the stories that just won't go away—the ones that leap out and send an electrical shock through my system, that resist all attempts at suppression or repulsion, that demand to be made.

While a feature-length film such as *The Most Dangerous Man* has more grandiose goals, both intellectually and practically, there are always surprises. The first surprise: it can actually make a profit if all the pieces fall into place. In the case of *The Most Dangerous Man in America*, my film partner, Rick Goldsmith, and I raised a million dollars and built a pop-up organization—with broadcast, a life in DVD, and educational distribution as the goals. What a thrill that it did much more. The film was nominated for an Oscar and Emmy, won the Peabody Award and nearly twenty international festival awards, was broadcast on dozens of public TV networks worldwide, and made a half-million dollars at the box office. Most of my examples that follow are based on the production and distribution of that film.

THE JOB(S) OF FILMMAKING

One detail that might find most aspiring filmmakers unprepared is the fact that a documentary maker actually changes his or her career several times over the course of producing/directing a film. Flexibility is paramount. As a totally independent filmmaker, the bad news is that the vast majority of my time is spent fundraising. The good news is that the fundraising process is also a way to focus and improve the filmmaking. Every proposal offers new opportunities to rethink the message of the film, to reconceive the most dramatic and compelling way to tell the story, and to reconsider the budget, build the project team and it also helps define the audience and how to best reach them.

Off the top of my head, here is an initial list of the job responsibilities of an independent filmmaker:

Director/producer

Writer/creator/storyteller

Fundraiser (including foundation research, proposal writing to public and private entities, pitching at public forums and one-to-one to private individuals, soliciting investment, organizing crowd-funding (such as Kickstarter/Indiegogo) campaigns, fundraising parties, and private screenings for potential funders

Researcher (including archival material, picture, audio, and film)

Supervisor of a complex database needed to track thousands of archival entries.

Director of documentary crew/interviewer (the job everyone thinks you do most of the time—but that you actually do less than 10 percent of the time—if you're lucky)

Supervisor of still photographer on the set, when you can afford it. I often do that myself.

Employer and supervisor of editor(s) and assistant editor(s)

Employer and supervisor of composer, animator, graphic designer

Director of recreations (i.e., actors, sets, props, larger crew)

Supervisor of rights clearances (including fair use for archival footage) and legal agreements

Manage preproduction, production, and postproduction budget

And then one day the film is completed (or at least you abandon the pursuit of perfection because you are out of time and money). Your job changes overnight from film producer/director to film distributor—often with very little experience or support.

Then begins the need for an entirely new set of job skills that include:

Fundraiser for distribution, audience engagement

Contract negotiator for international sales, television broadcasts, theatrical release, DVD and VOD releases

Educational distributor. In the case of *The Most Dangerous Man in America*, educational distribution is self-distribution through New Day Films cooperative. If you enjoy the ongoing work of distribution, you'll make a larger percentage of

the income by doing it yourself, but it's a big job. *The Good War and Those Who Refused to Fight It* has had a very good run with Bullfrog Films as educational distributor. Finding the right distributor for your film is an important research task. Ask others who have similar films for their recommendations.

Audience engagement supervisor working with professionals in that field, volunteers, and interns

Collaborator with press and public relations professionals. If your film gets on the radar be prepared to appear on TV, radio, in newspapers, on public panels, and during extensive question and answer periods at theatrical, semi-theatrical public screenings, and at film festival screenings.

Supervisor of interactive website design, including writing and development of concepts with webmasters

Cowriter/editor of educators guide for the film

Of course, the relative proportion of these tasks varies depending on the film itself and how one chooses to tell it. An observational film requires much less research and much more shooting than a historical film based on archives. An experimental documentary has very different requirements than an environmental or nature-based program even though these all fall under the same broad category of documentary.

Some films require a good deal of emphasis on music, while others use none. Sound effects and sound design can play an important role or none at all. Reenactments are expensive and sometimes risky, but also can be invaluable to tell a story that no one was there to document. They often call for animation.

For some films, access is an initial issue of major proportions. This was the case with the Ellsberg film. Daniel and Patricia Ellsberg live within miles of me. We have mutual friends who introduced me to Ellsberg when I was starting research for *The Good War and Those Who Refused to Fight*. My buddy claimed Ellsberg knew more about the history of WWII than almost anyone. It was no exaggeration. I met him at the neighborhood café where he has breakfast most mornings and started in on the subject of WWII and pacifism. Luckily I had brought multiple legal pads. I completely filled two with notes as we sat through breakfast, through lunch, and without a break until 3 p.m. I was awestruck by his command of the subject and enthusiasm for sharing information. The idea of making a film about him was planted that day, but I had another film to make first.

A few years after finishing *The Good War*, Ellsberg's book, *Secrets*, came out and I read it. The idea of a documentary on the Pentagon Papers now seemed a complete no-brainer. He had done the research and written the bones of the story and what a dramatic story it was, complete with the main character and his wife of forty years right there in my neighborhood. I wrote a treatment and set about to research, and it turned out that Rick Goldsmith, a fellow member of the filmmaker community at the Saul Zaentz Media Center offices, was very enthusiastic about joining me. But there was an immediate obstacle. There were several other filmmakers with the same good idea. And they were a heavy-hitting group. At one time our

competition included Errol Morris, who backed out, luckily. I'm sure Ellsberg would have made him first choice after the stellar job he had done on Robert McNamara in *The Fog of War*. I would have, if I'd been Ellsberg. But yet another talented doc maker and Academy Award winner was still in the running. My partner had included Ellsberg in the Academy Award-nominated film he had made years earlier and that was a plus. In the end I believe Patricia Ellsberg tipped the balance. I believe she felt I would be a sympathetic teller of their story and knew I was committed to telling this as a love story, as well as a story of political intrigue. Patricia, a practicing Buddhist, and Dan, having been arrested for acts of nonviolent direct action dozens of times, had great enthusiasm for the films on pacifism I had made. My friends and colleagues who were close to Patricia Ellsberg vouched for my sincerity, and I think this put us on top of the heap of filmmakers vying for his hand. We bought the rights to *Secrets*. Goldsmith and I were ready to begin. From day one Daniel and Patricia were the subjects made in heaven. They always made themselves available whenever possible and never made demands or asked to see cuts. Once they were on board they totally trusted the process and us.

When we finally had a fine cut, I took it to the Ellsbergs to get their feedback. I remember the day well. We sat downstairs in their tenant's little flat, since the Ellsbergs didn't have a TV and the tenants did. Patricia took my hand and squeezed it almost nonstop and whispering in my ear, "It's a masterpiece, it's a masterpiece." Daniel Ellsberg took many pages of single-spaced notes. I was terrified to read them, but they turned out to be invaluable insights into the events we documented and his perspective on them. What a gift to have Ellsberg as our brilliant collaborator on the story of his life. His near-photographic memory for dates, characters, and events made the process so much simpler.

The same held true in recording the voice-over. Following a lengthy debate on the voice of the film, Ellsberg and I locked ourselves into a small recording booth at KPFA Pacifica Radio in downtown Berkeley with a lengthy narration script. Many hours later we emerged with a pitch-perfect and thoroughly fact-checked narration rewritten and read by the man who had lived the story. I believe it is the backbone of the film and lends it deep authenticity.

Like most, if not all, long-form documentaries, the film emerged from a very long process of chipping away at complex and intersecting storylines. We interviewed dozens of players on the phone and filmed more than thirty-five interviews, many more than we had anticipated. Still, one dramatic element seemed missing: Where was the Watergate scandal in the story? If only this had something to do with Watergate! And then we interviewed John Dean, a key figure both in the Nixon administration and also in that legendary affair.

It was a hot day in Beverly Hills in a home filled with priceless art, including a dozen jaw-dropping Matisse cutouts on the dining room walls. The scourge of nonstop lawnmowers tried the soundman's skill. It had taken a lot of persuading to gain Dean's cooperation. The events of Watergate had sent him to prison and it was painful to recall his memories, but he opened a window on the significance of an event prior to Watergate. He confirmed what we had only dared to surmise, that in his opinion the break-in to the office of Dr. Lewis Fielding,

Ellsberg's psychiatrist, and the cover-up of that, rather than the Watergate break-in, was actually the pivotal element that brought down President Nixon, ultimately leading to the lone presidential resignation in history. That perspective was far from common knowledge. It made our story even more significant.

There was another day that will remain tattooed on my frontal lobe. It was our encounter with Egil Krogh, the head of Nixon's notorious White House "Plumbers" unit and the man who authorized the break-in to Dr. Fielding's office. Krogh confessed and was imprisoned for his participation in the cover-up. I found it ironic that Krogh is currently senior fellow on Ethics and Leadership at the Center for the Study of the Presidency and Congress, but a more straightforward, honest fellow you wouldn't hope to meet. He was certainly not the evildoer I had expected to encounter that day.

Krogh pulled up to the house in Tacoma, Washington, where we were conducting local interviews. He and Ellsberg warmly embraced. Turns out they had already found common ground. Krogh immediately complained of a leak in his car that was worrying him on the trip from Seattle. Without taking a beat, the two ex-president's men, the world's most famous leaker and his former nemesis, crawled under the car to inspect the "leak." We fell into gales of uncontrollable laughter at the absurd synchronicity of it all.

A similar moment occurred in Ellsberg's basement, a huge cavern of file cabinets chockablock with his writing, documents, and photos. In pursuit of some obscure piece of documentation, I was wandering through this treasure trove when I spotted a cabinet simply labeled "PLUMBERS." Curiosity overcame us but the filing cabinet was jammed. A quick trip to the car; the tire jack was applied to the problem and we broke into Daniel Ellsberg's Plumbers file in an impetuous act of historical reenactment. Sadly, the contents were not as dazzling as we had hoped. To my amazement, Dr. Fielding's actual file cabinet, the one that was broken into, is on display at the Smithsonian American History Museum.

While we conducted a large number of interviews, I was surprised that most of them made it into the final cut. It would take much too long to map the development of the story and how it emerged over more than a year of editing—from the clay of a "civics lesson," as our ITVS partner described the cut we presented the day before Christmas, to a dramatic film noir treatment of this four-decade-old political thriller. For months there remained the question: Would it be the story of the "Pentagon Papers" or a biopic of Ellsberg? We began our quest aimed at the former and ended up making the more personal story, albeit with many voices contributing to the telling of this history. The story was woven over years through a maturing understanding of the times and events that shaped Ellsberg, his actions and inner life, as well as the president's and nation's reactions.

To quote George Lucas, *"A movie is never finished, only abandoned."* Many mishaps and revelations later, the film was finished, or at least ready to screen on 35 mm at New York's legendary home to documentary film, The Film Forum. Bless the incomparable Karen Cooper—her enthusiasm for the film seen in early rough cut launched our success. And then Thom Powers, Toronto Film Festival documentary programing director, gave us our

major festival premiere. The Forum at IDFA (International Documentary Film Festival of Amsterdam) was a major turning point for the film. Film pitching at one of a number of marketplaces can be an important element of funding, promoting, and finding broadcast and distribution partners internationally for a documentary. IDFA's international cofinancing and coproduction market is Europe's most important breeding ground for new documentary projects.

The IDFA Forum is a terrifying experience for a filmmaker, or it was for me. You have seven minutes to present your film. First you show a three-minute clip, have three minutes to pitch and a minute for your sponsors to speak on behalf of your project. In our case, Jan Rofekamp of Films Transit, our international sales agent, and Claire Aguilar of ITVS stood up with us. The room is packed with bleachers of observers and dozens of commissioning editors from around the globe. These are the tastemakers of the world TV marketplace. Most intimidating of all is Nick Fraser of BBC's *Storyville*, an intellectual, writer, and creator of one of the most intelligent series on the box; he can dismantle a filmmaker in one fell swoop. The team who preceded us got a taste of his particularly terrifying disdain for bad films. I think he said something similar to "Why are you here? This is not a film." And then we were on. We talked, we played our painstakingly produced three-minute clip, Jan and Claire did their thing, and what followed was a very, very, very, long moment of silence broken by the Greek commissioning editor standing up and very loudly proclaiming, "All I can say is WOW!!" In the meetings that followed, we were able to secure much of the funding we needed to finish the film. A year later we came back to IDFA to screen the film and won the Grand Jury Prize.

Such festivals and marketplaces are an opportunity to meet and learn from other filmmakers and industry leaders. I've been to IDFA four times to attend their ten days of ten theaters running outstanding docs from noon to midnight. The festival hosts daily panels, discussions, and workshops as well as the Forum pitching sessions. Each evening ends with a chance to hang out with the world's best documentary makers. IDFA is my personal mecca for keeping up with developments in documentary style and innovation, for screening the best of the genre, for professional development, and for global networking. I've also thoroughly enjoyed and learned much at the Sheffield Doc/Fest, the UK's top pitching venue, and Independent Film Week in New York City. I understand Hot Docs in Toronto is great but I've never made the cut. These opportunities to grovel publicly for funding and broadcast are highly competitive as well as very expensive for competitors. But they are a major opportunity to realize the international recognition needed to get a film to its audience.

Documentary film takes in a large piece of real estate intellectually, spiritually, and politically. As traditional journalists become an endangered species, documentaries are stepping in to fill the gaps that print and TV news journalism once monopolized. As delivery of information and analysis moves from the printed page to the home page there is an expanding place for short-form documentaries to be part of online daily news. *The New York Times'* Op-Docs are probably the prime example, but *The Guardian, Washington Post,* and HuffPost are among many outlets building that genre. I recently produced a twelve-minute documentary for

Exposefacts.org that premiered as a broadcast on *Democracy Now* and *HuffPost*, and it was widely disseminated on the Internet through news and activist platforms in the days that followed.

In my opinion, the blurring of these lines doesn't necessarily make documentary makers into journalists. I hear documentary makers call themselves artists or journalists and I've been labeled both. I don't believe I fit neatly into either category, although I can be persuaded to fit into either on occasion. I see myself more as an educator with very large classes, or as a historian with limited academic credentials. I feel deeply honored to be the only documentary maker to win both the Erik Barnouw Award from the Organization of American Historians and also the John E. O'Connor Film Award from the American Historical Association (2001, 2002, 2010, and 2011) for outstanding history film.

When it comes to audience engagement, as a former teacher of school-age youth, I keep students and teachers in my mind as I make films. They are the audience I imaging watching the film as I make it. But I'm thrilled if my films function as a helpmate for activists, creating fodder to be used by those doing the hard work on the ground and in cyberspace, organizing citizens to participate in decision making, and to care about issues. I'm also satisfied to entertain people as well as educate. That's why I focus on personal stories—intimate histories of love and family and the interior lives of my characters rather than facts and figures. It's keeps people engaged in the love story while I hope we are delivering a one-two punch about the misuse of power, militarization, and injustice.

While documentary definitely has a market in education, it is not strictly educational; it is an art form that draws from a vast visual, aural, and storytelling toolbox, and if it is effective it reaches the heart, not just the mind. But so does a good educator. Humans don't learn from stacking up facts. Humans learn when they take a perspective, a thought, and most important an emotion into their hearts. When I show my students *The Most Dangerous Man in America*, there is usually a warm and excited response, but hey it's Berkeley. My students seem to feel empowered to speak their minds. One young man promptly dove into the lively conversation, saying, "Yeah, it was really cool. I don't care about politics, but every time I started to fall asleep, there was that love story! That kept me tuned in and finally I understood what the dude had done. Wow!"

I understand there are documentary filmmakers who make films for the market, with the goal of producing what sells and what is fundable, and I hear they actually make a good living at the enterprise. I truly wish I had a bit more of that gene. I'm afraid it's too late to apprentice myself to one of those documentary filmmakers, or I would consider it. My credit cards probably wouldn't be maxed out if I went about this in a more realistic way, so please don't follow my example. But by the time I finish fundraising, producing, directing, and distributing the moth-to-the-light films, there isn't time to make those other films—the ones that would be easily funded and make money.

I make films when something important is staring me in the face and I have some privileged access; it seems it's my responsibility to make that film and I fear that no one else will

bother to make something so wildly noncommercial. Actually I probably wouldn't choose to make documentaries if I didn't have a passion for the subject. I might go back to radio production or kindergarten teaching.

Producing a long-form documentary takes many hands and hearts and copious amount of cash. I had dinner with a friend recently who is an artist; her work is mainly pencil or ink drawings of in-your-face political and absurdist subjects. At one point in the evening, we compared the tools needed to do our work. She needs a pencil and some paper. Total cost: about ten bucks. I, on the other hand, need a small squad of skilled collaborators and a million dollars. She can put out an impressive product in a few hours. My filmmaking process can take five years—now plug your ears, hopefuls. Much of that time is unpaid.

Ben Tsiang, founder of CNEX, and I copresented at AIDC (Australian International Documentary Conference) in Adelaide a couple years ago. Tsiang created CNEX, a remarkable organization committed to producing ten independent Chinese documentary films a year for ten years by investing his own money in the enterprise. Tsiang had been a very successful entrepreneur and dot-com start-up star in an earlier life. He began his remarks by saying, "People ask me how to become a millionaire making documentary films. It's easy, I answer: start out as a billionaire." So without a trust fund or expense account, the kind of art that requires a paper and pencil is probably what I should be pursuing, but nooo, I had to stumble upon this line of work, and I'm hooked. No part of me wants to pull the ladder up behind me, but I do want to share some reality of this profession as I've experienced it.

The bad news: the model for truly independent documentary filmmakers of serious long-form documentary in the United States does not easily monetize. The good news: there are other models. You can become skilled at film shooting or audio recording, archival research, or editing and primarily make your living at those jobs. If you are willing to primarily do commercial work, such as advertising or corporate storytelling, or making films for nonprofits with healthy budgets, you can certainly make a living at this. I know folks who are computer engineers and make a nice living, work their own hours, and make docs on the side. Of course, teaching is the most common job for a filmmaker, and that's a great gig if you are a talented teacher and lucky enough to land one of the very few tenured or faculty positions in the field. At the community college where I've taught for many years there is one tenure track teacher in the multimedia department of more than thirty talented and highly skilled teachers. I noticed the other day that community college adjunct instructors are being organized along with McDonald's workers. They are among the lowest-paid workers in the United States. I teach because I love it and I get great interns. But it's not a viable economic alternative.

Another approach is to build a niche market for your work with a well-heeled clientele. Are you a lawyer with a desire to make films? Make films about lawyers. Perhaps you're a doctor interested in medical subjects or an engineer interested in documenting innovations in your field of general interest. Or then again you can just keep your well-paid job, or be nice to your spouse or partner who has one, and make docs as a hobby. Of course there are a few filmmakers who have figured out how to make it all work as full-time director/producers.

They tend to be great salespeople with a strong business sense. When you meet one of them, ask them how they do it. Don't ask me.

According to film distribution guru Peter Broderick, some documentary makers make a killing. He gives inspiring workshops about the possibilities for successfully releasing a film theatrically and selling millions of dollars' worth of DVDs and downloads of documentaries. On the whole, these projects are self-help or related to diet, health, food, hobby, animal, children, or sports. Peter was extremely helpful in advising us in making deals for the Ellsberg film and we did end up making a nice profit, but certainly not on that impressive scale. If you're interested in learning more about Broderick's self-distribution model, you might want to subscribe to his occasional and informative online newsletter.

I've been clearing out my files over the past few months, as I moved my office after eight years, and in the process I threw out a few projects that had succumbed to political obstacles, bad timing, less than red hot inspiration, insufficient interest from the target audience, but mostly to lack of money. These doomed film projects filled drawer after drawer of my files and never took a breath. What went wrong there? What made Studs Terkel, Mr. Rogers (TV personality), *Una Storia Segreta* (the story of Italian American internment during WWII) stumble and fall while the Ellsberg film and WWII conscientious objector film survived gestation and burst onto the PBS small screen fully formed and went on to theatrical release and a shelf of trophies? They were all good ideas. There's been a lot of talk recently about the value of failure, and I do subscribe to the value of an occasional flop on the path to success. I have learned to move on productively after such a fall from grace and not dwell on all the rejections that are inevitable along the way. A thick skin is invaluable in this business.

I just spent three days with a gaggle of brilliant women at a Chicken and Egg Pictures workshop. Their motto tells it all. "Chicken & Egg Pictures supports women non-fiction filmmakers whose artful and innovative storytelling catalyzes social change." Cofounder Julie Parker Benello hosted an editing workshop with the incomparable Vivien Hillgrove as mentor. Cofounder Judith Helfand reminded us several times of her mantra: "Your problem is my problem, I just haven't had it yet." Each film shown was a masterwork and deserved to be made. These women shared the struggle it has been for each of us to put together the chaotic patchwork of funds and organizations, private donors, and government agencies, foundations, and corporations, public television here and abroad, producers and investors, NGOs and journalists. This is not a business for those who are not driven by a passion to tell stories that matter. It is just too damn hard unless you are independently wealthy. And even then you still have to make a great film; you just avoid spending a few extra years being a fundraiser.

I've been spending a lot of time in Australia over the past five years and long been aware of the situation for documentary filmmakers in Europe and Canada. Australian public funding supports independent film production, documentary and narrative, including some personal and experimental film. Those filmmakers complain about cutbacks, but if you have a decent idea and a track record of delivering films in Australia and tick all the boxes you may be eligible

for 40 percent of the Australian spending in your budget as a tax rebate on your feature doco (as they call them). There is also substantial funding available from Screen Australia and the individual states: Screen Queensland, Victoria, and New South Wales, etc. An even more generous tax rebate is available for Quebec film and television production. In that Canadian province the rate was increased to 45 percent for single documentaries in 2010. At a recent women's film funding event in Los Angeles, making films in Australia to cash in on the tax advantages was a subject of recurring interest.

Elsewhere in the world—where there is less spent on weapons of mass destruction and more on a commitment to health care, education, child care, and equity—the arts also receives a nice piece of the pie and serious documentary film is part of that slice. The possibilities for broadcasting thoughtful documentary in the United States and worldwide are certainly the victim of fast, cheap, and dirty reality TV. Most of my students walk into my Documentary Traditions class at Berkeley City College with knowledge of documentary that runs the gamut from penguins to *Amish Mafia*. And why should they understand the roots of documentary filmmaking, the masterworks of Robert Flaherty and the Mayles brothers, Frederick Wiseman, Barbara Koppel, and Werner Herzog? One has to seek out serious documentary, but thanks to the Internet and particularly platforms such as Fandom, which curate a great documentary collection, this is becoming easier. Television's documentary fare is primarily limited to the degraded world of reality TV.

The History Channel, a subsidiary of A&E, no longer broadcasts history—its slate of programs runs the gamut from *God, Guns and Automobiles* to *Cajun Pawn Stars* to *Appalachian Outlaws* and a few war series, as well as such religious fare as *Revelation: The End of Days*. Discovery Channel, the number one pay TV programmer in the world, which once broadcast Herzog films, now limits its offerings to such series as *Billy Bob's Gags to Riches*, *Naked and Afraid*, and *Moonshiners*—all aimed at the thirty-five-year-old beer-drinking male demographic that rules television programming on the appointment viewing dial. There is a staggering array of choices, but it's like living in a place with only fast-food joints and no decent restaurants.

At the moment, the only slots for broadcasting serious documentary films on US television are HBO, Sundance, IFP channels, and PBS, and even that has recently come under siege. But documentary filmmakers are organizing and fighting back. The week before Christmas 2014, the New York City PBS flagship station, WNET, suddenly announced Independent Lens (IL) and POV would be moved to a minor PBS cable channel. IL and POV are the most important US broadcast outlets for independent documentary. Overnight, it seemed doc makers nationwide had spontaneously germinated a new organization, the Indie Caucus. The caucus organized large public meetings with PBS leaders across the country to hear the stories of filmmakers, educators, and community members who value the films we make. They won a postponement of the altered broadcast schedule. It was a reminder that making documentaries isn't just a profession or a pastime, it's a movement. Its member filmmakers make a commitment to truth-telling. They care enough about their stories to sacrifice stability

for the bliss and agony of making docs, and they know how to organize when needed. But that chapter isn't closed.

DOCUMENTARY FILMMAKING ON THE DIGITAL PLATFORM

In 1990 I leased an AVID editing system with a couple of partners—I believe we paid $64,000 for thirty-six gigs of digital storage. The drives daisy-chained and stacked up were about as high as my desk. A thirty-six-gig flash drive now costs fourteen dollars and easily fits in a small pocket. The landscape of making documentary films in 2015 has been completely transformed as the technology of production has become available to everyone with an iPhone and a laptop. But not everyone with a paintbrush is the new Picasso. We truly live in a land of documentary plenty when it comes to quantity but finding quality is perhaps even more of a challenge.

I used to think about documentary length as a choice between one hour versus ninety minutes. I'm always in favor of "the shorter, the better," especially if you hope to bring your story to classrooms. Many teachers don't have hours to spend with their students. Sometimes, however, the story is just too complex to compress into an hour. The Ellsberg story really felt to us that it needed to be ninety minutes long, and our broadcasters generously made no demands to cut one second of it. POV added a conversation on the topic at the *New York Times* auditorium to fill out a two-hour broadcast slot. I think only one country of nearly twenty that aired the film made a shorter version for their audience. It used to be necessary to make both a broadcast hour version, which differs in length by network and by nation, as well as a feature-length version appropriate for theatrical release and festival screenings. ITVS at one time only funded one-hour TV programs, but that's not true anymore.

The Internet platform has changed all that. No more "appointment viewing" with advertising or pseudo-advertising framing the content The advertising is either eliminated by subscription fees or built in at intervals. It can be downloaded or streamed and who knows what's next? The forms, formats, and delivery modes are in complete transition. The end of the DVD is here or nearly so, as the possibility of watching on a wristwatch, a phone, an iPad, et al. are making us rethink the images we create to fit the box in which they are viewed. The long form is still an option, but so is the VERY short form, and the TV hour or half-hour. Documentaries with homes on the Internet offer new and exciting opportunities for length, interactivity, and sharing. I have never been a techie, and certainly I'm no expert on new technology but I've been learning from "hacktivists" and Silicon Valley types, and I keep up as much as my brain will stretch because of my current production on global digital free speech. While I still hang on to the power of the well-told feature-length story, I'm really thrilled by the possibilities of this new landscape.

I am building films differently now than I did a few years ago. I have a film in production at the moment, titled *The Boys Who Said NO!,* which I'm making with a wonderful committee (not an oxymoron in this case) of former Vietnam era war resisters. We launched a website

as soon as production began and clips of the film have been released on a regular basis. We built audience, raised consciousness, raised money, and began to engage the audience from day one and will continue until after the film is in the marketplace. We also began to build an assembly of the film from the clips, roughly structuring the film from these scenes, which point to ideas, images, moments, and characters that elucidate our story.

The construction process is being built from completed but not perfected scenes instead of "staying ugly longer," as master editor Vivien Hillgrove would say. So rather than the film emerging publicly—like Athena from the head of Zeus—in its fully evolved adulthood, it grows with the affection and participation of the audience who care about the issue, giving feedback and support along the way. *The Boys Who Said NO!* has coaxed nonviolent activists and Facebook friends into the filmmaking process. These early adopters feel ownership for the film as it evolves and share the story with others.

This method also allows for fundraising in small doses, which is appropriate with an issue that draws committed adherents to the principles of civil disobedience and nonviolence. These folks give again and again with each clip. And because legendary folk singer and war resister Joan Baez is at the center of the story, our clips are posted on her website and available to her hundreds of thousands of devotees, many of whom have become part of our cyber-family. The funds are modest but enough to stay in production and make continual progress as we seek foundation and broadcast support.

This same group makes up the core audience for a series of fundraising parties, and will become our initial supporters when we launch a crowd-funding campaign. We can count on them to buy the film—hopefully in multiples when it's released, spreading the word through their networks. Draft resistance is a subject with a relatively small group of adherents, but scale up from pacifists to pet lovers and you get the picture. You can build a substantial audience if you find a niche to produce for, and the more people populating that niche, the better.

Building the final film from web-friendly scenes, released in advance, will also streamline our educational materials, allowing for finished programs whose lengths are tailored optimally for the classroom as we continue to grow the broadcast and festival versions. Please check out www.theboyswhosaidno.com to see how we are creating the pieces of this historical film.

Over the past few months I've yet again had to rethink my approach to filmmaking. I just directed a short film that takes an entirely different approach than the long-form documentaries I've been producing and have been directing for decades. Journalist/activist Norman Solomon of ExposeFacts.org and the Institute for Public Accuracy invited me to direct a short film on a whistle-blower whose case he had followed closely. We cut a twelve-minute piece titled *The Invisible Man: CIA Whistleblower Jeffrey Sterling*. The short documentary was released the day after Sterling was sentenced to three and a half years in prison for sharing details of a bungled classified CIA operation with *New York Times* reporter James Risen. Sterling denies he is Risen's source. Our short documentary is not so much a piece of journalism as a portrait of a whistle-blower and his wife caught in the crosshairs of the US system of secrecy and that has not previously been told in public.

Democracy Now and the HuffPost had exclusive rights for a day and then the clip was promoted globally. Our plan is to build audience with this short piece through major outlets and produce a more in-depth documentary on this dramatic story of an African American, former CIA officer accused of leaking a secret CIA operation to Risen. The project was produced in just over two months, from start to finish, for a very modest budget, and as I write this today Norman Solomon is sending me more and more online postings of the film and his writings on the subject. It's a new distribution model that I'm just beginning to understand, but what potential to deliver important stories to the public at a lower cost!

The old models remain alongside the new ways of working. It is a wonderful time to begin making documentaries. The only absolute necessities are a good story and a passion for the subject. Get out your iPhone and make a film so we can watch it on our watches. If you have a great story it will find an audience and who knows where that might lead? The Oscars? Another day after a few drinks I might share that story of the worst day of my life.

JUDITH EHRLICH coproduced and codirected the 2009 Academy Award-nominated film, *The Most Dangerous Man in America, Daniel Ellsberg and the Pentagon Papers*. It won the George Foster Peabody Award and thirteen international festival awards, including the Special Jury Award at the IDFA (International Documentary Festival Amsterdam) and Docaviv (Tel Aviv); Best Documentary at the It's All True Film Festival (Sao Paulo); audience awards at the Sydney International, Traverse City, Mill Valley, and Mendocino film festivals; Best of Fest at the San Luis Obispo Film Festival; and the Freedom of Expression Award by the National Board of Review. *The Most Dangerous Man* has been chosen to represent the United States at INPUT in Seoul, and as part of the State Department's Documentary Showcase. It won all major history film awards: the John O'Connor, Eric Barnouw, and History Makers awards. *The Most Dangerous Man* premiered at the Toronto International Film Festival and had a very successful theatrical run with First Run Features, making a half-million dollars at the box office and opening in more than one hundred cities. The full ninety-three-minute film was broadcast in October 2010 on PBS as part of the POV series, and was rebroadcast in June 2011 to celebrate the fortieth anniversary of the Pentagon Papers. It was supported by ITVS and ZDF/Arte and has been sold to fourteen international TV networks.

Ehrlich coproduced and directed the ITVS documentary *The Good War and Those Who Refused to Fight It*, a story of men guided by principle to take the unpopular position of pacifism during World War II. This revealing look at questions of war, conscience, and the spiritual life of committed individuals was broadcast nationally on PBS in 2002 and rebroadcast in 2007. In 2003, *The Good War* won both major US history film awards and was selected for participation in more than a dozen major international film festivals. Ehrlich is the only filmmaker to win the John O'Connor Award of the American Historical Association and the Eric Barnouw Award of the Organization of American Historians twice. She delivered the keynote addresses at the 2010 Sydney International Film Festival, on "War and Film," and at the national College Media Advisors Conference, with twelve hundred college newspaper editors and TV station managers attending in New York City. Both films are represented by First Run Features for DVD sales. *The Most Dangerous Man in America* is represented by Films Transit for international sales, and New Day Films is the educational distributor. It is available for download on Netflix and on VOD through Warner Brothers. Ehrlich is represented by Linda Lichter of Lichter, Grossman, Nichols, Adler and Feldman.

Ehrlich is currently in production on *The Mouse That Roared, The Boys Who Said No!,* and *The Invisible Man*. She is consulting producer on five films. Ehrlich has produced dozens of prize-winning educational films and radio documentaries over the past twenty years, and teaches documentary film history at Berkeley City College. She is a graduate

(with honors) from the University of California, Berkeley, in political philosophy and holds a master's degree (with honors) in education from the University of Vermont.

Ehrlich can be reached at: ehrlich.judith@gmail.com

Websites: www.judithehrlich.com or www.mostdangerousman.org

FESTIVALS AND AWARDS RECEIVED

Nomination, Academy Award, Best Documentary Feature, 2009

George Foster Peabody Award, 2011

Special Jury Award, International Documentary Film Festival (IDFA), Amsterdam, 2009

Freedom of Expression Award and One of Five Best Documentaries Award, National Board of Review, 2009 (USA)

Audience Award, Best Documentary, Palm Springs International Film Festival, 2010

Audience Award, Best Documentary, Mill Valley Film Festival, 2009

Best in Fest, San Luis Obispo International Film Festival, 2010

Best Feature Documentary, Boulder International Film Festival, 2010

Audience Award, Best Documentary, It's All True Film Festival, 2010 (Brazil)

Audience Award, Best Documentary, Fresno Film Festival, 2010

Best Documentary Award and keynote speaker, Sydney Film Festival, 2010

Audience Choice Award, Mendocino Film Festival, 2010

Special Jury Mention, Docaviv Film Festival, 2010 (Israel)

Audience Award, Best Documentary, Traverse City Film Festival, 2010

Tikkum Olam ("Heal the World") Award, Philadelphia Jewish Film Festival, 2010

John O'Connor Film Award, American Historical Association, 2010 and 2002

Eric Barnouw, Best History Film Award, Organization of American Historians, 2010 and 2002

History Makers, Best History Film, 2011 (International)

Nomination, Cinema For Peace, Paris, 2010

Selection, US State Department Documentary Showcase, 2011

6 11 HARD-WON LESSONS OF DOCUMENTARY FILMMAKING
FROM *INEQUALITY FOR ALL*

BY *JACOB KORNBLUTH*

ABOUT THIS CHAPTER

INEQUALITY FOR ALL PREMIERED at the Sundance Film Festival in 2013, and was released nationally at the end of that year. I have had the privilege of getting to travel throughout the country (and beyond) and talk with people about the making of the film and the importance of widening income inequality.

But virtually during all of the question and answer periods about the film I have been involved with were through the lens of the issue—why income and wealth inequality matters, and what to do it about it from a political perspective. Very rarely have I had the chance to discuss *Inequality for All* through the "lens" of filmmaking.

What follows is exactly that: eleven lessons about documentary filmmaking gleaned from my experience making *Inequality For All*. They track chronologically, starting with the process of coming up with the idea and all the way through release of the film.

LESSON 1
The "job" isn't filmmaking; the "job" is getting rejected.

When people hear that this was my first documentary film and that my background is in directing comedy, the first question they often ask is "How did you get Robert Reich to be in your movie?"

My answer? "I asked."

Like any filmmaker with ideas, I've asked people thousands of times to be a part of a film. Some of them were movie stars. Some were crew people. Some were just regular people with busy lives. Almost all of the time the answer was "no." They all have their

reasons—they are busy, they've never heard of me, they just don't want to. Whatever. Every single time I've asked it's with the belief they'll say yes. I try to think through why I believe it'll make sense from their perspective, and work that logic into the request.

It still almost never works. I talked to an actor early in my career when I was just working on sets as a production assistant and trying to figure out how filmmaking worked. I was envious of the lives of actors, but everyone on crews is envious of the lives of actors. I said some version of "Man, you actors have the greatest job. All you have to do is act, and all these people are running around trying to make it as easy for you as possible." The actor's response stuck with me through the years. The response (and I paraphrase): "Acting isn't a job. Acting is a joy and a privilege that almost anyone would kill for. You know what my job is? My job is getting turned down in auditions. Every day I go to an audition, I get rejected. And when I get rejected it doesn't feel like they are rejecting my work. It feels like they are rejecting *me*. That's my job. Acting is a fun diversion from my job of being rejected." This stuck with me for obvious reasons. Any job in the arts has a lot in common with this. Every time I've made a film, I've been approached by people who think it must be the coolest job ever. I've been lucky enough to make my living as a director for the last fourteen years, and there's no question about it—making movies is a great gig. But that isn't the job. As a filmmaker, most of my day is about dealing with rejection and hearing "no." If you can take that, you are ready to be a filmmaker.

LESSON 2
Documentary filmmaking is about access.

But occasionally you hear a "yes." That's what happened with Reich. Here's how it came about.

I was a comedy director, and I asked Robert Reich if he would consider being in an indie comedy I was trying to put together. I incorporated why I thought it would work for him into the ask. I lived in Berkeley, he lived in Berkeley, and I told him it would just take one day and be fun. I knew he was not just smart, but funny, so I thought I'd give it a try. He wrote back almost right away. "Sure."

My jaw almost dropped as I read the reply. You just never know. But you can't hear "yes" unless you ask.

That was the good news. The bad news was that he was such a busy guy that rehearsal or meeting would be impossible. He'd just show up for the shoot, and we'd hope it would work. He was wonderfully personable when he showed up, but he didn't realize he was supposed to read the script or memorize his lines ahead of time. Despite that, he was amazing, and he and I very quickly got along. At the end of that day, he said, "If you ever want to make short videos, just let me know." We exchanged contact information.

A week later, I phoned Reich. It was around 2009, and everyone was debating something called the "public option" for health care. As much as everyone was debating, I didn't know what the public option actually was about. When I asked my political friends (I don't consider

myself anything or anywhere near being a political expert), they would go off on some half-hour diatribe about the fight—the other side is trying to do this or that—but they never told me what it was about. I turned on the news, and it was much the same. It seemed to me like a bunch of talking heads screaming at one another, but after watching for hours and hours I was as confused as ever. On that first call, I asked Reich if I could film him on camera, explaining the public option. He agreed.

It was such a simple shoot. My friend brought a camera and sound equipment, and we set it up in an empty classroom. I asked, Reich answered. I edited it a bit, and posted it on Facebook, with the idea that a few of my friends would see it. What happened genuinely blew me away. Over the next twelve hours it went viral. I went out for a bite to eat, came back a few hours later, and had something like five hundred e-mails from people writing basically "thank you." With no advertising—and in the early days of political videos on the Internet—about a half-million people watched it. This was unheard of in 2009. I was shocked. Nothing I had ever done before had gotten a response like this.

Just as important, Reich was as blown away by the response as me. He had been told by his son that young people were no longer reading books, and Reich had been looking for a way to reach young people. Our little experiment had given him hope that I could be the one to help him do this.

After that, we made a series of short videos. The premise was that I'd be the first audience and give Reich some sense of what people wanted to know. Over each video, our trust and the collaboration strengthened. The videos were really finding an audience, and Reich and I were both getting really good feedback on them. I began to make the connection that I may have something to contribute toward helping people understand big economic issues. Even though I had no background in economic issues and had never made a documentary on that subject, I started thinking that I should make one. I wanted to tackle a story that would explain the economic uncertainty and confusion that me and all of my friends were feeling.

At one point I casually mentioned this interest to Professor Reich, and he told me he had also been thinking about the big issue involving the direction of the economy. In fact, Reich said he had just written a book about it. He handed me a manuscript to the book, *Aftershock*, and asked if I might be interested in giving it a read.

LESSON 3
Irrational exuberance is an essential ingredient to making a film.

I can't tell you what a joy it was to read that manuscript. On the first page was a graph on the incomes of the top one percent over the last century, with the peak years of income concentration in 1928 and 2007. It hit me with the force of revelation: 1928 and 2007 weren't just the two peak years for income concentration over the last century—they were also the two years just before the two largest economic crashes of the last one hundred years. And the graph looked like a suspension bridge. The minute I saw the graph—what I immediately started calling the "bridge graph" because it looked like a bridge—I knew I wanted to make a movie

about it. This was before the cccupy Wall Street and Tea Party movements, but I could feel it: the story of our troubled economic times hadn't been told yet, and this book might have in it a way to tell that story.

And then I had the thought—irrational, exuberant—that I've had with every film or creative project I've made. It's as if logic—and all the possible negatives—get shut down for a second. In that moment, I think with absolute certainty, this: if I could just do this one project, and get this film made, I'd be happy. It would mean I had done something worth doing. It doesn't make sense, but it isn't supposed to. It's crazy, and crazy is what it takes to get a film made.

What I've written so far may make it seem that it was quite a linear progression to this point. But consider where I was at that time: I had never made a documentary. I didn't know how to fund a documentary—it's a very different set of players than in the narrative world. And when I did talk to people who might fund the film, my pitch was that I was going to make a movie "explaining the economy." Remember, I had no economic background. Also, if I were being honest, I'd have to say that "explaining the economy" doesn't sound like a feature film. It sounds pretty boring, actually. And—surprise, surprise!—the potential funders thought so, too. Even if I found someone who did like the idea of a film about big economic issues, there wasn't any way to communicate why my version of the story was going to be better than anyone else's idea. I was just another guy with a concern.

But in a meeting with Jen Chaiken (who wound up as a producer on the film), the key to my version of a film about the economy became crystal clear: Jen had worked on docs before, and the key to making them, she said, was access. If you want to make a doc about adopting special needs kids, you needed access to a family. If you wanted to make a film about physics, you needed access to physicists. There were plenty of people with stories or cameras; for her, the ones who actually made films had somehow reached a point where they had special access.

I wanted to make a film about the economy, and I knew a great economic thinker. Robert Reich didn't trust just anyone, he trusted me. At the time, I wasn't even sure if the film was going to solely focus on Robert Reich, but now I had a way in and that helped clarify my thinking. The film would be focused on Robert Reich.

LESSON 4
Making films takes a long time; make sure you care enough to fight through the hard times.

I have spent much of my creative life thinking about the restrictive distribution channels for filmmaking. I certainly hear this complaint all the time from young filmmakers: "How am I going to get my film made?" It doesn't matter how much success you have in filmmaking, this is a concern for everyone working in the business. But it can be overwhelming.

For me, with *Inequality for All*, I knew I had a topic in income equality I cared passionately about. But there were so many hurdles to getting the film off the ground. I needed to learn enough about economics to make a film about economics. I guessed that would take a year

of reading—and I was right, it did take that long. I needed to learn about documentaries, since (as mentioned earllier) I had never made one. And I had to find a way into a story about economics that would work. I had the question: Was this worth my time? How do I know if it is worth my time before actually making the film and finding out?

In my way of figuring out the answer, I realized that the "me" test and "the world" test both matter. Think of it like this. Draw a simple line graph and number it 1–10. Measure how much you personally care about an idea. Now do the same for "the world" (you could also call this "the audience" or whatever else you choose), and draw the same line graph for 1–10 for the audience (or "others," or "the world").

In practice, I would tell people about my idea for film, and see if they responded. What I was looking for were two things: (1) when people said "no" or didn't seem interested, I wanted to look inside myself: Did I care enough to defend the idea and remain committed to it? and (2) Did "the world" care? Were there enough people who became excited thinking I would be confident this was worth pursuing?

First, an aside. If you are hearing "no" all the time, you probably shouldn't make that movie. At the very least, you need to rethink your pitch. If no one wants to hear you talk about it, it is hard to imagine they are going to want to see it when the movie is done. Or the other extreme, if people are jumping over themselves with excitement whenever you tell them your idea for a film, it doesn't take a brain surgeon to know you are on to something and should make that film right away.

But experience has shown me that it never plays out that simply. The journey to make a film is long and complicated. Inevitably, there are going to be times along the way when you feel that no one but you believes in it. You need to have something in the film that you believe in your soul has meaning. If you are doing it for someone else, or because someone else thought it would be a good idea, or that you never felt to your core that the idea in the film is worth pursuing, it is going to break down somewhere along the way. A director NEEDS that belief. (I'll have more about this later.)

But that isn't enough. You have to be open enough to listen and see how the ideas hit others. The notion of the fiercely committed artist who makes the film she wants to make, naysaysers be damned, is a beautiful one. As I already said, there is always a time when an artist feels alone and has to defend their idea to the world, but you have to see what is interesting to others if you want an audience.

My experience with *Inequality for All* was that the more I discussed the idea of the film with people, the more I realized that people were dying to have a "story of the economy" that really connected the dots and explained the anxiety and uncertainties they were experiencing. I was sure that if I could deliver that, I'd make a film that was worth making. But I also heard over and over that people didn't want to hear a lecture. They were deeply fatigued by partisan fights where a so-called "conservative" debates (screams!) a so-called "liberal" in a fight to see who has better solutions.

As another aside, I absolutely hate that twenty-four-hour news cycle/TV news vortex, but I understand it. It is driven by the fact that conflict gets ratings—"if it bleeds,

it leads," scary sells, etc., etc. Having something clearly explained . . . not so much. Or so the thinking goes in TV newsrooms. I watched the news after the economy collapsed in 2008, dying for some sense of an EXPLANATION. Not a debate, but something that helped me to understand what had happened. Over and over, I'd turn off the TV after watching and have the sense that I was more confused than when I tuned in. This system felt to me like it was broken. Part of my motivation in making *Inequality for All* was as a kind of antidote to this broken system.

But I also had a sense that this felt like a personal journey for me. I really wanted to connect the dots and unify all the thoughts floating around my head into one cohesive story. And the picture of the bridge graph felt like my way in.

LESSON 5
Funders aren't just buying a story, they're buying a storyteller,
OR, your personal story matters.

Up front, I'll say that lots of filmmakers don't believe this. They believe that the work and the filmmaker are separate, and it doesn't (or shouldn't) matter what your biography shows. My feeling, however, is that in documentaries—from a funder perspective, at least—you are funding a storyteller as much as their story. If you think about it, this makes sense. With a documentary, there is usually no script. You just have a concept that may, or may not, play out the way you think it will, and you have the filmmaker. Both are important considerations (storyteller and story) if you want to fund a project.

For me, I'm not a natural self-promoter, but I knew it was very important for me to know how I presented myself. I can say that *Inequality for All* really started to catch on with funders when I said—with conviction—that *Inequality for All* is the film I've been waiting for my whole life to make, a project that goes to the core of who I am and how my personal narrative relates to the narrative in the film.

Why does that matter? Consider two biographies of someone trying to make a documentary explaining the economy. One person is the son of Bill Gates, and an economic PhD, who wants to make a film about the struggling middle class. The other person was raised in poverty by unemployed teachers, made some comedies, and now wants to make a film about the struggling middle class. You imagine very different films from people with those biographies, right?

My biography was the latter. My parents were both public school teachers who were extremely political. I was steeped in political ideas from a very young age – and from a very young age I couldn't imagine what any of that political stuff had to do with me. I liked discussion and nuance; politics seemed all about black and white. I didn't like stories like that, and I didn't like politics.

I was raised in a house that valued education, but I also grew up very poor. I knew how poor we were because I had to turn in the "free lunch" forms to school every year, and I saw our income listed on the form. My father died when I was eleven, and my mother somehow

got through on $9,000 to $15,000 a year raising a family of four. But when I was a freshman in college, she died. As we puzzled through the finances of her "estate," I'll never forget the feeling of despair. I was eighteen, I had a younger brother and sister who were fifteen and thirteen, and I had no idea how we were going to make it through. We were kids used to having nothing, but at that point we were genuinely scared.

As lots of people have done, we made it through. After dropping out for a semester, I went back to college and finished. But I always was aware of not having much money. I noticed the effect it had on decisions—whether to order dessert at a restaurant, whether you ordered a fancy coffee drink at the coffee shop. Such things I think were more on my mind than kids who had families with lots of money.

In a way, I had the confidence that I had something unique to say before I had any real idea what exactly this could be. To elaborate, what I knew most clearly as a young man was that I was passionately driven to express myself. I couldn't get away from it, it kept me up at night, and that drive is with me to this day. It came from the feeling, at least in part, that the economic bottom had dropped out from my world and I felt alone. I would say that this need to express myself is the single most consistent motivating force in my life.

And I loved stories—though, at first, I didn't necessarily love movies. Movies seemed so simple—good and evil was fun and all, but it didn't really get my motor running. Before I knew what I liked, I knew what I didn't like. I knew I hated didactic storytelling. People just didn't seem purely good or purely bad to me, and the movies I grew up with mostly felt like that. I wanted to see stories that reflected my reality.

It wasn't until my early twenties that I began to see glimmers of what I did like. I liked what I thought of as "humanist" directors—think Sydney Lumet with *Dog Day Afternoon*, or even Richard Linklater with *Slacker*. These movies weren't flashy or overtly political, but they expressed a genuine affection for flawed humanity and didn't overly reduce people to being good or bad. In movies like that, I was seeing glimmers of storytelling that reflected my experience.

Soon after, I got into comedy. As most people in comedy, my need for it came from sadness or loss. On some basic level it seemed like life was hard, and it was better to laugh than to cry. I didn't want to tell anyone what to think. That's why, when I finally began making these videos with Robert Reich, it gave me the amazing feeling that this was me coming back to my roots. It felt good to be thinking about economic questions from an emotional perspective, and I began thinking that my background—economically challenged, anti-political, lover of stories but not necessarily issue documentaries—wasn't a deficit to making an issue documentary at all. Rather, it was the perfect background to make sure a story about the economy that was fun to watch and didn't feel like taking your medicine. If I were making a film about getting your tonsils taken out, I'd want to make darn sure it was at least a little funny and took you on a narrative journey. That would be the perfect approach to bring to economic inequality.

LESSON 6
What is your "voice" as a storyteller? This is crucial, and more difficult than you think.

I knew that to make a documentary about economic inequality that was interesting, I'd have to draw my inspiration from beyond just documentaries. But I had made a narrative comedy, and then a narrative drama, and my interests were all over the map. What was my "voice" as an artist?

Knowing what you like and who you are, and what you can bring to a film is harder than it sounds. What if you like superhero movies AND small films? Maybe you are a policy nerd who likes to "wonk out" on spreadsheets but also likes to read the more lowbrow stuff like *US Weekly*? Maybe you like both hip-hop and Sneaker Gazer pop. What can that stuff do to inform your filmmaking? Filmmakers talk about this stuff all the time after it happens, but it is tough to know as you are going in what your influences are.

For me, this began by finding inspiration for my desired documentary through inspiration that wasn't documentary films. I'm not sure you can tell my background is in comedy in any concrete way when you watch *Inequality for All*, but it was clear to me that I was going to try and make a film about economic inequality that finds moments of humor and lightness.

I can also say that, for me, I'm continually thinking what my take on a film is going to be that is different from anyone else's take. It is tied into my biography, and helps define my "voice." In addition to liking movies, I really like ideas. Big, abstract, paradigm-shifting ideas that change the way we see the world. For much of my life those ideas have been very compartmentalized—the stories about people told with comedy and warmth, and the love of ideas. With this film, I saw a way to combine them. I knew that if I could tell a personal story with warmth and humor, and blend into the story an idea that changed the way a viewer saw the world in some small way, I could make a movie in "my voice" unlike any film on the economy that another person could have made.

LESSON 7
Filmmaking is a team job. The director's job is to know what's good about that, and to use it.

After thinking about the film for over a year, it was time to start shooting. We knew shockingly little about what the story would contain. We had the book, *Aftershock*, as a jumping-off point. We didn't even know that the classroom was going to be such a big part of the structure of the film. The basic idea was to film Robert Reich talking about economic inequality and general economic issues. We'd see where that took us, and adjust from there.

Let's take a second to think about all the uncertainties we were facing at that point. For over a year I had been reading about economics. I had met the producers, Jen Chaiken and Sebastian Dungan, and we had endless conversations. But we hadn't really raised any money, and we had no idea what the story really would involve. How could we pull the trigger and start shooting?

Well, occupy Wall Street happened. The producers and I began to think that the story we had been sitting on was about to break into the national consciousness. We were afraid all the talking and research would be for naught. At the time, it felt like it was now or never. So we jumped.

Sebastian Dungan has a background in indie narratives and Jen Chaiken's background is in documentaries. They had a company they had formed together called 72 Productions. It was an interesting package for funders—not the usual documentary team, but not a team with no idea what they were doing, either.

They were also very hands-on producers, which was something I really needed. First off, they knew it was time to start shooting, and pushed like crazy to make it happen. They assembled the camera crew, and dragged me kicking and screaming to do the first shoot.

Looking back, I remember it feeling a bit out of control. In narrative films, I had a shot list and a script. Here, we had no script, and I was out with a crew with no shot list. How would I know what to do? But as soon as that uncertainty passed, I immediately felt the strength of all the conversations I ever had with the producers. We had talked it out for over a year, and those talks helped influence each of my decisions. I may not have known it going in, but I quickly realized I had a highly refined sense of exactly what the story would involve.

This was the first and clearest sense of how valuable the team is to making a film. When it came time to shoot, despite my uncertainty going in, I was amazingly grounded on the biggest issue—what to focus on in the chaos of shooting something occurring in real time. I was confident and sure of myself. But this first emerged from an intense collaboration with Reich and the producers, and it became more refined every time I talked with the camera people or other crew members. I became increasingly confident with the story. It was with this "being part of a team" aspect of filmmaking that I fell completely in love with the process. I'd talk to the crew before every shoot—we had different camera, sound, and other technicians from shoot to shoot—and tell them how I wanted it to feel, and what I thought we were after on the shoot day. Then, I'd watch them think about it, see what bits of the story hit them, and then figure out how to shoot the material to make it happen.

An assortment of things I loved were going on as part of these mini-collaborations. I was refining what I thought about the story each time I talked about it. I was learning how to communicate with individuals, which was also helping me to figure out how to communicate the important bits of the story overall. At the same time, I was learning from everyone else as they made decisions. When the cameraman thought that this house or that house would tell the story about what middle-class America was going through, they were often right. Or, if I disagreed, it led to a discussion about what they thought they were after, which made me understand more clearly why I had disagreed. When the producers thought we should shoot a fancy event, they were often right. If I disagreed, I had to explain why I thought it didn't work for the story. With each conversation, the story clarified.

For much of the beginning of the film shoot, I was often aware that we were finding a story in the chaos that was happening all around us. But I learned to work with it, and it is difficult to describe how profound it was to be part of a team of serious artists, all contributing

and making the story better. I found it tremendously invigorating, and it pushed me far past where I could have been had I been working by myself. It is certainly true what I've heard from other filmmakers—that production is a kind of war and a test of your endurance, and that the real goal is to survive. After production, many filmmakers say, you can assemble the pieces into a story and get back to the storytelling you love so much. But for me, I found production to be exhilarating because I was working with people who I knew were brilliant at what they did. Every day, the story got clearer. Every day, the people I was working with made the story better than it would have been had I been working by myself or not taking as many suggestions from my collaborators. And—I'm jumping ahead here a bit—it all added up to a strange combination. I've never felt like I had less control over anything that I've made, and I've never felt anything that turned out more like I imagined it going in. At the same time, making *Inequality for All* was a collective experience. It was also a very gratifying personal experience.

LESSON 8
People always ask what challenges one faces making the film. The truth is that every day is a different kind of challenge.

As I've said, it was hard to get people excited about making a film about the economy. It was always hard to know for certain that any given shot or scene on any one of the sixty days we shot was going to add up to the whole. This is what makes directing a film such a lonely endeavor, and one that keeps you up at night.

What I should point out is that I knew a limited set of things. I knew I wanted to make a film about the economy. I knew Robert Reich was a great communicator, and a great on-camera presence. But no one talk or lecture he gave put the whole movie together. I would go to a talk of his, I'd see him talk about some aspect of the economy, and I'd have to project that there would be other pieces that would all tie together to make a movie. But what if it didn't? That's the hardest part to describe. Now that it is a movie, it seems that all the decisions about how to put it together were inevitable, but when you are in it you experience it very differently.

For example, since we didn't know where to start with the movie, one of the initial things we did was shoot what we called the "spine" of the movie. This was a set —it turned out to be a set with a graphic window behind Reich, in which we had a whole script, many chapters long, that Reich was going to read to the camera, similar to an on-screen narrator. Bob began this, and right away I had the feeling it wasn't working and was too stiff. Of course it didn't work—no one sounds natural when reading from a script—but that was the only way we could know what the story would involve. The script was seventy-five pages, so to do it all we had five hours ahead of us. Time was money. Did we keep doing this? What if this scripted read was the perfect antidote to the informality of the rest of the film that we had yet to shoot? If we pulled the plug on this scripted read, it would be unlikely we would have the chance to come back and reshoot it. These are the types of decisions that

make every day of filmmaking a challenge. One wrong move, and the whole movie might not work.

Ultimately, we hurried through the scripted part, hitting the highlights, and saved some time for an informal discussion. As it turns out, some of the scripted material made it into the film, but most of the material from the "spine" shoot that made it into the movie was from the informal talk that we had saved. The interesting thing, though, was that going through the scripted material first gave us the confidence that we had covered what we needed to cover, so that the conversation had a relaxed and informal feel I don't think we could have gotten otherwise. Filmmaking is following your gut, and it is a high-stakes challenge that feels like you are on the brink of failure every day you do it.

Another challenge occurred when we shot a scene at a union rally. All we knew was that there was a union rally more than four hours away, that Reich would be speaking there, and that the campaign to counter the union was strong.

The minute we showed up at the rally, I could feel that people were suspicious of the cameras. The ones who were pro-union were risking their jobs—the best jobs in the area—to be there and stand up for what they believed. You could see that those who were anti-union were angry—they felt that the ones who were pushing for a union might mess it up for all of them. The people didn't want us to be there. Some politely told us that we should go. It was constantly touch and go, me explaining to people that we had been approved to shoot—by whom, they wanted to know—and that we had driven long distances at great expense to cover this event. They were resistant the whole time. It wasn't their fault we had come so far, this wasn't something they wanted on the record, we could be doing real harm to someone there by putting them on film. We got told at least five times that we were going to have to leave, but I kept smiling and talking. The longer we talked, the more they forgot their suspicions of us.

Finally, people got used to us and the event kicked off. You could see that the anti-union people were on one side of the room, and the pro-union people on the other. I instructed the camera operators to hang back and to not get in anyone's face. When Reich entered the room, the tension in the air was palpable. As difficult as shooting that night proved, it was also electric to see him handle a room like that. He said what he had come to say, confidently, and then took questions. A man raised his hand and said he was "a proud Christian, a proud employee," and that he thought management had treated him better than he deserved to be treated. He was speaking with a light tone that felt like armor to the emotion underneath; my heart went out to him. It was in a difficult moment such as this that I became keenly aware of this fact: you can never tell when something truly memorable is going to happen. That's what makes documentary filmmaking such a challenge, and also why it is so rewarding to be there. But every day is a challenge, and every moment needs to be taken seriously and fought for—if you don't feel that pressure every day of shooting, you aren't doing it right.

LESSON 9
Documentary interviews aren't about the best questions; they are about opening people up.

After working as a documentary filmmaker whose job it is to talk to real people, I've learned this: people have certain things that they want to talk about. As a director, my job is to be human and be myself. I rarely look at notes to see the questions when I'm talking to people. I stay engaged with the person I'm talking to, trying to let my natural curiosity be my guide as to what to ask. In general, the questions I write down are important guides as to what I want people to talk about, questions that can be useful. But it is also a hindrance if it keeps you from seeing what people want to say. Listening to what people want to talk about almost always makes for better interviews than pushing your agenda on people.

For example, when we were at the union rally, a woman came up to me. Her husband worked at the plant, and she was friendly. I decided to interview her, even though I had limited time and I was at the rally to talk with workers. She was Nancy Rassmussen, the Mormon/conservative woman in the film. When I sat her down and talked to her, I found her riveting. Without me really asking, she jumped right in with what she wanted to talk about—she was worried about her husband's job and her family's economic health. She told me she had joined the Tea Party because she felt so frustrated. Then she told me she had tried to join occupy Wall Street. She was emotional, nearly crying. She introduced me to her husband, Ladd, who told me about his struggles with his job. He was fantastic. I had found two important characters for the film.

For another character, I had in mind that I wanted to talk to students at Berkeley, so I went to the adult learning center. I was talking to everyone in the center, just getting a sense of their stories, and a woman burst in talking about a job interview she had just had. It was for a paralegal position. She thought they were going to offer her the job, and she really needed the work and the money to support her daughter and help with the bills. But also she was afraid that if she took the job, she would get stuck and would give up on her dream of becoming a lawyer. I was riveted—how much did she make? She had no hesitation. She said that last year they made $36,000 to support a family of three. This isn't broke, but it is tough to make it in the Bay Area on that amount. She and her husband, Moises, were continually making choices—if we pay for this, we can't do that. They tried to budget, but felt like they were always a bit behind.

Again, I wasn't there to film her, but I had my eyes and ears open, and she jumped into the picture. You could see that her story was simmering in her, and that she was dying to talk about it. With someone like her—her name is Deborah Frias, and she and Moises wound up being characters for the film—all you have to do is turn on the camera and the story jumps out at you.

Another character, Robert Vaclav, was a student in Reich's class. I had asked the instructors whether there were any students who might be living the middle-class struggle Reich was examining in class, and Vaclav's name came up. He was older than the other students, and was going back to school after being laid off from his job in retail. He was married, had a

couple of kids, and when the classes gathered in groups he often used his own life experiences as examples. But when I spoke with him, he was hesitant. He thought I was looking for people who were really down on their luck, and he didn't feel that way. Yes, he had seen a lot. Yes, they had money concerns. But they had a strong network of friends and he wasn't sure that if I dug into his life I would only be interested in the suffering he thought I was after. I assured him I wasn't after suffering. I wanted people who felt they were going through some hard times the way a lot of people in America were going through hard times—imperfectly. They weren't perfectly poor or depressed all the time, but they were dealing with money issues every single day.

Robert lived in a house with a friend who had taken them in. It was a nice place on a cul-de-sac in the suburbs. It was quiet and safe. Inside, there was two floors and a nice kitchen. When you walked in, you had no clue of anything having to do with money troubles. The family was making breakfast when we showed up. They had a daughter in middle school, another daughter in elementary school, and like families everywhere they had to get the kids ready and out the door. Erika, Robert's wife, immediately caught my eye. I just had a feeling that she had some things she wanted to talk about, and if I just gave her a chance, I'd really get the story. I asked her if I could ride with her as she went about her day. She said sure. I got in the car with her and her daughter, and we hit the road. I was in the back seat so the cameraman could be in the front passenger seat, so I couldn't see her face. We just headed out. The minute we hit the road, as she stared blankly ahead at traffic, she started telling me what was on her mind. She was proud, and none of this was conveyed with a note of self-pity, but money concerns were haunting her everywhere she went. It was Wednesday, and she didn't get paid until Friday. She had twenty-five dollars in her account. One of their big costs was gas, but she had a full tank now so she was going to be fine until Friday. It was great that Robert was back in school and trying to make something of himself, but it put the burden for supporting the family on her. There was no margin for error. They had to pay for after-school care for their daughter, but then they couldn't afford a phone for her to carry with her. Erika worked late, and Robert was involved at school. Erika was worried that she couldn't check in to make sure her daughter had made it home okay.

The whole time we were filming this, I was thinking of all the ways their story could work in the film. They seemed like such a together family from the outside, but I could feel the struggles when I hung out with them for a few minutes. Maybe that was the story. Or, maybe the daughters were the story? I kept coming back to the fact that my connection with them came through the class that Robert was taking, so I stuck with him as the jumping-off point and went from there into the story of their family. Now that the film is over, all of that seems reasonable. But when you are there, holding a camera and experiencing the many ways that each family is interesting, it is incredibly hard to make decisions. That is why it is so important to both know what you think makes them interesting going in, and to also stay open to the great story that you weren't expecting but that is happening right in front of your face.

For a number of reasons, perhaps the most challenging—character to find for the film was someone we called the "1 percenter." The film was called *Inequality for All*, and I knew

the promise in the title was that the widening inequality of income and wealth wasn't just bad for poor and middle-class people—it was bad for all of us. I knew that I wanted sympathetic middle-class characters. But don't films need a villain? There was a strong argument within the filmmaking team that we did need this. We knew we'd be covering some pretty abstract economic concepts. People would ask us all the time: "I know you are making a film about the economy, but what is the STORY?" If we had a sympathetic host, sympathetic characters, and no villain, then it was tough to know how this was going to pull together for a feature-length film. We began to make lists of all the 1 percenters we could imagine. There are many conservatives who we knew would disagree with us, and a lot of very wealthy people who would be interested in having a venue to express their views on economic inequality. There were also more than we probably would have guessed going in who were of the opinion that growing economic inequality was bad for economic growth. All of these people—perhaps because they were so wealthy—were very difficult to reach. It would be difficult to meet them, sit and have a conversation with them, and then decide who would be the best subject for the film.

Ultimately, I went on instinct. I had read about Nick Hanour in the Huffington Post, and saw that he was included in a magazine article in which he discussed his wealth. I had also seen a TED talk that Hanour had given on inequality and its consequences for growth, that wound up being "censored" by the TED people. I just couldn't stop thinking about him. He was passionate about the topic in a way I hadn't seen much. I hadn't met him, but I had a talk with the producers and we decided to pursue him as a character. We'd contact him, and—sight unseen—pay for the flight to Seattle for myself and a crew to shoot him for a day.

When we got to Seattle, we went to Hanour's house, but he didn't want any information that would identify the house and where it is located. We asked him to give us a tour of the place. It was a remarkable house, and not just because it was a very nice place. It seemed like two places, with one side containing what he called "the museum" with its sixteenth-century tapestries, incredible works of art, and a vaulted ceiling. It seemed like a mansion. But the other half of the house included a modest kitchen with mail and boxes lying around, and a rec room—this was where he and his family spent all of their time. His house was just like he was—he could present a fancy exterior if necessary and liked nice things, but at his core he was a middle-class guy with middle-class values. He walked us around and described his lifestyle; he didn't exactly live modestly—he flew around on a private jet, after all—but he only spent a small portion of his money. He had enough awareness to know that middle-class people spend a bigger share of their money, and that spending almost always took place in the town or city where they lived. Rich people such as Hanour spent a smaller share of their money, and they spent it throughout the world. For that reason, the money a rich person such as Hanour spends does less to help the local economy than a middle-class person's spending would. A middle-class person's spending, much of which goes to groceries and local stores, has a "multiplier effect" for the community. The money they spend at their local grocery store results in that store hiring more help, and those employees spend the money they make on haircuts, toys, etc., and those businesses, in turn, hire more.

This is a "virtuous cycle" that we cover in the film, but it was amazing to hear a wealthy individual, whose ten-figure income and extensive wealth clearly puts him in the top 1 percent, talk about these things. I knew we had hit the jackpot. But we still hadn't nailed it. I interviewed him for two hours, and then we decided to go out for lunch. On the way to lunch—and once the cameras had turned off—Nick began talking about his family business—a pillow factory. The best way to illustrate the problems that growing income and wealth inequality creates for an economy, he realized, was to illustrate it with pillows. This was a business he knew intimately, and he knew that rich people might make one hundred or one thousand times what the typical worker makes, but they don't buy or sleep on one thousand times the pillows.

As Nick and I were walking, I silently gestured to the camera person, who began filming. This occurs a lot—people have a certain formality when you sit them down and ask them questions on camera. They aren't comfortable or relaxed, and often I find myself wondering what the "key" will be to get them to talk as they were before the cameras were turned on. Often, I will say "cut," and then we will just talk a while. I try to shut up, and let them do the talking in these situations. I'm trying to find out what it is they wanted that I haven't given them the chance to say yet. Often, by turning off the cameras, they relax and start talking.

In Nick's case, it was leaving his office. Something in that experience made him feel more natural. Working with an experienced and talented camera person helped—she knew to just turn on the camera and stay out of the way.

That interview was gold, but it didn't make it into the movie. That occurs all the time, too. You have a moment you believe is gold, but for whatever reason it doesn't work for the movie. In our case, the talk led to two concrete shots—a total of about five seconds in a ninety-minute film. One of the shots is of Nick eating a bowl of Vietnamese Pho, and the other of him driving his Audi. What it did was lead to the idea of rethinking the whole conversation and having it take place at his pillow factory. We went to Los Angeles and with him visited his pillow factory. This is where the majority of the segment about why wealthy people with an increasingly larger share of the national income and wealth is bad for growth fits into the film. I hear over and over from people who see the film that this is one of the more memorable parts of the entire film. As we were walking, Nick was talking about how, as a business owner, the only thing that creates jobs is customers. When you have to make more pillows because people are buying those pillows, you have to hire more people to make them. There is nothing that a wealthy guy like Nick does to "create jobs." Having customers makes jobs. It was obvious to him, but counter to the narrative out there that you can't tax the "job creators" or they won't make jobs. He was getting excited, explaining how ludicrous that was from a business owner's perspective. I followed my nose. One interview led us to a pillow factory in L.A., and as a result we had a memorable scene in the movie. As is often the case with docs—the way it happened was something I could never have drawn up in advance—when it works out it is even better than anything I could have imagined ahead of time.

LESSON 10
Editing is where the writing of your story happens, and doc editors are real storytelling collaborators.

So we finished shooting the movie, and started to think about editing, an arduous process in and of iteslf. We had more than five hundred hours of footage. We had various storylines—the arc of economic inequality over time, Robert Reich's personal story, and a list of characters from various backgrounds that we had followed. This isn't even mentioning the stories that we thought might still have to be built, including the story of Henry Ford, who paid his employees double what his competitors were paying their employees to work on his cars. He was called a socialist at the time, but he realized it was a savvy move to pay his employees enough to buy one of the cars. This thinking transformed the business of making cars. There were numerous stories such as this throughout history—all types of fascinating tidbits that might make the film play better. Where were we going to start? How would we ever make the decisions we needed to make to tell the story?

This was a terrifying and daunting time for me. So much money had been spent, so much time of my life invested in the project, and I wasn't sure where to start. That's why I found it so great to work with an amazing editor. Initially, she brought fresh eyes to the material. Just as I was down, she was up, and excited to jump in. For the first few weeks, the editorial team (lead editor Kim Roberts and additional editor Miranda Yusef) just watched what we had shot, and they would pepper me with questions from time to time. Then they started with the material that jumped out to them; it was often what I thought was compelling, but not always. Having a chance to see those first scenes come together was a real revelation.

In working on *Inequality for All*, one of the first things I remember coming together was what we began calling "the bully scene." It is a scene at the end of the film where Reich describes growing up and being bullied, and that he sought out protectors to keep the bullies away. One of the protectors he remembered was Mickey Shwermer. Reich went about his life, and years later learned that Mickey had been killed by racists while organizing in the South. As Reich described it, that moment changed his life. It was when he realized that he couldn't let the bullies win, and he'd have to stand up for people getting economically bullied in the modern world. The scene was emotional and powerful from the get-go, and seeing it went a long way toward casting off the fatigue I felt after production.

When we had assembled a fair amount of scenes, we set about doing a first draft of a "script." This involved attaching the scenes to note cards on the wall, so you could visually take in what you had from the story and what you needed. I thought this "story wall" was an absolutely invaluable tool. I was still a bit groggy—even a month after production, I was worn out—and it was fantastic to have a great editing team to bounce these ideas off. But after the despair I felt from seeing the mountain of production footage we had to make sense of, I was starting to see that there might be a light at the end of the tunnel. And that "light" was a path forward to finishing the film.

Finally, we had an assembly. The assembly was well over two hours long. I am a believer that it is better to initially keep everything in the film. Basically, don't cut too soon. That way

you can see what you have. So we showed people the assembly, and asked for notes. What happened was that their notes were all over the place. Some people were seeing one film—a film about economic inequality—and others were seeing more of a biographic film about Robert Reich. Which was it? Some thought the economic stuff was boring, and others felt that the personal details for Reich "softened" the hard-hitting content about the economy.

This was where the editing collaboration deepened. Anyone who makes documentaries knows how vocal doc audiences can be. You ask them for an opinion, and they flood you with opinions. I was overwhelmed, and again unsure on how to push forward. Kim Roberts told me that in the original meeting I had with her I had said, "You have to believe the messenger to hear the message." I had written it down, and put it on a notecard on a wall in my office while we were making the film. What I meant was that we were making a film about economic inequality—and that was the message. But to believe it, you had to believe and like the messenger, Robert Reich. Early in the cut of the film, these two pieces were not yet working together and making one movie, and so the notes from people who saw the film were naturally trying to make sense of what was wrong. Rather than hearing all the specifics of their notes, we honed in on one goal: for *Inequality for All* to work, we had to make the story of the "message" (economic inequality) work, and also make the story of the "messenger" (Robert Reich) work. The movie wasn't going to work unless both of those tied together.

How to do that was a different story. We tried a number of things, and while it got better, we continued to get feedback about the film that was all over the place. It was clear that it wasn't playing as one film. It had always started with the "big-ness" of the problem of inequality. Then one day I was repeating my familiar "you have to believe the messenger to understand the message," which was beginning to feel like a platitude that didn't mean anything, when Kim Roberts said, "Maybe we should start with the messenger then." She pulled a scene with Robert Reich walking to his car, which was a Mini Cooper, and put it at the beginning of the film. From inside the car, he says he identifies with his car, that it felt like "me and my car facing the rest of the world." We showed the film—virtually untouched in many ways from what some had seen earlier and been confused over—and people, generally speaking, loved it. Their notes switched from the big concerns ("this feels like two stories and you should throw away one of them") to "I think you should take a few seconds off this scene but, by and large, this is an amazing film I can't wait to tell my friends about."

One great thing in this process was showing the film to Reich. He was always gracious, and he really understood what we were after. I remember showing the film to him as it was coming together, and it sort of hitting him that the film was going to be pretty good. He said at some point, "This is a major work. It is going to do a lot to help bring this issue to people's attention." All of the work, and the struggles, suddenly seemed worth it. I had taken an issue I was passionate about—economic inequality and what it meant for our economy and our democracy—and poured several years of my life into making it a story that was accessible to a number of people. Often, it had seemed a futile task. But as it really began coming together, it was difficult to not feel a sense of pride—pride that only going through the crucible that

is creating a feature film has given me. I made my peace with the film, flaws and all, and was ready to show it to the world and see what it thought.

LESSON 11
Releasing a film is letting go of something you love.

Spending as much time with a film as I did with *Inequality for All*, you wind up relating to it like a person. You talk to the film. You give it a personality. You can get pissed off with it, and fall in love with it all over again. If you are lucky, the film comes out into the world. While that is a happy event, it always feels a little like the relationship I had with the film now in some way ends. Lots of filmmakers describe it as letting your baby go off to school; they now have friends of their own, and have to learn to fend for themselves in the big bad world.

Our film premiered at the Sundance Film Festival. When it first showed, I sat in the packed audience and looked around. People were riveted. They gasped in some areas, laughed in others, and were clearly moved by the film. At the end, when the lights came up, we got a standing ovation that lasted several minutes. As they were clapping, and I was on stage with Reich and all of the collaborators who had worked so hard on the movie, I was overwhelmed with pride. I made the film because I cared about the issue, but there is nothing as rewarding to a filmmaker as making a film and having it move an audience in a packed theater. In that moment I couldn't help but think about all the films that had moved me while I sat in the audience. There is a tremendous power in cinema, and it is a real privilege to have the chance to be a part of making something such as this. After the screening, many people came up to me with some version of "thank you." It was one of the most gratifying professional experiences of my life.

Afterward, the film went into a bidding war and we had an opportunity to choose our distribution partner. We settled on Radius, a division of The Weinstein Company. The film was released in September 2013, and did the best box office for any issue-driven film since *Waiting For Superman* several years earlier. It was a critical hit as well, with a 90 percent positive score from the aggregating site Rotten Tomatoes.

Was it a success? At the time the film came out, economic inequality was a bigger problem than it was when we began making the film. The problem has since continued to grow. But I always return to the fact that I had made my peace with the film before it went out into the world. I couldn't control how the audience received the film. I definitely couldn't control if it fixed a problem I care so deeply about —widening economic inequality, and what it meant for our economy and our democracy. But I could do my part. I could say my piece. As any citizen, I could raise my voice to the best of my ability and be heard. That's exactly what I did, and I couldn't be more proud of the result.

COPYRIGHT © BY MARK ALTENBERG. REPRINTED WITH PERMISSION.

JACOB KORNBLUTH is an award-winning writer and director of feature films, TV, and theater. He has had three feature films premiere at the Sundance Film Festival—*Haiku Tunnel* (Sony Pictures Classics) and *The Best Thief in the World* (Showtime Independent) are narrative films, and *Inequality for All* (Radius/Weinstein) is a documentary. *Inequality for All*, his most recent film, won the Special Jury Prize for excellence in filmmaking at Sundance 2013, and generated the best box office for an issue doc since *Waiting for Superman*, and is now on DVD and streaming. In 2014, Kornbluth worked on the Showtime series about climate change, *Years of Living Dangerously*, executive produced by James Cameron, Arnold Schwarzenegger, and Jerry Weintraub. His work on that show won an Emmy.

Jacob began his career as a writer and director in the theater. He collaborated on and directed three successful solo shows in San Francisco, *The Moisture Seekers* and *Pumping Copy* (both with Josh Kornbluth), and *The Face by the Door* (with Christina Robbins). All three were nominated for or won Best of the Bay awards and successfully toured the country. A later version of *The Moisture Seekers* (titled *Red Diaper Baby*) has been included in anthologies of the best one-man shows of the 1990s.

Jacob lives and works as a screenwriter and a director in Berkeley, California.

7 LET THE FIRE BURN: A PERSONAL HISTORY

BY *JASON OSDER*

▶▶ 1

ON MAY 13, 1985, the Philadelphia police and the revolutionary group MOVE met in violent confrontation. The conflagration was the culmination of a decade of simmering conflict that had claimed the life of a police officer eight years earlier. That incident had resulted in nine members of the group being convicted of conspiracy to commit murder. The 1985 event ultimately claimed the lives of five children and six adults, and destroyed three city blocks in a fire that city officials allowed to burn.

I was eleven years old, living on the outskirts of Philadelphia in 1985. It is difficult for me now to separate authentic childhood memories from the time spent years later studying the events and watching footage to create the documentary *Let the Fire Burn*. I think I remember seeing the smoke on the horizon, but it is possible that I only saw it on TV. Although I can't remember specifically how adults tried to explain the incident, I remember overtones of political, social, and racial tension.

More than anything, I remember being scared. Children my age had died in a massive fire in the city I called home. Their parents could not or did not help them. The police seemed to be at least partly responsible. At the time, I was unable to articulate such ideas as racism, police brutality, and militarization. As a child, I lacked the ready-made frames that adults possess to help understand and thus emotionally negotiate public tragedies.

The adults in my life seemed flummoxed and unable to answer even rudimentary questions about the incident. What was MOVE? What did it want? Why did the police act so violently toward the group? Or, the answers one overheard to these questions were disparate and contentious. The American dialogue around race was not where it is today, but these tensions were obviously present. So were other confusing

and conflicting details: MOVE was a "cult" and/or "deserved" whatever happened to them. The police "did what they had to" given the circumstances. Much of this missed the central fact from my perspective: there were children in the house.

Childhood, for those lucky enough to have one in the traditional sense, is a bubble. Your parents teach you that the world is a fair place; that as long as you play by the rules you will be safe. This is a white lie designed to protect children. The world is not a fair place, and sooner or later an event comes along that your parents cannot shelter you from. The bubble is burst. For a whole generation, this moment was 9/11. My parents' generation will always talk about where they were when they heard that JFK was shot. For me, the moment that burst the bubble was the MOVE fire.

I can't say without hyperbole that my social consciousness awoke on that day. I can't claim that the dream of making a film was born. It's hard to say with any honesty the events that shape us. I do remember that starting around that time my awareness began to rise. I began to ask questions about the world and the role I had in it. Today, I have more vocabulary to bring to bear. Words such as equality, social justice, and dehumanization help to define the questions I began asking at that still-tender age. Answers remain hard to come by.

Less than six years after the fire, I moved away from Philadelphia to start college in a southern state. Everyone in my high school had known about MOVE. It was part of our cultural fabric in Philadelphia. We might not agree with each other or with our parents about who was to blame. We might not even have an opinion, but we all had a shared tragic reference point. The young people I met from all over the country when I started college in 1991 by and large had no idea what had happened just six years earlier.

Again, I cannot say that I met this ignorance with a steely determination that the story must be told, but it did bother me that no one knew about it. At age eleven, without any real context, I knew intrinsically that an injustice had occurred. At age seventeen, I felt it was a second injustice that what seemed like crucial and recent national history was not part of the shared American consciousness.

2

I'm not sure of the exact date when I began work on a documentary about these events but I remember the conversation well. It was late spring or early summer, 2001. My friend John Aldrich and I had just finished film school at the University of Florida and both moved to the Washington, DC, area. We were riding in his car when he asked me if I had any good ideas for feature docs. I replied that there was this thing that happened in Philadelphia while I was growing up that had always stuck with me. Just like that, we were working on a film together.

Fresh out of film school, we had a firm idea of the things we were looking for in a documentary topic. In our preliminary research, it seemed that the story of MOVE had many of these attributes: compelling characters, arresting visuals, conflict, and drama. Most of all, it had saliency. One of the things we had been trained to look for were those stories

that would make people feel that this was something they *should* know more about but didn't. We felt confident we had found a story that needed to be told and would make a high quality documentary. If anything, we wondered why no one had already tackled this for the big screen.

Then September 11 happened.

I remember walking around deserted northwest Washington that afternoon. I was thinking of the events of the day and about May 13, 1985. This was natural because I'd been doing the research, but it also felt similar. I was taken back to age eleven. It was the same basic zeitgeist: fear and confusion.

I was thinking hard that afternoon. I think we all were. I remember my head hurting. Was this nascent project still valid? Would anyone care about this incident, already sixteen years in the past, in the shadow of this new atrocity? Should I turn my attention to something more newly topical?

There was a phrase being thrown around on the airwaves that day, the idea that "civilization itself had been attacked." I thought a lot about that. It seemed wrong to me then and it still does. There will always be violent acts and immoral actors. I don't think that qualifies as an attack on civilization. As I worked my own moral compass that day, seeking a new orientation, I realized something: civilization is not under attack when three thousand people are murdered in a spectacular act of terrorism. Civilization is under attack when eleven lives are taken in an act of state-sponsored violence and it is forgotten. The MOVE tragedy was not suddenly less salient; it was more so.

Public tragedy and collective memory are intrinsically interwoven. Both age and media play a role in this equation. My parents' generation all know where they were when they heard that JFK had been shot. Seeing the events of 9/11 unfold live on TV marked those college students I have taught for the past decade. For me, that first experience of a public tragedy was the MOVE fire. I did not want it to be forgotten.

3

From the beginning of the filmmaking process, we had a number of goals regarding form and effect for *Let the Fire Burn*. Looking back, these goals stayed remarkably consistent, even if their execution was not exactly what we initially envisioned. Some of these early goals were:

1. The story should be told by the voices of participants.
1. The film should strive to be unbiased. This would be achieved primarily through the juxtaposition of conflicting points of view.
2. The viewing experience should be intellectually and morally challenging. The film should invite viewers into a context they think they understand, and then offer more information that undermines that understanding and comfort. (I liked to say, "The story has a large 'but-what-about...' factor.")

One Day in September, Kevin MacDonald's expertly crafted documentary about the kidnapping of Israeli athletes at the 1972 Olympics in Munich, was an early model. This film deals with another violent conflict between opposing ideologies from the not too distant past. It takes advantage of the rich archival record for dramatic effect. The real heart of the film, however, is a handful of intense original interviews. They juxtapose the wife of one of the slain Olympians, a German official who seems oblivious to the weight of his responsibly, and a proud Palestinian militant.

There existed conflicting views concerning MOVE, and this provided us with one thing we felt confident about: we believed we could capture them. We didn't want to interview just anyone who had something to say about the MOVE history. That would lead to a very bland sort of mosaic—a film from the outside looking in. One of the things I admired most about MacDonald's film was that the interviews really represented opposing realities. The events of the film represented a tragedy to one of the subjects and a triumph to another. This tension drove the film and we felt that something similar could be achieved in a documentary about MOVE.

In these early days of production, we began to compile a series of interviews, while collecting as much archival material as we could. We were not so much interested in experts or even witnesses, but real participants, people whose lives changed forever on that day. We envisioned a dramatic but fairly traditional historical documentary in the style of *One Day in September*. We would make the most from the potential of the rich archival record, and would augment that with the emotional and opposing testimonies of participants whose experiences shaped their lives.

4

One interview subject stood out as an exclusive and we thought it could be the heart of the film: childhood survivor Michael Ward, known within MOVE as Birdie Africa. Along with adult survivor Ramona Africa, Michael was the only other person to emerge from the fire alive. He had rarely spoken to the press. Even those who followed the story closely had mostly never seen him speak as an adult.

Interviewing Michael Ward was an emotional experience. When we shot the interview, and for some years later, I still thought that it would be the heart of the film. In fact, it is not in the film at all, but a thirteen-minute excerpt is included on the DVD.

The location of the interview was the law offices of David Shrager, a prominent Philadelphia attorney. David had represented Michael pro bono since the time of the fire and been a much-needed interlocutor between him and the public world. When I had found Michael's address and sent him a registered letter some months earlier, he had forwarded it to David. In the intervening time, we had built a relationship of trust with David, which had earned us the interview with Michael.

When working with a delicate subject for a documentary, one thing that can prove useful is an interlocutor of this sort; a trusted person with some authority to broker the kind of trust needed with vulnerable subjects. David was more than qualified in this regard. He had stepped

into Michael's life with much-needed support. (Michael had actually stayed at David's home after being released to the hospital.) Moreover, David was a great champion of the powerless throughout his career. His most notable case was the national class-action lawsuit on behalf of hemophiliacs who contracted HIV through blood transfusions.

David saw protecting Michael as his top priority, but he also saw a duty to history. He recognized what I had perceived when I moved away from Philadelphia after high school: this history was largely unknown to the American public. We had earned David's trust, and thus the interview with Michael on the grounds that we were the ones who could do justice to the story.

I had watched Michael's videotaped deposition at age thirteen many times. (It appears extensively in the film.) During the interview and watching it later, one unshakable feeling was how similar Michael at age thirty-three was to Michael at age thirteen. If there was an emotional take-away from this interview, it was arrested development. Some part of Michael Ward was still trapped in 1985, the day his mother died and he escaped. While that can't really come as a surprise, now that I had met Michael, it was palpable.

The interview did have some factual take-aways. Michael seemed to give credence to one of the most shocking charges to be leveled at police: they had fired on MOVE members trying to escape the burning building. Michael's timeline, however, was far from clear, and it did little to resolve conflicting versions across the main witnesses. As time passed, versions of the story diverged and consensus became harder to come by.

We got our exclusive interview along with most of the others we were seeking. Each had strengths and weaknesses. The idea that the facts diverged didn't really bother us, as that was part of the point. This would work with the Rashomon-style storytelling we had envisioned.

5

Also early in the process, we discovered a major cache of archival material relating to the incident. The footage that wound up being the heart of the film was mostly housed at Temple University's Urban Archive. The Urban Archive is in the basement of Temple's main library in North Philadelphia. In the spring of 1986, the Pennsylvania Special Investigating Commission (also known as the MOVE Commission and featured heavily in *Let the Fire Burn*) concluded its administrative work. Their full collection of assets, including videotapes, transcripts, and the scale model of the block, were granted to Temple. This also included more than twenty-four hours of live news coverage that the commission had requested from the stations as evidence. The terms of this grant were memorialized in a memorandum of agreement, which compelled Temple to make the material available to the public while simultaneously protecting the copyright holder of any given photo or piece of video.

I had located a single source for the majority of the archival material that I would need to tell the story, but it was embroiled in a messy legal status. Temple had come to interpret that grant agreement to mean that the collection could be viewed in its facility, but not duplicated in any way. Temple's position was that to use anything in the collection for a film, I would first

need a letter from the copyright holder. For some of the sources, the newspaper photographs, for instance, this was not difficult. But the televisions stations (in 1985 independent local stations, now owned and operated by the major networks) wouldn't talk with me.

This was not a huge surprise because television stations are notoriously dismissive of independent documentary filmmakers. It's no mystery to see why; if you have a news station to run, the easiest thing to say to most people who call looking for footage is no. In this case, I would try to impress upon them that all I needed was a letter, no tape pulls or anything like that. Nevertheless, I generally was unable to gain any traction with any of the stations. The politics around this dark chapter in the city's history probably didn't help matters.

I learned some other things during this period about copyright law and investigative commissions. I knew that I was stuck, but my research had revealed the complex nature of that stasis. The MOVE commission was what is considered an extralegal body. It was empaneled by the mayor and had no legal standing to subpoena or indict. There is much less precedent for materials associated with an extralegal body than a court of law. For instance, had a court of law subpoenaed the videotapes from the stations, I would have been in a better, clearer position.

Moreover, the commission had ceased to exist in any meaningful way. There was no one to go back to and discuss the intentions of the grant agreement. I did speak to an elderly William Brown III, former chairman of the commission. He was upset by the deadlock I described. Paraphrasing: "They wanted us to bury that information in a mountain somewhere, but we insisted on housing it in the city, where people could access it, where people … could come along and tell the story." He was pissed, but he couldn't really help me.

One of the greatest assets of this project, the power and breadth of the archival material, had also become its biggest liability. Along with the expected challenges of fundraising and storytelling, the issue of accessing the news footage was at the crux of creating this film. For several years, it was a Gordian knot that we could not slice through.

6

The real breakthrough didn't come until 2007 when I joined the George Washington University School of Media and Public Affairs as assistant professor. It is impossible to overstate the difference that institutional support played in completing *Let the Fire Burn*. On a fundamental level, being a member of a faculty allows one the privilege to focus on creative endeavors that most people do not have. The stability and time my new position afforded me played a major role in getting the film done, as did becoming part of an intellectual community.

There were also more direct ways that being at GW helped me break through the barriers that were preventing me from telling this story—what I came to think of as the power of letterhead and lawyers. I suppose the proper word is *imprimatur*, but in practical terms I always thought letterhead and lawyers: the combination of dedicated legal services and the name of a major educational institution.

I think most artists, including documentary filmmakers, have a healthy distrust for large institutions. The very nature of bureaucracy is anathema to the independent artist. I felt that antipathy then and I still feel it. But to tell the story I wanted to tell, to do the work I needed to do, I had to overcome that feeling. In the years it took to work through all of this, one of the things I learned was a new way of looking at and working with institutions.

During some of the more difficult times, several mentors gave me similar advice that amounted to this: don't think of the time passing as wasted; instead think of it is the time you are using to grow into the person who can make the best possible film. The entomology of that word *imprimatur* is from the Latin. It means, literally, "license to print." The fresh-out-of- film-school filmmaker who began work on *Let the Fire Burn* would probably have resented this whole idea. I believed then that the gatekeepers should just let me in. Looking back, I realize my mentors were right. I learned a lot of things along the way, and did have to grow into the person who could make the film.

7

With access to the Temple archive and the financial and legal boost of GW propelling me, I cut a new trailer and began a new round of pitching and fundraising to complete the project. A major milestone in this effort was being accepted to IFP's Independent Film Week. Formerly known as the Independent Film Market, Film Week is one of the biggest opportunities in the world to introduce new films to potential industry partners.

The heart of the event is a series of meetings with funders, distributors, agents, and programmers. Often likened to speed-dating, this is a potential-laden but arduous process of taking fifteen-minute meetings in which you rush against the clock to describe your film, gauge interest, and get feedback.

Fifteen minutes is not a long time, and this all becomes a bit of a brain scramble, but some themes did emerge from this series of quick meetings:

1. There was great potential in the story and it was compelling to buyers. Many of the people I pitched to had some knowledge of the incident, but displayed surprise that it has not had a bigger historical impact, that a film had not already been made, or even just that twenty-five years had already passed.
3. The traditional historical style, even as it was expertly rendered in a film such as *One Day in September*, would not be marketable in the independent film world. Television might be a different story, but if I were trying to make a film, talking-head interviews interspersed with archival footage (the format of the trailer I was pitching at the time) would not sell.

This feedback came out through a pattern of conversation that became strangely repetitive in my time at Film Week. A commissioning editor would watch the preview, seem mildly

interested, and then seem to mentally check an internal playbook and ask the next question in the flowchart for a historical doc pitch:

"What makes it relevant?"

I would begin to answer that question in a literal sense and terms that I thought were appropriate. The story of MOVE is relevant because eleven people including five children died in an act of state-sponsored violence in a major American city, and many of our citizens (particularly those young enough to have not lived through it) are completely unaware that this ever occurred. It is relevant because innocent people, including children, continue to suffer and die around the world due to political violence, prejudice, and dehumanization.

Usually around this point, the person I was meeting with would interrupt. Yes, that was all well and good, but what they really meant by relevant was whether there was going to be an element that felt more like reality television. There was a trend in historical documentaries at the time to blend traditional historical elements with present-day observational scenes. Would the characters be reunited on onscreen or return to the place where the events occurred? This is what the buyers were really asking when they used the word *relevant*.

Film Week is designed to vet a project and help a director hone it for the marketplace. I got a lot of positive feedback on the pitch, but also had to work through the criticism. I concluded that, regardless of my feelings about the inherent relevance of this history, I had to accept the overwhelming diagnosis of these professionals that traditional historically documentaries were not currently marketable on the big screen.

Their overwhelming prescription, however, seemed like a shortsighted trend. It felt voyeuristic to seek access to subjects in the present when the heart of the story remained uncovered in the past; I remained confident of that as a storyteller. It was relevant because it was relevant, not because we had HD vérité footage of a survivor crying while they did the dishes twenty-five years later. There was enough history here for more than one feature film. It could be told factually and dramatically in a creative way.

So I borrowed some money and hired an editor.

8

My first mentor in documentary filmmaking said something toward the beginning of our relationship that always stuck with me. "Making a documentary film," he said, "is not that complicated. It's just about one million decisions." He paused and added, "Well, maybe eight hundred thousand." I think there is something to that, but also that the decisions are interdependent and not all of equal importance.

Choosing Nels Bangerter to edit *Let the Fire Burn* was certainly one of the most important decisions I made in creating the film. The role of the documentary editor on any documentary (let alone one made solely of archival footage) is monumental. Editing is pretty much the key to documentary. There are no great documentaries that aren't well-edited, not even many good ones. It's just not possible.

Part of the nature of the collaboration between an editor and director is bringing "fresh eyes" to the material. Although this works in different ways on different projects, the director, in general, has been exposed to the footage, the characters, and the story more than the editor has when he or she comes onboard. In this case, Nels likes to point out that I had been wading through this material—both archival and interviews—for nearly a decade by that point, and then he came onboard and reviewed everything we had in about three weeks.

We met then to discuss an approach to editing the film, and it was Nels's suggestion to leave out the interviews and make an all-archival pastiche. As I remember the conversation, it was almost like we had to dare each other to make this bold creative move. I recall asking, "Do you think you could make it work?" And him replying, "Would you really let me try?"

Ultimately we decided to try it because the creative risk and opportunity cost were low but the potential ceiling was high. If we could accomplish something different with this unique collection of archival material that did justice to the history it represented, it would be something special. If we couldn't make it work, we felt it would be clearly obvious. We were confident that this approach would either yield an innovative film or fall flat on its face. There wasn't much middle ground and we thought we would be able to spot a face-plant.

Conceptually, there were many reasons why this technique was possible for this film, but it would be wrong to suggest that we realized and understood them all when we decided to cut the film in this style. Rather, we decided to attempt this style and in the process of cutting it we discovered a filmic language and embraced it.

9

There is an adage in documentary filmmaking that the final step in making a film is screening it for an audience. It is the audience who then explains to the filmmaker the film she or he has made. The first public screenings of *Let the Fire Burn* were unpublicized sneak previews at a wonderful film festival in a medium-size college town. Early in the week, I had the opportunity to do some developmental mentoring sessions with experienced filmmakers and film industry people. It was in these sessions that I began that final step of understanding my own film.

Whether I realized it or not, I expected the film to be met with anger or at least some tense emotions. This is how the subject of MOVE had always been in my life. As a child, if there was one constant on the issue, it was anger and disagreement. While making the film, I faced a raft of resistance, especially in Philadelphia. Now, a well-respected filmmaker and grant maker was telling me that my film could be screened in communities in crisis as a discussion-starter. I had not yet seen the film with an audience, and I was dumbfounded. For me, this issue had always been divisive, and here was an experienced professional telling me my film could help bring people together.

Then we screened, and I began to understand. I had been to other documentary Q&A sessions about controversial subjects, and seen filmmakers challenged for their choices and representations. I thought this would be aggravated by the provocative choice to leave out the very context and reflection that historical documentaries are known for, while assuming this "less mediated" approach would cause more angst from the audience to be directed at the film and myself. I was wrong. From the very first screening, the questions I received had very much the content I had hoped for, but their tone was completely different than I expected.

Audience members did seem angry in a way, but they also seemed sensitized, aware of the people around them and cautious of their feelings. It felt more like the immediate aftermath of a public tragedy than the arguments that happen after the dust has settled. People were contemplative and considerate, not exercised or argumentative. The film seemed to present a thin target to take shots at, and nobody much wanted to.

Even challenging questions were phrased with care and respect. In that first screening, the question of context and representation was raised in very much that tone. Paraphrasing: "In isolating this history and treating it more like a drama or morality play, you do not provide, at least in the context of the film, the tools that viewers need to fully understand events. In particular, there is no specific context of race relations nor are police in Philadelphia and the nation at large explicitly evoked in the film. Can you discuss that decision?"

It's a good question, and I was glad it was asked—and it continues to be asked in different ways and venues. There is a cogent critique there of the approach of the film, and a de facto defense of a more traditional and contextualizing form of historical documentary filmmaking. It is important that these debates about representation (in documentary film and otherwise) continue and I am pleased if this film helps foment them. Every filmmaking choice, and especially those that break from convention, carries both benefits and liabilities. We knew this as we were making the film, but now we were coming to understand how these choices played out; coming to understand the film we had made.

This kind of storytelling is often about drawing lines: what will go in, and what will stay out. At drawing the line where we did, very close in time to the events themselves, much more responsibility to contextualize the history is left to the viewer. That does have liabilities, but it also has benefits. The essence of what we were trying to achieve represents a more present tense experience of events. We believed that if we succeeded, the film would have an emotional resonance and create a need to discuss, interpret, and learn more. The first signs that this goal would be validated also came during that first week of screenings.

It was at the closing night party, a big rowdy affair, the likes of which I had not seen since my own college days. A young woman approached me, obviously having had more than a few drinks. Again, paraphrasing: "I saw your *bleeping* film!" She poked me in the chest and was slurring her words. "I can't *bleeping* believe that happened! I can't *bleeping* believe that happened and no one *bleeping* even knows about it! I called my mom, to ask if she had ever heard 'bout it and she never *bleeping* heard about it either! I can't *bleeping* believe it!"

This remains one of my most cherished reviews.

10

Nearly two years have passed since these events. *Let the Fire Burn* has screened at more than one hundred film festivals, had a limited theatrical release, then home video and public television. I get almost daily e-mails and tweets about the film. It continues to screen for public audiences and discussions with surprising frequency. I will soon visit Community College of Philadelphia to screen and moderate a panel looking back at events thirty years later. This will be my fourth visit to CCP, which has become a major home for the community engagement.

Some of this continued interest is due, in part, to such events as the thirty-year anniversary and Black History Month. Sadly, the last two years have also seen a number of incidents in the United States that are reminiscent in one way or another of MOVE. On the very day we opened the theatrical run in New York, the Boston Police had locked down that city to hunt for the marathon bombers. A year later, I was getting calls from reporters in Ferguson, Missouri, seeking my perspective.

Many comparisons, historical and current, come up in discussions following screenings of *Let the Fire Burn*. From Tulsa, Oklahoma, to Waco, Texas, the Danziger Bridge shootings in the aftermath of Hurricane Katrina, the continuing drone war—I encourage these comparisons, so long as they are roads toward more inquiry and critical thinking. No one anymore asks, "What makes it relevant?" I do have mixed feelings about that. In one sense, it feels nice to be "right" about the inherent saliency of the history; however, it is sad that this is so obviously the case because it argues against progress.

In the final analysis, there are a lot of ways to measure the success of a documentary. I like to think that at the highest level there is a sense in justice at play, even if it is not the highest sense of justice possible. Inarguably, an injustice occurred on May 13, 1985, in Philadelphia. Regardless of what one thinks of MOVE, its politics, or lifestyle, there is no justification for the damage done to life and property by the city of Philadelphia that day.

There is no repairing this injustice. The life destroyed cannot be restored. This was the fear and helplessness I felt at eleven years old. The world is not a fair place and a movie is never going to change that.

There is a second injustice when no one is held responsible for a preventable tragedy. Many would argue that those responsible for the fire were never adequately held accountable for their actions. There are examples of a documentary being influential in exonerating or convicting people, but this was never the direct goal here. It is important, however, to ask: Does the MOVE fire fit a pattern of a lack of accountability in America when police kill people of color?

Finally, there is a sense of historical injustice: the injustice that occurs when and if these events are not remembered and recorded as part of our history. This is the injustice I perceived at age seventeen when I moved away from Philadelphia and learned that my peers from other parts of the country were unaware of the MOVE fire. History is not what happened; it is what is written down, what is recorded, and what is shared about what happened. I would hope this is the yardstick by which *Let the Fire Burn* is measured.

JASON OSDER is the director and producer of the award-winning documentary *Let the Fire Burn*, assistant professor at the George Washington University School of Media and Public Affairs, and a partner at Amigo Media, a color-correction, postproduction, and training company. *Let the Fire Burn* premiered at the 2013 Tribeca Film Festival where it was awarded the prize for best documentary editing and a Jury Special Mention for best new documentary director. It went on to play in theaters across the United States and at festivals around the world, receiving accolades including three International Documentary Association award nominations, the Cinema Eye honor for best editing, and the Independent Spirit Truer than Fiction Award. The US broadcast premiere was on PBS in 2014. Jason was named one of *Filmmaker Magazine's* 25 Top New Faces of Independent Film in 2013. He is coauthor of *Final Cut Pro Workflows: The Independent Studio Handbook*, and creates online training courses for lynda.com.

8 FOR NO GOOD REASON

BY *CHARLIE PAUL, DIRECTOR*

LUCY PAUL—PRODUCER

THE PROCESS OF MAKING a documentary is what reveals the story itself—the hidden version of what you are exploring is what becomes the vulnerable and interesting part of your subject and film. If you are fixed in your approach, you are likely to miss the wondrous landscape that reveals itself during the journey. If there was a plan with our film—that was it! We took more than ten years to make the film and for the first five of those years, Charlie Paul, our director, had a completely free rein to see the artist Ralph Steadman whenever his diary allowed, and with no fixed agenda. During those initial years, his time spent with Ralph was entirely unhindered by production restrictions—capturing the creation of Ralph's art, his processes, his studio, his subjects and collaborators whenever and wherever it was possible. There was no specific agenda. Those visits with Ralph were part of Charlie's research on learning about his subject and exploring the occasion or event, however small or obvious the meaning of it may have been and were vital in shaping their relationship and trust in each other.

CHARLIE PAUL—DIRECTOR

I am fascinated with the creation of art, and have been since my fine arts degree at the Byam Shaw School of Art in 1984. In my final year there I played with the process of recording my paintings on film as a time-based medium, recording on film a blank canvass to finished artwork one brush stroke at a time. My final degree project was a progression of this process—a painterly animation consisting of cutouts and house paint being manipulated. This first film was frantic and hard to follow with fluctuating light and an unstable camera, but this experiment inspired me to design a method that

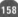

would allow me to cleanly capture the purity of this creative process, creating a bridge between films and painting that retained the integrity of the artist's decisions and exposed the journey the painting had taken. I was captivated by the results, and having found my niche I spent the following years developing relationships with a number of artists, spending time in their studios, gaining their trust, and capturing on film their art as they created it.

It was from these short film experiments that I gained a commission for a television series. Paul Ashton, arts commissioner at Bristish broadcasters Channel 4 recognized the potential of this new art form I was developing and funded a series called *Inside Art*, featuring the work of four contemporary British artists: Peter Howson, Eileen Cooper, Martin Jones, and Nicola Bealing.

Since I was a young punk, Ralph Steadman has been one of my favorite artists. I was introduced to his art through Hunter S. Thompson's novel, *Fear and Loathing in Las Vegas*, which I read in the mid '70s. I was captivated by the mark of his pen, the way his static drawings appear on the edge of going somewhere. They have energy. So over the years I followed his work book by book, of which there are many.

Ralph's endeavors to create space on flat paper results in him using an amazing variation of materials—photographs, photocopies, etc. Found objects are overlaid with pen and brush and then sprinkled with a splatter. I wanted to observe and capture how he creates these dynamic spaces, and discover his work through my filming process.

As an artist, Ralph is hard to categorize. He writes and illustrates books for children, guides for alcoholics, insightful studies of renowned artists, hilarious and satirical cartoons, and his own versions of literary classics. As a filmmaker, I was drawn to this diverse output and how they connected. Keen to meet him, I wanted to know what made him do all this.

I knew that Ralph loved photography, and I had read that he dabbled in capturing his own drawing process on film. This fascinated me and I wanted to see the footage. So I sent him a letter telling him about the films I was making, and asking if I could visit. To my amazement, a few weeks later I received an invite to visit Ralph in his studio at Loose Court.

I was so surprised at receiving Ralph's invitation and keen to meet him that I forgot to make an actual plan for my first visit. I wasn't sure what to expect, except that I wanted to capture his art using the process I had applied to my previous films. But I also knew Ralph's art was different from anything I had tried to capture before; he worked on paper, his line was unrehearsed and definite with little or no corrections made to the indelible ink, the inks sat in pools on the papers' surface, and his use of montage and sprayed ink often preceded the forming of the image Ralph was pursuing. Altogether very intriguing and something only my cameras would reveal.

I remember my first visit vividly. Ralph lives just outside a town called Maidstone, in Kent, an hour and a half from London in a part of the country called "the Garden of England," and Ralph's home is the epitome of this. As I drove in through the hidden gates, at the end of a secluded road, I was greeted by an enormous mansion surrounded by beautiful mature gardens, outbuildings, orchards, and ancient monuments. Sculptures of found objects welded onto

foreboding figures loomed from the undergrowth, with this physical juxtaposition of old and new reminiscent of Ralph's art. His environment "felt" right for the man I was about to meet.

RALPH'S REPUTATION AS THE "wild man of art" grew from his years associated with *Rolling Stone* magazine, Hunter S. Thompson, and the political and social causes he has championed in his art. He created angry, vitriolic art that illustrated the injustices in the world, focusing on the wrongdoings of anyone who abused their position of power—no one safe from his ascorbic pen. This is what apparently made him a dangerous man to be around.

The image of this person turned out not to be the man who greeted me at the front door of the imposing mansion. On first impression, Ralph is a gentle well-spoken Welshman, eager to please and mostly concerned for other people's well-being; he welcomed me at the front door with the warmth of an old friend and ushered me into a cozy kitchen for tea—this was to become our rhythm for the many hundreds of visits I made over the subsequent years.

Ralph is a family man, evident as soon as you walk through his door. Anna, Ralph's wife and partner in the Steadman Art Collection, presides over a house rich with the life and mess of children and grandchildren. Anna's role as Ralph's "keeper" in making sure he is safe, healthy, and on track is immediately evident. Anything however small involving Ralph must first pass by Anna. Appropriately, it was at the kitchen table where I explained to them both of my past projects and interests in Ralph's artistic output. Happy with my intentions, it was Anna who suggested, "Why don't you take Charlie into your studio." We left the kitchen, walked from the back door across the garden to Ralph's studio, and it was in this moment that *For No Good Reason* began. Upon the first step into Ralph's studio I knew immediately this was an artist I felt compelled to explore further, and a space I wanted to spend more time in.

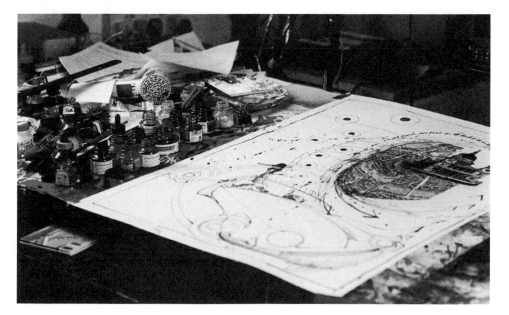

Ralph's studio is a stand-alone building a stone's throw from the back door of their house. It's a series of adjoined rooms each supporting different aspects of Ralph's output; the main studio space holds his worktable, and there is also a computer room, printing room, plan chest room, and photographic room. In these rooms are the tools that make Ralph's art possible. A photocopier, easels, drawers of paper and pictures, books, cabinets of memorabilia and inks everywhere. What makes this place extraordinary is the way in which it has become so complete in its representation of Ralph's output over the years. As you discover in my film, almost every drawing and photograph Ralph has ever produced is in a drawer somewhere in his studio. Within minutes of my being in

his studio, Ralph is rummaging through these perfectly preserved pictures with the relish and speed of a possessed man. I am seeing and able to touch, for real, the art I have seen in the publications of his that I treasured: *I Leonardo, Treasure Island, Alice in Wonderland, Curse of Lono*—drawer after drawer of original art. I was hooked and wanted to see it all. Ralph's attention was waning and the need to throw some ink around took him to his drawing desk.

Ralph always draws at his same desk, which is a large wooden surface tilted at a gentle slope toward him and his inks within easy reach, pots of dirty water and rags in a beautiful chaotic mess. The walls around are splattered with the remains of his signature flick of the wrist. Watching Ralph paint for this first time confirmed my thoughts that I somehow had to find a way to record onto film him creating. We talked as Ralph painted, and as the picture developed so did our relationship, plotting the next move, discussing Ralph's technique and intentions, and all the while I was thinking about how this might translate to film. The day disappeared, Ralph had exhausted himself and so we agreed to continue our conversation another time. As I was collecting my things to go, something extraordinary occurred. Ralph disappeared into the back room and returned carrying a cardboard box of what looked like archive tapes. He offered them to me, saying, "Here, take a look at these, but you must return them…" I thanked him, said my goodbyes to Anna and the family, and left clutching the box, feeling slightly confused by this gift he had entrusted me with

That turned out to be the beginning of a fifteen-year filmmaking process. It was the spring of 1999.

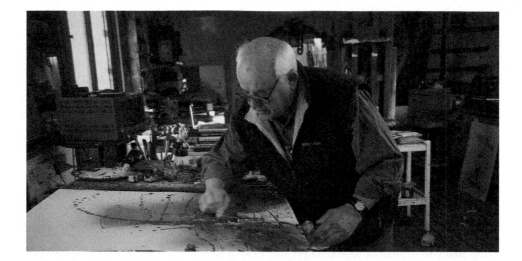

Back at my studio in London, I explored this treasure trove I had been entrusted with—hours and hours of tapes, around eighty in total, filled with Ralph engaged in various activities: puppeteering; throwing ink around; footage from above his drawing desk as he worked; film of him around Loose Court with friends; fooling around with Hunter S. Thompson in Owl Farm; Bill Murray and Johnny Depp in Aspen, Colorado; making paranoids with Richard E. Grant; and much more. Through this archive Ralph's history was opening up to me, with his life and the experiences that inform his art unfolding in these films. It triggered a desire within me to delve deeper. This archive was the catalyst for further conversations with Ralph, an excuse to go back to Loose Court and begin my own exploration into the making of his incredible art. I had fallen upon an opportunity to look beyond the canvas into the darkest recesses of Ralph's warped imagination.

My first attempt to capture Ralph's art-in-progress as he created was on a 16 mm Bolex camera, which I suspended above his worktable. Digital photography was in its infancy and not proven in its ability to capture the texture and feel of paint I was looking to capture. Also, digital cameras were still very expensive and I had no budget as such in the early days. The film approach, of course, looked great, but it was not going to allow me to keep up with Ralph's prolific daily output. And the expense of developing and transferring the footage to video meant I had to find a low-cost and low-maintenance alternative.

The first piece of art Ralph produced for my 16 mm film camera was an image for a newspaper article written about the traffic congestion on the M25 motorway—the London ring road. This picture was later used on the cover of Ralph's post–Hunter book, *The Joke's Over*. The picture consisted of photocopies stuck down, with ink and paint creating a circular swish that led to a car driven by Hunter S. Thompson and a typically petrified Ralph in the passenger seat. As I had hoped and predicted, capturing Ralph's every step of creativity by stop-frame on film described his artistic process perfectly.

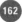

On my next visit to Loose Court I positioned a camera above Ralph's drawing desk, with a filming unit of my own construction. This consisted of a Nikon D200 digital DSLR camera, mains adapters, daylight balanced florescent lights, and a hanging shutter release cable (a one-button unit). One switch was by the drawing desk, which, when switched on, lit the whole space and primed the camera. Then all Ralph had to do was take a single digital frame when he came to a natural pause during the creation of an image. With his understanding of cameras, Ralph adopted the process brilliantly.

For the next few months I would visit Loose Court every couple weeks to refresh the overhead camera's memory card and chat about what Ralph had been up to recently. The previous week's frame sequences became a portal into what was occurring in Ralph's studio on a daily basis and the catalyst for informed discussion. I was able to explore Ralph's perspective on life, translated through his art, and use these new paintings to remind Ralph of historical works that covered related topics. Ralph likes to keep things and is a staunch guardian of all his original art. We would spend hours looking through his enormous archive in the many plan chests under almost every surface in his studio.

To have such comprehensive access to Ralph's original art was a biographer's dream. Images familiar from cleaned-up publications took on a whole new meaning when seen with all the workings visible, and whole collections of paintings burst from the paper with new colors, textures, and detail, and the actual touch of the author was legible for the first time.

Filming the pieces of art using angled lights to describe surface reliefs revealed the strength and direction of Ralph's every stroke and gave these heavily worked A1-sized paintings a whole new dimension. I wanted to record these beautiful surfaces as the eye would see them, as if you where holding the paper in your own hands and holding it to the light. To achieve this, I needed to move the camera around the art. I decided to shoot all the original art on 35 mm film; I believed it was the only medium able to record this delicate light at play as it reflected off the surface of pooled Indian ink with carbon scribbles on top.

Another reason for the choice of film owed to the fact that Ralph's art consists of dark areas of ink surrounded by large expanses of white paper, hatched with the lattice of Ralph's fine pen work. These were difficult images to capture, with sometimes more than eight stops of film latitude between the brightest and darkest exposures. So, to make the most of the textures and to avoid exposure issues inherent in the digital cameras of the time, film seemed the only option.

To capture the irregular surface of these materials on Ralph's art paper I needed to film the pictures from a severe angle with soft directional lights reflecting off the contours and into the lens. I also thought the camera's lens needed to travel over the surface with a shallow depth of field (sharp focus foreground with a soft focus background), allowing the camera's movements and specific focus to take the viewer's eye to the relevant part of the image. This method allowed me to show the audience as near an experience of viewing art as possible, as if you where actually in front of it, inspecting the contours and textures of the work and only focusing on the bit that captured your interest.

Using a motion control rig was the only way to do this with preprogrammed camera moves timed to work alongside already recorded conversations with Ralph. This became the purpose of the film's rostrum camera, to show in pictures what Ralph was saying in words. So it was simply a matter of visiting Ralph's studio and recording stories, pulling out the art that was relevant to those stories, taking it back to my studio and filming motion control sequences that complimented the audio from that day.

I was keen to capture new footage using old cameras and obsolete formats that were of the period from the story Ralph was recounting. Super 8, 16 mm, and 35 mm cine film was combined with Polaroid and film still sequences to create a genuine reflection of the way Ralph would have used the medium of the day. This was particularly challenging with the *Paranoids* section, in which I was shooting with 35 mm film using motion-controlled animation of a Polaroid-developing picture that often did not appear. This is because I was using original stock that had been obsolete for many years and has a short shelf life. These differently shaped clips would then be processed and transferred to the film's digital format, cropping them to a 1:185 picture area for cinema release.

The "original format" concept is seen in the opening sequence of the film, as Ralph exclaims "What we are doing here?" the sequence takes the audience through the evolution of formats from celluloid to digital starting with Super 8, and progressing through 16 mm, 35 mm, videotape, and Mini DV before settling into a current digital format.

These self-made rules and routines helped me put a shape to the way I would approach Ralph's art and his stories, and gave me a process from which the film's language could evolve and create something more than a journalistic approach to the challenge.

SCRIPT

There was no agenda set for my visits with Ralph. We rarely even had a plan. A typical day began at around 10 a.m., with a greeting by Anna in the kitchen with a cup of tea. Ralph would then escort me to his studio, where I would unpack my cameras and we would pick up from where we left off on the previous visit. Easily distracted, Ralph would show me things around the studio—his latest drawings, requests for new work, e-mails from friends, colleagues, family, and commissioners. We would chat to friends via Skype. I would rummage around the studio for pieces that were of interest, all the while recording our ideas and conversations. Then we'd break for a long lunch after which we would return to the studio for further exploration and creativity until the early evening. I would return to London with a nugget of something I hoped would make a contribution to the bigger picture.

Whenever I interviewed Ralph about his life, he would recount small snippets of his past, but rarely the episode or story I had inquired about. Ask him to repeat it and he will tell a different story altogether. So as a biographer it was both a positive and a negative. It meant that over the years if the same story kept simmering to the surface it was important to Ralph and deserved a place in the film, but at the same time I was able to pick up random stories and place them into context with his whole story. I wanted to craft a theatrical experience that mirrored the diversity of Ralph's personality, art, photography, music, experiences, and all from one location—his studio. This way of picking up haphazard stories in interviews became an ideal approach in reflecting Ralph's manner of conversation, and informed the way I was to visually complement the audio throughout the film.

Most of the film work was done during the morning of my visits, since following lunch Ralph tends to become easily preoccupied with the day's events: radio news, newspapers, phone calls, etc. We would amuse each other by approaching the day's ideas with a blank piece of paper, cameras poised to capture the start of a picture and then film it in its creation, all amid such distractions as the grandchildren running through the studio, visitors dropping in. and phone calls from friends and work colleagues around the world. As these other things sidetracked Ralph, I would find myself gently guiding him back to the piece of art in progress of creation. If Ralph was not in the mood to create new art, we would go through his archive.

It would give Ralph immense pleasure to pull out his archived pictures, these snapshots of his history. We would talk about the intention of the drawings, and what it meant to him at the time of creating them. Photographs, publications, memories of assignments with Hunter; over the years Ralph would tell me time and time again the same stories and then occasionally there would be a new element to the episode, and sometimes new images or recorded archive would reveal itself, triggering a thought in my mind of a previous link and something I could connect to the elements and create a bigger segment of the story. It was like stitching a patchwork together.

An example of one of these chance discoveries is the day Ralph produced from a dusty drawer a drawing called *New York Bum*, and I noticed a series of photographs had been pasted onto the drawing. I asked Ralph where they came from, and this unearthed a perfectly

preserved stack of negatives containing one thousand pictures of New York, taken by Ralph on his Minox miniature still camera during his first visit to New York City in 1974. This was the week before the Kentucky Derby and his initial contact with Hunter S. Thompson, who was to become a lifelong friend and collaborator. These lost photographs perfectly illustrated and reflected Ralph's American search to capture the dark side of the city and inject social comment into his drawings. Scanning these negatives gave Ralph the material to recount in detail his intentions and the memories and events that led to these extraordinary photographs being taken. These images gave me so much material to edit and eventually created a stand-alone segment in his slowly evolving story. Music was then written and performed to the edited visuals of the photographs and audio of Ralph's voice telling the story.

This pattern became the journey the film took, one finished chapter was put aside in pursuit of the next unique passage, the weeks passing to years with the film slowly growing. It was punctuated by 9/11, the invasion of Afghanistan and Iraq, earthquakes, oil spills, elections, and the suicide of Hunter. Ralph would always greet me in the morning with fears of the future, and we would go into the studio and try to put these woes onto film and paper.

Over the years of my filming in Loose Court there were many visits from friends, colleagues, and acquaintances that by chance coincided with my visits, and at the same time triggered new areas to explore in my film. Many of the visitors—Tim Robbins, Will Self, and others—that were captured by my camera did not find a place in the film, but these regular visitors gave Ralph new impetus to create flurries of work. During the years there were also long periods when Ralph did not want to work, especially after Hunter killed himself. These quiet periods would allow the dust to settle and give Ralph time to recover from some of the demands the filming created. This was the most relaxed production period for the film and gave the filmmaking process a natural pace that reflected Ralph's life as it unfolded. As this was not a commissioned production, the relationship between Ralph and I was the only driving force behind the film's progress. And neither of us were keen to finish, as it would mean the end of our time together.

BACK IN CHARLIE'S STUDIO

Throughout the process of filming at Ralph's studio I had continued editing the materials back in London in order to isolate and develop some of the subject areas I was going to pursue. The task: deciding on those subjects worthy of the timeline needed to reflect Ralph's art across the wide spectrum of his output, as well as including key publications and his meaningful work relationships. Once we had established which key stories were important for the film's storyline, it was a matter of finding Ralph's art that visually supported these episodes. Studio rostrum sessions and motion control shots were loosely stitched together using After Effects and Final Cut pro as my primary editing tools. The editing process allowed me to realize what was visually necessary, to create an engaging and relevant pictorial landscape to accompany

Ralph's incredible stories. Sometimes it felt necessary to create additional sequences by building small sets and filming scenarios in my London studio space. By using my motion control rig I devised camera moves that could literally fly around these fabricated scenes, creating worlds that have their own filmic attitude, much as Ralph's work. An example of this visual fabrication would be the recreation of the America's Cup. The story as told by Ralph involves rowing with Hunter over to the bow of the *Gretel* in order to spray "Fuck the pope" at the waterline, fleeing when spotted and then letting off distress flairs in the harbour. Because the entire adventure was a disaster, nothing was written or drawn at the time so a full recreation was staged using a rowing boat and a cardboard pontoon. The sea was created using cling film. These reconstruction scenes were fun to imagine, construct, and shoot, and in some way gave me an understanding of moments in Ralph's life. All the key artifacts and items from Ralph I would take from his studio to my own studio to record them. This allowed me to explore and reinterpret them on film and immediately fit the sequence into the time line of the edit. The shooting and editing processes ran alongside each other.

I came to filmmaking from painting, and like many artists I like to surround myself with my creative tools. I began work on *For No Good Reason* in my photographic studio in London where I could create, paint and film utilizing a variety of different techniques and ingredients, using the specialist cameras, lights, and materials selected for this particular project. It proved to be an invaluable in allowing me to glue the film together using the same process Ralph would use as an artist, making a montage of different mediums with found and familiar objects gathered from all aspects of the story, creating a physical bond between the film and its subject.

The manipulation of physical materials using light and film to create a time-based art has fascinated me throughout my time as an art college student and subsequent career. Animators such as the Czech surrealist Jan Svankmajer, who combined Claymation with the real world to create a surreal landscape, influenced the work of the Brothers Quay and others. Filmmaker Ray Harryhausen created armature-animated characters that seamlessly interacted with their environment to form incredible action scenes. Filmmaker Georges Méliès created amazing in-camera effects in his daylight studio, using the simplest of film-editing techniques. Nick Park, director of *Wallace and Grommet*, took the voices of ordinary people and re-imagined their characters in Plasticine. Terry Gilliam's film *Brazil* took us to a richly textured apocalyptical future, while Aleksandra Petrov painted incredible animations using oil paint on glass. These pioneers of filmmaking merged art and film to create a new world within film that today still resonates with me—and incredibly, without the use of computer-generated assistance. These were some of my art school/film influences and they allowed me to believe that as an animator I could seamlessly incorporate fantasy and the real world.

EDITING

After I had found the New York Minox photographs and selected highlights from Ralph's archive, created numerous time-lapse sequences and filmed key pieces of art, I felt all of these things revealed themselves to be worthy film clips for the direction of the story. I cut a trailer from these to show the BBC. The trailer attracted strong interest for commissioning as an episode of a documentary strand. I believed this was a singular project and that the assets where rich enough for a theatrical experience. It was a tough decision, but my producer was brave enough to allow me to continue trying to make a stand-alone ninety-minute feature film that would be built for cinematic distribution. This is where our naivety began to affect the production; it's one thing to have a hobby with a friend filming artistic episodes and spending your spare time and cash creating a superb off-line edit, but committing to a feature film is committing to a much bigger beast. To confirm with ourselves that we had the subject and material for a feature film, we had to find an editor with the experience to agree it could work and then make it happen. After much research and many interviews, we found our superb editor in Joby Gee. After viewing some of the rushes, Joby showed an interest in the film and wanted to come on board. He began viewing the hours of amassed footage and archive, and attaching them to a feature film time line, the duration of which was ninety minutes, but the journey of the film was far from decided.

We now had an editor committed to the project, but in my mind we hadn't finished actually shooting the film. So over the following two years we edited in blocks, mostly of about ten weeks interspersed with the opportunity for me shoot more footage, either of reconstruction with Ralph at his studio or of his art in my studio. This process inevitably highlighted certain

holes in the plot as we worked together. Joby would then have to move to another editing project and I would be able to shoot more footage to fill in some of these undeveloped areas. Joby would then return when next available, and we would update the time line with the newly shot footage. We spent the edit time we had together building these beautiful sequences from Ralph's stories and the images that accompanied them, but as a whole film experience it needed something more solid to hang these stories from and an emotional arc. One of the many great talents Joby brought to the process was a clear overview of the audience's journey along with his keen sense of rhythm and pacing. What had become very separate sequences in an extremely interwoven time line following Ralph's life, had to be re-positioned, resulting in the creation of a new time line that corresponded with the release of Ralph's books in tandem with his relationships and his work with Hunter set within a weekend visit from Johnny Depp as guide. It meant we could keep many of the sequences we had previously created but reframe them within the new context. I felt this new time line gave my potential audience a direction in which the movie could continue to flow.

Finding the original master negative, tape or files, and tracking down the relevant copyright holders and securing permission to use the material was not always possible, so it was sometimes necessary to find alternative footage or do the best with what I had. Initially, when I was cutting some of these diverse materials together, I was approaching it in a factual filmmaker's way, juggling limited resources and researching alternative possibilities. But having my own film studio I was able to create new footage and I began to approach the challenge of historical reconstruction as an artist and not a documentarian. This removed the shackles of reality, and therefore the rules governing standard documentaries. I was now making a docudrama.

From the outset of this project I wanted the focus of my film to be on the audience's appreciation of Ralph's art, since this is what drew me to the subject in the first place. I didn't want to stray into the familiar documentary film territory of the subject's personal history leading the film. His art needed to be center stage. So instead of beginning the film with Ralph's parents and where he was born, I chose to start the film with his first publication, and discover Ralph through his art and artistic output.

Ralph is a great story teller and throughout the production of the film, he would reveal his stories. There were stories within stories, and Ralph's art within Hunter's stories, which all had to appear within the framework of Ralph's life. Using the premise of a weekend in Ralph's studio to frame the exploration of his work allowed the film to move through time without getting lost in the twists and turns of life. So even though we didn't start at the beginning with Ralph's birth, the journey involves *I Leonardo*, 1960s America, and Hunter S. Thompson's memorial in 2005; all segments appear chronologically to the date the art was created in Ralph's studio.

All along I wanted to replace my presence in the studio with a visitor, someone who could assist the weekend visit storyline by receiving these stories and occasionally point Ralph in the right direction. For this role we chose Johnny Depp, a long-time friend of Ralph's and the guardian of Hunter's estate. I knew there was chemistry between the two and felt

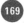

the audience would appreciate seeing these two characters enjoy each other's company. So after many months of negotiation and arrangements, Johnny came to Loose Court for filming.

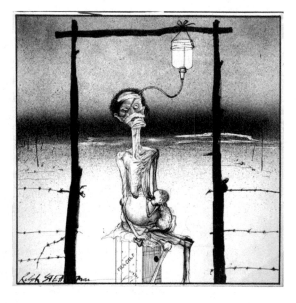

Shooting in Ralph's studio with Johnny was a dream come true. The two had shared so much history, and even though Johnny knew Ralph's work intimately this was the first time he had been to Loose Court, so everything was new, yet familiar to him. The shoot agenda had been planned around the edits already done. Ralph's publications where laid out in order of appearance, and the props and art were prepared in advance so that ten years' worth of previous investigations could be delivered to the set in one weekend. Johnny, being the ultimate professional was a priviledge to work with. Unlike any of my previous filming sessions with Ralph this shoot schedule was specific and required Johnny to gently keep Ralph on track. Johnny understood the demands of the limited time we had with him, repeating lines to fit into conversations that had occurred years earlier. The weekend flew by as Ralph and Johnny wandered around the grounds, rummaged through drawers, and dug out familiar art. An enormous amount of footage was shot that weekend. Everything fitted seamlessly into the cut's continuity, as Ralph's studio had changed very little in ten years of filming with him. Ralph even wore the same woolen waistcoat.

MUSIC

Throughout the film-making process I wanted the accompanying music to be a driving force within the film. My love of nearly all genres of music helped me find tracks that worked really well and sometimes Ralph's art suggested unexpected musical ideas. When I first saw Ralph's Minox prints from New York I had noted images from an out-of-town bus arriving in the city. These photographs immediately brought to mind Stevie Wonder's brilliant track "Living for the City." The song starts with the audio of a young man getting off a New York bus and engaging in conversation with some shadowy figure. This combination of music, story and atmosphere was the soundscape I needed to lay out the plot that dictated the order in which the photographs appear in this segment. Starting with the bus pulling up and passengers sitting in the bus, the blind man with his dog watching the bus, and so forth. Without this audio plot all I had were one thousand random pictures, but with this track as a guide I could tell the story of Ralph arriving in a bus on his first trip to

New York City in search of the New York vagrant. I must add that at this point in an edit, as a director, you need to look at the possibilities of clearance before you get too attached to a song. In this case "Living for the City" was not an option for our available budget. Certain tracks came to the edit this way while others were introduced to the film by Joby as suggestions for experimentation. These included two tracks from the band Low. The sentiment and musical structure of *"Point of Disgust"* informed the edit and the words suggested the images and how to present the message I intended for the human rights section of the film In another track from Low titled "Lordy" that I used in the final scene, I found the perfect frenetic quality in the music to accompany the energy of the picture edit. This last montage of art shows the vast quantity and the character of work Ralph created over his life time. I wanted the pace in the final scene of the film to be visually and musically opposite to the meandering, inquiring opening sequence.

Some of the other tracks were composed specifically to the picture edit. An exclusive visual section was sent to the selected musician for their musical interpretation.. This is when the music director, Sacha Skarbek, became an invaluable player in the film's production. Ed Harcourt, Joanne Perrica, Thom Crawford, Lucinda Belle and Slash all contributed by receiving cut footage and interpreting musically what they viewed in pictures. Working with Sacha and these musicians in this way created tailored tracks, that in my mind delivered perfect visual and audio synchronicity. Further recordings where scored by Sacha and recorded by an orchestra in, Nashville or laid down by session musicians in his West London studio.

The film was looking and sounding tight, and flushed with excitement and anticipation we entered the off-line edit of *For No Good Reason* into the 2012 London Film Festival. Without BFI support and no industry track record, to our surprise it was accepted. Securing the funds and completing the film from picture lock to DCP for the premiere in the three months available was a huge challenge for Producer Lucy Paul. Firstly we had to source all original materials and with some of the film clips going back more than ten years, much of the logging was incomplete and inaccurate making the conform a difficult process. We had a complex grade, a title sequence to create, sound design and remix, tracks to formally license, finalize contracts with contributors, insure and indemnify the film and produce all the relevant paperwork required. Without these back-end requirements in place we would have been going to market with an impossible film to sell. Along side this Lucy handled the publicity creating all the literature, biogs for key talent, press kit and marketing merchandise for the premiere and all to the standard and integrity that matched the film's production values. This was to be the most intense period of the film's production.

POSTPRODUCTION

Throughout the making of this movie the process of filmmaking changed. What was a film-dominated medium became a digital-dominated one, and the irreversible change was something of which I became very aware. Not only was I finding it harder to manage my

own film stock, I also had to incorporate previously filmed materials from Ralph's archive and other sources. Film and photography have a habit of being passed around and incorporated into other people's histories, and often your original source for a film or audio clip have no clearance rights to pass on. Securing the rights to use materials in a movie is a slow and painful experience, and the more you hurry the process, the more painful and expensive it gets.

Throughout the cleanup and postproduction process I wanted Ralph's art to inform the final look of the film. Ralph will take an anatomical drawing, run it through a photocopier to warp it, and mount it on a canvas and paint around it. He will blow fine dust and splatter ink, scratch and draw over it, and in the end what you get is this multilayered picture of juxtaposed images that engage you in a complex visual journey. I wanted to create the same combination of textures using all these different film ingredients. I wanted all these different qualities to be seen in the film with all their inherent glitches visible—film grain, editing tape, scratches, and flare all preserved in the cleanup process and included in the final print. I felt this unique fingerprint of paper and celluloid was soon to be banished from film production by digitization, but to me it was such an important part of the character of Ralph's film. It's what makes Ralph's art so wonderful.

All along I wanted to create an opening title sequence that offered the audience a chance to settle down and enter the spirit of the film. I also wanted to create a sequence in a fictitious space, intended to be a warehouse full of Ralph's forgotten memorabilia, while revealing real elements and props from the film, creating an epic motion control camera move while shooting on 35 mm film. I wanted to bring to the audience the question, was this is a movie or was this a documentary?

The title sequence became a homage to celluloid, starting the shot on the punch hole on a 35 mm negative (used to locate the first frame of an exposed roll). The camera follows the 35 mm negative to a 35 mm positive print, then onto 16 mm cans of Ralph's archive (rushes from Mike Dibb's film *I Leonardo*). Here the journey picks up a strand of 16 mm print from my first time-lapse of Ralph's art. Passing through a Rank Cinema delivery docket we continue on to a single strand of Super 8 film that, in turn, takes us to a Super 8 film viewing box, and finally arriving at the splicing and editing process. Following the Super 8 rushes from when I first interviewed Ralph and asked the question, "So Ralph, what are we doing here?" (these words were later rerecorded by Johnny Depp), we then see Ralph's response to the question filmed on Super 8 print stock, but this time refilmed from the viewing box onto 35 mm negative film (new stock) as picture in picture.

This sequence alone contains scores of elements that are relevant to the film that follows. Everything on the shelf has meaning and everything connects to the film to create a history from which to draw these new stories—Hunter's golf ball typewriter; letters and first publication with Ralph; William S. Burroughs's Polaroids; Ralph's cameras, pens, and brushes; instruments; books; and even a McGuffin (Alfred Hitchcock's parcel that is never explained) are all glimpsed as fleeting suggestions to the film ahead. The production time taken to create

this opening segment took a week to build light and shoot in my studio in London. It was shot on a single roll of 35 mm and makes me happy every time I watch it.

As delivery of the film to the London Film Festival rapidly approached, clearance issues continued to rattle my producer. The montage of Rembrandt self-portraits were originated through the Internet and when we tried to find high resolution reproductions of the paintings, all turned out to be owned by various people all around the world. Then after locating the owners we had to negotiate a deal to purchase these files, as well as the rights to have them appear in the film. Some images were not available so the edit had to be changed to remove the images not available and accommodate those that we could source in this high-res format. It was a messy and protracted affair but I was determined that this segment would be of a quality that best resembled the original art, and I really wanted to create a rich cinematic content that didn't dip into low-res archive. This same approach had to be made for all pictures included in the film in addition to video and film archive from many sources. This and many other unforeseen issues created a wealth of nightmares for the producer throughout the final weeks of completion.

Archive audio was also causing last-minute complications. The answer phone messages Hunter had left on Ralph's machine in the early '80s existed on an obsolete audio cassette that could only be played on the equipment it was originally recorded on. This then was rerecorded and cleaned up, a process that required hours sourcing Dictaphones and answer machines from thirty years earlier before we could include these sound bites in the final movie. Even my own filming endeavors often had to go through heavy postproduction, as quite often in the early days of filming I didn't have a professional crew and sound equipment; the cameras I used were not crystal-locked and were internally noisy, and the film often had no sync reference marks and were separated from the audio by years of logging neglect.

Amid all these unexpected costs, to finish the film on time Lucy had to negotiate a deal with a postproduction house that could handle this volume of work in such a short amount of time, and for me there was only one company that could finish it to a standard I had become accustomed to in my advertising career. That company was Rushes Postproduction in London's Soho. This outstanding postproduction house had the capability to transfer all film formats to digital 2k, had machine rooms that could handle the vast amount of raw and JPG files that contained Ralph's art, had London's top colorist Simone Grattarola to grade the film, and the gifted Flame operator Brian Carbin to seamlessly stitch it all together as a single full resolution cinema print. The film was almost complete for the big screen, but Rushes Postproduction only handle picture, which meant I now had to find a re-recording mixer and after all the effort put in to date, only the best would do.

Luckily for me my brilliant producer, Lucy managed to negotiate a deal at Molinare in London who successfully handle many feature documentaries. There was a lot to be done in a very short time. This included ADR with Johnny Depp reading Hunter S. Thompson's writings; balancing recordings of original string scores recorded in Nashville and tracks created by original artists Slash, Jason Mraz and Tristian Prettyman, Lynval Golding, Ed Harcourt,

Thom Crawford and Joanne Perica, and Lucinda Belle: orchestration by Sacha Skarbek: debugging my terrible sound recording over the years; and creating new voice-overs and extensive foley that only became apparent once the film was finished. This was all brilliantly done by the multi–award-winning George Foulgham and his assistant Nas Parkash, and in record time and to the highest of abilities.

There are many unforeseen elements to gauge the work-load of post-production required on a documentary. One unexpected example was the way Johnny Depp delivered his read of the Kentucky Derby. Brilliantly, Johnny's experience has taught him to read these long passages with gaps between each word; this allows total control for the audio re-mixer to edit and remove the air between each word, creating perfectly pronounced passages that read at the speed and tone that Hunter would have talked, and without the slurs and stumbles. This approach was a revelation to me and a seriously positive word-editing aid when it arrived down the wire just before our final sound session.

So here we were at the final stage of completion on our film we had financially managed the edit, the online, the audio, and making of a DCP to premiere at London Film Festival in order to find a distributor. It is a very costly and difficult place to find yourself with a project for which you want the very best. Even the budget for the wrap party to adequately reward all the cast and crew who did so much for so little had to be found before we could secure a central London venue in which to hold it close to Leicester Square where the premiere screening was due to happen

The funds to cover these costs had to be secured prior to any financial returns from a buyer/distributor. Fortunately for us, because of Ralph's existing profile and our substantial marketing efforts, we had a superb launch at London Film Festival and gaining interest from Sony Pictures Classics. You couldn't expect more for a film's premiere screening. The London Film Festival was the most high-profile home screening we could have hoped for. It generated lots of interests from journalists with wide coverage across most publications and newspapers. The film even reached national and international daytime broadcast news. Lucy signed a deal with Sony Pictures Classics to handle distribution in United States and Australia territories, agreeing to a launch in NYC and broad theatrical release. The film was complete and would finally have a life of its own. Well, almost. The final sting in the tail is that when you deliver a film to a distributor or sales agent you must also provide what's called deliverables. These are all the materials, both picture and audio, used to reconstruct the film, and in various forms that will allow multiple language, size, and title options throughout the film for world viewing options. The cost of these deliverables can run into many thousands of pounds.

That is the financial journey you go through to get to a position where your film can begin to make a financial return through worldwide theatrical release. Although theatrical distribution is a wonderful and I think optimum environment in which the audience can view your film, cinema is now only a small part of the distribution plan. The other platforms: video on demand and the internet are considered more important distribution channels in the long term for reaching a wide and large audience. For small independent films theatrical

release is more of a marketing tool to gain publicity and to boost the profile of your film to reach its potential audience. So we were blessed to see our film in so many cinemas across the United States and Australia and realize our naive and ambitious dream.

It was important to me to take time when making *For No Good Reason*, partly because in telling someone's life story you have to get to know them to be confident in the responsibility you hold as the filmmaker , and partly because it was a love of the process as well as the end result that was meaningful for me. In filmmaking, it's the journey as well as your destination.

Working with an artist is a thing you can not schedule and hope always to have fruition, because if the artists' creations don't deliver, you move on to the next creation; it's the process of always being there to continue that is important to the artist. That is the artistic process. So I could happily leave Ralph on some occasions, knowing that nothing from that day would end up in the film. But that was OK. And that meant our relationship was one that allowed space for creativity to flourish without objectives or time restrictions; it was simply a process of filming the productivity of Ralph's unguarded creativity, and that's perhaps why I was invited back time and time again for fifteen years, and continue to return even now that the film is finished.

I wanted to base the film on facts but treat them as fiction. This is because I felt that Ralph's life and stories were theatrical enough to create a hybrid between what actually occurred and the fictional account that Ralph recounted. This encapsulated the essence of Gonzo. When I first met Ralph the stories he told were fantastic but I often sensed that, as with Hunter's writing, these stories were Ralph's version of events rather than the absolute truth.

Gonzo journalism is about recounting a real event in a fictional way, therefore gaining license to create a world that is wild and often totally unbelievable, but holding onto the idea that these things really happened. This is the premise in which both Ralph's and Hunter's work flourish and provide the model for the way in which I made my film about this artist.

On reflection, making your first film is always going to be intensely challenging. It's always going to be difficult, and it's always going to be disappointing. But you learn to take the knocks, and they make you stronger and more determined. Once you've made a film you are a film director, and will be able to stand your ground and make your next film armed with the knowledge from your first project. The mistakes you made along the way become assets in your armory of knowledge. Making your first film is all consuming, and moving on is difficult. How do you find something as interesting and compelling as your first film? But that's creative life; we have to keep moving forward. I make films because I like the process of making films. I love the journey you take when you're making a film.

CHARLIE PAUL has been directing film, television projects, and commercials for twenty-five years. During this celebrated career he has been awarded more than thirty international awards including from D&AD, Clio, British Arrow Craft Award TV Golden Break Awards, British Television Advertising Awards, and a BAFTA for his series *Inside Art*.

Paul is the creative director and cofounder with Lucy Paul of Itch Film production company. Itch also runs a motion control studio in central London.

Paul has a background in fine art. After earning his degree from the Byam Shaw School of Art, Paul began as an animator creating short stop-frame painted films. This led to the commission of his first commercial, *The Faroe Islands*, which was made for cinema with a story read by Sir Anthony Hopkins. The commercial won multiple international awards and positioned Paul as a sought-after commercials director.

Paul continues to work mixing live action and animation, and during the last ten years has developed specialist knowledge and experience with shooting using motion control.

He has built a loyal and vast client base with commercial clients including Universal Music, Warners Music, Atlantic, Harrods, Samsung, Bacardi, Nescafe, McDonald's, Becks Brewery, United Biscuit, Subway, Sainsbury's, Kellogg's, Littlewoods, Pizza Hut, Diageo, Unilever, CO-OP M&S Retail and Procter & Gamble.

It is this constant flow of commercial work that has enabled Paul over the years to realize his long-term obsession of observing art as it is created. With his unique vision in fine art, Paul has made a number of innovative films working with artists as they create. The camera is positioned facing the canvas to capture by stop-frame the creation of the artwork from blank canvas to finished piece.

It was working with this process that triggered his introduction to renown UK artist and cartoonist Ralph Steadman, resulting in a ten-year project to create the award-winning feature documentary *For No Good Reason*. The film won critical acclaim on the festival circuit and was released theatrically in 2014 across the United States by Sony Pictures Classics.

Paul is currently working on two artist portrait films, one with Scottish artist Peter Howson, with whom he is also creating an art installation for a forthcoming exhibition, and the other film with Eileen Cooper, the current keeper at the Royal Academy.

9 BRANDON TEENA & EDIE AND THEA

BY *SUSAN MUSKA AND GRÉTA ÓLAFSDOTTIR*

I'M A DOCUMENTARY FILMMAKER and have been producing and directing documentaries for nearly twenty years, together with my partner Gréta Ólafsdottir. In this chapter, I'll focus on our experiences making two of our films, *The Brandon Teena Story* and *Edie and Thea: A Very Long Engagement*, both of which have had long lives and are used to raise awareness. *Brandon Teena* was our first film, and *Edie and Thea* our most recent project. The underlying theme of *Brandon Teena* is hate crime, which at the time (early '90s) was not specifically recognized against LGBT people, and for *Edie and Thea* it's the discrimination against gay people under the law. Those are the big themes, and they are played out through the actions of everyday people.

Both documentaries come out of an activist tradition of filmmaking, the urge to express injustice creatively on film, with the aim of informing and inspiring action. Documentary filmmaking is an art and we are working on perfecting our skills as storytellers. One needs not only a creative eye, but also a mind bursting with questions, the ability to persist in your quest over sometimes a seemingly unbearable amount of time, and a sense of humor and humanity. It is a lifelong journey, and as the saying goes: *the journey is the destination.* That said, it is always a relief to finish a film.

HOW WE WORK: "PRODUCED, DIRECTED, SHOT AND EDITED BY ..."

Often we are asked, "Who does what? Who is the producer and who is the director, who shoots and who edits?" Gréta and I are a two-woman documentary filmmaking team. We don't identify individually as editor, director, producer, cameraperson, because we both do all of those things. We're documentary filmmakers. We've learned

to do things ourselves out of necessity, but also in the tradition of the great documentary film-making teams of Leacock and Pennebaker, Pennebaker and Hegedus, the Maysles brothers, Berlinger and Sinofsky, and those who just do it themselves, such as Barbara Kopple.

We like the fluidity of being a two-woman team, and appreciate the intimacy that a small and consistent crew can bring to a filming situation. In an interview, we can set up quickly and are non-threatening to the subject. If we came to talk about or film something sensitive, and brought a big crew, we would never be able to gain the trust and the frankness that we strive for in our interviews. In public places we are not "in your face" and sometimes simply under the radar, because we are women. We are often filming people or situations where it is best to set up quickly and make the subject forget about the camera. We do hire others to work and consult with us on projects, especially during the editing process, but ultimately we handle the main decisions and do the work ourselves, and thus are responsible for the product. All of our films are about different themes, because for us it is very important that we are personally interested and challenged by the story; this gives us the impetus to keep on caring and fighting to tell the story.

OUR FIRST FILM: *THE BRANDON TEENA STORY*

Gréta and I met in New York City. She was working as a photographer, and I was temping and doing freelance video and film production work when we began making *The Brandon Teena Story*. At that time I was a volunteer news producer for Dyke TV, a radical activist public access television program that was a fantastic place to gain television experience. In New York City, Dyke TV gave me the chance to explore social justice issues, hate crimes, and sexuality; it was amazing to be working in a kind of laboratory that produced activist media. In my position as a news feature producer I got to know people who suffered from being who they were, who were discriminated against, beaten, and killed once they dared to come out of the closet—or not. One of these cases was in Nebraska, a rape and triple homicide that made national news. The title of the AP wire story was "Dressed to Kill," and underneath was a photograph of a smiling, attractive, androgynous person, who had been raped and killed. In the article, the person was identified as Teena Brandon, known to girlfriends as "Brandon." The article described Teena Brandon as dressing like a man and dating local women, and lying about being a man; this provoked some new friends who raped and later killed him, along with two other hapless victims. Everyone in the story was so young, in their late teens and early twenties.

Brandon's story as a newspaper headline immediately attracted me and I wanted to cover it as a news feature for Dyke TV, but the show couldn't afford to send me to Nebraska to film. The budget was tight at the station and staff members were all volunteers. Fortunately, a friend, the writer Donna Minkowitz, was working at *The Village Voice* and she also had seen the "Dressed to Kill" story in one of the New York dailies. She pitched the idea of a cover story based on Brandon's murder to *The Voice*, and it was willing to send her to Nebraska to investigate the story. This turned out to be my ticket to Nebraska; Donna didn't know how to

drive a car, and to get around Nebraska driving is required. So *The Voice* agreed to pay my way to Nebraska; my obligation was to drive the rental car for Donna when we were there. I was in essence a kind of chauffer, but otherwise free to investigate and film to my heart's content. And we were off to the Midwest.

It was an exciting trip for Donna and me, taking off from Newark Airport, and soaring into the heartland of the United States. Neither of us had ever been there, and it seemed so far—and so different—from New York City. We flew into Kansas City, Missouri, and drove north to Falls City, Nebraska, where we based ourselves during the upcoming arraignments for the accused killers, John Lotter, and Thomas Nissen, who had also raped Brandon days prior to the murders. They were both local boys. Donna and I stayed in the Stevenson Hotel in Falls City, across from the Richardson County Courthouse. The Stevenson was a grand hotel that had seen better days, with massive dark wood trim and no phone connection in the rooms, reminiscent of the hotel in *The Shining*, but with nicer people. Downtown Falls City was drab and quiet, with a Dollar Store, a pizza parlor, and a one-screen cinema with a marquee that looked like it was from the 1920s. The gray stone courthouse stood somberly and alone on its snow-scarred hill in the very center of town. This was where the arraignments would take place. It was January 1994.

The triple homicide that took Brandon's life occurred in Humboldt, an agricultural hamlet on the rail line in southeastern Nebraska, on the night before New Year's Eve, in 1993. Before Brandon was murdered, he had migrated from Lincoln, the capital city, to stay in Falls City, a small town not far from Humboldt; there he hung out, made friends, and dated a local woman, until he was raped and murdered.

At the time, Richardson County was an area emotionally scarred by recent cult murders. The leader of a white supremacist Christian cult, Michael Ryan, spoke to a higher power through his arm and used pliers to peel the skin off of disobedient followers. The Ryan case involved the murders of some of his followers, child abuse and death, extreme torture, and animal abuse. Ryan was eventually tried and convicted; today he sits on death row in the Nebraska State Penitentiary. The revelation of this horrible event and its trial had an effect on the esteem of the entire town. There was an almost palpable cloud of shame or depression that surrounded people when they spoke with "out-of-towners." Less than ten years later, Brandon was killed nearby in a triple homicide. Prior to the murders, Brandon had reported being raped, in Richardson County, by the same two guys who killed him.

With the freedom of a rental car, we were able to explore this rural area almost without restriction, aside from our own sense of protocol or morals. We drove over bumpy country roads to visit the scene of the crime, outside of Humboldt. The crime scene was a remote farmhand's cottage in a desolate setting. It was set on a rise, away from the main road but connected to it by a long dirt driveway full of frozen mud ruts. Inside this squat, sagging little building, Brandon had been shot repeatedly, alongside Lisa Lambert, a young single mother who worked in a nursing home, and Philip Devine, a college student visiting from Iowa. Lisa

had given shelter to Brandon after the rape and was afraid to stay in Falls City, and also to Philip, who was in the process of heading back to Iowa after breaking up with his girlfriend, who lived in Falls City.

When you drive toward Falls City from Kansas, the first thing that catches your attention as you across the state line is a sign that states "Nebraska . . . the good life." It's a stark contrast with the description that was given by us by a law enforcement officer as he told us that Falls City used to be a "sundown" town, and the law is still on the books. Under the law, black people were not allowed in town after dark.

Philip Devine, who happened to be black, was the first victim in the triple homicide that took Brandon's life; he was executed almost casually by a bullet to the head, just after the killers entered by pushing through the locked but flimsy door into the living room. Then the two proceeded to the bedroom, where they shot Lisa and then Brandon; for good measure, but surely out of anger and hatred, one of them repeatedly stabbed Brandon "to be sure he was dead." Lisa's eighteen-month-old son witnessed all of this from his crib. Thomas Nissen, one of the convicted killers, told the court, in a deadpan voice, that the only reason they didn't kill the baby was because they had run out of bullets.

Shivering in the January frost, surrounded by fallow fields and ghosts, I felt a connection to the bleak banality of senseless murder in the American Midwest. The house was of nondescript color, its paint peeling. Drooping garlands of yellow police tape festooned the rickety front porch. The yard, demarcated by rusty barbed wire hitched to worn wooden posts tilting in various directions, consisted of trampled dead grass and islands of dirty snow, garnished with broken bits of plastic toys, pieces of lumber, a broken cast iron star from an old railing. A child's swing dangled from a naked tree branch, swaying as though some invisible child had sprung off it just moments ago. Beyond the tatty fence were old cornfields, with endless rows of stumps and broken stalks. There seemed to be no sound, no living thing. Winter and maybe the sadness of it all had bled the color from the scene as well. We waded around to the back of the house, where the door was open.

Strands of the same "crime scene do not cross" tape littered the back porch steps. The door was slightly open, and the kitchen looked eerily as if the inhabitants had just stepped out for an impromptu trip to the quick shop for quart of milk. Certainly not like people had been murdered in the next room. Dishes stood in the dish drainer, a couple of plates and coffee mugs perched on the table. A college football letter jacket, maroon with white Naugahyde sleeves, hung on a hook in the entryway. We'd seen photos of Brandon wearing that same jacket. More crime scene tape cordoned off the doorway into living room where Philip Devine had been found, dead and slumped against the sofa. Through the door we could see a corner of the bedroom where the baby had witnessed the execution-style slaughter of his mother and her friend Brandon. We were struck by the peculiar quietness, and specks of dust filtering through the room caught in afternoon shafts of light; we were voyeurs, intruding into a private space. Not inclined to cross the yellow tape, we left the

little house and its burden of unhappy memories. But not before filming some of the dreary ambience.

RESEARCHING THE STORY

To reconstruct the story of Brandon's life for our documentary we needed to find the people who knew him at different stages of his life. We began with those who were involved with him in Falls City shortly before he was killed. We found people to interview through the phone directory and by asking around town. We went to the local newspaper office to get names that had been printed in its local coverage of the crimes. Through initial meetings and interviews we were able to make other connections. We met the key players in the love and murder drama, including Brandon's last girlfriend, Lana, her family, and their relatives. Lana was best friends with the accused killer's family, so we were able to connect with them. I filmed our interviews and Donna took notes. We also made note of other press and media who were there to scoop the story. We met other reporters and were sure to follow up on their coverage later. Some of these reporters became friends of Gréta and I over the years, and were instrumental in keeping us informed on what was happening as the case went on when we were not able to be in Nebraska.

While researching and interviewing, we were being observed by townspeople wondering who we were talking to, and why. We were careful to maintain a respectful attitude and kind demeanor toward each person we came in contact with, even if we were disturbed by the behavior of some of these people, or the stories they told us. It was important to be prepared with questions for each interview, and be able to follow up if the interview took an interesting but unexpected turn. We showed interest in each person's life and their part of the story. One of the most important parts of making documentaries is to really listen to people and not interrupt as they tell their sides of things. This is key to being able to get people to open up and offer a detailed account of their story, instead of sound bites. So never interrupt your subject and always show respect, no matter how much you disagree with the person. Believe me, people can tell if you are listening or faking it, thinking of something else, like your next question.

We were sure to get release forms to use and quote the material we were recording. This cannot be stressed enough as part of the documentary filming process, as other media soon moved in to try and get exclusive rights from people whose stories we needed. Because we were there so soon after the murders, and got the appropriate release forms, we were able to avoid the stress of not having the right to use our work if someone came along after us, and got people to sign an exclusive rights and life story contract.

We were seen eating breakfast and lunch in the hotel dining room or the local diners, walking around the downtown area, and even going to karaoke night at the local VFW hall. This way people felt a little more familiar with us. We tried to be friendly in an approachable way, and not intrusive or aggressive. We chatted and were open about what we were there for, but also were able to talk about things other than our film project.

We also didn't pressure people to talk if the moment found them hesitant or unprepared. This worked for *The Village Voice* story, as we did get enough interviews for Donna to create a good picture of both Brandon and the crimes, and it worked for me, as I gathered enough material to produce for the short news feature. Back in New York, Gréta and I looked at all the material, and decided that Brandon's story could be developed into a feature documentary, our first. We ended up returning to Nebraska again and again, to film around the two murder trials. We also made trips in between the trial. Each time, another person who didn't want to be filmed initially came forward and felt ready. Although the amount of time we spent in Nebraska filming spread out over nearly four years, it was worth the time because we were able to gain the confidence of cautious people, get quality interviews, and not feel like we had taken advantage of anyone.

There was another thing that helped us to develop our documentary film and gain access to people who were involved with Brandon: we made sure that we were generous with our time and to gave our contact numbers in New York City. Some of Brandon's girlfriends, friends, and family members, as well as families of the murderers, came to New York before the trials to speak on television talk shows, such as Geraldo Rivera, Phil Donahue, and Sally Jessy Raphael. Just as we had been nervous about going to Nebraska, so were the Nebraskans nervous about coming to New York City. So they called us to take care of them and show them around when they came to New York. We gladly did so, and these initial bonds have been maintained over the years, some to this day.

One funny but useful aspect of being transparent with our information was that we were able to hear from the two murderers after they were sentenced to the penitentiary. We received letters, and a lot of collect phone calls. This expanded to other prisoners who had information to share with us (or not!) about the case. We made sure to convince the callers who might be released that indeed New York City was not a safe place to visit.

To film John Lotter and Thomas Nissen, who were by now incarcerated—one on death row, the other for life—we needed permission to film in the Nebraska State Penitentiary. We got on the visiting lists of both convicted murderers, but to film we needed clearance from the prison warden and the Nebraska Department of Corrections; this involved a lot of persistence on our part in the form of letters and telephone calls. Because we are independent filmmakers and not a known entity, such as a network news program, we had to convince the warden and commissioner that we were not trying to make an exposé of the prisons in Nebraska, but that we were indeed covering a story involving crime and justice. For all they knew, we were some kind of undercover human rights investigators. We carefully and respectfully crafted our letters and made phone calls, and were repeatedly refused permission. We did not give up, and eventually we were able to film inside the Nebraska State Penitentiary.

Southeastern Nebraska at the time was not a gay-friendly place. Kansas was more progressive, so most of the time Gréta and I stayed just over the border in northeast Kansas, in Hiawatha, at the Heartland Hotel. Sometimes we would get notes under our hotel room door, from LGBT people who knew we were staying there. We met some lesbian couples from

Falls City that way. They told us that they found other gay people by seeing who checked out the Rita Mae Brown books in the local library. One couple kept a shotgun behind their door, just in case.

A FEW MORE THOUGHTS ON EDITING AND STORYTELLING

One hurdle in making *The Brandon Teena Story* was solving the challenge of making a film about someone who is not alive, and who did not leave behind much in the way of personal records, such as journals, photos, or films. We did not want to use narration to fill in the gaps. We spent a lot of time following leads on photographs, from high school yearbooks to family photos to girlfriends' photo booth snaps. There were no home movies to be found. The only "live" recording we managed to get was a mini audiotape of the sheriff's interrogation of Brandon when Brandon was pressing charges against his two rapists. This tape was loaned to us by the Sheriff's Department, which had told us about its existence in the first place. We were excited by this find but crushed to discover that it was badly recorded, with the microphone end of the recorder pointed toward the booming voice of the sheriff, practically rendering Brandon's already weakened and frightened voice almost inaudible. On top of this there was a lot of crinkly static sound on the tape. Using sound programs on the editing system, we were able to clean the sound a bit, but we needed professional help to make it clean enough to use in the film. Our good friend Lora Hirschberg of Skywalker Sound stepped in and saved the day, cleaning the tape enough so that Brandon's voice is clearly heard. This interrogation has turned out to be one of the most important parts of the film, and is used today in police trainings in Nebraska to teach officers how *not* to interview rape victims.

Since we shot more than eighty hours of footage, much of it interviews, we had to transcribe all of the material in order to edit it. Without that step, it is impossible to remember who said what and when. Logging and transcribing is the first important step in editing. It can be tedious, and certainly it's time-consuming, but knowing your material will ultimately save time later while editing. We also made index cards of what we thought would be key story elements and created a paper edit of the index cards on the wall in the edit room. This enabled us to physically see the flow and chart the dramatic arc of the story. This comes from the now old-fashioned "paper edit" of linear editing systems, such as film. And it works well to have some visual way of organizing the story threads, one where you can look at the whole map and move it around without fear.

We began cutting at home, and then got a fellowship to edit at the Wexner Center for the Arts in Columbus, Ohio. We drove there, a ten-hour trip from New York City, with our old Jeep stuffed full of boxes of Betacam tapes and Super 8 film. In those days the raw material was heavy and took up a lot of space. Editing at the Wexner Center was a dream; it is on the campus of The Ohio State University where we stayed in faculty guest housing. While we were there, for a week at a time, often longer, we were able to focus solely on editing our film and that was really a luxury. We worked with highly skilled editors on high-end equipment.

There is something to be said about "retreat"—where you are able to be apart from the rest of your usual life and clearly focus on the task at hand. Having the support of a top arts center and its facilities also gave us emotional support and a boost of confidence. Our film looked like a million dollars when it was finished.

It's difficult to stand back from your own editing work to say what is effective or not as you are cutting it. Sometimes a supporting character is too strong and charismatic and distracts from the story. Some of our favorite characters in *Brandon Teena* ended up on the cutting room floor. When we were doing the final online edit of the film we removed the entire introduction segment and replaced it with a totally different construct. We made a forty-eight-hour trip to Nebraska to interview one of Brandon's ex-girlfriends and when we came back we changed the whole beginning of the film. Never be afraid of doing drastic changes in your edit if something is not working; no matter how much you love the footage or the person. Let them go if they distract from your story. The only thing that matters in the end is the strongest story possible, and if that means cutting out your favorite people, so be it.

As we edited, we had some really great input on *The Brandon Teena Story*, including the master storytelling team of Joan Didion and the late John Gregory Dunne, whom we met in Falls City. We invited friends and professional editors to look at our work-in-progress. Often we didn't have the time to set something aside and look at it later with fresh eyes. Friends' input in these situations is very helpful. They gave constructive advice on what to tweak and what to get rid of, or to add. This was tremendously helpful for *The Brandon Teena Story*, and we have continued to do this with all of our projects since then. On that note, be sure to give thanks and appropriate credit to everyone who helped out, even in a small way. Appropriate thanks and agreed-upon credits are an inexpensive way to show gratitude.

FINANCING THE FILM

A common question during question and answer sessions is "How did you finance the film?" For first-time feature documentary filmmakers, as it was for us at the time, the answer was to work as much as possible at other jobs, doing freelance work for news teams, industrial videos, health-care videos, and also temporary office work; for Gréta, it was freelance photography assignments. None of these paid very well but every little bit helps. Although *The Brandon Teena Story* was relatively low budget, we needed to borrow money from friends and from our credit cards to make the trips to Nebraska to film. At one point we rented an apartment in Falls City for a month so that we could attend one of the murder trials.

This is the first film syndrome, where the filmmakers go into debt to get their film made. It's also why first films are often the best of a filmmaker's entire career (at least in my opinion), owing to idealism and "the sky's the limit" mentality. The pressure to film events that were

happening now and people who were available then but might not want to be filmed later was very stressful; one person who had refused to be filmed during our trips to Nebraska called us while we were editing to tell us she was ready to be filmed. So we quickly flew out to Lincoln to take the interview. It was worth it.

Friends we borrowed money from were unsure that they'd get repaid in a timely manner. We were unsure of that as well. We got a small business loan for our production company, which helped us to keep filming, and some grants, such as the Jerome Foundation grant, and Art Matters, for emerging filmmakers. These grants were important, not just for financial support but for boosting our morale during the often discouraging process of trying to raise funding. Grant writing can be a process of repeated rejection, and if you take it personally it is demoralizing. Other friends donated their services, in both filming and also for grant writing. Our grant writer helped get us a fellowship and residency at the Wexner Center for the Arts; this residency, which we visited at least four times for editing, was integral in enabling us to finish the film, including the online edit. Our friend, Oscar-winning sound mixer Lora Hirschberg, did the sound mix for us. We joined the IFP and showed our rough cut there. A well-known international distributor was interested in the film, which also raised our hopes that the film could be completed and get out into the world.

We learned a lot along the way, and a couple of things stick with us: (1) if you believe in your story, stick with it. We received advice from professionals to cut parts from *The Brandon Teena Story* that we felt strongly about, and we refused. Later, we knew the part that we kept in the film, the last part of the film dealing with the aftermath of the murders and the justice system, helped to make Brandon's story even stronger, and made the overall story more poignant by looking at the backstories of the murderers as well; and (2) start thinking about your soundtrack early on and try to avoid licensing popular music. We didn't know how expensive this could be and ran up a huge rights budget (huge for us). Then we hired a music supervisor who renegotiated the rights to the country music, which we believed was so integral to the film. We will never again get attached to a lot of popular music for the soundtrack. Fortunately, after we won prizes at the Berlin International Film Festival, HBO Cinemax licensed the film and we were able to pay off that part of our debt.

When *The Brandon Teena Story* was accepted into the Berlin International Film Festival, we had to make a 16 mm film print, as the festival only showed celluloid film from a projector. Conversion from digital Betacam tape to film was an expensive process, and very stressful. When this was being done I was in Zambia making films for a public health project there, and Gréta was in New York getting the film ready to take to Berlin. She received the print—it had to be made at a studio in California and shipped back to New York City—and took it up to DuArt's screening room to view. She was supposed to leave with the print for Berlin two days later. Imagine her shock as the film was projected in the screening room and the colors were totally off. People were green! Skies were red! Gréta is a fighter and she insisted that the print company make another, corrected print, check it, and ship it to her express, which it did. And we had a winner at Berlin.

How long did it take to make *The Brandon Teena Story*? Four years, and then at least another two years traveling to film festivals and screenings. It felt like it took forever, but now we know that four years is nothing if you are doing an investigative documentary, or following any kind of process in real time.

THE PHENOMENON OF THE STORY

We're drawn to personal stories that affect us emotionally and have some type of dramatic arc that engages us. Often we don't know *exactly* what that is until we are editing, but it is always there. What challenges do the characters face? If the challenges enrage us or intrigue us, then we are even more interested in telling that story. And who are the characters themselves? Although it's personally more comfortable to like your protagonists, you will often have to interview or engage with people who are antagonistic or difficult to be around. When those times come, we make a conscious effort to look at the big picture, and put aside our personal reactions to that person or situation and just film, for the sake of the story. Then afterward we go and have a drink!

We don't commit easily or casually to making a documentary, since it is so time-consuming and can involve years of your life. Each documentary is actually a relationship for us, a relationship that can be very frustrating and challenging; if it is meant to be and the film can be completed, it will be rewarding as well. There is always an undercurrent of anxiety that you won't get enough of the right material, that the story isn't as good as you initially thought, or that the story is revealing itself to be different than it seemed. Sometimes you don't even know just how good and complex the story is until you are deep into the filmmaking process. Sometimes films can ruin filmmakers, financially and emotionally. A film is like an expensive date, playing on your time and finances. If all goes well, it will turn into a beautiful relationship, one that lasts for years after the film has been released.

Because of this relationship to the documentary subject, there is no such thing as total detachment while filming, at least for us. We do get involved with the people we are filming as it is natural for humans to do that, and it is a way of building trust. You need to *know* your characters to tell their story. People, and animals, will not cooperate openly if you don't establish this trust, and this will show up on film. This means learning the art of listening and observing, on and off the camera. The only way to do this is to practice, to make a film where you are interviewing or following someone intensively. The fine line is between caring and listening, but not getting so involved that you actually interfere with the subjects' lives and drastically alter the course of their drama while you are making the film. One obvious benefit of caring about the subject is that if you are interested and care about your characters, if you have some sort of relationship with them, then you will fight to complete your film and find the story. All of our films are about different themes, because for us it is important that we are personally interested and challenged by the story; the personal investment ensures that we will stick with the film.

EDIE & THEA: A VERY LONG ENGAGEMENT

Our film *Edie & Thea: A Very Long Engagement* came to us in a completely circumstantial way. We were actually shooting material for a friend, who is also a community organizer. It was 2007, and he was helping gay New Yorkers go to Toronto, Canada, to get married. At the time New York State recognized same-sex marriage but it was against the law for public officials to actually perform marriage rites. So if you were a same-sex couple who wanted to get married you had to either leave the country for Canada, where same-sex marriage was legal, or go to another state. Canada was the closest option. Our friend, Brendan, told us he was helping two older women, a couple, to go to Canada to get married. He suggested that we might even want to make a film about them. We were not interested as we had some other projects in development, and were not grabbed by the equal marriage issue as a documentary subject. But when Brendan told us that the women were in their late seventies and one was quadriplegic, we became more intrigued; we like older women, they are underrepresented in media, and these women were facing an obvious challenge. So we agreed to meet Edie and Thea at their home.

When we met Edie and Thea, we all hit it off instantly. They are smart, beautiful, dynamic women, the sort of people we prefer to spend time with. They liked us as well. It was a case of love at first sight. When we learned they had been formally engaged for forty-two years, we offered to arrange the filming of their marriage ceremony for them in Toronto; we planned to combine it with an interview with them to make a video of their trip and their wedding celebration. We thought that it might be a documentary short subject for film festivals.

We conducted an initial interview with Edie and Thea, and then filmed them leaving for their trip to Toronto. This was not an easy trip for them because, as mentioned, Thea is a quadriplegic. She had a motorized wheelchair, which she drove with the only finger she could move. She needed a full-time assistant to accomplish the simplest tasks that required movement. One of her aides was her physical therapist and wheelchair specialist, who went along to take the wheelchair apart to bring on the plane, and then to assemble it again upon landing. Some of their other family of friends went along as well—to help, but more important, to witness their marriage. Friends of ours in Toronto filmed the ceremony and sent it to us.

Before we had time to review the footage, we were nominated for an award by an established filmmaker for a film or work-in-progress, which forced us to quickly put together a short and moving trailer. We decided on a name for the project: *Edie & Thea: A Very Long Engagement,* inspired by the French feature *A Very Long Engagement.* The name had layers of meaning, about engagement as a formal step before marriage, engagement as being totally involved, and a very long engagement as being involved in something and/or someone for a very long time.

We did not win the award, but the director of the Sundance Channel saw the trailer and called us about coproducing a feature-length documentary about Edie and Thea. This was good news and we immediately jumped on it. Because of the Sundance support, we were able

to plunge right in and make the film. With a coproduction in place it becomes easier to attract other funders, as they are now confident the film will actually get completed and shown.

Edie and Thea lived across town from us, so we could pack up and film at a moment's notice. We made an agreement with them that we would never film them for more than an hour at a time, because of Thea's energy level, and that if they were going to go out, say for a stroll in the park, or to the theater, we would go along and film. Nevertheless, Gréta and I were anxious that we might not have enough material for a strong feature-length documentary. We wanted to make the film visually arresting, but for that we needed more than interview material with the occasional cutaway. We'd asked Edie and Thea about photographs and they insisted they had none. Then, one day, Thea called and told me they had found some photos and that I should come over. I walked over to their place. Edie showed me into the living room, where albums and photos covered every available surface, from coffee table to computer to harpsichord. They'd opened up the long Danish modern sideboard cabinets and they were filled with albums and slide carousels, all filled with images of their lives together. This was a treasure trove from their past, and proved to be the visual thread of the film.

As a younger woman, Thea had been an accomplished amateur photographer who also gave talks about her travels, accompanied by a slideshow, to different audiences. This eye for photography carried over into her private life with Edie, which proved to be richly and gorgeously documented. We decided, together, to set up the slide carousel and film as Edie and Thea watched and reminisced about the images projected on the screen (on the sliding door). These afternoons of filming their reminiscences and reactions to the slides turned out to be the basis for the film's dramatic arc. These photos were an amazing find, an eyewitness to their lives together, and very complete. The comments and stories from Edie and Thea were also spontaneous and real, as they were reacting to images that they hadn't looked at for over twenty years.

While in production, we interviewed and filmed their friends, colleagues, and women who had lived closeted lesbian lives parallel to Edie and Thea. But as we edited segments, something wasn't quite working. A good friend watched the rough cut, and advised us to cut out everyone except for Edie and Thea. This was a rash and daring bit of advice, and we took it. We were pressured for time because of our contract with Sundance Channel, and felt that we needed to rely on advice we could trust. This suggestion made sense once we began to implement it. Theirs is an intimate story, a love story, and the delicate interplay of the slide imagery and the two women themselves carry the story well.

While we were editing the film, Thea died. We were in the airport in Iceland waiting to board a plane to Berlin, when we received the call from Edie. I started to choke up and cry while on the phone. Edie said, "But honey, you knew this was going to happen..." I did, but Thea was so alive and vibrant that we'd forgotten—even though she was quadriplegic and totally dependent on others for her every function—how serious her condition actually was.

While we were in Berlin, Edie was hospitalized with a major heart problem. Her doctor said it was a heart failure—called "broken heart syndrome"—that sometimes happens to people when their spouses die. Edie's condition was touch and go, and we were in the midst

of helping her plan Thea's memorial service at The LGBT Center, complete with a slide show, disco music, speeches, Thea's favorite shrimp cocktail and champagne, and a marching band playing "When the Saints Come Marching In." Edie issued commands from her hospital bed and we produced the event.

THE DOCUMENTARY AFTERLIFE

Both *The Brandon Teena Story* and *Edie and Thea: A Very Long Engagment* began with award-winning festival runs, followed by theatrical engagements, broadcasts by major stations, and then DVD release. Nearly twenty years later, we are still screening *The Brandon Teena Story* as outreach to LGBT youth in university classrooms, and it has been reissued as a deluxe anniversary DVD. It is still used in Nebraska to train police and sheriff personnel in how *not* to question people pressing rape charges. The film itself was prescient in the recognition of hate crime and transgender rights.

As we were working on *Edie and Thea*, the marriage equality movement in the United States and around the world was gaining momentum. The film became an even hotter commodity because of this timely topic; that and the fact that Edie is a dynamic, charismatic, and sexy role model—and a strong advocate for gay rights. Edie decided, since she had the evidence of her marriage well documented in the film, to sue the US government to repeal DOMA, the Defense of Marriage Act, in which the federal government does not recognize same-sex marriage, and penalizes gay couples by levying inheritance taxes on the surviving spouse. When Thea died, Edie was exempt from paying inheritance tax to New York State, as the state recognized marriage equality. The US government, citing DOMA, charged Edie several hundred thousand dollars in taxes, not recognizing her as a legally married surviving spouse. The case drew worldwide attention and the film continues to be in demand. We're busy working on a short documentary follow-up about Edie's case, which she won.

In summary, these two documentaries have bracketed our mature adult lives over a span of twenty years. The two different worlds that we entered while making these films have enriched our lives, taught us that things are rarely as they first appear, and that life is one long journey of learning and growing as people. Although the films stand on their own, for us it is the response of the audience—to the reflection of injustices in our society, as shown through the characters and their conflicts—that is the most rewarding and amazing to us. I don't think any other career would have been quite so interesting or fulfilling in that respect.

Filmography—Producers/Directors: Susan Muska and Gréta Ólafsdottir

BLESS BLESS Productions is an independent documentary film production company, founded in 1996. Bless Bless Productions has offices in New York City and in Reykjavik, Iceland. Since founding their production company, Susan Muska and Gréta Ólafsdottir have produced and directed the award-winning documentary films *The Brandon Teena Story* and *Edie & Thea: A Very Long Engagement*. Awards for *The Brandon Teena Story* include the Berlin International Film Festival's Teddy for best documentary and the Siegel Säule Audience Award. The directors were nominated for an Emmy Award for Excellence in Investigative Journalism for *The Brandon Teena Story*.

Recognition for *Edie & Thea: A Very Long Engagement* includes a 2011 GLAAD award nomination for outstanding documentary; it has received twenty-six audience and jury awards in the United States and internationally. *Edie & Thea* is a coproduction with the Sundance Channel. Both films have been broadcast internationally and domestically, and are available on DVD and Netflix.

Their other works include *Through the Lens* in 2000, funded by the European Cultural Cities project, and which kicked off Reykjavik's year as a city of culture in 2000; and *Women, the Forgotten Face of War*, which premiered at New York City MOMA in 2002 as the opening film for a series honoring the Rockefeller Foundation's 15th Year Anniversary of Media Fellowships. In 2002, *The Brandon Teena Story* received a Jury Award for best documentary at the Astra International Documentary Festival. The film has been widely used in university classrooms, and is also part of a two-year campaign by Amnesty International in Germany to end violence against women. It was also included in "At War," a multimedia exhibition at the Centre de Cultura Contemporania de Barcelona, Spain; and "War, Displacement and Genocide in Europe," at the Project Centre for Contemporary Art in Dresden, among others. European broadcasts include YLE and RÚV.

Susan and Greta produce and direct all of their documentaries. They have received a fellowship from the Rockefeller Foundation, and grants from NYSCA, Wexner Center for the Arts, Astrea Foundation, Ben Silverman Foundation, MacCarthy Foundation, Joy Weiss Foundation, and individual funding from such as Rosie O'Donnell and Hunt Alternatives.

They received a grant from the Arcus Foundation to design and implement a community outreach program and establish partner organization relationships for *Edie & Thea: A Very Long Engagement*.

They are currently in production of a feature-length documentary about genocide justice involving Rwanda and Sweden. *Looking for Shorty: The Way of the Owl*, an international feature-length documentary about "human" nature, is in preproduction.

Susan and Gréta are instructors at Parsons in the Communication Design and Technology Department. Gréta is a documentary and short-films consultant for the Icelandic Film Centre. Susan teaches presenting and communications at the Gender Equality Studies and Training Program, and at the Land Restoration Programme, part of the UN University, at the University of Iceland.

10 TRANSCENDENT ACTS: WHY WE MAKE DOCUMENTARY FILMS

BY *LOUISE VANCE*

▶▶ *ON THE RESEARCH TRIP* for my first national television documentary, I stood in the somber, wood-paneled main room of the Massachusetts Historical Society with its executive director, an older gentleman in a charcoal suit, who had offered to meet me there on a Saturday morning, outside public hours. He casually asked, "Would you like to see an early draft of the Declaration of Independence?" The question created a wave of light-headedness. "Yes," I managed, with a nervous laugh. He showed me to the elevator, pressed B for basement, and I followed him through rows of drawers containing archival documents, many pre-revolutionary. He stopped in front of a glass-lidded case lined in deep crimson and pulled out two pairs of white gloves, handing one to me. "It's written on cotton rag," he said, unlocking the case and lifting out the document, no larger than a sheet of hotel stationery. He smiled, and with Brahmin reserve, presented it to me.

There was Jefferson's handwriting, clear and inky black, the page crowded with cross outs and revisions. It catapulted me back two centuries to a desk in Philadelphia, inkwell and pen poised as its author considered the right words for what he wanted to say: to the King, to the colonists, to the world. I held the page lightly in both hands, determined not to drop it. A charge ran through me. *How on earth did I get here? How do I get to do this?*

How did this product of the suburbs, this grandchild of immigrants, this lucky, serious, first-time documentarian get to peer into the mind of Thomas Jefferson as he struggled to enshrine the nation's independence? And what did that sublime moment teach her? The Committee of Five, as it turns out—the men Congress had appointed to write the Declaration—had only arrived at the final version we now know after poring over a series of drafts, working through their disagreements to reach compromise. Jefferson, with stunning inconsistency, had condemned the African slave trade in his

early manuscript, despite accumulating great wealth and personal gain from slave ownership himself. His language, denouncing slavery, was removed by the Committee on the grounds of political expediency, because the framers argued they could not get congressional approval with it in place. Ah, the messy business of democratic politics, even then.

As I handed this flawed, undeniably visionary blueprint back to the historian, I did not connect one key point: that, for me, as a woman of European ancestry, the document was strangely other; as it had done with enslaved Africans, the Declaration of Independence ignored the existence of half of its white population, the female half; the new country it ushered into being afforded my gender no rights of citizenship. But how would I have made that connection? As filmmaker Ken Burns once said when asked why he made his film, *Not for Ourselves Alone,* "Women are starkly absent from the American narrative." At age thirty, that insight was buried in the headiness—the sacredness, really—of the moment, and wouldn't awaken in me for another fifteen years. But when it did, in a burst of urgency, it would propel me to create the most challenging—and most personally meaningful—film of my career.

We weren't shooting in Massachusetts that day. We were still in preproduction for that state's episode of the five-year, twenty-million-dollar TBS series, *Portrait of America*—a massive documentary effort that created quite a stir in the 1980s. I was gathering deep context, immersing myself in primary sources—documents, photographs, location scouts, research interviews—so I could assume the weighty responsibility of characterizing the early days of the American Revolution and other seminal events in Massachusetts's history. As the film's producer/director/writer, I was committed to telling the truest story I could in the screen time I had: just forty-seven minutes. The most accomplished documentary teams in the country were being brought in to make films for the series, and together with our executives, we were determined to make something of lasting worth.

It was the best job I could have imagined. I was sponging up the craft of documentary filmmaking from pros: senior producers with network credentials who taught us to work tirelessly to find the overarching story—the thematic premise of the film—and support it with ten to twelve compelling, character-driven stories. On our research trips, we preinterviewed dozens of people across the state and read reams of background material before locking in our real-people cast. We were required to write a detailed 25- to 30-page film treatment and defend it in an all-day treatment meeting with senior staff—adjusting if needed—before planning the shoot. We were laying the foundation for a $450,000 production, and it had to be right.

All this heavy preproduction required a high degree of self-discipline. After the treatment was approved, many additional steps were required, most of which were left to our own judgment. Who should I hire as my cinematographer? How probing are my interview questions? How thorough are my shooting scripts and shot lists? How carefully planned are my twenty-five shoot days? These questions mattered, I learned, because documentary, when done well, is a precise medium. A film's intricate construction, all the moving parts, must not distract from the immersive experience of watching it. Documentaries should feel inevitable, as if we just stumbled on a fascinating piece of life unfolding gracefully before our eyes.

During the time *Portrait of America* was in production, generous budgets such as ours were "in place" for television documentaries at the major broadcast networks and the cable giant, Turner Broadcasting System, where I worked. But as the cable industry transformed and the number of channels grew exponentially, the pie, in terms of viewers, was cut into tiny slivers, and advertising dollars shrunk accordingly. This drastic reduction in revenue forced television executives to find new ways to stretch production dollars and pull in more viewers. Reality shows, game shows, newsmagazines, and competition shows proliferated— much cheaper to produce—and the heyday of network television documentary units came to an end. Thankfully for lovers of the genre, the PBS strongholds *Frontline* and *American Experience* remained—beacons of intelligent storytelling, rigorous production processes, and gorgeously crafted films. They are still the gold standard of American documentary, even as successive generations of independent filmmakers blend genres and find surprising new ways to tell nonfiction stories.

Fast forward to 2015. The vast majority of documentaries being made in the United States today are independent productions, meaning that a few determined individuals, a handful of renegades, are creating them. A small percentage of these films gets some funding from media giants such as HBO, Netflix, or CNN, and each year a few dozen nonfiction films are broadcast on PBS's *Independent Lens* and *POV* series, which pay modest transmission fees to producers. But, by and large, making a documentary these days is a labor of love. To illustrate:

Recently I interviewed a gaffer in New York City for an upcoming shoot, asking her what kinds of productions she generally works on. "I try to mix it up," she said. "There's despair when doing a documentary because of the low pay, small crew, and tight budgets. And there's despair when you work on commercials, which have all that money but no real value to society. So I switch off. That way I don't linger too long in either kind of despair." Her wonderfully dry delivery aside, there was truth in her words. A forty-person crew for a thirty-second car commercial, versus a three-person crew for a film about the crisis in cancer care in America? It sounds absurd, but that's the reality. Money is the engine that drives such disparities. How much profit will a production generate? And who is willing to pay up front for that return?

Because of the albatross of funding, documentary films that tackle controversial or overlooked subjects—as most do—require a herculean effort over many years to complete. Producers usually raise the production and outreach budgets from a myriad of sources: foundations, individual donors, corporate sponsorships, crowdfunding, donated labor, and in-kind services. But in the end, even a terrific film may never find a home on television or in the highly competitive world of major film festivals. And as online venues quickly replace television as the prime way to reach audiences, and even as more docs find their way to limited runs at your local theater, the most common scenario behind the scenes is still that the documentary filmmaker either absorbs the distribution costs themself, or hands their film over to a distributor who reaps the lion's share of the profits. From a financial standpoint, for most independent doc-makers, it's a pretty grim scenario.

So why do we do it? Why would anyone take on what appears to be an undeniably crazy mission, devoting their highly marketable skills to a production venture that probably will never turn a profit? The answer is different for each filmmaker and each film, but it's safe to say it's not about the money. It's something more, well, *noble*. Filmmaker Eric Slade sums it up this way: "We do it for the creative challenge, and because there are important stories to be told and no one else is going to tell them. I think it's noble because we do it to make the world better—more fair, more creative, more interesting, more just. And for the most part, it's donated labor. Everybody I know who makes documentaries does something *else* to make a living. And yet it's probably the most difficult, challenging thing we do in our lives—this thing that won't pay the rent." He adds, "We do get free drinks at film festivals, though, and we get to feel like a celebrity for about twenty minutes."

Ever since the first strips of celluloid ran through a tiny conveyor belt of sprockets and rollers, sending flickering images across a blaring light and into the hearts of wide-eyed strangers, the allure of film has never wavered from its original purpose: to catalyze emotion. To move hearts. Such a simple idea, really: rapid-fire photography that captures twenty-four, thirty, or sixty images per second, then plays them back at the same speed so that people and places magically come back to life. What an incredible thing, when you think about it: to preserve scenes outside of time so they can live on and touch people through this mechanical illusion.

That film flicker—whether in Hollywood features or in the recent surge of digital documentary filmmaking—is trying to say something in a way that will wake us up. In documentary, the mission is not only to change lives for the better, but also to change *life* for the better. Our collective humanity, the entire canvas, is raised up almost imperceptibly when a documentary film fights its way to audiences to deliver a previously untold story. With all the savage acts we are exposed to minute to minute through our devices—the greed, hatred, and delusion that mar the world and bombard our delicate consciousnesses—it is a noble endeavor to labor for years without pay to hoist a corner of the human condition up a notch, even as it sinks somewhere else. It's essential, I believe, to keep us from drowning.

I used to think of it this way: we documentarians are forging a parallel history of humankind. There are the history books, and then there is what we do. But while conducting research for a script I wrote for Oregon Public Broadcasting's *Bridging World History* series, I began to see it differently. I learned that scholars scour the written—and now digital—record when they set out to "write" history. They look at public documents, census data, personal letters, art, and literature. In other words, *if it's not recorded somewhere, it didn't happen*. So if we want to preserve people and stories and events that fall outside the predominant cultural narrative, it's up to us to "write" them into history ourselves. And what more powerful medium in which to do that than documentary film?

Here's a little story I wrote into my independent documentary film, *Seneca Falls*: women's rights pioneer Elizabeth Cady Stanton's father was a judge. In the early nineteenth century, women would routinely visit Judge Cady in his home study to plead for mercy. Time and

again, the judge would tell these women—the ones trying to divorce a violent abuser, the ones who sought to inherit family property, the ones who wanted custody of their children or longed to go to college, the ones who needed to keep their own wages because of some dire circumstance—*the law does not allow it*. Young Elizabeth hid in the corner of her father's study listening to these women's pleas, vowing that when she grew up, she would tear out all the pages in her father's law books that made women cry. She dedicated her life to doing just that, petitioning legislatures and running campaigns to overturn law after law, statute after statute, in state after state. In the cause of equality, she risked her father's love, her good name, and her inheritance. But she never waivered.

Through some sort of otherworldly will, Stanton and her small band of allies achieved most of the legal reforms they set their minds to as the decades wore on, though she and her friend Susan B. Anthony did not live to see American women gain the right to vote in 1920. In making my film, I came to understand that winning the vote is the "safe" story that has been passed down. It implies that everything else was fine for "free" women in the eighteenth, nineteenth, and early twentieth centuries, with the one little exception of the ballot. The pure fact is that when Stanton and Lucretia Mott and their band of social reformers called the country's first public protest for women's rights in Seneca Falls, New York, women had no legal, social, political, or civil rights. None. This was America in 1848.

One might say: "How can this be true? Why have I never heard of Seneca Falls? Why isn't this taught in school?" Those were my first thoughts when I received a mailing announcing a huge celebration marking the 150th anniversary of the birth of the women's rights movement, to take place in Seneca Falls, New York, in a few months' time. That was the moment when, for me, lightning struck. *I have to make a film about this.*

I had told stories of fishermen and farmers, Iranian soldiers and Amazonian rubber tappers. I had interviewed politicians and writers, actors and scientists, businessmen and scholars. I'd carved out a place on camera for hundreds of people, famous and not. How is it, then, that I'd never told the story of my own tribe, American women?

This was the first time I was embarking on a production without funding from a network, institution, or corporate client. It'll be easy, I reasoned. *Who wouldn't want to fund this story?* I called eight women friends from the Bay Area film community and told them my intention to chronicle several journeys to the 150th anniversary celebration at Seneca Falls, and weave them together for a feature documentary. That afternoon, I wrote up a one-page pitch for HBO, faxed it to New York and got an almost immediate "no." *We need emergency funding*, I pleaded. *This historic gathering of tens of thousands from around the world will pass unnoticed if our cameras don't capture it.* I was on a mission.

The next day, all eight of my industry friends gathered around my dining room table, and off we went, cell phones buzzing, seeking funding from film studios, TV networks, PBS, ITVS, foundations, and individuals. It was madness. Glorious, fun, manic madness. After a week of this, we switched gears and went after Hollywood feminists. Still, no funding materialized.

On the event website, I discovered a San Franciso theater troupe whose teen members would be performing their original play at the celebration. I tracked them down and went to a "pass the hat" fundraiser for their trip expenses being held that evening. I fell in love with them. So spunky, so original, so strong, so insightful. I thought that if they're this great now, how will they be during and after the trip? And there it was. I had my story arc, my characters, and a theme of great social import. I asked them if I could record their one-week journey to Seneca Falls, and they said, "Why not?" I was elated. I had my film.

The troupe's road trip to Seneca Falls gained attention through a pair of written columns in the *San Francisco Chronicle*. A community outpouring of support followed. Strangers sent what they could: a few bucks, or a hefty donation. Relatives of the girls heard about the documentary and wrote checks. Five days before my crew had to hop on a plane, our $23,000 shoot budget miraculously came through.

Eleven years and eighty-four grant proposals later, my film, *Seneca Falls*, aired on PBS on nearly one hundred fifty stations across the country, often in prime time. For two years after that, it screened at universities, women's summits, film festivals, community events, girls' empowerment conferences, and even a few theaters around the country. I had achieved the goal: to raise awareness of the event in 1848, but also to shine light on the bigger story—that women in America had freed themselves.

In the worst moments of my own journey with this film—when five sets of computer drives failed, when footage had to be reimported again and again, when two editing houses that had become my angel facilities closed their doors for good, when I ran out of funding for so long that I had to learn to edit myself, when I gave thanks to a generous editor who became my one-woman technical helpline, when rejection after rejection came in the mail from foundations, and later festivals—I will admit: I grew despondent. But then something would pull me back. I'd remember the man at an early rough-cut screening who said, "It's no accident that you and your editor Miriam are working on this film. Susan B. Anthony and Elizabeth Cady Stanton are reaching across time and holding your hands steady." That was a trick of the mind, of course, but it worked.

The vast majority of funders, networks, series, and wealthy women I approached over the years did not see this film as worthy of funding. But six grant-making organizations did—most of them small family or community foundations. And so did hundreds of individual donors. So I carried on, enlisting help from the filmmaking community in San Francisco when funding would run out, and always they came through with donated services or reduced rates, and the ever-important moral support. It's because of their willingness to champion this documentary that it exists at all.

When the film was nearly finished, I was invited to screen it at a small public celebration of the 160th anniversary of the Seneca Falls Convention. As I walked through Women's Rights National Historical Park—built in the 1980s largely through a campaign by local women's rights supporters—I stopped before a carved wall, a monument to the one hundred signers of Elizabeth Cady Stanton's daring Declaration of Sentiments, which she had delivered, in

a quiet voice, standing behind a podium at the original convention. That afternoon at the screening, as I introduced my film, I rested my hands on a handsome wooden podium, having learned, just moments before, that it was *the actual podium* from which Stanton, Frederick Douglass, and the other speakers had delivered their impassioned pleas for justice in 1848. I pressed my palms into its smooth, varnished surface. I was touching history again, as I had when I held Jefferson's draft of the Declaration years before. This time, I was connecting with the woman who had rewritten his entire document, correcting it, if you will: "We hold these truths to be self-evident: that all men and women are created equal." With that bold assertion, Stanton, a writer of towering intellect and an activist of fearless determination, demanded that the nation address the unfinished business of the American Experiment.

When I began this film, I could not imagine the sheer force of rightness it must have taken for this young mother to rewrite the nation's most revered document just seventy-two years after the American Revolution. And then, through my research, I learned this: on their honeymoon in 1840, Elizabeth and her husband Henry—both dedicated abolitionists—sailed to London to attend the World Anti-Slavery Conference. There they met another fervent activist, a Quaker minister from Philadelphia named Lucretia Mott. On the first day of the anti-slavery conference, the two women were barred from participating because of their gender. They were told to sit silently behind a heavy curtain while the men debated how to end the scourge of slavery. Although they had just met, they became fast friends and vowed, upon their return to America, to call a meeting to address their own lack of rights as women. Eight years passed, but they followed through, placing a newspaper ad to call the fateful meeting in Seneca Falls. It was the spark that set women free.

For filmmakers, as much as for their films' subjects, one can't help but wonder: What sustains this stubborn passion to travel a long, difficult, often lonely road, wearing dozens of hats, while running yourself ragged on an engine of belief? For some documentarians, it's a quest to bring the guilty into the light of judgment. For others, it's a way to promote understanding and smooth the prickly edges between groups of people who would never encounter each other in real life. For still others, it's about holding up exceptional lives—lives that matter—or exposing a crucial corner of history or present-day reality that's being overlooked. Underneath these motivations, I believe, runs an inherent idealism, a sort of stubborn optimism that insists we, as a society, keep moving in the right direction. And the more imperiled our freedoms and safety and dignity become, the more society needs that brand of noble optimism.

Decades before I became a documentary filmmaker, I was a lover of true-life stories. While my fourth-grade classmates were burying their noses in *The Hobbit*, I was devouring accounts of every famous person's life I could find, usually between turquoise covers etched with red letters on the "Biography" shelf at the school library. Amelia Earhart, Daniel Boone, Harriet Tubman, Thomas Edison—these were lives that stood out from the rest, people who somehow broke free and followed a path to renown. Their tales captivated me. Being a dutiful child, I never questioned who defines, and by what standards, which actions and which

people are heroic. I just trusted that some force far bigger and wiser than me would guide me toward all the stories worthy of my attention. Documentary film would later explode that myth.

The documentaries we make often delve into places where no one else has gone; they frame a new story—sometimes a headline-grabbing tale with villains and heroes, sometimes a quiet peek into a human struggle or triumph. There's a trust on the part of the viewer that what they're seeing actually happened, unadorned, and that no one is manipulating the story. Of course, as a filmmaker, you actually *are* pulling the strings, with each of the hundreds of editorial and creative decisions you make. But manipulating is too strong a word. Portraying, curating, presenting—these are more in line with what ethical documentary makers do.

As a profession, documentary filmmaking belongs to the curious. The diligent. The open-minded. The openhearted. Making a film is a process of discovery—of your themes, your story arc, your characters, your point of view. You feel your way through, the way writers and visual artists do. And in the multiyear process it takes to finish a film, you learn more about your subject, yourself, and the larger world than you could ever teach.

Great documentary makers seem to me to be part poet, part visual artist, part detective, part iconoclast, part humanitarian. If you don't appreciate how limited—and limiting—your own personal experience is, if you have little empathy for the suffering in the world, chances are you will not find a home in the realm of documentary film. As an independent documentary filmmaker, you will help people discover an infinitely complex world. You'll help them see nuance. You'll help loosen their rock-hard positions so they can take others' experiences into account, maybe for the first time.

That may explain why you take on film projects against any rational thinking. That's why you'll argue in grant proposal after grant proposal that this is a film that will change lives, serve the underserved, avert harm. You'll argue this because you believe it—you know it—and that makes you put aside your distaste for begging strangers for funding. As I've told my friends on many occasions, "I get so tired of shaking the tin cup for money." For many of us, that part of indie filmmaking is the toughest, because in some strange way, you become your film. The rejection letters aren't just saying no to the film, but to you, as well. This merging in your mind is unhealthy; be on the lookout for it, should you join the ranks of this citizen army. The truth about funding is that it's actually something of a science: it's about relationships you need to forge. It's about the current program priorities of the funders and the passions of the individual donors you approach, and ultimately, how well your project matches those. And it's about the people who sign the check trusting that you have the fire, and the track record, to complete the film. All of those elements must be in play for funding to arrive.

Like all film, documentary is a collaborative medium. But it's not a democracy. It's hierarchical—a bit like the army—helmed by a director (or a codirecting team) who holds the vision, and built on the skill of crew members who contribute the essential ingredients: clean, well-recorded sound; artful cinematography; a beautiful script; inspired editing. Films need musical scores that complement but don't overpower scenes, and elegant graphics that

establish a visual tone and efficiently convey parts of the story. They require a producer's organizational and budgeting skills, and writers who can express potent ideas in a few well-chosen words. And in the home stretch, they rely on sound mixers who file down the rough edges of voices and sync sound to thousandths of a frame—professionals who have more filters and mixing tools and sheer talent than could ever be described here.

To head up a documentary project, you'll need resourcefulness, self-belief, fortitude, patience, and exacting standards. Oh yes, and an openness to change direction as you uncover new material. Are you passionate about your project? If so, that passion will carry you far. Independent feature director John Sayles describes the formula for success this way: "Talent plus persistence equals success."

I would add "luck" to that equation.

You see, stuff happens. Airlines "lose" tripods, interview subjects get laryngitis, freak rainstorms drench the sunniest of desert cities when an entire day's shoot was planned for outdoors. Cameras have been known to run backward, mystery hums have made their way into sound tracks. So you learn to expect the unexpected. And as an early mentor liked to say, "You're a producer. You're paid to worry." He paced a lot. I adopted his approach, and it's saved my hide more than a few times.

If you have what some call "producer's luck," extraordinary things can go your way. Once, while filming a story with Stormy Mayo, director of the Center for Coastal Studies in Provincetown, Massachusetts, we took a small research vessel out into the north Atlantic at four in the morning to spot and identify whales. "We may not see any," Stormy cautioned. We did, in fact, see sixty-three whales that day, the highest number spotted in a single day in the center's history. And something else happened: an adult female great blue swam under our thirty-two-foot boat, jolting it sharply, and knocking me overboard. I held on to a ridge of wood along the water line as the whale passed beneath me, and the crew pulled me back on board by my feet. I was drenched to the bone. The footage, however, was spectacular.

Decades ago, when documentaries were shot on 16 mm film, there were frequent horror stories: the million-dollar flood in the law office because a hot light was placed too close to a sprinkler on the ceiling; a "hair in the gate" or scratched film, or footage of a cathedral wedding that's stolen from a production van and couldn't be reshot. Even today, with docs being shot digitally and often by multiple cameras, the most heartbreaking problem I still hear is lost footage. "The file just disappeared," my students tell me. "The whole shoot is gone." The lesson there, of course, is to back up the digital files you shoot to at least two, preferably three, drives, both at lunch and also at the end of the day. Take the time to do it. As another senior producer once told me, when in doubt, *do what's best for the film.* Not what's most convenient, not what will keep the crew happiest, not the path of least resistance, not the easy way out after a fourteen-hour day. *Do what's best for the film.*

People sometimes ask me how I got started as a documentary filmmaker. It was a pretty random path, actually. As all young women of the baby boomer generation, I had been told I could choose between three careers: secretary, nurse, or teacher. Becoming a teacher would

make my father proud, and it seemed like the best fit for me. I'd benefited from such gifted teachers in the planned suburbs of Long Island, where the immigrant experience was still fresh in our families, and where the will to make something of yourself ran through those weary travelers and straight into their children. Much was expected of us. That may be why I was so drawn to stories of dogged determination against long odds. I was fascinated by other people, other times, other places. I wanted to crawl up inside life—to see it all and consider it all. Literature was my way in.

After college, with my English teaching degree in hand, I entered the workforce only to learn there were two thousand applicants for every teaching job, due mainly to teaching deferments issued to young men to keep them out of the war in Vietnam. I didn't have a chance, given my lukewarm student teaching evaluation and my shyness in front of a classroom. So I took the first job I could find—an assistant at a three-man ad agency, which led to my first job in television the following year.

Within a few months of being hired as a secretary in the promotion department at the NBC affiliate in Denver, I learned that the station made local documentaries. Intrigued, I walked across the hall and introduced myself to the public affairs director, offering to do research—or whatever she needed—as a way to learn about documentary production. She peered at me over her glasses. "Well, I do need something," she said. "I need some research for a prisoners' rights documentary we're doing. But I need it by Monday. And I can only pay you twenty-five dollars." "Great," I said. I would have done it for free.

That weekend I spent nineteen hours in the University of Denver law library scouring thick law books filled with abstracts of cases that recently had been decided. I took a ream of notes, went home and typed a ten-page report on what I'd found. I cited cases on dietary restrictions, censorship of mail, solitary confinement, and the definition of cruel and unusual punishment. I even included a history of prisoners' rights and their origin in English common law. I guess I was gunning for an "A".

The documentary's reporter came to my desk late Monday morning. "Is your husband a lawyer?" he asked. "My husband's a photography student," I said. "Where'd you get this?" he asked, waving my research paper in his hand. "I wrote it," I said, forcing a smile. "Huh," he said, turning on his heel. I was promoted to public affairs specialist three weeks later.

When the prisoners' rights doc aired, I took a photo of my television screen as my "Researcher" credit rolled by. It was surreal to see my name, knowing that tens of thousands of strangers were seeing it, too. It was my first time inside the megaphone. My voice, my work, could resonate louder and further on television than in any classroom. Even better, I could stay in the background, off screen, diligently doing research, and when the program aired, it would fill the minds and hearts of those who had enough interest to tune in—those, as the Buddhists say, with just a little dust in their eyes. I had the power to educate on a grand scale. It was a heady feeling, and I was hooked.

It dawned on me soon after that I now bore the great responsibility to make sure that whatever I contributed to this medium was thorough and unbiased. It had to be right. *I* had

to get it right. No teacher to grade my work, no key to show me right and wrong answers. Just my internal compass, my ethical core. This realization was an intellectual rite of passage for me. I had entered the stream of journalistic integrity.

I was fortunate to have started working in this field when documentary making was a rarity. The club was small, a sprinkling of us working at big city television stations and networks around the country. We worked at the castle on the hill—lucky enough to have landed a mysterious, glamorous job that carried quite a bit of prestige. Inside the walls of television, we had a seriousness of purpose. We were serving the public, educating them, crafting shows with strict standards of excellence. Our station's license renewal depended on how well and how often we created such programming. As quaint as it sounds today, we still believed the airwaves were a public trust.

About fifteen years ago, I was in the bedding department at Macy's, in San Francisco, looking at sheets, when a tiny woman who appeared to be in her late sixties struck up a conversation with me. "Such a pretty yellow," she said. "Like butter," I said. She turned and stared up at me. "Where are you from?" she asked. "Here, in the city," I said. "I am from Europe," she said with sudden deliberateness, "thanks to Mr. Hitler." She wore a delicate gold necklace with a tiny "H" studded in diamonds. "I am Hilda," she said, extending her soft, bony hand. "I'm Louise." I said, grasping it lightly. She did not let go for twenty minutes.

Hilda was fourteen years old when she was forced into the Nazi concentration camp at Auschwitz. Standing in front of me that day, her pale blue eyes watery and rimmed in red, she told me of the Nazi who poured ink all over her passport, turning it black. She told me how she had to polish his boots with her tears. She was being carried into those memories on a towering wave of shock and grief that seemed not to have abated in the five decades since. Every two or three minutes, she would stop herself mid-story and say, "You have kind eyes," or turn to my husband and say, "Your wife is sweet. You're sweet, too." Eventually, her speech slowed, and the three of us walked outside to get some air. We asked Hilda if she'd like to meet for coffee sometime. "No," she said. "We don't need to do that." We said goodbye, but the encounter has never left me. Hilda had released her trauma to willing strangers. We had given her witness. "H for Hitler, H for Holocaust, H for Hilda," my husband would later say. That was all he could think of when the sparkle of her necklace caught his eye.

Sometimes you need a witness.

There are sorrowful chapters of life that we documentarians tell because the act of witnessing them seems to lessen the pain. Our films provide a forum to explore and share these difficult experiences with strangers, so that we can all agree that, yes, this happened; yes, it was impossibly hard; and yes, the human spirit was nearly extinguished, but somehow it survived. And now, we must commit ourselves to doing what we can to see that something like this never happens again.

One hundred days before Rosa Parks refused to give up her seat to a white man on a public bus in Montgomery, Alabama, kicking off the boycott that ignited the modern civil rights movement, a young boy named Emmett Till was savagely murdered in Mississippi for

allegedly catcalling a white woman. This act of brutality shocked many in America and in countries globally who read accounts of it in their newspapers. Those readers were doubly shocked when the murderers were swiftly acquitted of the crime. I know about Emmett Till not from history books, and not from history class. I know about Emmett Till from the exquisite *American Experience* documentary, *The Murder of Emmett Till*. The bold insistence to bring tragic stories such as his to light is part of a proud tradition of documentary filmmaking at PBS. Making such films, I believe, is vital to the health of societies. Just because such stories bring out a fundamental discomfort with the cruelties of life, and just because they don't necessarily offer hope or answers, doesn't mean they should fall into oblivion.

Somehow, when a story is told in depth and with compassion, even the darkest deeds committed by human beings can offer a path to what's good and decent. Our collective storehouses fill with a bit more knowledge. For a time, we feel more connected. We are less quick to judge, less apt to hate. Documentaries unlock a gate, letting in a rush of, what? Goodness, I think. The energy—the intention—that passes through our work is goodness. We are better for collecting it, directing it, and sharing it with others. We are conduits for that mercy.

Documentaries can also offer a way to relive moments when human beings acted honorably, or showed a great rush of decency. In *Not in Our Town II: Citizens Respond to Hate*, a film I coproduced with The Working Group's Patrice O'Neill. One particular scene comes to mind: a firefighter in Harlem, New York, named Pete the Greek stands straight-backed in his dress blue uniform in front of a candy apple red fire engine, telling why he and his wife sent one hundred engraved Bibles to a Baptist congregation in Dixiana, South Carolina, after their church was burned to the ground by white supremacists. I will never forget the look on Pete's face, the way his brow furrows as he says, "I just thought it was wrong. And it was un-American. And I wanted to make it right somehow." My words here describing the scene do not do it justice. When our production team watched the edited segment, we all broke down in tears. When the clip played on an episode of *Oprah*, Pete's humanity was undeniable. The striking visuals of firefighters and burned-out buildings, the story itself, Pete's character, and the sincerity of his words came together with undeniable power. Oprah wiped away tears. Her guests were visibly moved. And I watched from home, impressed all over again with the way documentary can pierce hearts with such stunning precision.

Perhaps the most courageous documentary filmmakers are those who choose to tell a story that not only resonates with their values, but also reveals essential aspects of their personal identities. People who carry shame or discomfort about who they are or how society has treated them can make bold statements to the world with their films. Creating this kind of personal documentary is an altruistic act, but it's also a way of declaring, "You will not define me. You will not deny me a place in this world. You will not undervalue me, or others like me." And while making such a film may be healing in the long run, it can also be painful and risky to place oneself at the center of the story and bare one's soul in such a public way. Filmmakers who do it go out on a limb both financially *and* emotionally, and in the case of political and corporate exposés, some even put their safety and freedom at risk.

For director Lucy Winer, what prompted her most recent film was a deep need to make sense of the five and a half months she spent in a state mental hospital as a teenager in the late 1960s. Setting out for answers, she created the daring and thought-provoking documentary, *Kings Park: Stories from an American Mental Institution*. In it, she delves into her own story, but also into the story of a particular institution and its relationship to the larger community. She achieves all of this with the utmost grace.

Winer's film gives voice to other former patients, as well as doctors, nurses, and ward attendants to whom these patients' care was entrusted. The camera is rolling as she returns to the crumbling grounds of the now-shuttered institution to confront her deepest trauma and most painful memories; she walks up a deserted stairwell to the ward where she was held, and later, visits her admitting psychiatrist seeking answers about the diagnosis that led to her institutionalization. What this filmmaker's courage does is help large numbers of audience members finally speak out about their own part in events that unfolded during the era of massive institutions such as Kings Park. At screening after screening over the past three years, mental health providers, patients, family members, and policy chiefs are together beginning to heal the confusion and shame many have carried for years, and come to terms with the latest failed public policy: the incarceration of people with mental health conditions in jails and prisons across America.

"My stay at Kings Park engendered a kind of terror which stays with me, and which I do not want anyone else to ever have to experience," Winer says. "But I cannot help but wonder, are we once again trying to hide away our problems where they can no longer be seen?"

For documentarian Eric Slade, what keeps him going is a commitment to the subjects of his biographical films, *Hope Along the Wind: The Life of Harry Hay*, and *Big Joy: The Adventures of James Broughton*, codirected with Stephen Silha and Dawn Logsdon. These films hold particular resonance for Slade, a gay man, in terms of his personal identity; they celebrate fearless and joyful gay figures, each of whom modeled a bold, original, genuine life. "The idea that I am making *the* definitive filmic record of their life carries a lot of weight and responsibility. I also try to keep in mind the finish line—that it will be *really great* when the film is done, out in the world changing things for the better."

Montreal-based director Eric Scott tells me that, for him, becoming a documentary filmmaker was largely about rebellion. "My parents were clear about the path my life was to take. They wanted me to follow in their 'success' and become a wealthy businessman, perhaps with a law degree, and join society's Jewish upper crust with no thought of doing anything else. As a teenager, I rebelled against this unimaginative, frozen idea of how to live a life. I rejected their idea of 'bigger and better' leading to happiness, which brought disdain from my family and social rejection from my peer group. So what keeps me going? My guilt at having been given so much, my desire to prove 'them' wrong, my compulsion to make others listen to what I have to say—especially if it's something they don't particularly want to hear, and to contribute something of transcendent value and worth to a bigger world." Scott takes on controversial stories involving identity and history, time after time. He is driven to do so.

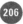

With every film you create, you're elbowing your way into the global conversation. You're piping up and declaring that this reality, this story, this point of view are worthy of attention. It's an addiction, you could say, to spending your days doing work that matters, and to the deep satisfaction that brings. So that's the privilege—to infuse your own sensibilities, your own worldview, into a film that will reach audiences. And that's why we need storytellers from all corners of society to bring us into their realities.

Probably because it's so hard, we independent film folks stick together. We root for one another in ways many might find surprising, given that we often compete for slots in festivals and broadcast. We show up at friends' early screenings and give thoughtful, constructive feedback. For me, this always feels like an honor, because while there's ego involved just to be asked, it feels good to know that in a small way, you enabled another film to be as good as it can be. We share contacts and hard lessons, and we donate what we can to friends' budgets. We promote friends' films and cheer their successes. We are engaged in a war against the forces of censorship and indifference. It's a great club to be in.

Many of us hover near cities where films are made. We take on corporate or commercial work or commissioned nonprofit films to pay our bills. Some of us edit or shoot for a variety of productions, others write grants or scripts for other filmmakers. We reinvent as needed. And while we're championing justice with our grit and artistry, we're having fun along the way. Making our films opens us up to exceptional people and life-changing experiences. Making films redefines us.

On a deep level, being in the documentary film community lifts us up and helps us rise over the muck. Our fellow filmmakers and their social missions, even filmmakers we've never met, form some sort of net that keeps us from sinking into despair about the condition of the world. We buoy each other's spirits. We do this out of respect and because we love film, and we do it because we love each other for taking on this pursuit. When I hear that someone is embarking on a new film, my first response is usually a twinge of concern, especially for a first-timer. Even if they are an experienced DP, or a talented editor, I think, *Oh my. They're taking on the whole thing. They're in for a long haul.* And yet, sometimes a film actually begins its life with an angel donor or major funder in place. But even when they don't, when the filmmakers stand on stage at the premiere, for an evening, at least, we all forget. We are just in awe that they crossed the finish line, and that their film is so vital and inspiring.

Last year, after I showed *Seneca Falls* to a group of high school students, I asked if anyone would be willing to express a feeling they were having as the credits rolled. "Hope?" said a smiling twelfth-grade boy. "Hope," I repeated, surprised and grateful. "I'll take it."

Years after you finish a film, its themes continue to resonate. Before making *Seneca Falls*, I viewed my civil rights as a given. Now, as I watch current events unfold, I hold my rights with gratitude to the small band of courageous souls whose activism forced them into law. My citizenship feels precious, but also precarious. To know how long and hard my predecessors fought to win these rights—and how recently that battle took place—lets me know how easily

they could slip away. So I vote. And I follow campaigns. And I keep up with issues. And I write to my representatives, both to thank them and to prod them into action.

In 1900, Susan B. Anthony finally persuaded the University of Rochester to allow women admittance. Just over a century later, I brought *Seneca Falls* to that university for a public screening at the Susan B. Anthony Center. As I left the city, I walked through the Susan B. Anthony concourse at the airport. Earlier in the day, I stopped by her gravesite. Against a humble white headstone etched with her name and dates rested two small bouquets of flowers, one with a note that read, *Thank you, Aunt Susan*. The headstone, about two feet high, seemed so ordinary. It wasn't a monument to greatness, like Frederick Douglass's massive tomb just a few hundred yards away. Yet she *was* great, in a thousand ways.

Utterly obsessed with getting a constitutional amendment passed that would enshrine the vote for women, and after testifying about it before every session of Congress for more than thirty years, after crisscrossing the country on trains giving speeches to angry crowds who ridiculed her, after seeing her image burned in effigy—after all this, in an act of desperation, Susan B. Anthony committed a serious misstep: she formed an alliance with racist groups in Southern states, agreeing to exclude black women from voting rights to help the amendment pass. In doing so, she compromised her legacy.

Many people will never forgive her for this sin—and, in fact, her best friend and lifelong ally, Elizabeth Cady Stanton, broke from her for a time because of it, forming an entirely separate suffrage organization. And in the end, Anthony's strategy failed.

Susan B. Anthony disappointed us on the issue of race, just as Thomas Jefferson had. Both made terrible, practical compromises, and yet, without question, both made tremendous contributions to the cause of freedom. These are the kinds of inconsistencies documentary research can uncover. These are the difficult truths found in the details.

The most editorially complex, high profile film I've made is *Iran: Behind the Veil*, a two-hour doc that aired on TBS and PBS in the mid-1980s. In writing, producing, and directing the film for Turner Broadcasting, I called upon four months of on-the-ground research and forty hours of raw footage captured by an Australian film crew that had gained the first Western access inside Iran since the fall of the shah, Mohammad Reza Pahlavi, six years earlier. The scenes the Australians brought back revealed life under the world's most powerful theocracy—the newly formed Islamic Republic of Iran—headed by its notorious revolutionary leader, the Ayatollah Khomeini.

Many of the images were jaw-dropping. In religious schools, we saw female students chanting "Death to America" in thundering unison; on the battlefront, we witnessed teenage boy soldiers kissing the Koran as they entered the Iran-Iraq War with the Ayatollah's promise of heaven; we glimpsed twenty-foot high "fountains of blood" in city squares—red-colored water spilling over tiered cement layers—a ghoulish sight meant to glorify the Iranian people's willingness to die for Shi'a Islam. Shi'a is the historically persecuted minority sect of Islam that identifies strongly with the Prophet Mohammed's cousin, Ali; martyrdom and unfailing loyalty to religious leaders are key features of the denomination.

In this once modernized, now thoroughly restructured society, Iranian women and girls were forced to wear head-to-toe black chadors and stay segregated from men outside the home. Females were stopped on the street if they dared to wear a trace of makeup, which, according to reports, authorities would remove with razor blades. Homosexuality was punishable by death. From the outside, it seemed a civilization gone mad. Separation of church and state—in that country, or in ours, or in any society—never seemed more urgent.

In addition to working with these startling images, our production team sourced stock and historical footage and conducted abundant new research; we shot interviews with Iranian exiles, a former UN ambassador, and experts on the region from academia. Five years earlier, while producing at CNN during the 444-day Iranian hostage crisis when fifty-two Americans were held captive after the US Embassy takeover by student demonstrators, my work had included research interviews with dozens of people with close ties to that story: US State Department officials, leading Middle Eastern experts, military advisors, think tank theorists, and "hostage wives," some of whom I had grown to know and respect. I brought this deep background to the documentary project, but I knew that reporting had been one-sided, and had barely scratched the surface. The film I was creating would not only test my journalistic integrity, but would demand a resonance with humanity that went beyond borders.

This was an immense responsibility, at once thrilling and terrifying. Having viewed Iran only through the peephole of videos sent by the hostage takers—eerie Christmas messages in which the captive Americans read prepared statements—it was now up to me to assess all the footage gathered of life inside Iran and on the Iran-Iraq warfront and sculpt an in-depth and unbiased story. The film crew had been escorted by government minders throughout its three-month shoot in Iran, yet still were arrested several times. My task was to filter out truth from propaganda, to compare what I was seeing and hearing on the videotapes with the informal interviews and eyewitness accounts gathered by the Australians—then weigh all that in the context of my new research. With time pressure to get the film on the air as quickly as possible, it was the most intense five months of my career.

An Iranian exile who spoke Farsi was flown in from the West Coast to be one of the film's two editors. On her own, she cut together a montage of street scenes in Tehran and called me in to watch it. It was lyrical and humane, in stark contrast with most of the other images on the tapes, and at the far end of the spectrum from news images that had leaked to the Western press—those angry, chanting masses that made the entire culture seem uneducated, unruly, and backward. I wrote narration to go along with the sequence the editor had cut. "When the morning sun strikes Tehran, a song rings out across the city, just as it has for centuries. The Azan. A call to the faithful to begin their day with prayer." Street scenes follow, exotic to us in the West, with nervous women and girls covered in black chadors, and boys playing soccer in casual Western-style clothing. The narrator continues: "The secular and the sacred have never been far apart in Iran. But under Khomeini's rule, what was once religious choice is now Islamic Law."

As Iranian orchestral music plays, we see the kind face of a well-dressed older man laughing with friends on a park bench, then a fruit vendor readying his cart for market. These images

are striking in their normalcy, in their humanity. But as the music grows more intense, we see posters and murals on the sides of buildings depicting the Ayatollah's face ten feet high. A worried young boy leans against one such wall, his childhood overshadowed by Khomeini's ever-present scowl. Soon we move to the sixth anniversary celebration of the Islamic Revolution, a massive demonstration in Freedom Square. The military presence, the disabled veterans from the ongoing Iran-Iraq War, the tense faces in the crowd, all paint a troubling picture.

Questions arose about the people I was seeing. Who are they, as a culture? How have they gotten to this extreme point in their history? What role has the discovery of oil and the accident of geography played in their destiny? Do the majority of Iranians support the Ayatollah and his iron-fisted, ultra-orthodox interpretation of Shi'a Islam, or are they his victims? Sources inside Iran to whom I had access—nearly two dozen in total—placed support for the Khomeini regime at between 10 and 15 percent. Although this was in direct contrast with the picture being painted on network television, I cited these figures in my script. I told American audiences other documented, uncomfortable truths: most notably, that the American CIA overthrew Iran's beloved, democratically elected leader, Dr. Mohammad Mossadegh, in 1953, and that the hatred for America that remains among some Iranians today stems from that coup and the installation of the often brutal regime of the shah. Mossadegh had nationalized the country's oil supply—the fourth-largest reserves in the world—upon being elected prime minister. His overthrow was the first in a series of Cold War-era CIA depositions of left-leaning leaders of other nations. I was swimming in deep waters now.

Where Iran was concerned, it became clear that the prevailing narratives on both sides were serving the dangerous notions of nationalism, exceptionalism, fundamentalism, and xenophobia. As I discovered the uneasy marriage between private oil wealth and geopolitical policy, between empire building and defending democratic ideals, I knew I had a chance to paint a multifaceted look at a country in turmoil. Part of that task was to present the long view, the story of the Persian people from ancient times to today. I wanted to recognize their culture as what it is: one of the cornerstones of civilization. When it came to US involvement in the region, I strove for impartiality, and tried to differentiate the Iranian people from the regime in power. I had no other agenda, no network executives weighing in. And, given the unique nature of the film, I knew the world would be watching.

Making *Iran: Behind the Veil* taught me that it matters who's making media. It matters because a variety of voices—a variety of sensibilities—are vital to an educated society. You have every right to tell the story you think the world needs to hear. The more radical it is, the more outside the prevailing narrative, the harder you'll probably have to push. But with mine, and with so many other filmmakers' documentaries, we did what we set out to do—we offered a cautionary tale. As former Iranian ambassador to the United Nations, Mansour Farhang says in his filmed interview: "It was not even in our political imaginations that men with turbans would come to rule our country." And yet they did, at first by mass persuasion and faith, and then by force. Thirty years later, men with turbans—religious clerics—still rule Iran, and according to a source I spoke with this month, the Iranian people still see freedom as a distant dream. "We have given up," she said. "What else can we do?"

Today, people across the globe have the opportunity to carry on the tradition of independent documentary filmmaking that began more than a half-century ago. Images still electrify. Narratives still move people. If the inclination is strong, and the story is there, there are few barriers to beginning. Learn the craft, join hands with fellow filmmakers, and create something unique and meaningful. Smooth and elegant or rough and harrowing, just make the film that's growling inside you, the film only you can make, the one no one else will.

Last fall, I was in a taxi at 7:30 a.m. on my way to a freelance senior producing gig in downtown San Francisco. Checking my inbox, I found a most unexpected e-mail from an Iranian immigrant to the United States who had seen *Iran: Behind the Veil* when it aired on PBS more than two decades ago. He'd been trying to track me down for a long time, he said, because the film had made a "magnificent impression" on him.

"I moved to the U.S. early in the revolution," he said, "and I remember the 444-day hostage crisis. When you are just a kid, you're not able to distance yourself from calamity. My classmates would point to me and say, 'are you like them?' meaning those angry faces that appeared on Nightline. When you aired your documentary, it was the first time someone actually talked about the poetry, the music, the garden paradise that was once Iran, and it made me so proud." His parents, he said, would play the film over and over in their old VHS machine. "It made a more lasting impression than you can imagine," he wrote.

Reading this tender e-mail, I felt suddenly teary, but also elated. It was so improbable that it felt like a dream. What odd timing, I thought—just as I'm heading into the heart of a tech-frenzied brave new world—to learn that the delicate care I'd taken to present a balanced view of the Iranian people in the context of their three thousand-year history had made such a personal impact.

I thanked the cab driver and headed toward the location. Above the city in the early morning sky hung a faint half moon. The sight of it filled me with the overwhelming sense that there are constants in this world, and that they apply to me and to all of us who contribute our work to the wider world. The constants that came to mind were these: that in everything I do, I strive for openness, fairness, humanity, and excellence. I hone words and images, and wait patiently for a poet's inspiration. I have the best of intentions. I am interested in connecting people, not dividing them.

As I crossed the street into a sea of young tech workers and well-heeled industry leaders from around the globe, I had the sense that I was in two worlds: one modern, one ancient. A line of narration from the film's opening segment came to mind, as if twenty-nine years hadn't passed since I'd written it: "They have seen eras of greatness and ages of oppression, but through it all, the Iranian character has bent, but has not broken."

There are constants in this world.

Of the dozens of honors that film won, none was more meaningful than an Iranian man's words arriving quietly that morning in an e-mail. The startling fact of that is still settling into my bones. His out-of-the-blue gift would have been plenty, but not five minutes later, part two of the lesson appeared.

As I'm walking down a long, beige backstage hallway in the basement of the Moscone Center, an entourage of about ten people is heading briskly in my direction, a triangular phalanx with former House Speaker Nancy Pelosi leading the charge in her characteristic cream-colored suit. As she nears, she looks me in the eyes and abruptly stops, causing her followers to slam on their brakes, too. "Oh, hi!" she says, extending her hand. "Hi," I say, shaking it firmly. Not sure if she remembers how she knows me, I quickly offer, "It's Louise Vance. I made the *Seneca Falls* film with the girls." "Yes, yes, of course," she says, squeezing my hand. "It's great to see you." "It's beautiful to see you here," I reply. She smiles and nods, and off she goes.

Sixteen years earlier, Speaker Pelosi had agreed to appear in a segment of *Seneca Falls* to informally meet with the film's teenage girls. Joined by three other esteemed congresswomen—Patricia Schroeder, Barbara Lee, and Louise Slaughter—these leaders spoke with the girls about the courage and daring of their foremothers on the "sacred ground" where their rights as women were born.

That might be where she remembers me from, I thought. Or maybe she saw my interview on CNN's *Amanpour* a few years back during the film's PBS launch. Or maybe she simply mistook me for someone else. Whatever the case, it was an unimaginable encounter for me.

Nancy Pelosi is the highest-ranking woman to hold elective office in the history of the United States. While speaker of the House, she was second in the line of succession for the presidency. She meets thousands of people a year. Whatever flickered in her memory that morning, I will probably never know. But I'd like to think it was our shared experience of being in Seneca Falls at that once-in-a-lifetime gathering, that place where Nancy—an only daughter among five brothers growing up with the mayor of Baltimore as a dad—and me, and those teenage girls, and the thousands of others who made that pilgrimage, deepened our reverence for the women and men who shaped America with their insistent cries for freedom, giving us the opportunity to lead lives of dignity. That was the great equalizer in the air at Seneca Falls. We were all humbled by the magnitude of that gift.

It's extraordinary where documentary filmmaking can take you: from viewers who express searing, unforgettable thoughts to historic figures you begin to know as the mere mortals they were and are; from funders who become friends to crew members and facility owners; to your film's own characters you have come to love as family.

The exciting thing is this: at this point in human history, each of us has the power to tell, and each of us can claim a platform. We are getting braver. We are growing up. No longer will we accept any unified doctrine about how the world works. No longer will we watch the nightly news, or scan our targeted and personalized home pages, with their predigested agendas, and believe that's all we need to know. We are seeing through the fabric that has blanketed us from a much wider, much richer reality. And we are shredding it, with every documentary we make.

LOUISE VANCE is a Peabody and duPont-Columbia award-winning documentary filmmaker who has been creating television and film projects for more than twenty-five years. Specializing in content-rich, real world stories, she brings a diverse range of issues, people, and cultures to mainstream audiences. Her body of work includes seven nationally televised documentaries for TBS, PBS, CNN, Free Speech TV—and, most recently, her independent doc, *Seneca Falls*, which aired on one hundred fifty-five PBS stations in 2010 and 2011. She was among the first thirty television journalists hired in 1980 to launch CNN in Atlanta, where she produced a tour of network operations for its inaugural broadcast. At CNN, Vance produced the network's midday and prime time news/talk programs, election coverage, special reports, and interviews with guests ranging from heads of state to prominent authors. Her efforts included on-location specials with Vice Presidents Mondale and Bush, Kennedy Center honorees, and United Nations ambassadors broadcast live from the UN studios.

Vance was named series senior producer/director for the five-year TBS documentary series, *Portrait of America*, in which she created two films and oversaw production of the series. Her landmark TBS doc, *Iran: Behind the Veil*, and its companion CNN series, *Iran: In the Name of God*, earned a Gold Hugo at the Chicago International Film Festival, a cable ACE award, a Monitor award for best network documentary, an Ohio State Achievement of Merit, and a duPont-Columbia Silver Baton. She has written and directed programs for KQED, Oregon Public Broadcasting, PBS, Discovery, and for leading firms, nonprofits, and educational institutions. Her projects include the Smithsonian Institution's interactive documentary game, *Tropical Rainforests: A Disappearing Treasure*; *Imagine: The Apple Education Series*; *A Passion for Justice: 21st Century Feminism*; and three advocacy films for the National Institute of Medicine. She curated and moderated *Information Warfare: Media Messages in Times of War*, a community film series for San Francisco's Intersection for the Arts, and has served on jury panels for the San Francisco International Film Festival's documentary competition. Vance earned a BA in English, magna cum laude, from the State University of New York at Albany. She is passionate about youth empowerment, greening the planet, and human rights, and is currently codirecting a documentary, *The Daughter's Voice*, about efforts to end a practice of child slavery in Nepal. Vance is an adjunct professor of communications at Sonoma State University, and an accomplished public speaker on the changing media landscape and issues addressed in her films. She leads "The Art of the Video Interview" seminars in academic and business settings, and advises documentary film projects on grant writing, scripting, and story development. When not in production, she

enjoys photography, travel, mindfulness practice, and writing, and shares life's adventures with artist and media designer Darryl Vance.

Filmography:

Portrait of America: Massachusetts
Portrait of America: Montana
Portrait of America: Texas (second unit director)
Iran: Behind the Veil
Iran: In the Name of God (series)
Tropical Rainforests: A Disappearing Treasure
The Making of Think Different
Livelyhood: Shift Change
Not in Our Town II: Citizens Respond to Hate
A Passion for Justice: 21ˢᵗ Century Feminism
Inside/Out: Real Stories of Women, Men and Life After Incarceration
Levi Strauss & Co.: Built on Values
Action for Justice: Making a Difference for Women and Girls
Bridging World History: Family and Household
What One Company Can Do: Levi Strauss & Co.'s Terms of Engagement
Adolescent Health Services: Missing Opportunities
Lost in Transition: From Cancer Patient to Cancer Survivor
The Mission Asset Fund: Investing in the American Dream
A System in Crisis: Charting a Course for High Quality Cancer Care
Seneca Falls
The Daughter's Voice (in development)

11 STUDENTS: SO YOU WANT TO MAKE DOCUMENTARIES?

BY *ART COHEN*

WHAT IF YOUR DOCUMENTARY had no sound? I am not suggesting that you make a documentary without sound, of course, but I am suggesting that you consider how you would tell the story if you could not use sound. It's an exercise that will help ensure that you make a film, and not a written report with visual wallpaper.

Film uses images and on-screen action to tell some or all the story, but in the documentary it is not always easy or obvious how to do this. How do you, for example, visually communicate the contents of a written report, or cover an important moment never recorded on film? What about shots that are easy to overlook, but might help the editor make a transition or communicate an important idea?

The standard term for these images is B-roll. This is a technical term from the early days of film and television production. Today the term is typically used to describe any piece of footage that plays over an interview or a narrator, as if it's an afterthought. "Oh, it's just the B-roll," or "I'll get the interview now and figure out the B-roll later," are common approaches to documentary filmmaking.

No! B-roll should never be considered an afterthought. The heart of the best nonfiction films is the B-roll. A film is about visual communication. Rather than an afterthought, the best nonfiction filmmakers think of the B-roll first. It's the main event. The best nonfiction films construct scenes where the B-roll does a lot of the critical storytelling. Actual footage of something happening on screen or of the location where an event happened is better than a thousand words describing it. The B-roll tells the story along with the interviews and narration.

The filmmaker Barry Hampe has suggested a different term for B-roll that I think more accurately describes its role in a nonfiction film. He calls it "visual evidence." The nonfiction filmmaker is always looking for visual evidence of the story. Sometimes the filmmaker can shoot this directly because he or she is at the event.

Sometimes it's necessary to acquire footage from other sources because the event occurred in the past. Sometimes the best available image is a still. Sometimes it's a document, animation, or graphic. The key thing to remember is that a nonfiction film is a film, not a book, and it works best when the filmmaker uses the full capabilities of visual storytelling.

THE VISUAL OUTLINE

So what about no sound? This exercise will force you to think of every conceivable image that might help you tell your story. Even when it might not be possible to acquire all the images you would like, the exercise will immediately pinpoint problems and issues and help you work around them, if possible. This exercise is valuable during the early planning stages of a documentary and will guide the director in creating shot lists. It may also be useful later, during the writing phase, or any time something new comes up or you feel stuck.

Step 1: It begins with a thorough understanding of your story. You cannot create a visual outline without enough research to understand the main plot points, the main characters, and the main locations of your story. The visual outline exercise kicks in once you have created at least a preliminary outline of your film.

Step 2: Working from this outline, start brainstorming a list of shots, images, graphics, and photographs that might be useful in telling your story. You can brainstorm with other people over several days or weeks.

Step 3: Now, arrange the images in an order that, when viewed in that order, tells as much of the story as possible. The images probably can't communicate every detail or nuance of a story, but often they can communicate action, mood, setting, orientation, identification, and more. For example, imagine that the first minute or two of a longer film begins with the following shots in this order:

1. WS kid playing video games.
2. CU face kid playing video games.
3. CU screen kid playing video games.
4. CU hands on video game controller.
5. CU hands on triggers of laparoscopic surgery instruments.
6. CU face of doctor in surgical scrubs and gloves looking up, away from patient.
7. CU of TV monitor showing patient's internal organs and a cutting instrument at work.
8. Wide shot of surgery as doctor looks at monitor and works the instruments.
9. Wide exterior, suburban home.
10. MS woman, in yard, gardening.
11. Same woman, meeting with surgeon.
12. Woman getting a blood test.
13. Woman meeting with anesthesiologist.
14. Woman arriving at hospital.

This sequence of shots suggests that playing video games may be good preparation for laparoscopic surgery. The woman we meet probably is about to undergo a laparoscopic procedure. No narration is required to communicate any of this. The images do all the work. And because the images do so much of the work, any narration we add can be economical; just three lines will work: "Can kids who spend hours playing video games amount to anything? Maybe they can be surgeons. Donna Jacobs is about to find out." The narrator does not need to explain the connection between a video game controller and laparoscopic surgical instruments. That's evident from the images.

In preparing the visual outline, do not leave out shots that seem impossible to obtain. If for example, your story were about a person recovering from an automobile accident, you would naturally want footage of the accident. But no one was filming the accident. It was an unexpected event. You should, however, include it in your shot list and work it into the visual outline. First, it is possible the accident was caught on a security camera, or someone took cell phone video. If not, you still need to discuss it in the film and its place in the visual outline will force you to consider alternatives. Perhaps there are police photos of the aftermath of the accident, or there's a photo of the crumpled car in a junkyard. If all else fails, perhaps you can go back to the location where the accident occurred, or consider an animated graphic. Perhaps, in the end, you will decide that documenting the accident isn't the main point of the film anyway and you won't need that footage.

In the early stages of the film, the visual outline is a planning tool; it helps determine what needs to be filmed, and helps you in estimating how many days of photography will be required to acquire that material. Combined with the list of interviews, it will allow you to estimate total production days. The list also suggests footage that might be acquired, perhaps at a lower cost than shooting it. For example, footage of a kid playing video games might be found easily in many footage libraries. The decision to acquire rather than shoot original footage depends, of course, on your budget, time constraints, and the goals of your film.

You may never use the visual outline as anything more than a planning tool. The final film is unlikely to follow your original visual outline. This is because you will not have acquired everything you had on your list, and you will probably acquire some unexpected material that was not on your list. It's also probable your thinking and knowledge of the subject will evolve as you work on the film.

During the writing phase, you might create a new visual outline reflecting what assets are actually acquired and then fill out the story with the interviews and narration. This approach creates a very visual film with economical narration. It often allows the interviews to focus on the emotional and thoughtful issues. It's important to note, however, that some stories revolve around the interviews; a compelling interview can be as powerful and effective as any visual. Some films and some topics should be built around the interviews, with the visuals brought in to fill out the story. But in most cases, great documentaries interweave visual storytelling and riveting interviews to create a whole greater than the sum of its parts.

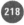

WHAT IS A DOCUMENTARY?

Similar to so-called narrative, or fiction films, the best documentary films tell stories. The best films are built around stories of people or "characters," and as with fiction films, have a plot. But documentary films present real characters and actual, verifiable events.

Often, one goal of the documentary filmmaker is to reveal the character of the people in his or her film through what they do and say. Part of a documentary filmmaker's skill is the ability to capture revealing moments and words. The plot is usually what happens to the character or characters. The plot is often, although not always, something out of the ordinary for the characters and/or for the audience. This could be something from the past, in which case you're trying to recreate the story, or it could be something about to happen, in which case you're trying to follow and capture the story as it happens. It could be a combination of both: the subject has just finished a last painting and is about to open a gallery show.

Many documentaries are about individual people and their unique experiences or situations, which is the story; however, usually the documentary filmmaker is also looking at a larger theme, which is the topic. A documentary that follows a person undergoing a medical procedure for cancer, for instance, may also be reflecting, sometimes inadvertently, on the larger themes of life and death, health and wellness.

Although fiction and nonfiction film share the basic techniques of photography and film grammar, they require entirely different approaches. The fiction film project begins with the script, which lays out the blueprint for the entire film including basic blocking, dialog, characters, locations, sets, and props.

The nonfiction film project begins with an idea and an outline. The script for a documentary film, in most cases, cannot be written until production is complete. It is during the production phase that the filmmaker gathers the raw materials. Shooting, in a sense, is part of the research. Since the film is built on those raw materials, it is not possible for the filmmaker to write a script until he or she knows exactly what raw materials are available.

Although they may not work from a script, experienced documentary filmmakers work from an outline. The outline is based on detailed research and suggests the interviews, questions, and images that will be required to tell the story. It's helpful, in fact, to think of the nonfiction film as similar to a research paper. Nonfiction filmmakers may spend weeks, months, even years researching the story before filming begins, similar to someone writing a research paper or nonfiction book. The research may include studying books, articles, and original documents such as letters and reports; it certainly includes detailed conversations with the people involved in the story, and sometimes with experts on the topic of the film. From the basic research, the filmmaker assembles an outline, and based on the outline determines who must be interviewed, what questions must be asked, and what images must be filmed or acquired to tell the story.

Once you have identified the people you are considering as the principal characters in your story, you should conduct preinterviews, on the phone or in person, with each of those people. Your purpose in conducting a preinterview is to determine whether the person is

articulate, to increase your knowledge of the story, learn who else is involved, and to identify the visual evidence you will need, etc.

Based on the entire body of your research you should be able to create an outline describing the story you will tell and how you will tell it. It should all make sense on paper. The story and the approach are likely to change as you work on your film, but this treatment will be a helpful starting place.

A critical issue when choosing a topic for a film is access. You must have adequate access to the people, locations, and materials required for telling the story, and this necessitates a thorough discussion with the subject or subjects of the film before you move forward. Access means the person or people whose story you are telling must agree to let you film all the key moments required to tell the story. And they need to be available to you for an adequate time to allow for interviews and other work required to complete the film during the period you have available for production. Access might include, if required, permission to film them at work or around family; it might mean having a camera present during some private moments. You may need access to other key people connected with the story such as the relative or friend who stood by someone or observed them during the events and has an important detail to add.

Also, be sure you have access to the historical materials that might be required to tell your story including photographs, home video, and documents. Investigate whether these materials exist, where they are, what condition they're in, and whether you can have access to them.

You must also have access to critical locations. For example, if you are telling the story of someone preparing for a competition, you will need permission to film the competition.

WHAT QUALITIES ARE REQUIRED TO SUCCESSFULLY PRODUCE AND DIRECT A DOCUMENTARY?

A documentary is a giant puzzle. In the beginning you might not even know the pieces, let alone the solution. The process of finding and assembling those pieces requires a number of qualities that begin, of course, with curiosity. In particular, the documentary filmmaker has a curiosity about real people, decisions, and events. They find reality interesting enough without the need to embellish. They want to know what makes people tick. They want to know what actually happened, what people were actually thinking and feeling, why people make certain choices or take certain actions, and how the sequence of events fits together. They are interested in uncovering truth and are willing to follow the facts rather than select or adjust the information to conform to their preconceptions.

In addition to curiosity, the documentary filmmaker must be tenacious and diligent, with the skills of a diplomat and the qualities of a good manager. Ultimately, the documentary filmmaker is a leader who can organize others and guide them to complete his or her vision. Few of us have all of these qualities, or do them all well, so it's not unusual for documentary filmmakers to collaborate on a project with people who complement them, sometimes as coproducers, sometimes as staff members.

The documentary filmmaker must be a diplomat because participants in documentaries are rarely paid. Their cooperation is voluntary. The filmmaker needs their help in a thousand ways from the time required to make the film, to access to private locations and private moments. A huge part of being a documentary filmmaker is getting this cooperation, which means understanding why a person might want to participate and why a person might not want to participate.

At times, the filmmaker might even have to become a psychotherapist. It's not unusual to find that in the middle of a long project a participant will get cold feet and decide to pull out or stop cooperating in some crucial way. Sometimes this can imperil a project and require an ability to calm people, quell their fears, and honestly answer their concerns.

The documentary filmmaker must be a good negotiator in a thousand different ways. It begins with negotiating with the key participants in your film about the kind of access you need and the amount of time required. You could find yourself negotiating with the managers of a location or venue to allow cameras, or for camera placement, or for access to a sound feed. You will negotiate with vendors on price, and with the manager of an arena for parking. Making a documentary film is a constant negotiation.

Tenacity is another critical quality. How far will you go to find that missing photo that fills a crucial hole in your film? How many doors will you knock on, calls will you make, or e-mails you will send to reach a crucial person who needs to be interviewed or has an important item or piece of information required to make your film? How far will you go to find that short piece of video in hours of repetitive security video? How many photo or film libraries will you visit or contact to find that rare photo to tell your story?

Of course, documentary producers must also be organized and have some basic management skills. We might also say disciplined. A film might involve keeping track of hundreds of facts, dates, time lines, names, addresses, equipment, documents, and all of the media. The documentary filmmaker must develop a system for cataloging all this information—and even more important, be disciplined enough to maintain it over long periods of time. It is especially critical to have a consistent and standardized system for record keeping and managing resources if multiple people are working on the project with you.

Ultimately, documentary filmmakers must be able to lead. Leaders develop a vision and can inspire others to understand and follow that vision. The documentary filmmaker has a vision for a film, and he or she must be able to communicate that vision to the cinematographer, sound engineer, editor, graphic designer, composer, sound designer, and the participants, the subjects of the film who are interviewed or appear on camera. The filmmaker must be able to inspire all of these people to do their best work and to understand, serve, and hopefully extend and improve the vision with their unique contributions.

WHAT IS YOUR PROCESS?

Once you have identified a story and carried out some research, what do you do next? To get anything done you must have a process. I have one for you, at least as a starting point

for developing your own. Not every producer works exactly this way. The precise production process and who does what on a project varies depending on the nature of the film, the producer's skills, work style and habits; the length of the documentary; the budget; and a variety of other factors, but this process represents standard industry practice. The production staff, including associate producers and production assistants, may actually carry out the producer tasks listed below.

A. DEVELOPMENT

1. Producer, reporter, or writer conducts research, develops the story, and creates a detailed outline.
2. Producer secures expressions of interest from key participants.
3. Producer develops a list of possible images and interviews, a production plan and schedule, a budget, and a written proposal, if required.
4. Producer raises money or otherwise persuades someone to fund the production.

B. PREPRODUCTION

1. Producer sets up an office (if required) and hires staff members (if required).
2. Producer, reporter, or writer conducts additional research as required.
3. Producer contacts participants with suggested production dates and schedules production days.
4. Producer hires crew members and rents equipment.
5. Producer makes travel arrangements.
6. Producer, writer, or reporter preps for interviews.
7. Producer arranges for permits or security.
8. Producer maintains good communication with all parties involved.
9. Producer and editor create a labeling strategy for recorded media and project files.
10. Producer, reporter, or consultant researches file footage, stills, and other images as required.
11. Designer begins design process for animation including the open, logo, and other graphics, if possible.

C. PRODUCTION

D. POSTPRODUCTION

1. Editor transfers media to editing drives.
2. Editor creates audio files of interviews and sends them to transcriber.
3. Editor watches all footage, including the interviews.
4. Writer watches all footage, and watches all interviews with transcripts.

5. Writer creates a script, probably multiple drafts.
6. Producer orders graphics, animation, music, etc., based on approved script.
7. Editor creates a first cut of the film based on approved script (with "scratch track" narration, if required). The cut is revised multiple times, as budget and schedule permit, until the script is locked.
8. Narrator records final narration with the guidance of the producer and the editor.
9. Editor inserts final narration and completes final touches, bringing film to "picture lock."
10. Colorist makes required adjustments to video with picture-locked version of film.
11. Composer composes music using picture-locked version of film.
12. Editor inserts music as required and prepares film for audio mix.
13. Sound designer mixes, adjusts, and creates audio tracks, and produces a final sound mix, usually with the participation of the editor and the producer.
14. Editor inserts final sound mix and creates and outputs final movie file.

E. WRAP

1. Producer and editor deliver film to all parties in required formats.
2. Producer receives final payment and pays all remaining bills.
3. Accountant delivers final project balance sheet.
4. Producer closes office.

DIRECTING

A documentary film requires directing, just as with any film, but often the producer or writer directs the documentary in consultation with the cinematographer. The skills of the fiction director are not all that useful for the documentary. There is no script to interpret through casting and set design. In theory, the narrative director is in complete control of the film and everything that happens in front of the camera. The sets, the lighting, the actions and movements of the actors, the way lines are read, are all within the control of the director. We often think of a narrative film as the director's movie.

While the narrative director creates an artificial world of people, places, objects, and events that serve the purpose of the story, the documentary director is trying to capture the actual world of people, places, objects, and events that are her or his story. The documentary director is more like a journalist. He or she is using photography to capture reality. Often the documentary director has no control—and should have no control—over what happens in the front of the camera. The director is likely to be as surprised as anyone by what happens and what is said. That's the point of a documentary at the most basic level. The filmmaker is documenting reality, discovering what happens rather than creating it. The director of a documentary often must be a diplomat, negotiating with the subjects of the film over what

can and can't be photographed, and with the managers of locations and venues to work out camera, lighting, and sound issues.

There are creative and artistic decisions to make. Will this be a film shot largely handheld with gritty lighting, or will everything be carefully shot on a tripod and lit beautifully? The subject and nature of the story will suggest the right style for the film.

There are situations where the documentary director has control, or at least some control. For example, the director may have some discretion in choosing the location for interviews and deciding how the interviews will be lit and framed. The director may have some control when filming something that is being shot just for the camera. For example, perhaps a potter is demonstrating how to create something out of clay on a potter's wheel just for the camera; he's not doing it for a client or for a live audience. The director might ask him to make several pots so he or she can shoot the activity from various angles.

The documentary director usually works closely with the cinematographer. Since often what is happening in front of the camera is unplanned, the cinematographer may have to make instant decisions about what to shoot and how to shoot it with little or no time for consultation. That's why the director must clearly discuss and plan with the cinematographer how to handle various possibilities and eventualities.

THE DOCUMENTARY CREW

The documentary crew is also often required to work with various limitations. When crew members have control they can take the time to set and light a shot the way they want; for example, during interviews and staged demonstrations. But they may not control what happens when following someone, let's say a political candidate, as he or she campaigns. The camera crew and the director have no idea where the candidate will go. He or she may wander into a room with little light or stand in front of a window. Under these circumstances, crew members must be skilled at adapting and using all of their knowledge to get the best result. Here are a few notes that might be helpful.

EQUIPMENT

The more you know about the shoot and what will probably happen ahead of time, the more likely you will have the right equipment for the task. Call or visit the location if you can. Consider how much time you will have at the location and how important it is to the overall story.

Questions to consider:
- Can I set up lights and what kind of lights do I need?
- If necessary, can I shoot with available light?
- Are there windows, and can I make the windows help me or will they be a problem?

- Are there noises such as machinery or construction in the area that might cause problems with sound?
- Where can we park in proximity to the building to unload equipment?
- Are there elevators if we are not on the first floor?
- Can we tap into a podium audio source, if necessary, or can we place our own microphone?
- How big are the spaces we will be working in?
- Will there be restrictions on where the camera crew can go?
- Is there power available for lights or other equipment if we need it?

LENSES

As a general rule, video cameras made for documentary shooting have zoom lenses, so the videographer can move quickly to change the focal length as required. Except in certain very controlled circumstances, prime lenses are not of much value. The standard zoom lens starts moderately wide angle and moves to moderately telephoto, and this might be all you require.

But if you know in advance you will be very far away from the subject you must film, you can bring a higher focal length telephoto lens suitable for the job. Keep in mind that the higher the focal length, you will need more light to make an acceptable exposure, you will have less depth of field, making focus critical, and you will probably need a tripod because every little move or shake is magnified, making handheld work difficult or impossible. On the other hand, if you know in advance you will be operating in a small space, consider a wider than normal lens. But be sure it's not so wide that the image begins to distort.

LIGHTS

Documentary crews try to travel light (get it?), especially when they are following someone and moving around quickly. In most cases, documentary crews will carry minimal lighting equipment, which might include a light mounted on the camera (although this is not always the most flattering light), a few small lights, a soft box, reflector, and a few gels.

When you have to bring the light level up in some locations, the simple solution is often to bounce a light or two off a white ceiling or a white card mounted on a stand, placing the lights where they won't be in the shot.

AUDIO

Audio is critical in a documentary. If you don't pay attention to audio, it can ruin your film. It's true that sometimes a skilled audio engineer can improve poorly recorded audio and make it acceptable, but not always. Audio that is distorted probably cannot be repaired. Electronic buzzes or loud sounds in the background can sometimes be

minimized so they are less offensive, but these fixes rarely work that well and usually require compromising the overall quality of the sound. Therefore, it is critical to record the audio right the first time.

It's best to have someone along on the shoot whose main job is paying attention to the audio. There are situations when a photographer can handle audio alone; many news photographers do this every day for simple interviews and press conferences where no one is moving. But a documentary crew should include an audio person, especially when following someone, when using more than one microphone, and when using wireless microphones.

SHOOTING

The rule should be to always use a tripod when possible. Go handheld only when necessary. Formal interviews should always use a tripod. Establishing shots and beauty shots should always be made from a tripod. Almost everything is better when shot from a tripod.

Handheld work might be required in circumstances where you are moving quickly to follow someone or to keep up with events where the locations are rapidly changing, or to get in close to certain situations. The best handheld work minimizes shakiness. Always stay as wide as possible. Any increase in focal length will magnify movement and make the shot shakier. Using a tight zoom when handheld requires much skill and experience; not only does any slight movement become very magnified, depth of field is reduced, making constant focusing essential. Instead of zooming, physically move in with the camera for the close-up, leaving the lens wide.

In general, don't pan or zoom, unless you have a very clear reason for doing so. The reason, generally, is to show relationships. For instance, you might start with a wide shot of a building, and zoom into a window on the third floor to show where an event took place. You might show a crowd of demonstrators and zoom in on a particular person who is important to your film. You might pan from one end of a street to the other to show the relationship of all the buildings to one another, or pan across some faces to show their relationship to one another.

When panning or zooming, be sure that each move is as perfect and smooth as possible, and always make sure the zoom or pan has a clear starting place (on a well-framed shot), and a clear ending place (on another well-framed shot). Be sure there is no "bauble" or slight bump when the zoom or pan starts and ends. Be sure the zoom or pan speed is consistent. Consider executing the zoom several times at different speeds, since it's always difficult to know what's required in the editing room. Pans of scenery might be slower; it's easier to make an edit in the middle of a slower move.

The documentary shooter should try to "shoot for the edit," which means adequate coverage of a scene so the editor can make it appear to be in continuous time. If possible, shoot a master shot and then the close-ups and details that match the action in the master shot. For instance, if a potter is throwing a pot on a potter's wheel, start with a master shot of the entire process, then ask the subject to do the entire thing again while you grab close-ups of

the subject's hands and the clay pot turning on the wheel. Make sure the subject moves his or her hands in and out of the shot the same way so the editor can make match action edits.

Also, be sure to get cutaways that briefly take us away from the action but keep us in the moment. Cutaways are particularly critical for documentaries. Since it's not always possible to obtain perfect coverage while shooting, cutaways allow the editor to "cut away" from the action and then cut back to it without a jump to compress time or maintain the illusion of continuous action; the potter's face, for instance, as he or she looks down on the work, or the face of someone else in the space watching the action.

Cutaways are sometimes the most important shots in the film because they show how people are reacting. If you are filming a street performer, you must grab shots of audience members laughing or reacting. If someone is getting dramatic news, the camera should probably focus on their face as they hear the news rather than the person delivering the news, because the reaction is the story.

THE FORMAL DOCUMENTARY INTERVIEW

There are interviews conducted "in the moment," immediately after the athlete has finished competition or just as the singer walks off stage following a performance. These interviews are usually short. They are designed to catch the emotion of the moment. They might be conducted with a handheld camera and a handheld microphone. The noise, activity, and commotion that surround the person are all part of the moment. The subject is often standing, sweating, holding a trophy. You should always get these "on the fly" interviews when possible and appropriate. They are part of the story.

The formal interview is usually the lengthiest interview with the subject. It covers all the main topics and is used throughout the film. It's usually a sit-down interview because it goes on too long for people to stand and remain comfortable. It's possible, if appropriate, to break it up over several sessions and locations. All the main characters in your film should sit for a formal interview or interviews. These are the main interviews around which you will build your film; you want to take enough time to get them right, and get what you need.

Consider the purpose of the interview and how it will be used in your documentary. Are you looking for accurate and reliable expert information, an opinion or impression, a detailed description of an experience or event, or an emotional reaction? Some interviews will fit into more than one of these categories.

You could divide the people you interview into the following types:

The Participant: Provides a first-person account as someone who has lived through the event or events in the story. Offers an impression, a detailed description of an experience or event, and/or an emotional reaction to that experience.

The Eye Witness: Provides a first-person account as someone who observed the event or events in the story. Offers an impression, a detailed description of an experience or event, and/or an emotional reaction to that experience.

The Stake Holder: Represents a point of view, or one of the sides in a story where there are multiple points of view and positions. Offers information, an opinion, and perhaps even an emotional reaction.

The Expert: Usually someone with appropriate credentials who provides background, context, and explanations required for your story. Offers an impression and/or emotional reaction.

The Person on the Street: Provides a sense of public reaction to events or information.

In most cases you should have preinterviewed the subject of the interview as part of your basic research into the documentary. Although the preinterview is a great starting place, documentary producers know that what finally ends up on camera might be different from the preinterview. Answers during the preinterview could raise new questions or require clarification. It's also possible that the producer might have uncovered new information since conducting the preinterview that must be raised with the subject. Also, once you start the subject thinking about the topics of your interview, he or she will remember new bits of information in the days and weeks following the preinterview.

Sometimes the interview subject says something powerful and surprising during the preinterview, but won't say it, or won't say it the same way, when you are recording. This occurs when the subject has second thoughts about what he or she said, or the way he or she said it. I suppose also that people just forget how they said it before. In either case, you can't make people say something they don't want to say, but you can remind them how they said it during the preinterview, based on your notes.

ASKING QUESTIONS

It's always best to get the subject to speak in complete sentences and to include your question in his or her answer. Why? In most cases documentary producers try to avoid including questions in the documentary. There are many reasons for this. Some believe the documentary flows more smoothly without questions breaking up the narrative. Others believe that if you keep the questions, you also have to occasionally show the questioner, which complicates production and introduces another character who might dilute the film.

One way to get people to speak in complete sentences is to not ask questions. If you ask, "Are you still living in Boston?" and the subject answers, "Yes," then the answer is useless without the question. Instead, raise areas for discussion. Ask the subject to "talk about" his or her views. Ask them to "describe" what happened. Ask them to "tell you" what it felt like. You can also ask questions that require open-ended answers, such as "why" something happened or "how" something happened.

Pay special attention to the use of pronouns. It's natural for people to say "he" or "she" as they describe a long, complicated story, or in response to a question. "What was Professor Jones like to work for?" "He was great." If we lose the question, viewers won't know who "he" is. Ask people to start again and use the person's name in their answer. You want the subject to say, "Professor Jones was great to work for."

In my experience you can simply tell subjects you want them to speak in complete sentences and to include the question in their answers, and they do most of the time. Stop them when they don't, and ask them to start over.

If you intend your film to not have a narrator, you might want to use the people you interview to perform some of a narrator's functions. The narrator usually provides basic background information, and may also be used to summarize key points or provide critical transitions. As an example, instead of a narrator saying, "Adam Jones moved to Boston in the summer of 2010 and found this apartment on Raymond Street," you could put some text on screen or make sure that one of your interviews, someone in a position to know, tells us the information. For instance, Adam Jones could say, "I moved to Boston in 2010, August I think, and found a place on Raymond Street." Or perhaps Adam's friend might tell us: "I believe Adam moved here to Boston in August of 2010. I certainly remember that crazy apartment he had on Raymond Street."

If you intend to use the interviews for narration, you must do some advance planning. While it's difficult to anticipate all the narration you will need, you can reliably guess some of it based on your outline. Consider who among those you are interviewing might provide the information required, and be sure to include a question designed to provide that information. You could certainly ask both Adam and his friend the same basic question about Adam's arrival in Boston, and choose the one that works best. It never hurts to have multiple options. Again, be sure people speak in complete sentences and include the question in their answer.

While you can't know for certain what narration you will need, you will cover many bases by asking all your interview subjects who, what, when, where, and why. Ask everyone to say who he or she is, what they do or did, when they did it, where they did it, and why they did it.

USING A REPORTER

If your film will feature an on-camera reporter, it's still always a good idea to follow the basic rule that interview subjects speak in complete sentences, include the question in their answer, and provide basic information that can be used as narration. Following that approach will increase your options and simplify writing and editing.

Following these rules, however, might be less important if you are using a reporter or narrator. Obviously if the reporter appears in the film, you can leave in the questions, which means the subject is less obligated to speak in complete sentences.

You may use the situation for dramatic effect. In some documentaries, especially news documentaries, a reporter could be an on-camera presence, conducting the interviews and

acting as narrator. As an example, here's an excerpt from Oprah Winfrey's interview with Lance Armstrong broadcast on January 17, 2013:

Winfrey: Did you ever take banned substances to enhance your cycling performance?

Armstrong: Yes.

Winfrey: Was one of those banned substances EPO?

Armstrong: Yes.

Winfrey: Did you ever blood dope or use blood transfusions to enhance your cycling performance?

Armstrong: Yes.

Winfrey: Did you ever use any other banned substances such as testosterone, cortisone, or human growth hormone?

Armstrong: Yes.

Winfrey: In all seven of your Tour de France victories, did you ever take banned substances or blood dope?

Armstrong: Yes.

USING A NARRATOR

Using a narrator is another way to get around answers that are incomplete sentences. For instance, if a senator just says "I think it should pass. It will mean jobs and a better life for our kids," we have no idea what "it" is. A narrator could set the question up: "Senator Jones is one of the sponsors of the public transportation funding bill," which explains the "it."

But asking the senator to speak in complete sentences and to include the question in his answer gives you the most flexibility, even if you are using a narrator or reporter: "I think the public transportation funding bill should pass. It will mean jobs and a better life for our kids."

CONDUCTING THE INTERVIEW

At the beginning of the interview, just after you start rolling, ask the subject to say and spell his or her name, and if appropriate, to give their title or credential. This becomes part of the transcript and gives you a reference for lower thirds.

Remind the subject to look at you during the interview and ignore the other people and equipment. Try to create a rapport with the subject so he or she feels that you are simply engaging them in conversation.

Consider opening the interview with some warm-up questions that don't require much effort, such as "Tell us how you became director of this organization."

Do not respond during the interview. Just nod. Your voice or any sounds you make will ruin an answer and make it difficult to edit. Unless the interviewer will be an on-camera presence who might intentionally want to interrupt the subject, don't speak over an answer,

and make sure the subject is done talking before you speak. If both you and the subject are talking at once, ask the subject to stop and start their answer again.

Watch out for phrases similar to "As I said before." You have no idea in what order responses will be used in the final film or if they will be used at all. In some cases it will make sense to ask the subject to stop and start again. Make sure they don't use your name: "I remember the first time, Art, like it was yesterday."

Listen intently during the interview. Is the subject speaking in complete sentences and including the questions in his or her answer? Is the subject answering the questions clearly and completely? Is the answer rambling and disconnected? Does the person start down a path and never finish an important thought? Are these the answers you had hoped to get? Has the subject raised new issues worth exploring? Is there anything in the subject's answer that requires clarification (an unfamiliar term, acronym, etc.)?

In any of these situations you may ask the subject to answer again. You may ask them to answer more succinctly or summarize an idea. Sometimes, if they are having trouble, leave the topic and come back to it later. It's OK to help them with an answer, so long as you don't over direct or suggest something they don't really mean.

One very important point is to listen for new material. Be prepared to explore this new material if you think it's relevant. Often it is these surprises that produce some of the best parts of the interview and could transform your film.

CHOOSING A LOCATION

The location and setting for your interview is a decision made by the director, and usually made in consultation with the cinematographer. Sometimes the location for an interview is forced by circumstances, but when there is a choice, the director should have a style and plan in mind for each setting.

This is a creative choice, which means there is no single right answer. But here are a few general rules that you can use unless you have a good reason to do something else. Fall back on these rules when you are not sure what to do.

LOCATION

If you can, use a setting appropriate to the person, perhaps one that reveals something about the subject. Interview a CEO in his or her office with a perfectly neat desk, a writer in his or her messy study surrounded by piles of papers, a designer in his or her workshop, a skateboarder in a skate park or skate shop, an athlete in the gym, etc. How much of the setting is visible in the shot depends on the composition of the shot; with a close-up or extreme close-up the setting and background will barely show in the frame.

Also, keep in mind that the setting is not the main event. In most cases the person's face is the most important thing in the shot. We want to see their expressions as they speak. So

avoid backgrounds that dominate the shot and take attention away from the subject because of bright colors, patterns, signs, or other distracting objects. When possible, light the background so it is darker than the person's face or set up the interview so the background goes out of focus. Sometimes the composition can become quite awkward when you try to squeeze in a sign or a building to help identify the subject. A subtle suggestion is better. A blood pressure machine mounted on a wall and an exam table in the background, even if they are slightly out of focus or only partially in the frame, is enough to suggest a doctor or nurse.

The ideal location is large enough to pull the subject away from walls and bookcases, which helps create a sense of depth and allows you to use a backlight. Move the CEO to the front of the desk, put the actor in the front row of the theater with all the empty seats in the background, the athlete with the entire gym behind him or her, etc.

Avoid action or activity in the background. It's fine to have action and activity during an "on the fly" interview, but during the formal interview it is distracting and it constrains your editing, since people and objects are changing position all the time.

FOCAL LENGTH

My usual approach is to select a shot and stick with it. I tend to go for close-ups and extreme close-ups, even to the point of cutting off the top of the head sometimes, because watching a person as they speak can be very revealing and powerful. I'll choose a slightly wider shot for interviews that are dealing with facts and information, and a slightly tighter shot for emotional interviews.

You could consider changing the focal length between answers while you are asking a question, which might allow you to make an edit without a jump cut. Changing it between answers allows the camera operator to reframe and focus when the subject is listening and not speaking. My experience is that this rarely works out in the editing room.

If you have a very skilled cinematographer he or she could be instructed to slowly zoom in during emotional answers and slowly zoom out when the answers become less emotional. The problem here is that these moves must be perfect. A slight bauble or shake, an imperfect stop or start, could ruin the moment. Very few cinematographers can be trusted to do this well.

SECOND CAMERA

A current fad is to set up a second camera, usually as a profile, although other shots might be possible. One advantage of the second shot is that it allows you to edit an interview without a jump cut and without B-roll cover. You can jump back and forth between different parts of the interview by simply changing the shot.

One problem with the profile camera is that it often makes no sense. Why do you want to see someone in profile? You can learn much more about someone, and they are usually much

more interesting, when you are looking directly at their face. The profile shot distances the viewer from the subject and makes it feel much more like the viewer is eavesdropping on a conversation or confession. If that's the goal, then do it, of course. But in most cases it serves no useful storytelling purpose.

Another problem with the profile camera is that it might constrain your lighting and setting. You may have to compromise the lighting so that it works for both shots, and the background for the profile has to work equally well as the main shot, and this might limit the choice of locations.

A second camera is useful when there is a reporter asking questions. Giving the reporter and the interview subject each their own camera makes it much easier to edit the interview. For this to work you must have enough lighting equipment and enough room to set up the second camera and lights. Once again, you have to look for a location with two suitable backgrounds. Make sure you don't cross the line. Both cameras should be on the same side.

A second camera might also be useful if you are conducting an interview with two or more people at once. Lock down one camera on a wide shot and use the second camera to get close-ups of each speaker. The editor can always go to the wide shot while the other camera is repositioning. Place the cameras next to each other and everything will cut.

You can do a group interview with a single camera, but the camera operator must react quickly and smoothly as each person speaks, and with a single camera you will need many cutaways. No matter how many cameras, it's always wise when interviewing a group to get about fifteen or twenty seconds of each person in the group looking at and listening to every other person in the group. If the reporter is a presence in your film, be sure to get a shot of the reporter listening. These cutaways will help with editing.

With two cameras in any situation, make sure the camera operators have clear instructions and a clear strategy. You want to make sure you never have a situation where both cameras are repositioning at once. If that happens, you have nothing. That's why it's important to have a strategy and a plan.

Pay close attention to any noise in the room. Appliances, ventilation, heating and air conditioning systems, people in the next room, activity in the hallway, construction work on another floor, or someone mowing the lawn outside can all ruin your interview. Sometimes these noises won't be there when you first set up, and then suddenly appear when you start the interview. Ask ahead of time if any of these things might be problems. Find out if you can shut off the source of the noise, if the windows can be closed, if the construction work can be temporarily suspended, etc.

It's very important that there be no music playing in the background. Music is not only distracting, but makes it very difficult to edit the audio, since the presence of music will cause

an audio jump cut when there is an edit. Always shut the music off, and if it can't be turned off, do the interview somewhere else.

OUTDOORS

Sometimes an outdoor location is appropriate. Conducting an interview outdoors is tempting, in part, because it appears to require less setup. Lighting comes from the sun, aided perhaps by a reflector. The background is already lit. Just set up a tripod and go. Even outdoors you will want people seated for a lengthy interview, so choose a situation where it looks natural for people to be sitting outside.

The main issue outdoors is sound. There's noise—planes fly overhead, a big truck passes blasting its air horn, people shout from across the street, someone mows a lawn. Once, when I was in a rural area, someone started up a chain saw. You have to be prepared to pause frequently as you wait for the sound to stop. We found the person with the chain saw, and he agreed to take a fifteen-minute break.

There's also wind. Sometimes even a light wind can be heard in the recorded audio. A windscreen can help, but in some instances nothing can mask it. Sometimes you just have to wait for the wind to subside, or move.

The other issue is changing light. On a partly cloudy day the sun could move in and out from behind the clouds, changing the lighting dramatically and perhaps even changing the color temperature, which could make editing trickier, since shots won't match. A very bright day might require a neutral density filter, and at the end or beginning of the day the color temperature could change as the sun rises and descends.

THE ACTIVE INTERVIEW

Sometimes it seems appropriate to interview someone while they are performing an activity related to the story. The furniture maker builds a table while being interviewed, the sculptor works in clay, the painter paints, the mechanic changes the oil, etc. Watching someone work while they talk can strengthen some interviews.

Just keep in mind that it becomes a challenge to edit the interview and maintain continuous action on screen. Generally these interviews should be shot wide, on a tripod if feasible. The trick is to shoot plenty of cutaways and match action cutaways, which can be staged at the end of the interview.

There is a form of this active interview where the subject is actually "showing and telling." The furniture maker is both showing us some aspect of his or her work and describing what he or she is doing. Consider creating a storyboard for this type of interview. Another approach is to shoot this as a wide master shot as the subject goes through and talks about the activity. Have someone take notes, or watch the shot afterward, then shoot a series of cutaways and

close-ups, including match action close-ups (hands in the right place, moving in and out of frame, etc.) that are designed to cut with the master shot. If there are enough cutaways, using the video and audio from the master shot as a framework, the editor can create a trim and smooth "show and tell."

THE WALKING INTERVIEW

Sometimes when a reporter is an on-camera presence, the reporter and interview subject could be walking, riding, or doing some activity together. They might be walking through the subject's neighborhood, touring a factory, museum, or some other space while the interview subject points things out. This requires a shooting strategy so the material can be edited later. Cutaways are critical. When the subject points to something, make sure to get a shot of whatever is being pointed to that can cut with the interview. If possible, include shots of each person listening to each other as they walk, and be sure to get some very wide shots where sync sound won't matter.

VISUAL EVIDENCE/B-ROLL

Always, always, always shoot some visual evidence of the interview subject in a different setting from the interview, even if you don't think you will need it. This might come in handy and help avoid jump cuts when you need to make audio edits in the middle of a sound bite. Try to have the subject do something related to the story, but even just a scene of the subject walking past the camera or into a building, sitting at a computer, or talking on the phone might be helpful in a pinch. This visual evidence might be a better way of showing the messy desk or other individual aspects of your subject without worrying about working those images into the interview setting.

WRITING THE DOCUMENTARY

The writer of the documentary is the person who organizes the material into a coherent story. If there is no narrator, the writer never actually writes anything; instead, they "arrange" sound bites and images. When there is a narrator, the writer both arranges images and sound bites and also writes the narration.

Sometimes producers might turn over all the raw materials of a film to an editor and ask him or her to create the film without going through a script step. In this case, the producer is asking the editor to be both the writer and also the editor. Some editors have the skills to do both, and there is sometimes a natural connection between writing and editing, especially in a documentary. But keep in mind that not all editors have writing skills. Also, many producers and other clients will insist on a written script step, because

working the script out in editing usually takes more time and is less efficient. Most of the time, documentary budgets control editing costs by delivering a detailed script to the editor before editing starts.

Transcripts are essential for interviews. The writer can quickly read through transcripts or conduct searches using his or her computer to find sound bites much more easily than watching or listening to video. The sound bites can be easily pasted into the script. Because you have everyone's exact words, you can often tell on paper whether sound bites will flow easily into one another, and you will know whether narration or set up is required to make a bite work.

You can transcribe the interviews yourself, but most likely you will want to budget for a paid service. Watch the interviews with the transcripts in front of you, highlighting sound bites you like and noting their time code within the clip. Sometimes an answer that reads well on the page won't sound good when you listen and watch it. Other times you might be surprised at something that does not read well on the page but is effective on the screen. If you are on an editing program, pull them into a bin or a time line.

It is more common in the documentary world for the producer to write the script. A long, complex film with lots of material could take weeks or even months to write. The writer must review and become familiar with all the assets of a film. The writer must watch every interview and every clip, and must be aware of all the graphics that are available.

In general, the best advice is to let the images tell as much of the story as possible. By this, I mean the writer does not have to tell us that the subject of the film grew up in a red house with two floors and a large yard if we can see the house in the shot. Instead, the script might just tell us that the subject of the film grew up in Brockton, while we look at the house. Together, the visuals and the narration provide a complete picture.

Let the documentary "breathe." By this I mean it's not necessary to have narration and voice-over wall-to-wall for every second of the film. When possible, let the action on the screen play out for the audience with sound full. You can drop in a brief line of voice-over when clarification is required. Sometimes it's also nice to raise the full sound up for a few seconds to help bring the viewer into the moment or to ease a transition.

Try to build scenes with multiple shots, even scenes with voice-over and narration. Instead of just one wide shot of someone doing something, be sure to use match action close-ups and cutaways to help the scene move along.

With interviews, when the subject is giving basic facts and information, or otherwise acting as narrator, you should try to find images to go over the interview. On the other hand, when a subject is discussing something emotional or otherwise gripping, it's often more desirable to let us watch the person as he or she speaks.

The script should show the exact words of everyone who speaks. The writer will cut and paste the bites from the transcripts. It might also provide information about where the bite and other visuals can be found.

Documentary scripts always use the two-column format, with video information on one side and audio information on the other. Many popular script-writing programs such as Celtx and Final Draft have two-column options. It's also fairly easy to construct a two-column script in most word processing programs using the table feature.

Here is an example of a two-column script. The first few rows suggest a sequence, but leave it up to the editor to construct the sequence. When the script says "Sound Up," it instructs the editor to use the sync sound recorded with the B-roll. The first actual sound bite is introduced in Row 4. A new row is created when either the scene changes or the person speaking changes. It's a matter of judgment. The numbers are useful when discussing the script with others.

	VIDEO	AUDIO
1.	Build sequence of people gathering at the starting line for race. Shots in *Bin—"Race Start."*	Sound up
2.	Race starts.	Sound up—gun shot.
3.	Shots of race in progress, focusing on Gary Jones when possible. Include shots of people cheering the runners. *Bin—"Race."*	Sound up
4.	CU of Gary Jones running. Shots in *Bin—"Race." Sub Bin—"Jones."*	GARY JONES *(Bin GJones—Clip 002)* I had a heart transplant about six months ago. I started running again just two months ago.
5.	Finish line as Gary Jones crosses.	Sound up
6.	Sequence of Jones as he is hugged and congratulated by friends and family. *Bin—"Race Finish."*	Sound up
7.	Continue sequence of Jones as he is hugged and congratulated by friends and family. *Bin—"Race Finish."*	GARY JONES *(Bin GJones—Clip 021)* When I first was told I would need a heart transplant, I thought my life was over. I'm really surprised to be here today.
8.	Continue sequence of Jones as he is hugged and congratulated by friends and family. *Bin—"Race Finish."*	JANE JONES *(Bin GJJones—Clip 008)* I remember the day we first got the call that a heart was available. It was raining, and we had all but given up hope. Gary was feeling very weak that day.

EDITING THE DOCUMENTARY

Documentaries often present special challenges for editors. Unlike narrative films, where the producers control everything that happens and carefully plan and shoot for the edit, documentary filmmakers often find themselves in situations where they have no control over

what they are shooting and can't always get adequate coverage. So while the goal of the documentary editor, in most cases, is to follow the rules of film grammar, there are often times when documentary film requires editors to invent unique solutions that test or expand the rules of film grammar.

It's best if the editor can review all the raw footage before the edit begins. If time is limited, the editor should at least become familiar with all the B-roll; sometimes the simplest little shot will catch the editor's eye and become useful at some point during the edit.

Always keep the sync audio with the B-roll. Mix it under any narration, voice-over, or music that might also be on the track. The B-roll is more effective if the audio is there. The choice to not use the audio is an effect, and must be justified by some special purpose.

On occasion, especially for projects with a tight deadline, the producer, writer, and/or director of the film might work directly with the editor, sitting with him or her during the entire edit, providing direction and guidance, making decisions together.

BUDGETS

Be sure when budgeting a film that you consider all your costs, even items that apparently don't have any cost because you already own them, such as a camera or editing computer. In reality they do have a cost, of course. Some of this equipment will depreciate in value and eventually require replacement with newer technology, and most of it will require insurance and maintenance from time to time.

You can calculate these costs and charge a rental fee for equipment you own. You can also make a profit by charging more than the actual cost, which is what an equipment rental company does. Even if you cannot collect the rental fee, or don't intend to collect it, you can use it to estimate the value of your in-kind contribution or investment in the project. If you base the fee on what a rental company will charge for the same equipment, you will have the necessary cash to rent equipment if yours breaks. If it doesn't break, you have made some profit.

Be sure to consider all costs including office space, travel, food, parking, transcriptions, outside services, acquisitions, music, and sound. Budgets are generally detailed estimates of future spending required to complete your film, and are necessarily educated guesses as to what something will cost. Often the estimates are based on experience, which is the best and most accurate way of making an estimate. People with many years of data about actual spending can make very precise estimates on future spending.

If you do not have a lot of experience, consult the various vendors you might hire. The cinematographer can estimate how long it will take to shoot and light interviews and B-roll, the editor can estimate how long to edit the film, and so on.

One other thing to keep in mind is that the cost of many resources is based on time, or could be evaluated based on time. For instance, staff members are paid based on the number

of hours, weeks, or months they work. Equipment is rented by the day, week, or month. Many services are also billed by the hour, day, month, or some other time frame.

If a company owns equipment or has employees, it will often establish an hourly or other time-based rental rate and charge clients and projects for use of the equipment or employee, even if the equipment is paid for or the employee is a staff person who would be paid anyway.

Below is a sample budget with a list of typical costs that might be found in a documentary:

ACCOUNT NAME	NO.	UNITS	NO.	UNITS	UNIT PRICE	TOTAL PRICE
PERSONNEL						
Producer	1	PERSON	26	WEEKS	1,500	39,000
Associate Producer	1	PERSON	26	WEEKS	950	24,700
Production Assistant	1	PERSON	26	WEEKS	600	15,600
Business Manaager	1	PERSON	26	WEEKS	1,200	31,200
Videotape Editor	1	PERSON	12	WEEKS	2,000	24,000
ubtotal						134,500
enefits 30%						40,350
Total Personnel						174,850
ADMINISTRATION						
Office Space	1	YEAR	1,000	SQ. FEET	25	25,000
Office Furniture	1	YEAR	4	DESKS	150	600
Computers/Peripherals/Network	1	YEAR	4	MACHINES	2,000	8,000
Copying	12	MONTHS	250	COPIES	0.05	150
Telephone	12	MONTHS	4	PHONES	150	7,200
Internet	12	MONTHS	1	CONN.	150	1,800
Office Supplies	12	MONTHS	4	PEOPLE	50	2,400
Legal	12	MONTHS	1	LAWYER	1,000	12,000
Insurance	1	YEAR	1	POLICY	3,000	3,000
Total Administration						60,150
TRAVEL						
Airfare	3	PEOPLE	3	TRIPS	600	5,400
Hotel	3	PEOPLE	9	NIGHTS	150	4,050
Per Diem	3	PEOPLE	9	DAYS	50	1,350
Ground Transportation	3	PEOPLE	9	DAYS	50	1,350
Total Travel						12,150
PRODUCTION						
Camera Person	1	PERSON	15	DAYS	350	5,250
Audio Person	1	PERSON	15	DAYS	350	5,250
Camera Package	1	PACKAGE	15	DAYS	1,200	18,000
Audio Package	1	PACKAGE	15	DAYS	300	4,500
Special Equipment	0	PKG	0	DAYS	0	0
Catering/Lunch	3	PEOPLE	15	DAYS	15	675
Total Crew/Equipment						33,675

ACCOUNT NAME	NO.	UNITS	NO.	UNITS	UNIT PRICE	TOTAL PRICE
POST PRODUCTION						
Transcripts	1	PRGM	10	HOURS	150	1,500
Narration Record	1	PRGM	3	HOURS	150	450
Narrator	1	PERSON	2	SESSIONS	850	1,700
Editing System	1	PRGM	12	WEEKS	500	6,000
Sound Design/Mix	1	PRGM	40	HOURS	150	6,000
Graphics Design	1	PRGM	50	HOURS	150	7,500
Total Post-Production						23,150
MUSIC						
Rights	1	PRGRM	25	DROPS	500	12,500
Music Editor	1	PERSON	25	HOURS	50	1,250
Total Music						13,750
STOCK FOOTAGE						
Rights	1	PRGRM	300	SECONDS	35	10,500
Work Prints	1	PRGRM	10	COPIES	150	1,500
Researcher	1	PERSON	120	HOURS	50	6,000
Total Stock						18,000
GRAND TOTAL						335,725

SOME SUGGESTIONS FOR WORKING WITH PEOPLE

Always be completely honest, direct, and clear in your dealing with any subject. You are asking them to be honest and open with you, so you must be honest and open with them. Never force, trick, or mislead the subject. Be honest about your own motives and goals. Try to see it from the subject's point of view. Understand why the subject wants to appear in your film. Understand why the subject might not want to appear. Do not force the subject by glossing over or minimizing legitimate concerns.

Don't start a project if you have not cleared all key issues with the subject. You don't want to discover after production begins that you can't shoot the competition or that he or she can't get you those crucial old photos.

Be clear with the subject about how much time you will need with him or her, and at each location. Send the subject a detailed schedule for each day of the shoot—as far in advance as possible—for their approval. Be clear about the time at the location vs. subject's time. As an example: "We need ninety minutes to set up, an hour for the interview, and thirty minutes to pack up. If we get there at 10 and have immediate access to the room, we can start the interview at 11:30, be done by 12:30, and packed up and gone by 1. Does that work for you?"

After you have negotiated details with the subject, send her or him a detailed note, in writing, reviewing the details. By being detailed and specific about what you need,

discussing the precise arrangement for each item on your list, clarifying who is responsible for what, and sending all of it in writing, it's much less likely someone will blow you off. If possible, do critical tasks yourself. Don't rely on the subject of your film to call their building manager to arrange for parking, for instance. It might not get done. Stay in touch with the subject and check in by phone a few days prior to the appointment to remind her or him.

RELEASE FORMS

It is advised that everyone who appears in your film sign a release form, and anyone who provides visual materials for your film also sign a materials release form. The form provides legal protection for everyone involved.

ORGANIZING AND MANAGING YOUR DOCUMENTARY PROJECT

Even if you are organizationally challenged, you will want to make an effort to manage and organize the materials and information required to make your film, using some sort of a rational system. Even people who are used to muddling through projects with minimal organization will get lost and confused when working on a film. Most films have so many moving parts that failure to organize can be catastrophic. Few unorganized people succeed as producers. Organizational skills can be learned, however, by just paying attention.

Your project will have many types of files, but broadly speaking they might be divided into three main categories. You might want to keep these in separate sub-folders.

Original Media—This refers to the contents of P2 or other storage cards. You could keep these in a separate sub-folder or even on a separate drive as an additional means of backup.

Assets—These are the media files required to build your film. Every film clip, audio clip, still photo, graphic, animation, and other media is an asset. These will include clips derived from the original media, and other material from a variety of sources.

Data Files—These could be scripts, transcripts, notes, spreadsheets, contact lists, editing software files that hold the edit information, and similar documents.

The key to a well-organized project is consistency. Develop a consistent way to name each file and stick to it. The consistency will help you navigate your material quickly and easily. A consistent naming scheme makes it easier to share files, sort files, quickly spot a specific file in a list, and search for files in a directory. The exact naming scheme can be anything you want, but here's a possibility you can adapt and modify to your needs. The project is called Country Day School.

<project>_<type or description>_<version or sequence number>.<ext>
CDS_Contacts_01.xls
CDS_beachscene_01.mov

CDS_beachscene_02.mov
CDS_TranscriptWJ.docx
CDS_Script_01.doc

BACKUP

Before you start a project make sure you have a backup plan for your digital files. Consider maintaining at least three separate copies of your files, which is now becoming an industry standard, but in no case should you have less than two. The simplest way is to create a project folder and make exact copies of that folder on the backup drives. Update the copies periodically, at least weekly, and perhaps more frequently, especially when new media files are added to the project. Once the media files stabilize, updates can be less frequent. There are a variety of other backup schemes, including incremental backups and frequent incremental backups (Time Machine, etc.) that you should explore.

The main problem backups are designed to address is drive failure. Although sometimes files can be recovered from a failed drive, the process is expensive, time-consuming, and can seriously set back a project. Sometimes the files are lost forever. A backup copy can be put back to work immediately, especially if an exact copy of the project folder on the drive that failed and there is no loss. A new backup should be created immediately.

Another reason for a backup is to allow a project to recover after a catastrophic event in the space where the drives are stored. If there is a fire, flood, or other disaster, the project is lost if all copies of the project files are stored in the space that's destroyed. To avoid this possibility:

Designate a main disk drive fast enough to work directly with your editing software and has adequate space for your project. Keep this in your work space.

Designate at least one backup drive that you can keep at a separate location from your main drive. This drive can be a cheaper, slower drive.

Designate a third drive for copy number three (this might be your frequent incremental backup). You may keep this drive in your work space.

FINALLY

These are the nuts and bolts of documentary filmmaking. While the process of creating them, as you read, is arduous at times and often very tedious, organization and discipline matter because that will leave the time and reflection you will need to create the compelling story you want to tell. That is the reason documentary filmmakers do what they do. We are storytellers. And when an audience experiences our film, we want them to be as interested and as excited about our story as we were to discover it and to tell it on the screen. The rewards of that can be immeasurable, both personally and professionally. Good luck in your work!

ART COHEN is an Emmy-winning filmmaker and journalist whose credits include PBS, National Geographic, WGBH, A&E, The Family Channel, USA Network, and WCVB, Boston. Cohen is also a reporter and anchor for the CBS–owned-and-operated all-news radio station WBZ-AM in Boston, and teaches in the film and video program at the New England Institute of Art in Brookline, Massachusetts. He has won eight New England Emmy awards.

He began his broadcast career in 1967 at public radio station WFCR-FM in Amherst, Massachusetts, where he rose to the positions of news director and program director. He was also news director at WMAS in Springfield, Massachusetts, and executive producer for news and public affairs at public radio station WBUR-FM in Boston, Massachusetts.

He began his television career at public television station WGBY-TV, in Springfield, where he produced a series on the environment titled *The Habitat Project*. In 1976, he joined WGBH-TV in Boston as a reporter for its news program and later produced a series of local documentaries and public affairs specials for WGBH. He has produced for the PBS medical series *Bodywatch* and was senior producer for *The Western Tradition*, a fifty-two-part instructional series on the history of Western civilization funded by CPB/Annenberg. He also produced segments and programs for the daily magazine show *Chronicle* on WCVB-TV in Boston. Since 1994 he has worked with Oceanic Research Group and Jonathan Bird Productions making underwater nature films, and is currently working on the syndicated public television series *Jonathan Bird's Blue World*.

Cohen is also a member of the board of directors of the *Gay and Lesbian Review Worldwide*, a magazine of criticism and ideas for the LGBT community.

ACKNOWLEDGEMENTS

BY MARY CARDARAS

FIRST, A HUGE THANK you to my research assistant, student, and aspiring documentary filmmaker, Kristi Stewart, who has been invaluable in getting this text to market. In fact, it was documentary film that changed her life and professional trajectory.

Thanks to the authors who participated in this anthology: Dr. Ted Barron of Notre Dame University; Sara Archambault of The DocYard; Tim Jackson, musician, teacher, writer, documentary filmmaker; Dr. Mark Levy of California State University, East Bay; Judith Erhlich, a filmmaker I greatly admire; Jacob Kornbluth, another filmmaker, who inspired me from the first time I met him; Jason Osder, Susan Muska, Greta Olafsdottir, and Charlie Paul, who have all produced and continue to produce wonderful films; Louise Vance, a veteran producer, writer, and teacher; and Art Cohen, a veteran journalist, producer, and teacher. Your work will inspire students to support documentaries and to seek out your films, both in progress and also those in the future.

Thanks to my students, who were the impetus and inspiration for this book. And to my colleagues in the Department of Communication at California State University, East Bay, especially Dr. Kate Bell, my friend, my confidante, and my thinking partner as we work to strengthen long-form journalism and encourage students to get into a profession we have both loved.

And last, but certainly not least, enormous gratitude to my family—Francesca, Harrison, Nicholas, and C.J.—for their enduring love, support, and patience.

ABOUT THE AUTHOR

MARY CARDARAS is on the faculty at California State University, East Bay, and is Chair of the Department of Communication. She teaches journalism courses, documentary film studies, documentary producing, politics, and media courses. She built the television, radio broadcasting, and digital film department at the New England Institute of Art and served as its chair for thirteen years. She has been teaching college journalism courses since 1991 at universities including LaSalle in Philadelphia; Syracuse, London campus; American International University, Richmond, UK; and Northeastern in Boston. Cardaras wrote and produced for CNN in Boston, Atlanta, and London. She also wrote and produced for World Television News in London and for numerous news departments in five major markets across the United States, spanning more than thirty years in journalism. She has conducted media training workshops for students and professionals in the Arab world and in Vietnam. She is the recipient of two Emmy awards for excellence in spot news producing and feature producing, and has been nominated numerous times during her journalism career. She continues to produce television programming and documentaries. She worked extensively with the Coolidge Corner Theatre Foundation in Brookline, Massachusetts, and with the American Repertory Theatre at Harvard University where she served as executive producer for the documentary *Chaos & Order: The Making of American Theater*. She served as President and Vice President of the Board of the Provincetown International Film Festival and also was its college liaison. Mary curated and managed the juried student film competition for PIFF. She holds a MS from Northwestern University in Broadcast Journalism and holds a PhD in international affairs and public policy and published her first book, *Fear, Power & Politics: The Recipe for War in Iraq After 9/11*, on the media and the Iraq War of 2003. She is currently in production on *This Just In*, a documentary about a renaissance currently underway in the news business as told through the stories of two, veteran award-winning female journalists, who should be retiring but are doing anything but because of their love of journalism and its importance to the country. Mary is also in post-production on the documentary short, *Sunday Dinner*, about food, tradition and the love of family—"A Chinese Story as American as apple pie." Mary is also building a longtime passion project, College Newsnet International (CNI), where student journalists and filmmakers from around the world will be able to post their stories and their documentary films.